Art and the Power of Placement

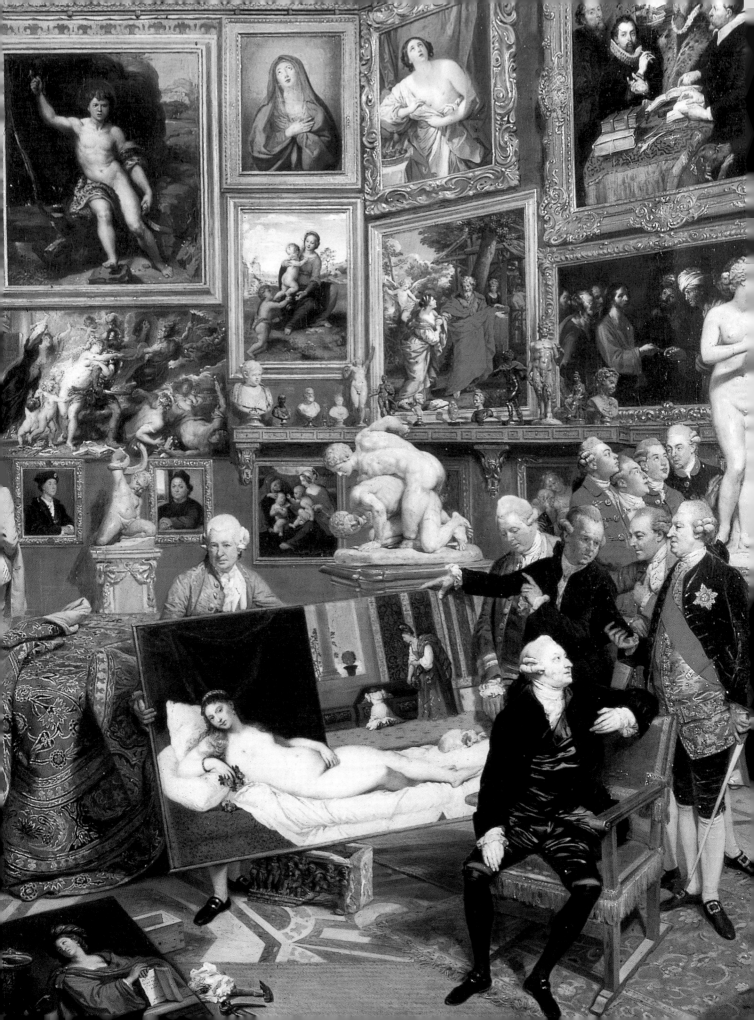

Art and the Power of Placement

Victoria Newhouse

THE MONACELLI PRESS

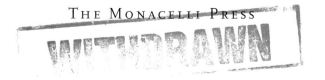

First published in the United States of America in 2005 by
The Monacelli Press, Inc.
611 Broadway, New York, New York 10012.

Library of Congress Cataloging-in-Publication Data
Newhouse, Victoria.
Art and the power of placement / Victoria Newhouse.
p. cm.
Includes bibliographical references and index.
ISBN 1-58093-148-0
1. Art—Exhibition techniques. 2. Museum techniques.
3. Site-specific art. 4. Aesthetics. I. Title.
N4395.N49 2005
707'.5—dc22 2004026136

Printed and bound in Italy

Designed by Pandiscio Co. / William Loccisano

Unless otherwise noted, captions list artworks from left to right.

Cover: *Nike of Samothrace* (c. 190–180 B.C.), Louvre, Paris
(Réunion des Musées Nationaux/Art Resource, New York).

Frontispiece: Johann Zoffany, *The Tribuna of the Uffizi* (1780),
detail (photograph © Raffaello Bencini, 2003).

Paintings, like people, have characters that need to be respected and "the effect of hanging can show them to their best advantage or constitute their downfall."

—Colin Bailey, citing Diderot and d'Alembert's *Encyclopédie*

This book owes its existence to three great scholars: Richard Brilliant at Columbia University, Brunilde Sismondo Ridgway at Bryn Mawr College, and David O'Connor at the New York University Institute of Fine Art. Without their advice and encouragement, I would never have dared navigate the perilous waters of ancient history.

Research was facilitated by the diligent work of Elizabeth le Cornec, with the help of Susan Train in Paris, Tobias Kämpf in Rome, and Andrea Milanese in Naples. Sabina De Cavi, Virginia Budny, the late Joel Honig, Sheree Jaros, and Annalisa Marzano contributed to the effort. Larry Busbea helped with all aspects of the research, and especially with tracking down elusive illustrations and obtaining permission to publish them.

Fabio Barry, Kathleen Christians, and Giorgio Ortolani in Rome, Rita de Maria in Naples, and Valerio Pappaccio in Herculaneum were all tremendously helpful.

Yvonne Dohna generously shared with me her recent findings on Canova's role in museum making, as did Chrystina Häuber her work on find spots for the *Laocoön*. Carol Mattusch allowed me to read an early draft of her manuscript on the Villa dei Papiri in Herculaneum and the sculptures excavated at that site. For everything related to the Villa dei Papiri and to the J. Paul Getty Trust's relation to it, I owe a special debt to Marion True, curator of antiquities and assistant director for villa planning.

Museum curators and staff members everywhere provided invaluable information and insights. To all of these I extend my thanks, and especially to Dorothea Arnold, Kevin J. Avery, and Gary Tinterow at the Metropolitan Museum in New York; Sylvia Ferigo-Pagden and Helmut Satzinger at the Kunsthistorisches Museum in Vienna; Gabriele Finaldi at the Prado in Madrid; Krzysztof Grzymski at the Royal Ontario Museum in Toronto; David Jaffé at the National Gallery in London and his former associate there, Amanda Bradley; Geneviève Lacambre at the Musée d'Orsay in Paris; Jeremy Lewison at the Tate Modern in London; Martine Moinot at the Centre Culturel Georges Pompidou in Paris; Gwyn Miles at the Victoria and Albert Museum in London; the late James Romano at the Brooklyn Museum of Art; Anna Maria Donadoni Roveri at the Egyptian Museum in Turin; John Taylor at the British Museum in London; the late Kirk Varnedoe at MoMA in New York; and Christiane Ziegler at the Louvre in Paris.

The manuscript benefited from the suggestions of a number of readers. Jane Kaskell, Brian O'Doherty and Barbara Novak, Mark Rosenthal, Suzanne Stephens, and my husband, Si, read and critiqued the book as a whole. Francis V. O'Connor's contribution was essential to the Jackson Pollock chapter. Charles Beye, David DeLong, Rita Freed, Alex Gorlin, Lauren Kinnee, Clemente Marconi, Marilyn Perry, Robert Rosenblum, Nan Rosenthal, Susan Stein, Ealan Wingate, and Christian Witt-Dörring made helpful suggestions for sections of the work. For translations of German- and Italian-language texts, I am indebted to Alexandra Bonfante-Warren, Gisela Brett, Karin Ford, Philip Glahn, Uta Nitsche-Stumpf, and Mary Lou Selo.

Like my last book, *Towards a New Museum,* this one took shape under the expert editorial guidance of Robert Gottlieb. The text was further refined by the skillful editing of Andrea Monfried and the conscientious copyediting of Mary Norris, all fault-lessly word processed by Sasha Porter. Gary van Dis and his team provided computer re-creations and plans. Design and production proceeded smoothly thanks to the talent and patience of Richard Pandiscio, Evan Schoninger, and Elizabeth White.

Introduction

Marcel Duchamp gave one of the most famous and influential demonstrations of the power of placement in 1917 when he transformed a common urinal into a Modern sculpture simply by displaying it upside down in an art gallery. Placement has affected the perception of art, however, since the first cave paintings. Where an artwork is seen— be it in a cave, a church, a palace, a museum, a commercial gallery, an outdoor space, or a private home—and where it is placed within that chosen space can confer a meaning that is religious, political, decorative, entertaining, moralizing, or educational. Placement can even affect aesthetic and commercial values, boosting or diminishing an artist's reputation. It is a key issue in the appreciation of art.

Placement—also referred to as presentation, arrangement, display, hanging (for pictures), and more recently, installation[1]—comes into play whenever and wherever a movable art object is seen. Among the myriad contexts in which art has been viewed, I have chosen examples from different historical eras and in different media to illustrate the interaction between what is displayed and how it is displayed. *Art and the Power of Placement* is not a survey; rather, it is a selection of case histories that demonstrate how placement affects perception and meaning. In my last book, *Towards a New Museum,* I selected museums that demonstrated the close relationship between architecture and art; for this book, I have chosen displays that highlight the link between presentation and art.

With few exceptions, art books, museum catalogs, and Web sites depict objects in isolation, with no indication of their settings, so it is easy to overlook the extent to which the perception of these objects is influenced by their presentation. Take, for example, the legendary Colossus of Rhodes (c. 280 B.C.), a 110-foot bronze representation of the island's patron Sun deity, Helios. Counted among the Seven Wonders of the World,[2] it stood for only fifty-some years before it was toppled by an earthquake. A medieval conceit had the Colossus straddling the harbor entrance, where ships would have passed between the legs of the giant male nude, their masts grazing its exposed genitalia (fig. 1). The placement conveyed a powerful image of

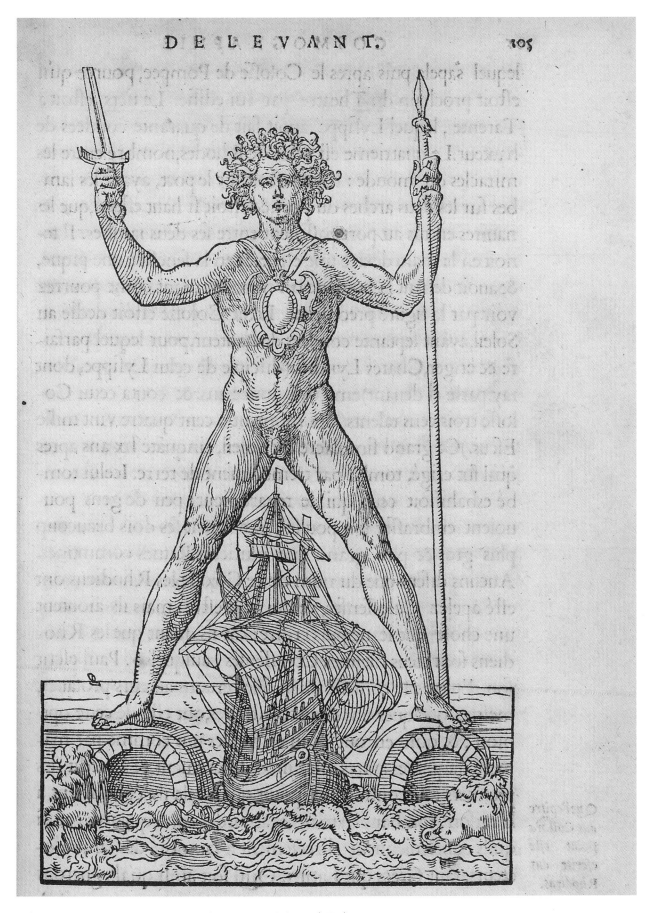

1. Colossus of Rhodes, from André Thévet, *Cosmographie de Levant* (1556).

male domination that would have been weakened in a more conventional installation. The idea was a complete fantasy, technologically unrealizable at the time,[3] but it was apparently irresistible to centuries of male-oriented societies. Responding to this aggressively masculine image, artists from the Middle Ages to the eighteenth century portrayed the statue astride the harbor. And despite numerous recent disclaimers, this is still the image replicated for tourist souvenirs.

Another instance demonstrates how placement can actually change the meaning of an artwork. Michelangelo's monumental marble *David* was commissioned by Florence's Opera del Duomo for a buttress of the cathedral. But in 1504,[4] as the statue was nearing completion, Michelangelo and the consuls of the wool guild[5] requested that a commission come up with alternative sites. The stellar array of artists on what today would be called a site-selection committee—among them Leonardo da Vinci, Botticelli, Ghirlandaio, Filippino Lippi, and Michelangelo himself—decided to place it in front of the town hall (fig. 2).

Had the *David* adorned the cathedral, he would have been a biblical hero; in front of the town hall, he became a symbol of the city government. Placed high up on a rostrum and parapet (now demolished)[6] next to the entrance portal and boldly facing south toward Rome, the *David* was seen by many in Florence as a warning to their Goliath: the exiled Medici who opposed the Florentine Republic[7]. The statue (replaced by a copy in front of the town hall) now stands lower in a gallery specially built in 1873 in Florence's Accademia; its sole connotations are those of an artistic masterpiece.

Placing art need not be considered on such a heroic scale. In the context of a private home, the simple act of hanging a painting requires important decisions: the choice of a room, the positioning within the room, the juxtaposition of other objects, lighting, wall color, and wall texture. Even the floor is a factor: a hard, shiny surface reflects light, sound, and color quite differently from soft, sound- and light-absorbing materials.

Waller Hopps, a former director of the Pasadena Art Museum (now the Norton Simon Museum) in California and the Corcoran in Washington, D.C., enjoys a reputation for masterly installations. Hopps insists that "the values change in a room when even one picture is moved: it's like the way a dinner party changes according to the guests."[8] When a picture is seen near a work of the same period or with others by the same artist, its style and composition are more readily apparent than if it is seen alone or accompanied by works of different periods or by other artists. Paintings hung in an asymmetrical arrangement can appear more decorative than they would in a straightforward display. And positioning at eye level a painting meant to hang over a door, or in some other skied (elevated) position, completely alters its impact, as do straight-on views of architectural sculpture intended to be seen high up on the exterior of a building.

In one New York apartment, three Modern paintings hang together near nineteenth-

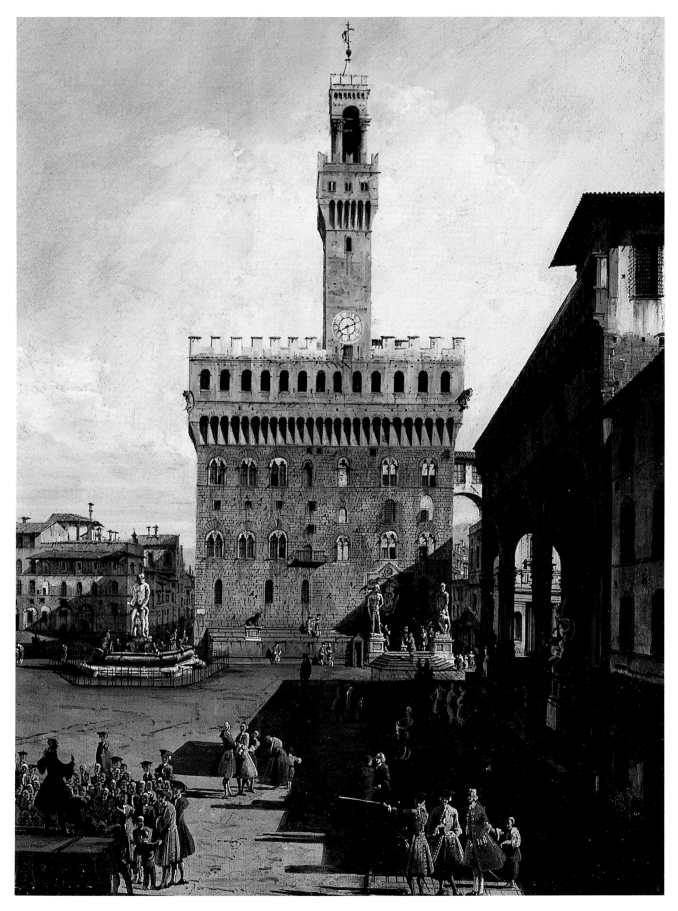

2. Bernardo Bellotto, *View of the Piazza della Signoria* (1740–45), detail showing artist's interpretation
of original placement of Michelangelo's *David* on parapet by entrance portal.

3. Private collection: Pablo Picasso, *Cafetière, Tasse et Pipe* (1911); Andy Warhol, *Do It Yourself (Violin)* (1962); Piet Mondrian, *Composition (with Large Red Plane, Blue, Gray, Black and Yellow)* (1921); in foreground, Alberto Giacometti, *Small Walking Man in the Sun IV* (1950).

century furniture in a grouping that would be unlikely in a museum: Picasso's Analytic Cubist *Cafetière, Tasse et Pipe* (1911), Warhol's Pop Art *Do It Yourself (Violin)* (1962), and Mondrian's abstract *Composition (with Large Red Plane, Blue, Gray, Black and Yellow)* (1921) (fig. 3). And certainly in a museum Giacometti's *Small Walking Man in the Sun IV* (1950) would never be placed as low as it is here. But the hang brings out surprising relationships, such as Picasso's and Mondrian's use of similar strong vertical and horizontal black lines, and the sculpture's height is ideal for viewing by people sitting on the couch.

Another residence integrates art with the artifacts of everyday life in a more unified manner. Two collectors of cutting-edge contemporary art used references to nature as a means to expand their loft space. The astonishing custom-made furniture they commissioned in imitation of leaves and flowers harmonizes with the landscape depicted in *Big Hole* (1989) by the English duo Gilbert and George (fig. 4). The bold visual dialogue between art and decor creates a dramatic *Gesamtkunstwerk*—a total environment in which all elements complement one another in a stagelike setting.

An Egyptologist and his wife, whose holdings were recently dispersed, had a different concept. To avoid what could have been a museumlike interior, they scattered their collection amid furniture and art from other periods and cultures (fig. 5). The brown

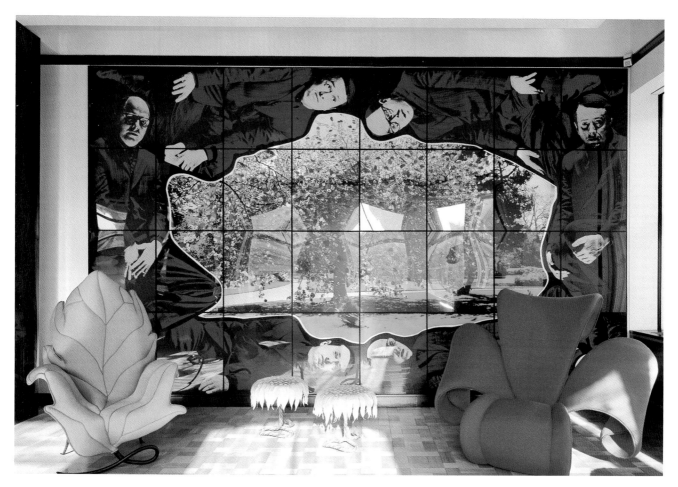

4. Private collection: Gilbert and George, *Big Hole* (1989); furniture by Gaban O'Keefe and George Warrington.

quartzite head of a Middle Kingdom nobleman was positioned so that a ceiling spotlight would illuminate the face's delicate modeling. Beside it stood a small table by the early-twentieth-century French artist/cabinetmaker Louis Majorelle, with a drawing of the same period by Gustav Klimt above it, and, on the table, a Gallé lamp and a carved wooden Egyptian foot, possibly New Kingdom. A spotlit New Kingdom black basalt bust stood at the other side of the table.

In each of these residences, placement was governed primarily by how the artworks could be best appreciated rather than by decorative considerations. Even when display conditions fall short of what might be considered ideal, art can be more compelling in a lived-in environment than in an antiseptic museum space. The artist Dorothea Rockburne says, "Although paintings might have to fight for their life, they look better in a home than in a museum because they're alive, you feel them; they haven't been intellectualized and categorized historically."[9] That art is enlivened by a personal sensibility, even when dwellings are made public, is acknowledged by the extraordinary popularity of house museums like the Frick Collection in New York, the Isabella Stewart Gardner Museum in Boston, and the Wallace Collection in London.

Historically, the nature of the art patron determined subject matter and placement. The Catholic church, for instance, commissioned inspirational altar paintings; local

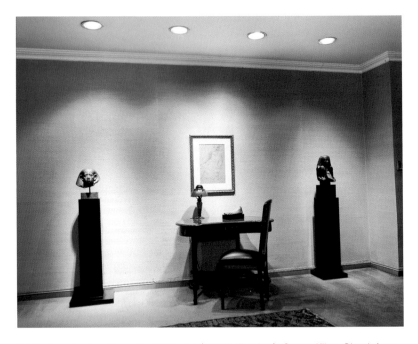

5. Private collection: *Head of a Nobleman* (Middle Kingdom); Gustav Klimt, *Sketch for a Portrait of Mrs. Blochbauer* (c. 1900); Louis Majorelle table with Gallé lamp and carved wooden foot (possibly New Kingdom); *Head and Torso of an Official* (c. 700 B.C.).

governments called for large works that preached civic virtues in public buildings. The numerous private princely collections that were opened to the public in Europe in the eighteenth century replaced these motives with an educational purpose that is still operative.[10] Public museums placed objects in a completely different way, used a different vocabulary to describe them, and addressed a different audience.[11] Among other changes, museums imposed clear directions for movement through their galleries, presenting "walk-by" viewing that after 1750 developed into chronological organizations emphasizing history rather than artistic quality.[12] All of this was intended for the many, unlike private or most religious environments, which offered static, solitary contemplation for the few. Without the constraints of public display, private collectors have always placed their holdings according to their own personal agendas, typically for aesthetic pleasure, social and/or political prestige, and entertainment. Viewing preferences have changed over time just as taste and the art market have changed, always with a decisive influence on the object.

How art should be displayed was already a hot topic in antiquity. Cicero (106–43 B.C.), for one, relied on the concept of decorum: matching artworks to given spaces. The Roman politician and philosopher deemed statues of athletes, intellectuals, mythological heroes, and divinities appropriate for one of his peristyle gardens because they were associated with the physical and intellectual pursuits at the Greek *gymnasia* on which the garden was modeled (see pages 92–94).

On the other hand, two centuries later, Lucian described statues apparently chosen by a wealthy Roman collector for their quality rather than for their associations with a specific place. In what he described as a "gallery"-type display in a courtyard, these statues were regarded as masterpieces; in Cicero's garden, the sculpture was primarily ornamental.[13]

From the late fifteenth century until well into the seventeenth, many collectors favored the *studiolo* and the cabinet of curiosities. Not only did the small rooms impose close-up viewing limited to a handful of people, but arrangements within them conformed

6. *Studiolo* of Isabella d'Este, Mantua (c. 1519), reconstruction.

7. *Grotta* of Isabella d'Este, Mantua (c. 1519), current state.

to specific intentions. Painting, sculpture, medallions, and other precious objects in the *studiolo,* and natural objects in the cabinet of curiosity, were placed in carefully thought-out programs typically devised to evoke a microcosm of the observable world, with the owner in a central position of power.[14]

In the context of a cabinet of curiosities or a *studiolo,* small objects were grouped in loose categories, like material or function, which anticipated museum classifications. The *studiolo,* with its more open display, was closer to the museum as we know it. The

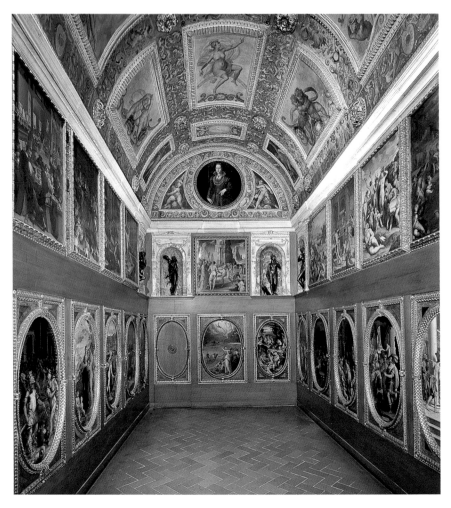

8. *Studiolo* of Francesco I de' Medici, Florence (c. 1570).

cabinet was more often than not windowless to ensure undistracted, solitary contemplation,[15] while this was only occasionally the case for the *studiolo*.

Isabella d'Este, a daughter of the duke and duchess of Ferrara and one of the great patrons and collectors of the Renaissance, seems to have been obsessed with installation. From the 1490s on, she spent thirty years decorating two versions each of a *studiolo* and a *grotta*, or artificial grotto, at the medieval Gonzaga Castle in Mantua[16] (figs. 6, 7). By 1519, these were located in two small adjoining rooms: the *studiolo* was only slightly larger than the *grotta*, which measured just nineteen and a half by ten and a half feet.[17] They are the first known arrangement by a woman of spaces specifically for an art collection.[18]

For the *studiolo*, the marchesa commissioned moralizing mythological and allegorical subjects—chosen to celebrate her own virtues—from the greatest painters of her time, among them Mantegna and Correggio.[19] Isabella voiced her opinion on everything from canvas dimensions and the size of figures to lighting conditions (each room had a window) and the sequence in which the paintings were hung.[20]

The *grotta* was more like a cabinet of curiosities in its eclectic accumulation of precious man-made objects and natural bizarreries such as a unicorn horn and snail shells.[21] Just as Isabella designated the placement of paintings in the *studiolo*, she decided how to distribute bronze and marble statuettes in the *grotta*.[22] It was, in fact, her installations, as much as the actual objects, that produced such a great impact. By

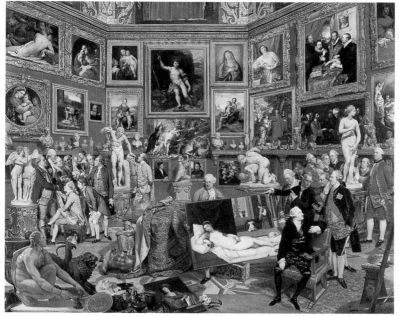

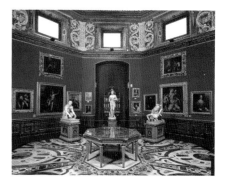

9. Johann Zoffany, *The Tribuna of the Uffizi* (1780), with shelf and drawers still visible.

10. Uffizi Tribuna, Florence (2004).

juxtaposing mythological paintings with old and new sculpture, the marchesa inspired learned discussions that made her chambers the center of the court's social life and lent her status in the political hierarchy.[23]

The fate of a *studiolo* modeled on Isabella's in 1575 by Francesco I de' Medici in Florence (where the family had long since been reinstated) forecast the waning, toward the end of the seventeenth century, of such settings for art. The prince adopted a decorative program (devised by Giorgio Vasari and Vasari's friend Vincenzo Borghini) in keeping with his interest in science: paintings and bronze statuettes represented the connections between art and nature, with subjects related to the four elements[24] (fig. 8). Starting on the ceiling and continuing downward on the windowless walls were representations of water, air, earth, and fire; on the doors of cabinets in which the designated objects were kept, symbols of the elements served as visual labels.

Begun by Francesco, the dismantling of the room, undertaken just over a decade after its creation, and the transfer of much of its contents to the generously proportioned, daylit Tribuna of the family's Uffizi Palace, represented a major change in viewing practices.[25] Solitary, meditative viewing was replaced by more sociable observation; torchlit silence gave way to sunlit animation; reverence was replaced by the qualitative evaluation of art. The drastic change in the space's scale and in the quantity of work displayed anticipated the flamboyant extravagances of the Baroque era.

Francesco based the decor of the octagonal Tribuna on the same allusions to the elements that had inspired the program for paintings and sculpture in his *studiolo*.[26] The dome's oyster shells represented water; the special window of its lantern, air; the floor's marble and semiprecious stones, earth; and the red velvet of its walls, fire. Additionally, the family arms and heraldic colors (red, blue, and gold) figured prominently in the room. At its center was an ebony art cabinet of Francesco's own design. This piece of furniture, of a type common in the Renaissance courts of northern Europe, was the true *studiolo*, containing treasures that evoked, in miniature, episodes of the owner's life.[27]

So at the outset, although the Tribuna was more accessible than the *studiolo*,

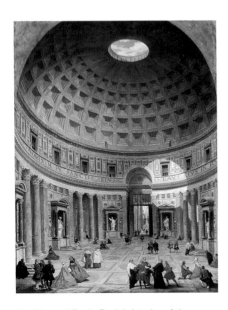

11. Giovanni Paolo Panini, *Interior of the Pantheon, Rome* (c. 1734).

12. Anton Maria Zanetti the Younger, inventory (1736), Public Statuary, Venice, designed by Vincenzo Scamozzi (c. 1590).

Francesco's installation was still conceived as the microcosm of a world that glorified him. Furthermore, the room retained many secrets: small curiosities remained hidden, well into the eighteenth century, in drawers below a shelf attached to the walls at eye level[28] (fig. 9). In 1743, the Uffizi, with the Tribuna its centerpiece, became a public museum. Eventually, the drawers disappeared and the room revealed its contents fully. Remarkably, the Tribuna has remained much as Francesco conceived it, but since its symbolism is unknown to the millions of visitors who now pass through it each year, the transition from private to public is complete (fig. 10).

Other Renaissance collectors devised installation programs based on context—especially classical settings for antiquities—rather than on self-promotion. The Pantheon was a favorite model. Daylight from the Roman building's central dome was considered ideal for viewing both paintings and sculpture;[29] the niches and enclosed tabernacles of its rotunda were particularly suited to the display of sculpture (fig. 11). It was the Pantheon to which the architect Vincenzo Scamozzi looked as he designed a gallery in which to exhibit the outstanding collection of several hundred Greek and Roman sculptures belonging to Giovanni Grimani, a Venetian church nobleman.[30] Located in the entranceway of the Biblioteca Marciana (which still stands facing the Doges' Palace), the gallery and its contents, known as the Public Statuary, were donated to the Republic of Venice by Grimani in 1596, becoming one of the first public museums (fig. 12).

About a decade later, Rubens added a Pantheon-like room to his house in Antwerp for the extensive array of ancient statues he had collected.[31] And by the late eighteenth century, the Pio Clementino in Rome had used the lessons of the Pantheon on a much larger scale, and to spectacular effect, for a public museum (see page 74).

In contrast to these historicizing settings, carefully created for sculpture since early in the sixteenth century, large groups of paintings were treated more casually. At this time, small panel paintings may even have been stored in drawers or closets until they were removed to accompany their owners on their travels. Even after paintings began

to be hung on walls, the practice of taking them down for close inspection seems to have persisted.[32]

By the latter part of the sixteenth century, artists in northern Europe were depicting spacious rooms in private residences with pictures stacked cheek by jowl and floor to ceiling, completely covering the walls. And for public exhibitions, like the ones organized by the French Royal Academy in Paris from 1663 on, the same type of display was adopted. In the early years of these state-sponsored shows of work by living artists—the precursors of the famous Salons—the organizers actually hung the overflow out-of-doors in the courtyard of the Palais Royal,[33] often so high that they could not be seen satisfactorily. In response to viewers' complaints about this offhand manner of display, in 1699, when the academy was allowed to move its exhibitions to the Grande Galerie of the Louvre, artworks were placed in a more respectful manner: paintings were lowered and given more space—although still stacked—and sculpture was shown against a background of fine tapestries (fig. 13). As in the private reception rooms this first Salon resembled, art was treated as decoration, its placement guided by the eighteenth century's obsession with balance and symmetry. This type of elegant installation, however, soon gave way to more mundane considerations.

Whatever pleasure and enlightenment the Salon provided, there was no mistaking

13. A. Hadamart, Salon of 1699, showing the first Salon held in the Grande Galerie of the Louvre.

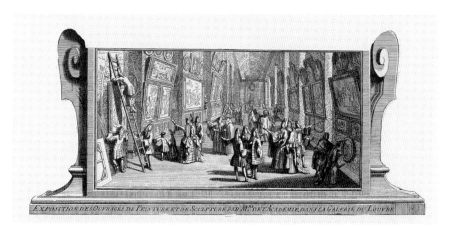

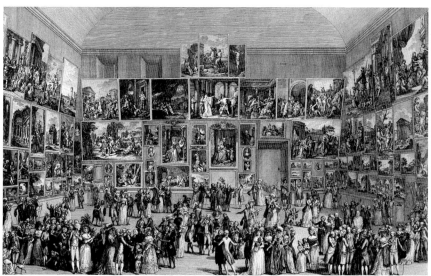

14. Pietro Antonio Martini, Salon of 1787, showing the exhibition in the Louvre.

the fact that such incentives were secondary to the exhibition's function as a marketplace. From the time of its inauguration until its abandonment by the state in 1880,[34] the Salon was the showcase par excellence for contemporary art—the equivalent of today's art fairs, but with church and state rather than private individuals as the prime clients. And commercial motivations soon completely outweighed all other considerations of how the art was presented. In a return to early, pre-Salon displays, the main criterion was the number of paintings that could be squeezed onto a wall[35] (fig. 14).

From some three hundred paintings and sculptures in early Salons, by the 1850s, the number of paintings had grown to more than five thousand; these were crowded together, with no regard for aesthetic compatibility or, for the most part, even for keeping together works by the same artist.[36] In Paris and London, where from the late eighteenth century the Royal Academy's annual exhibitions at Somerset House mimicked Salon installations, artists began to rebel against the system.

The British introduced the infamous "line," an eight-foot-high molding above which large canvases enjoyed greater prestige than the smaller ones below, a device that eventually found its way to Paris. Placed symmetrically in more controlled arrangements than those of their French counterparts, the canvases in London were nevertheless just as crowded and equally subject to the scattering of submissions by the same artist (fig. 15). To facilitate the installation and removal of paintings, artists were urged to use thinner frames than usual, producing a uniform effect.[37]

Dissatisfied with display techniques, as well as with the selection process endorsed by the London and Paris academies and by the international expositions inaugurated at mid-nineteenth century, a number of painters took matters into their own hands. In England, as early as the 1780s, Gainsborough withdrew works to protest the Royal Academy's poor lighting; Turner followed suit some twenty years later with the creation of his own gallery.[38]

In France too, there were artists who rejected an official context in favor of a personal

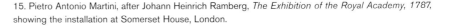

15. Pietro Antonio Martini, after Johann Heinrich Ramberg, *The Exhibition of the Royal Academy, 1787,* showing the installation at Somerset House, London.

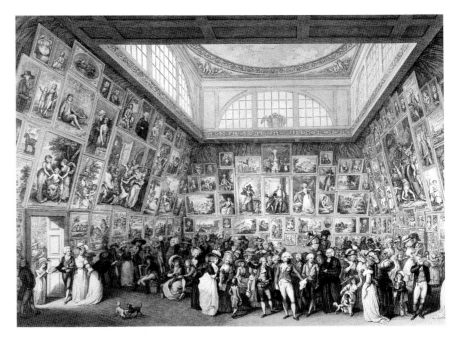

16. Frederic Bazille, *L'atelier, rue de la Condamine, 9* (1870).

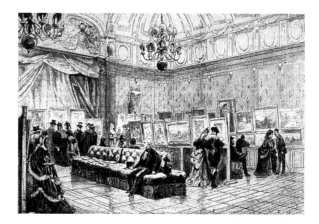

17. *Exposition de peinture au Cercle de l'Union Artistique.*

one. Jacques-Louis David in 1799 and Gustave Courbet in 1855 and again in 1867—with Edouard Manet imitating his example—were among those who sacrificed the sales potential of official venues in order to control the way their work was seen. In much the same manner, artists in the 1970s began to adopt alternative exhibition spaces. Today, installation artists are among the post-studio practitioners for whom the site is an intrinsic part of the work[39] (see figs. 27–29, 32).

David's choice and arrangement of his own exhibition spaces and his use of large mirrors to display large paintings were particularly inventive.[40] For the exhibition of his *Sabine Women* (which measured approximately seventeen by twelve and a half feet) in 1799 and for other extremely large paintings later in his life, the artist controlled how the pictures were seen. *The Sabine Women* was placed in a well-lit room at the far end of which a mirror reflected it. The viewer was thus encouraged to scrutinize details at close range, to step back and take in the entire composition, and then to observe the painting's reverse image in the distant mirror. The paid exhibition lasted for five years and brought the artist considerable profit and acclaim together with some criticism. For this installation as well as for those he devised for sizable works in the 1820s, the painting was presented as the mirror of itself—art reflecting art—instead of as the mirror of nature, as tradition had it. David's installations were intended to produce a quasi-religious, contemplative mood, a concept that became increasingly popular as the nineteenth century progressed.

When Degas and the Impressionists began to organize group exhibitions in 1874,

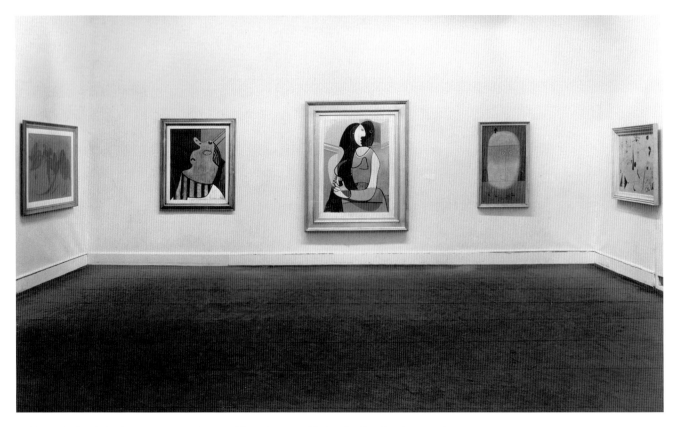

18. "Fantastic Art, Dada, Surrealism," curated by Alfred Barr, Museum of Modern Art, New York (1936–37).

they too chose small spaces such as the photographer Nadar's former studio, where viewers could focus their undivided attention on the paintings, generously spaced in two rows on well-lit, fairly neutral-colored walls.[41] The artists modeled rooms on their studios and residences and embellished display spaces with draperies like those in private galleries (figs. 16, 17); they introduced plain white frames as a substitute for gilt, and eventually frames that blended with the wall tones. Rocking chairs and settees were added in an attempt to re-create the domestic environment for which this work was intended.

In London, James McNeil Whistler extended the concept even to the guard's uniform in an elaborate white and yellow environment that he designed for an exhibition of his etchings at the Fine Arts Society in 1883.[42] Almost simultaneously in Paris, the idea of creating a residential setting for the exhibition of art was summarily rejected by Seurat and the Neo-Impressionists on the ground that it relegated art once again to the status of decoration. By 1886, the Neo-Impressionists were insisting on achromatic walls and the complete removal of draperies and plants from the gallery.[43] In their deliberate separation of art from its setting, this group paved the way for the sparse white-cube galleries that became standard in the twentieth century.[44]

With the new, Modern vision of art as a self-sufficient entity, rather than as a functional, religious object, an illusion of reality, or a decoration, came the tendency to isolate it in so-called neutral spaces, removed from everyday life. Inspired by European innovations in the late 1920s, especially in German museums such as the Folkwang in Essen, the concept was adopted and canonized in the 1930s by the founding director of the Museum of Modern Art (MoMA). Alfred H. Barr Jr. startled the museum-going public by substituting for tiered hangings in traditional decorative interiors eye-level,

single-row alignments of generously spaced, chronologically ordered paintings on stripped-down walls covered with unobtrusive beige cloth. Explanatory labels, often grouped at the entrance to a gallery, linked works historically and conceptually to convey the overall nature of a room or an exhibition[45] (fig. 18).

In its attitudes toward installation, however, Modernism was no more constant than other eras. While Barr and his disciples treated art as something sacred to be studied and communed with from a respectful distance, avant-garde artists took the opposite stance. The First International Dada Fair in Berlin in 1920 and the International Exposition of Surrealism in Paris in 1938 are but two instances of artists using presentation to reinforce the message of the art, and to enlist the viewer's interaction with it,[46] and beginning in the 1950s, the classic white cube has in turn been continuously challenged.[47]

Even the preference for old-fashioned, stacked hangings was never completely abandoned. In the semiprivate museum he founded in 1925 in the Philadelphia suburb of Merion, Albert Barnes adopted a symmetrical, tiered hang for his superb collection, placing paintings in idiosyncratic visual relationships with, for instance, antique wrought-iron hardware, tribal and folk art, antiquities, furniture, and porcelain (fig. 19).

Now, in the early twenty-first century, despite the elaborate legal provisions to maintain the museum as its founder left it, Barnes's personal vision is threatened by a court ruling that would allow the collection to move to downtown Philadelphia. The protracted struggle to break Barnes's will in order to accommodate potential donors to the financially strapped institution vividly demonstrates how charged an issue installation can be. In Renaissance Venice, Grimani's installation of Greek and Roman statues survived for more than two centuries, until the arrival of Napoleon. In the faster-moving present, Barnes's installation may last for only a fraction of that time.[48]

That neighbors of the Barnes Foundation wish to control traffic and parking is understandable at a time of phenomenal growth in the audience for art. The current annual attendance of five million at New York's Metropolitan Museum of Art compares with three and a half million twenty years ago; it is matched by the Louvre's present 6.1 million, up from under three million in the early 1980s.[49]

Increased attendance has generated an endless cycle of mounting costs, met in turn by attempts to augment income by attracting ever more visitors. As Philippe de Montebello, director of the Metropolitan Museum, says, "The competitive hyperactivity of most museum programs today is no longer the glow of health but the flush of fever."[50] And in addition to widespread emphasis on museum stores and gourmet restaurants (food—at a café—and public art display were first combined at the 1857 Salon),[51]

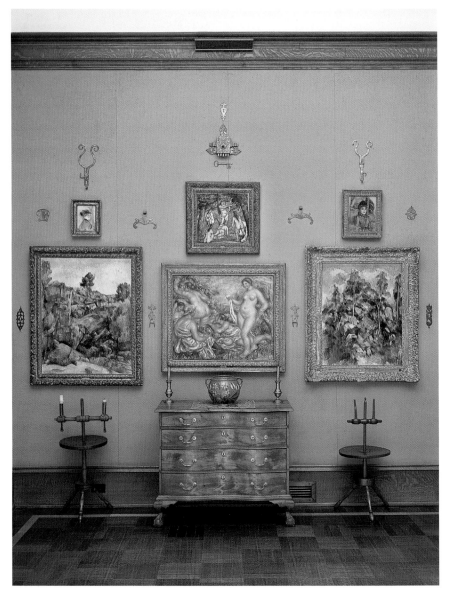

19. Barnes Foundation, Merion, Pennsylvania (founded 1925): at center, Renoir, *Bathers* (c. 1918), flanked by Cézanne, *Rocks and Trees* (c. 1900) and *Bibemus Quarry* (1898); above, Cézanne, *Five Nudes* (late 1870s), flanked by two small portraits by Renoir; antique wrought-iron hardware; Chippendale bureau; Moravian pot.

institutions are often faulted for upstaging exhibited objects with popularizing installations and sensation-seeking architecture, designed to maximize marketability rather than to enhance the art.[52]

Staffs devoted exclusively to exhibition design have been in place at major American museums since the late 1960s, using an array of devices previously undreamed of. Sound and occasionally smell, re-creations of the place in which the art was made, and suggestions—or replicas—of the setting in which it was first seen, not to mention ever-present videos and Acoustiguides, are now common fare.

Ironically, apart from technological innovations, much of what now seems new has in fact been around for some time. There is just much more of it, and it is more widely publicized and more competitively conceived than ever before. From the moment, about

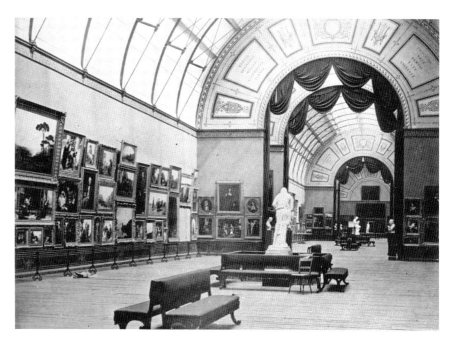

20. "Art Treasures of the United Kingdom," Manchester, England (1853).

two hundred years ago, when architects began to design the first purpose-built museums, they have been criticized for including self-indulgent "luxuries" with no functional justification.[53] And today's quest for intimacy at private institutions like the Pulitzer Foundation in St. Louis (2000) harks back to the first Impressionist exhibitions and to the *studiolo* before them, just as the frenzy of today's art fairs repeats the chaos of the Salons and international expositions.

The Dutch architect Rem Koolhaas has described the current museum visit as an experience of body parts, in which artworks are "subsumed by motion, noise, smell and the physical presence of flesh."[54] But the same noise, crowds, and deterrents to serious viewing that characterize today's most popular temporary exhibitions and tourist destinations were all in place for "Art Treasures of the United Kingdom," Manchester's blockbuster of 150 years ago (fig. 20). Not only did the sponsors of that phenomenal nineteenth-century art extravaganza erect an enormous structure expressly for the exhibition, but they built a special railroad station to facilitate access for the 1.3 million people who visited the show within four months.[55]

Nor is the competition between art and popular entertainment new. In London already in the 1770s, one-man and eventually single-painting, or Great Works, exhibitions drew on every conceivable commercial ploy to attract visitors. Typical of such ventures was Théodore Géricault's 1820 display of his *Raft of the Medusa*. For the painting's exhibition at the Salon of 1819, the young artist made the mistake of having the picture placed too high in the Louvre's monumental Salon Carré, an installation that defeated his effort to make viewers feel as if they were among the men on the raft.[56] Hung far above eye level, the painting lost the close engagement of its audience; figures reportedly appeared scaleless and the composition without perspective; even the colors seemed monochromatic.[57]

These failures were rectified the next year in London, where the painting was shown at William Bullock's Museum at Piccadilly,[58] known as the Egyptian Hall because of its Egyptian Revival architecture. The gallery offered a carnival-like combination of art and

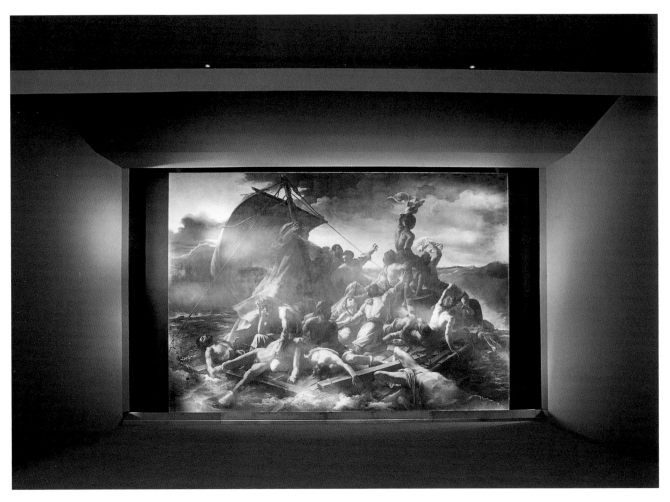

21. Tate Britain, London (2003): Pierre-Desiré Guillemet and Etienne-Antoine-Eugène Ronjat, after Théodore Géricault, *Raft of the Medusa* (1859–60).

curiosities that included stuffed animals, twenty-five thousand fossils, and Napoleon I's armored coach seized at Waterloo. Bullock's flamboyant advertising of Géricault's show, with its emphasis on the *Raft of the Medusa*'s size and its lurid evocation of shipwreck, starvation, and cannibalism, was designed to compete with popular attractions of the day such as live military reenactments and panoramas. (These last, often featuring battle scenes painted on hundreds of feet of canvas that surrounded visitors in specially built rotundas, were a favorite entertainment throughout the nineteenth century.)[59]

Bullock placed *Raft of the Medusa* relatively close to the floor in its own gallery, to bring viewers back into the picture, so to speak. Positioned at the raft's edge, they felt like participants in the drama. The canvas's isolation, low hang, and focused illumination at the Egyptian Hall were loosely reconstructed in 2003 for the "Constable to Delacroix" exhibition at London's Tate Britain, which featured a full-size nineteenth-century copy of the *Raft* in lieu of the original (fig. 21). Hung in a small, specially designed room, the picture almost completely filled the end wall and was further compressed visually by a gentle inward slope of the walls, floor, and undulating ceiling, all of which were dark gray. The gallery was unlit except at the painting's sides and from a shallow pit at its foot, creating a glow of artificial light simulating the daylight that would have illuminated the canvas in the earlier London installation and making the scene appear to float in space.

Bullock was branded a "Barnum" by his contemporaries,[60] but for all its theatrical

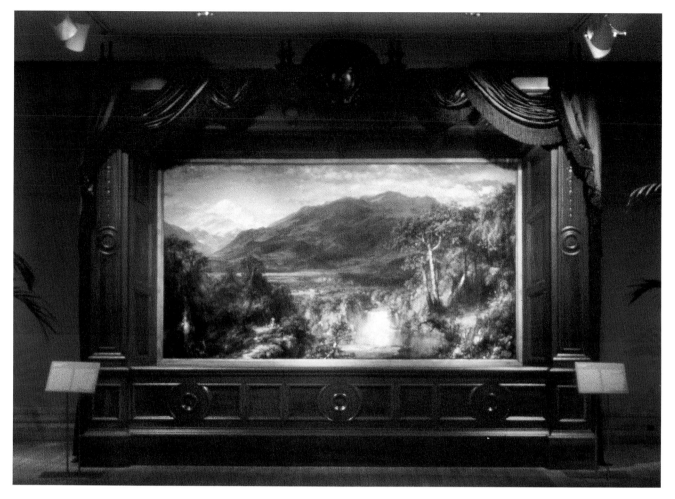

22. Metropolitan Museum of Art, New York (1993): Frederic E. Church, *Heart of the Andes,* reconstruction of 1859 display.

gimmicks, his show contributed to a new critical assessment of *Raft of the Medusa*.[61] His sensitive installation—seen without the political implications the painting had in France—must certainly have influenced the responses of British critics, more generally favorable than those of the French to the Salon display. As was usual for solo exhibitions, Géricault provided a low-grade lithograph as an inexpensive souvenir that fed into the commercial nature of the enterprise. The show was a tremendous success, attracting some forty thousand visitors in seven months at an average admission fee of one shilling and providing the artist with substantial receipts.[62] (Attempts to introduce paying exhibitions in France, beginning with David and continuing through the 1855 World Fair, were never successful.)[63]

American artists were quick to pick up the financial implications of such methods. To arrange and publicize the exhibition in 1859 of his monumental *Heart of the Andes* at New York's Studio Building (still standing on West Tenth Street), Frederic E. Church hired John McClure, a promoter with a proven record in displaying British blockbuster paintings.[64] McClure may also have helped devise the picture's spectacular installation.

In an evocation of a stage proscenium, Church placed the painting in a gargantuan neo-Renaissance black walnut frame; the elaborate cornice held a curtain rod from which rich green swags were draped (fig. 22). The frame stood on the floor, probably against the short wall and opposite the entrance of a thirty-by-forty-foot room, two

23. Charles Saatchi Gallery, London (2003): Damien Hirst, *The Physical Impossibility of Death in the Mind of Someone Living* (1991); Chris Ofili, *The Holy Virgin Mary* (1996); Damien Hirst, *Hymn* (1996); Sarah Lucas, *Au Naturel* (1994) and *Human Toilet* (1994); Ron Mueck, *Dead Dad* (1996–97).

stories high. The skylight was masked, and the walls were either painted black or draped in dark fabric to reinforce the impression that light emanated from the painting itself, a panorama technique that Bullock had also used for his installations. The arrangement seemed like a window casement, and *Heart of the Andes* was seen as if it were a real landscape, an impression that was reinforced by the recommendation that viewers use opera glasses to examine the picture, as well as by two descriptive booklets written in the manner of travel guides.

Critics deplored Church's mix of ideal and real, which, like Bullock, earned the label "Barnumesque." But the public loved it. Daily attendance averaged over five hundred, and in the last days of the three-week exhibition, long lines of people waited for hours to get in. Not only was Church enriched by the gate (twenty-five cents per person) and

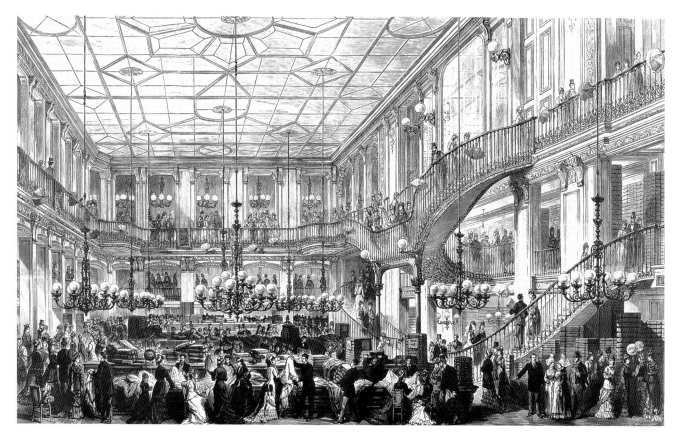

24. Central Gallery, Grands Magasins du Louvre, Paris (1877).

by subscriptions for the obligatory engraving, but the exhibition, which traveled to six American cities, established him at the pinnacle of the New York art world.

By the latter part of the nineteenth century, presenting art in theatrical settings as paid entertainment had become quite common for single-picture exhibitions. For the display of his panoramic landscape *Domes of the Yosemite* at the Studio Building in 1867, Albert Bierstadt went so far as to construct two balconies from which spectators could view the work, a gesture that anticipated alternatives to straight-on viewing that began to appear in the 1950s. Frank Lloyd Wright's Guggenheim Museum in New York, where visitors look across the rotunda to upper and lower ramps, is one example.

Today, the English advertising genius Charles Saatchi is branded by the press as the art world's "Barnum."[65] His extravagant promotion of an exhibition of controversial contemporary art—he called it "Sensation: Young British Artists from the Saatchi Collection"—was the equivalent of William Bullock's insistence on the horrific in *Raft of the Medusa*. Equally commercial motivations prompted Saatchi's relocation in 2002 from a remote, stripped-down modern gallery in West London to a forty-thousand-square-foot space in a showy Edwardian building—London's former town hall—at the center of one of the city's most popular tourist areas (fig. 23). But like Bullock before him, Saatchi enriches the London art scene, in his case by bringing national artists to international attention.

Saatchi's exhibitions exemplify the crossover between culture and commerce that is so characteristic of the art world today. The current exchange has its roots in the 1850s, when the first department stores, such as the Bon Marché in Paris, enticed

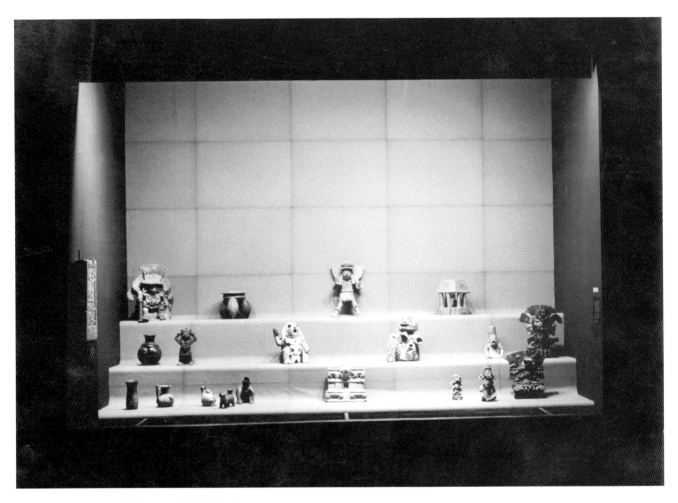

25. "Twenty Centuries of Mexican Art," MoMA (1940).

customers with display techniques eventually adopted by museums. Once the focus of pious worship and sensual delight, then a means of moral and intellectual improvement, art eventually became—and remains—an object of consumer desire.

In the 1860s and 1870s, the palatial Beaux-Arts buildings occupied by Marshall Field's in Chicago, Macy's in New York, and the Grands Magasins du Louvre in Paris resembled contemporaneous museums. Like museums, stores displayed selective concentrations of merchandise, albeit grouped by function rather than by age or national origin (fig. 24). Toward the end of the nineteenth century, fanciful displays, art galleries, and restaurants became routine attractions in the new temples of commerce.[66]

In 1904, Mitsukoshi in Tokyo held the first exhibition of paintings in a Japanese department store: Rinpo works were shown in conjunction with the winning entries in a kimono design competition. The management's establishment three years later of a permanent fine-arts gallery on the premises was soon imitated by other leading department stores, and the tradition continues today.[67]

Encouraged by the success of the French department stores, the organizers of the two Paris Salons in 1889 treated visitors as avid shoppers amid seductive, commercially inspired displays.[68] Museums, however, were generally slower to adopt the Salons' ornamental and sensual decor, as evidenced by a comment made by retail magnate John D. Wanamaker in the early 1900s: "In museums most everything looks like junk

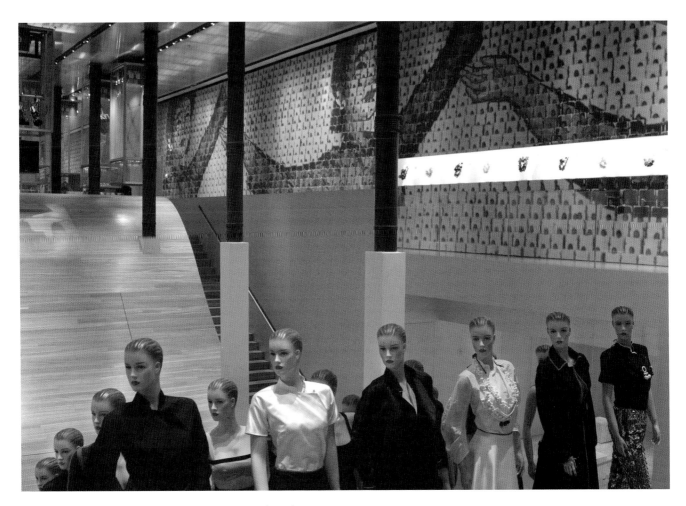

26. Prada, SoHo, New York, designed by Rem Koolhaas (2001).

even when it isn't, because there is no care or thought in the display. If women would wear their fine clothes like galleries wear their pictures, they'd be laughed at."[69]

Increasingly sophisticated art displays put museums in a no-win situation: they are criticized as commercial if they do and dowdy if they don't. In 1940, for its exhibition "Twenty Centuries of Mexican Art," MoMA was faulted for making art "look like goods in an elegant Fifth Avenue shop window."[70] Yet to an early-twenty-first-century eye, the show's installation looks fairly standard for the time (fig. 25); one multilevel arrangement is not very different from the Metropolitan Museum's permanent display of Oriental porcelain at the top of the grand stairway.

At the outset of the third millennium, the commercial/cultural exchange continues. For aggressively competitive museums, as for retailers, display has become a sophisticated form of show business. At the SoHo branch of Prada in Manhattan (2001), for instance, Rem Koolhaas provided dramatic open-link cages for clothing displays and removed most of the main floor to create an amphitheater. Films are screened and performances take place in a spectacular wavelike structure that opens into a stage. Stepped seating also serves to show shoes and fashion (fig. 26). Likewise, many successful European department stores are offering exhibits and performances in a throwback to the century-old cultural aspirations of their predecessors.[71]

Since the 1960s, artists themselves have developed the relationship, notably in

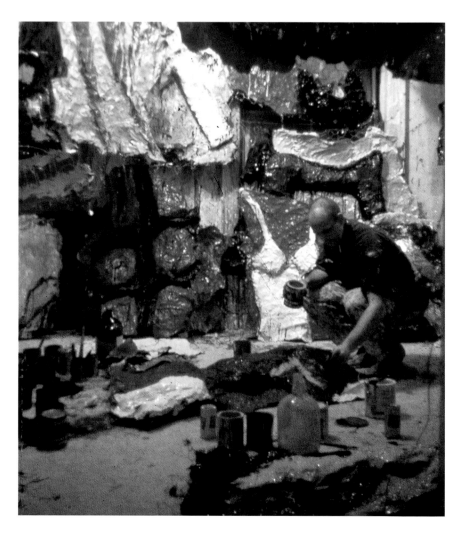

27. Claes Oldenburg, *The Store* (1961).

the case of Pop Art's images of mass consumption. With *The Store* (1961), Claes Oldenburg offered for sale, in a rented storefront, plaster and papier-mâché sculpture of everyday objects; the display was based on neighboring Lower East Side storefronts (fig. 27). *The Store* was followed in 1964 by the European Fluxus group's *Fluxshop* in Amsterdam, and in 1965 by Warhol's *Supermarket* at the Bianchini Gallery in New York.

In the early 1980s, Jeff Koons presented Hoover vacuum cleaners as art in what resembled a storefront display. The vacuums, stacked or paired in his series *The New,* were placed in Plexiglas vitrines lit by fluorescent tubes and exhibited in the windows of New York City's New Museum of Contemporary Art (fig. 28). Koons equated the object-lust of consumerism with Modernism's relentless pursuit of art innovation, comparing the semireligious aura of unused household appliances (virginal, implicitly immortal) with that of art objects.[72] The mirrored, retail-style showcases in which Janine Antoni placed heart-shaped chocolate boxes and tinted lard lipsticks chewed from six-hundred-pound blocks of the two materials for an installation entitled *Gnaw* (1992) are a more recent incorporation of consumer marketing devices into art (fig. 29).

For a retrospective of his work at the New York Guggenheim in 2000, the Korean video artist Nam June Paik provided yet another form of commercial/cultural crossover.

28. New Museum of Contemporary Art, New York (1980): Jeff Koons, *The New* (1979–80).

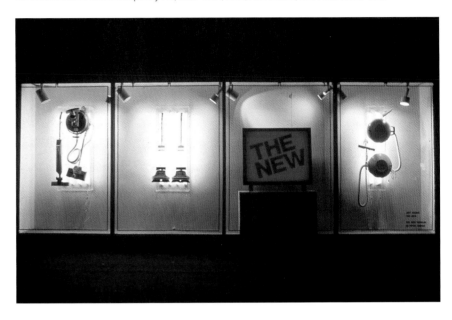

29. Janine Antoni, *Gnaw* (1992), lard and chocolate blocks, with chocolate boxes and lard lipsticks in mirrored showcases at back.

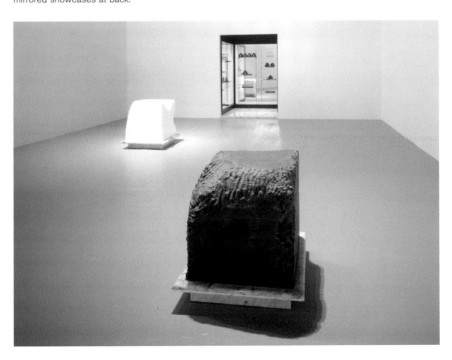

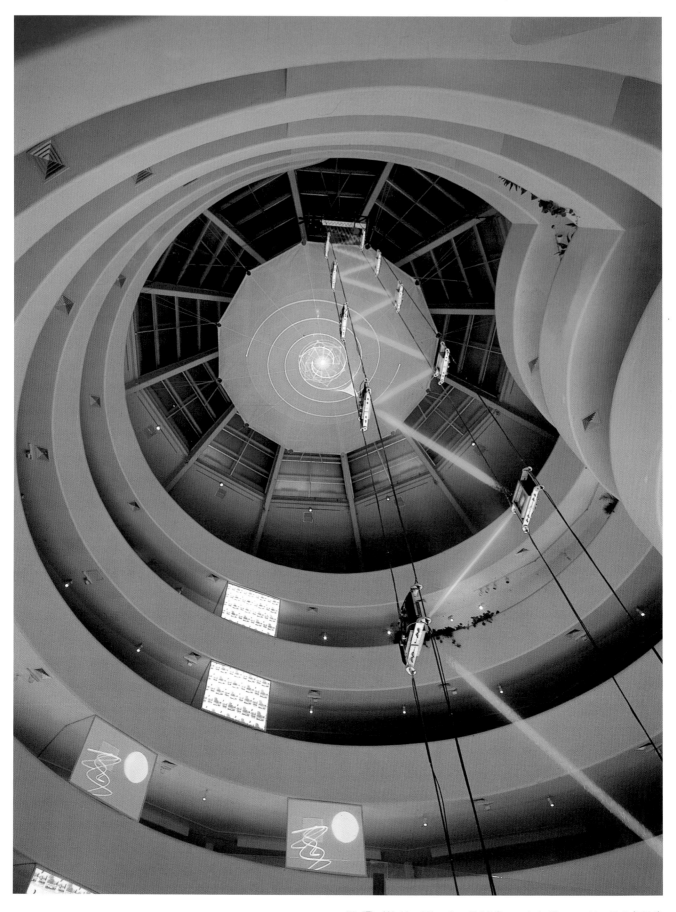

30. "The Worlds of Nam June Paik," Guggenheim Museum, New York (2000).

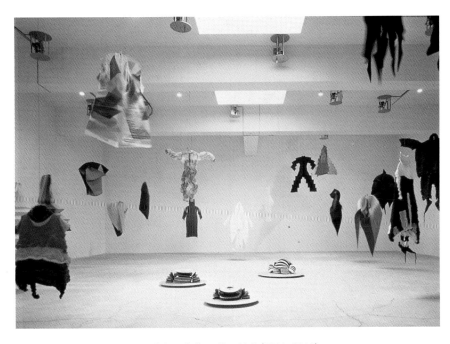

31. "Issey Miyake Making Things," Ace Gallery, New York (1999–2000).

Punctuating the museum's spiral ramp with video screens and adding music, along with a seven-story waterfall with a play of laser beams in the rotunda, Paik created an environment more like an early music video or a popular discotheque than a museum (fig. 30). The reverse took place when fashions were displayed as if in a museum, complete with "Do not touch the artworks" labels, for "Issey Miyake Making Things," a ten-year overview of the designer's work, at the Ace Gallery in New York in 1999–2000 (fig. 31).

Installation can determine the line between art and commerce. Paul McCarthy, an internationally acclaimed artist who works in a variety of media, presented *The Box* as an installation piece in the lobby of the IBM Building in New York City in 2001 (fig. 32). In a fifty-foot-long, twenty-foot-high wooden container, McCarthy created an exact, full-scale replica of his studio in Pasadena, with its clutter of boxes, tools, found objects, and video equipment. The box was presented on its side: set at ninety degrees, the floor became a wall, the wall became the ceiling, and so on.

An unusual billboard for Absolut Vodka, erected above a Manhattan construction site, also re-created an interior (fig. 33). The billboard's three-dimensionality, with IKEA furnishings, appliances, and even dishes and books built out from each "room" of the Absolut bottle-shaped surface, was in its own way as surprising and unsettling as McCarthy's *Box*. Both confounded expectations and were deliberately disorienting. Had it been in a museum, "Absolut New York" would have been perceived as an art installation. And in fact, the billboard found its way to a museum: for their exhibition "Absolut Stockholm, Label or Life—City on a Platform" at the Modern Museum Project in Stockholm in 2000–2001, two Dutch artists, Liesbeth Bik and Jos van der Pol, reconstructed "Absolut New York" at its original scale. The artists' only intervention was to spray-paint "Stockholm" over the original advertisement.[73]

Just as the relationship between art and commerce has deep historical roots, so do other aspects of display. Indeed, presentations rejected by one generation are frequently taken up by another, like old clothes that suddenly appear up-to-date. The thematic (rather than chronological) installations that were introduced in 2000 by several

32. IBM Building, New York (2001): Paul McCarthy, *The Box* (2001).

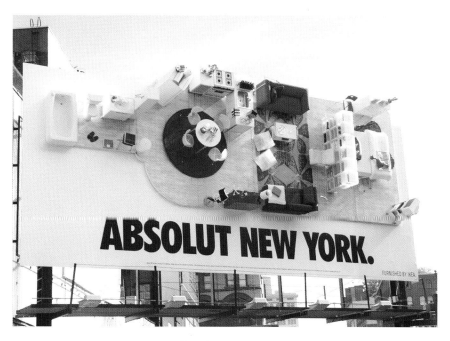

33. Absolut Vodka billboard, New York (2000).

major museums—among them, the Tate Modern in London and MoMA in New York—recalled the way antiquities were often exhibited in the eighteenth and nineteenth centuries. And tiered hangs, discarded by most museums after World War I, have also come back into fashion.

Since 1975, several American museums have adopted such installations for historic paintings. Both the Renwick Gallery in Washington, D.C.—in its Grand Salon, built in 1859—and the Metropolitan Museum in New York—in a 1980 approximation of a similar gallery—exhibit some of their nineteenth-century American paintings frame to frame, floor to ceiling, on brightly colored walls. In 1996, the Boston Museum of Fine Arts (MFA) reinstalled its Italianate Koch Gallery with Renaissance and Baroque paintings stacked on the walls, as they still are in Old Master galleries such as the Pitti Palace in Florence and the Doria Pamphili Gallery and the Villa Borghese in Rome (figs. 34, 35).

Not only do such installations re-create a historic ambience, but they have the practical advantage of accommodating many more pictures. George T. M. Shackelford, chairman of European art at the MFA, points out that the new installation released at least fifty paintings from storage.[74] A more subtle asset of grouping pictures tightly is the minimizing of less distinguished works, which are often shown for comparative purposes; the eye tends to pass over them and focus on their more important neighbors.

In 2000, the exhibition "Above the Line," at the Courtauld Institute in London's Somerset House, reconstructed an installation typical of those of the Royal Academy, which occupied the building from 1780 to 1836 (see fig. 15). The display prompted the art historian and curator Robert Rosenblum to remark that the sloping effect of large paintings high on a wall (as they were often positioned in the Paris Salons as well) made them loom larger and seem psychologically closer than canvases hanging flat nearer the viewer.[75] And Susan Moore, a London critic, went so far as to say that the show's historical hang "belied the modern orthodoxy that works of art can only be viewed in reverent isolation."[76]

It is not only for historical paintings that old-fashioned, crowded installations have

34. William I. Koch Gallery, Boston Museum of Fine Arts (1996).

been endorsed. In 1960, the late David Sylvester, a British critic and curator, reputedly "the most respected and sought-after hangman in the international art world," applauded Alfred Barr's "perverse hang of pictures from floor to ceiling."[77] Intended by MoMA's director to demonstrate the museum's need for more space, the installation had just the opposite effect on Sylvester, who described it as "marvelous."

Chuck Close is one of several contemporary artists who, for shows they have organized for others, prefer to cover gallery walls with artworks. The exhibition he curated at MoMA in 1991, "Head-On: The Modern Portrait," included paintings in dense arrangements; drawings, some propped on tiered shelves; and sculpture, placed on consoles attached to a wall (fig. 36).

A similarly traditional style of installation will serve the Emanuel Hoffmann Foundation's collection of experimental art at the Schaulager (viewing depot), a facility designed by Herzog and de Meuron and inaugurated in 2003 in Münchenstein, near Basel, Switzerland. For the depot's open storage, the director stacks art objects vertically on the walls, grouped according to medium and artist.

Whether viewing conditions resemble those of the past or herald something entirely new, they always affect our perception of art. Just how context and placement exert this influence is an elusive question, subject to the many factors that, together, constitute the spirit of an era. A few specific works from different periods, seen over time, demonstrate the implications of the charged zone where spectator and art object meet.

The first chapter, "The Complexities of Context," addresses the nature of the spaces where placement occurs.[78] Not surprisingly, the chapter begins with a museum—the Louvre in Paris—and the history of the increasingly prominent placements of the *Winged Victory of Samothrace (Nike)*. A completely different set of contexts comes into play for the *Laocoön,* which, except for one brief interlude, has never been seen in a museum gallery. Purchased at the time of its discovery in 1506 by Pope Julius II,

35. Poussin Room, Doria Pamphili Gallery, Rome.

Michelangelo's great patron, the *Laocoön* was soon put on display at the Vatican in a private outdoor garden. The complex transformations of that garden into a more formal, semi-enclosed courtyard that became part of the Pio Clementino Museum have had a devastating effect on the public's awareness of the sculpture. At the Getty Villa in Malibu, California, copies of ancient Roman bronzes will be exhibited in a copy of an ancient Roman villa, in turn copied from Greek antecedents. In substituting replica for reality, context replaces content.

The second chapter, "Art or Archaeology," describes the exhibition "Egyptian Art in the Age of the Pyramids," which originated in Paris and then traveled to New York City and Toronto. Here, it is the manner of display within the museum context that is at issue. In tracing the same objects from one exhibition to another, it becomes clear that installation can define the very nature of what is being shown. In Paris, at the Grand Palais, artifacts were presented in an archaeological setting that evoked the circumstances in which they were discovered. In New York, at the Metropolitan Museum, and in Toronto, at the Royal Ontario Museum, the same artifacts, in neutral settings, were shown as timeless works of art.

"Jackson Pollock," the third chapter, is concerned with the presentation of Modern artworks in museums and in other contexts: the studio, commercial galleries, and private residences. Pollock's largest works were greatly enhanced by the artist's own placements; in installations that ventured too far afield of these installations, the paintings lost their impact. The effect of placement on Pollock's paintings illustrates the sensitivity of all artworks to the way in which they are displayed.

In the concluding chapter, "Placing Art," I submit a number of recent displays that offer particular assets and liabilities. Instead of setting forth hard and fast rules that would soon become obsolete, I suggest some tentative guidelines. Among these are an awareness of the conditions in which the works were created and respect for how each artist intended them to be viewed.

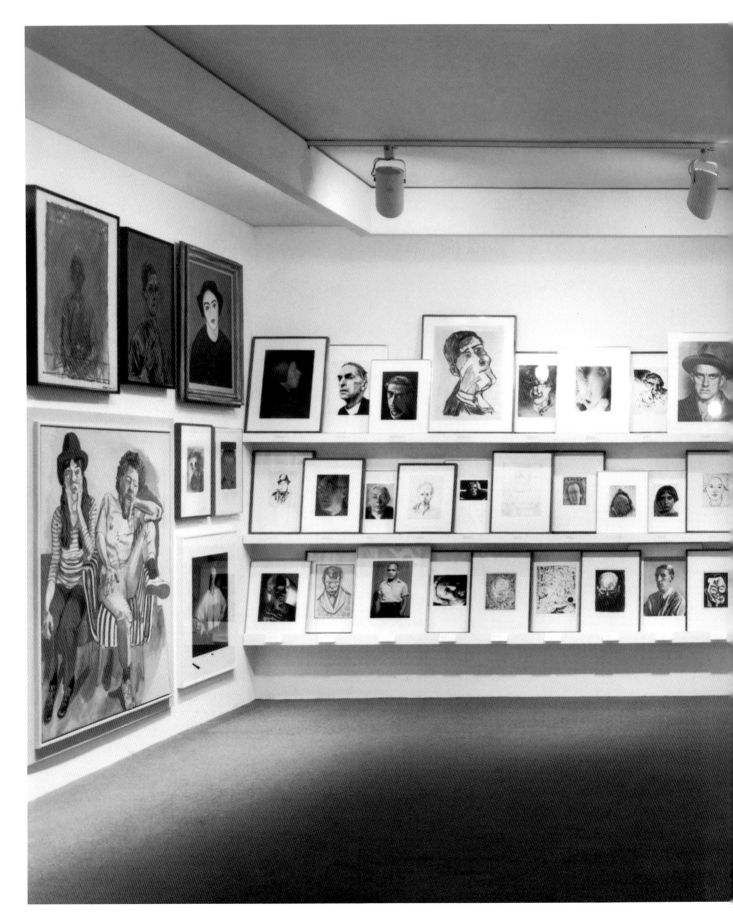

36. "Head-On: The Modern Portrait," curated by Chuck Close, MoMA (1991).

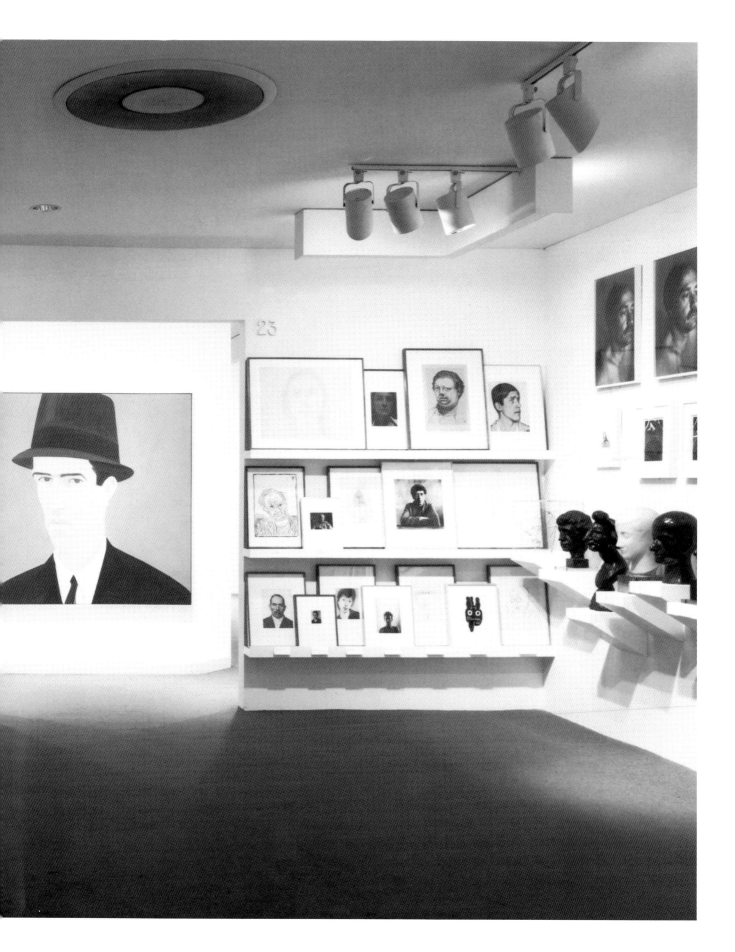

The Complexities
of Context

How Place Affects
Perception

Barely three years after the Louvre became the first national public museum,
Antoine C. Quatremère de Quincy, a sculptor and leading theoretician of the day, first
articulated the importance of context for the appreciation of art. In 1796, at the suggestion
of his friend the political activist Francisco de Miranda, Quatremère published a series
of letters in Paris denouncing Napoleon's plundering of Italy to fill the city's new museum,
insisting that Rome itself was the real museum.[1]

For Quatremère it was essential not only to see Rome's art objects and architecture
in relation to each other but to experience them with an awareness of other influences
on their creation. By questioning the validity of displaying what are now called site-
specific artworks in museums, the Frenchman posed a problem that remains
controversial to this day.

The Elgin Marbles at the British Museum are perhaps the most famous case in
point. Named after Britain's ambassador to the Ottoman Empire, Lord Elgin, who brought
them from Athens in 1811, these spectacular mid-fifth-century-B.C. sculptures belong
to three distinct programs, all conceived as integral parts of the Parthenon, arguably
the greatest temple of all those known from ancient Greece. Built entirely of marble
to the highest standards of design and execution, the Parthenon crowns the summit
of the Athenian Acropolis. Today, 30 percent of its marble sculptures are in London.

The sculpture, executed under the supervision of Phidias, the foremost sculptor of
classical antiquity, consists of high reliefs of embattled figures on the metopes (those
in London consist of men, the Lapiths, and centaurs); a continuous low-relief frieze
depicting a religious procession, possibly the one known as the Panathenaic, on the
walls of the cella; and figures carved in the round representing the birth of Athena and

37. British Museum, London: Elgin Marbles (mid-fifth century B.C.).

her contest with Poseidon on the east and west pediments.[2] All were placed at a great height, just under or above the cornice line, and were seen from the ground. The figures were actually carved with this viewpoint in mind; for instance, the metope reliefs become deeper nearer the tops so that the front plane leans forward slightly (an idea similar to the tipping forward of skied paintings).

As they are presented in London, at eye level, the sculptures are not only viewed from an incorrect perspective, but the respect conveyed by placing representations of the gods (perceived by the public as near incarnations of the deities) high above mere mortals is lost (fig. 37). Even more disturbing is the sculptures' reversed presentation: originally mounted on the Parthenon facing out, they now face each other across the gallery's interior, thereby destroying the narrative of the frieze and the overall processional relationship of the different groups to one another. The British Museum's institutional interiors and London's pale daylight complete the decontextualization of sculpture that was once part of a riotously colored temple bathed in bright Mediterranean sun.

On the other hand, the Greek government's efforts to recover the sculptures, most recently to exhibit them in a new museum, would not produce a more authentic context. The Greeks propose reuniting the Elgin Marbles with their own Parthenon sculptures (also partial) in a gallery with a direct view of the Acropolis. Even if allowances are made for the lack of color, which was essential to reading the sculpture from a distance,[3] and was also an important aspect of the architecture, only the actual replacement of the fragments on the building, clearly an impossibility, would return the sculptures to a semblance of the conditions under which they were seen originally.

A single sculpture executed at a different moment in history, and for an interior,

demonstrates the same point. It is difficult to visualize Bernini's *Ecstasy of St. Teresa* deprived of its elaborate setting in the Cornaro Chapel (1652) of Rome's Santa Maria della Vittoria (fig. 38). The altar tabernacle is a veritable little temple in its own right, bowing forward to frame an oval niche for the statue.[4] Its polychromed marble columns and plinth, its elaborate broken pediment and simulated golden sunbeams are a stage set for the saint's transcendent vision (the transverberation). Three sources of natural light, notably an architectural lantern functioning as a hidden skylight, illuminate the simulated rays, contributing to the drama.

Bernini took literally the theatricality of his creation, inserting boxes on the side walls of the chapel, like those overlooking a stage, from which sculptural representations of members of the patron's family discuss the epiphany. Furthermore, by enshrining the *Ecstasy* in the architecture, Bernini makes it possible to see the sculpture in its entirety only from the church's nave, exactly on the central axis of the chapel. From this defined viewpoint the scene becomes a tableau vivant; the pictorial quality would be lost without the framework.[5]

Freestanding sculpture and easel painting can also be affected by changes in context—for example, when a statue is moved from one country to another. If the countries are antagonists, a cult object in one land might become plunder in another. Religious sculpture worshipped by the Greeks, often as the actual presence of the god,[6] when seized by the Romans and exhibited in the imperial capital as an art object could become symbolic of conquest. Alexander the Great carefully bore in mind the political implications of displacing art: before looting Persepolis, he returned to Athens that city's beloved bronze statues by Antenor of the tyrannicides Harmodios and Aristogiton, which Xerxes had carried off in 479 B.C.[7] Wherever they may have stood originally, the prominent position they occupied in the agora upon their return reinforced their symbolism as protectors of power and democracy.[8]

Like the Roman artworks referred to by Quatremère, the marble statues known as the *Winged Victory (Nike) of Samothrace* and the *Laocoön* were in all probability made for specific sites. This was not the case for a group of small bronze sculptures found at the Villa dei Papiri in Herculaneum, which, unlike the *Nike* and the *Laocoön,* could have been placed anywhere but were in fact found in the spots where they had decorated the villa's peristyle garden.

All these sculptures have at one time or another been exhibited in pseudo-historical settings based, with varying degrees of literalness, on what was known of their original contexts. For the *Nike* at the Louvre, the settings ranged from rooms with overhead mosaics evoking antiquity to the grand stairway's suggestion of a hilltop, such as the one where the statue was found. At the Vatican, the niche designed by Bramante for the *Laocoön* recalled the architecture of antiquity; removal from that niche, and changes

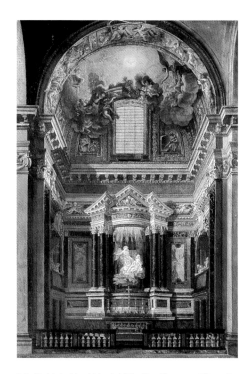

38. Guidobaldo Abbatini (?), *The Cornaro Chapel of Gianlorenzo Bernini, Santa Maria della Vittoria, Rome* (mid-seventeenth century).

in the setting itself, had major repercussions for the statue. For the original bronzes from the Villa dei Papiri, a series of historicizing presentations in the Archaeological Museum in Naples gave way in the 1970s to modern, white-cube galleries. In a challenge to this clinical display, copies of the statues will be exhibited at the Getty Villa's re-creation of the Papiri's peristyle garden in Malibu, California.

The museum context proved more favorable to the *Nike* than to the *Laocoön*. The goddess's move from relative obscurity when she entered the Louvre to her present preeminence there was intimately linked with her presentation. Shown first as just one of many statues, the *Nike* gained in prestige with her increasingly prominent repositionings and was finally selected for solo display—the museological way of signaling a great masterpiece. Unlike most works of art that are shown abstracted from their setting, the *Nike* is routinely photographed at the top of the grand stairway from which she has become inseparable.

Quite the reverse is true of the *Laocoön*. When the sculpture was transferred in 1511 from the Belvedere Villa to the pope's private Statue Court at the Vatican, the priestly group immediately enjoyed a near-religious veneration. Although the statue has remained in almost the same spot to this day, multiple changes in the court—in terms of both architecture and display, and finally its incorporation into the Vatican Museums complex[9]—have had a tremendous impact on the sculpture's status. Furthermore, by inviting unfavorable comparisons with the Elgin Marbles in London, the *Laocoön's* brief display in Paris under Napoleon Bonaparte further diminished its standing. Context—and presentation—changed the look and importance of the *Nike* and the *Laocoön*. The Getty display of reproductions of the Villa dei Papiri bronzes suggests that context can even substitute for authenticity.

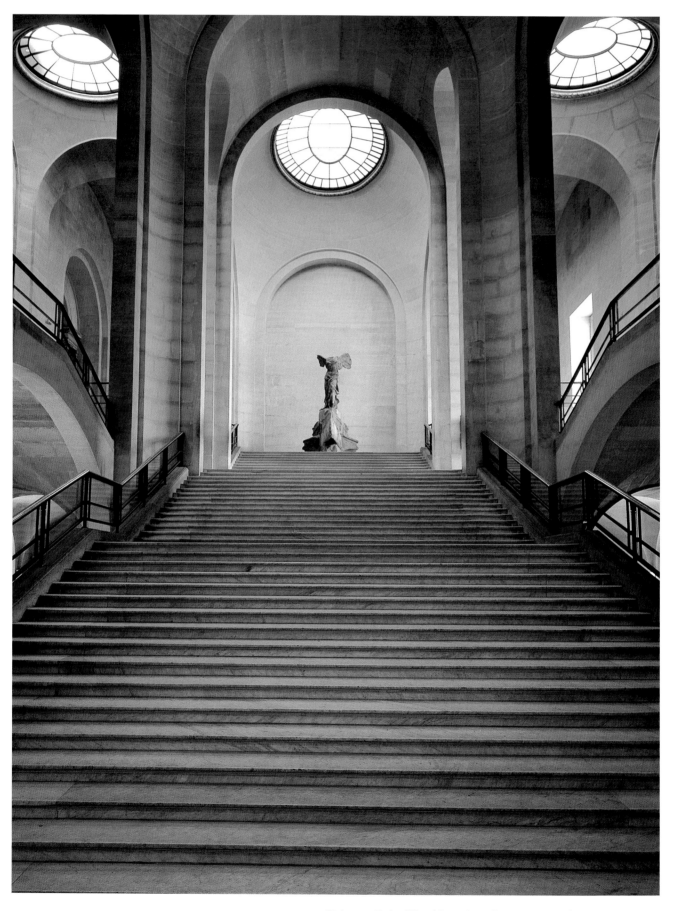

39. Louvre, Paris: *Nike of Samothrace* (c. 190–180 B.C.), current installation.

THE WINGED VICTORY (NIKE) OF SAMOTHRACE

Nike, usually portrayed with wings, was the goddess of victory. The deity, who ruled over athletic as well as military contests, was extremely popular, and statues of her were known already in the archaic period. The sculpture from Samothrace, an island off the eastern coast of Greece, captures a flying Nike at the moment she alights—a messenger announcing victory rather than an active figure in battle.[10]

Now gracing the Louvre's monumental Daru Stairway, the soaring marble figure is an acknowledged masterpiece of Hellenistic art, and it is synonymous with the museum (fig. 39). But for all its fame, the sculpture is one of the most elusive objects in the history of art: opinion is still passionately divided as to the figure's exact date, authorship, patron, and even precisely what occasion it was meant to commemorate.[11] Since about 1980 there has been a general consensus regarding its dates, but only in 1998 was the *Nike* formally cataloged and placed between 190 and 180 B.C.[12]

By the time of the Hellenistic era that followed the conquests of Alexander the Great in the late fourth century B.C., sculptors had become more skillful and had expanded their range of subjects and compositions, giving statuary greater pictorialism and illusionism as well as a new relationship to its surroundings, especially to natural settings.[13] More significantly, the casual placement of statues—both outdoors in temple sanctuaries and inside in the temples themselves—had given way to more careful arrangements.

The late-classical *Nike* by Paionios, at Olympia, forecasts something of the change in attitude (fig. 40). Although not as tall as the nearly eleven-foot *Nike of Samothrace,* the Paionios sculpture, at about six and a half feet, was an imposing, over-life-size figure, represented in flight: her ballooning drapery, her stance above an eagle—as if she were riding on the bird's back—and the presentation on a triangular pillar just under twenty-eight feet high all contributed to this illusion.

Dedicated by the Messenians and the Naupactians to celebrate their victory over Sparta in 425 B.C., the statue stood barely a hundred feet away from the Temple of Zeus.[14] Instead of facing the temple, as was customary for votive offerings in this part of the sanctuary, the *Nike* was turned away from it to greet those approaching (fig. 41). Furthermore, it was positioned in the same line of vision as an earlier Nike, in gilded bronze, also by Paionios, that crowned the apex of the pediment.

Among the vast number of statues and dedications scattered near the temple, the proximity of the two Paionios sculptures would have made them stand out, conferring an unprecedented degree of importance on the sculptor. Their placement also conveyed an important political message: the earlier statue surmounted a golden shield dedicated previously by the Spartans and thereby emphasized their defeat.

For all its innovation, the installation at Olympia must have made the statue there appear more iconic, and less widely visible, than what is believed to have been the far

40. Paionios, *Nike* (c. 425 B.C.),
reconstruction (1936).

41. Temple of Zeus, Olympia (mid-fifth century B.C.), reconstruction model.

more dramatic, illusionistic staging of the *Nike* at Samothrace. If indeed, as many think, the *Nike* at Samothrace was placed as if hovering at the top of a hill, she would have been seen from all points in the Sanctuary of the Great Gods. She would also have been the first thing perceived by seafarers, for whom these gods were patrons. By comparison, the *Nike* at Olympia would have had the presence of a passing bird.

The change in thinking about presentation seems to have been inspired by celebratory processions, such as the yearly Panathenaea in Athens. In the form it had taken already by the sixth century, what may have been a week-long celebration included a torch race and the carrying of the peplos, a finely woven robe, to dress the statue of Athena Polias on the Acropolis, where sacrifices were offered to the goddess.[15]

By the third century B.C., remarkably theatrical effects began to characterize some Greek processions on special feast days and at yearly festivals.[16] Attended by the city's entire population, including slaves, parades of devotional images were accompanied by sacrifices, gymnastics, and music, frequently amid public banquets. At exuberant Dionysiac festivals, the god's attributes of peace and prosperity were represented by wine, grape juice, and milk liberally distributed to the crowds and, notably, by flying doves attached to floats built to look like grottoes.

As these processions, in which cult images were wheeled through the streets, became more elaborate, sculpture in fixed positions also began to enjoy theatrical settings.[17] At Messene in the Peloponnese, for example, at one edge of the Temple and Sanctuary of Asclepius, small temples, such as the Temple of Artemis Laphria, each showcased a single statue (fig. 42). Opening only to the main temple, these little structures offered a single, frontal view of the cult statue they contained: colossal figures reached from floor to ceiling, almost completely filling the space,[18] as did the *Athena Parthenos* and *Zeus* at Olympia (see figs. 236, 237). At Messene and other Greek towns in the Hellenistic era, cult and votive statues also occupied exedra-shaped niches with colorful mosaic floors, sometimes protected by bronze bars and barriers in museumlike settings.

42. Temple of Artemis Laphria, Messene (as imagined in the Hellenistic era), from Philippe Le Bas, *Voyage archéologique en Grèce et en Asie Mineure* (1888).

These increasingly sophisticated displays suggest a spectacular presentation for a statue as important as the *Nike of Samothrace*. Indeed, it seems to have been intended for a place of honor at the Sanctuary of the Great Gods, where various devotional buildings were erected from the archaic to the Hellenistic era (fig. 43). As usual in ancient Greece, each of the ten identified structures was carefully positioned for maximum effect in relation to the topography—here within a series of hilltops separated by a deep north-south gully cut by two streams, one at the eastern edge and one at the western. The Nike was found on the gully's southwestern rim.

A rectangular exedra dating from Roman times, carved into the slope and open to the north, framed the sculpture (the height of the walls is unknown); the goddess stood on a shiplike base placed diagonally, so that she faced across the sanctuary to her right rather than straight ahead. In this position, the figure provided a close-up view to visitors sheltered under the long colonnade of the stoa, to the west.

The entire complex is relatively small, the structures crowded together in the shallow valley.[19] In contrast to the buildings, which would have been difficult to see from afar, the *Nike* would have been clearly visible to the crowds of pilgrims arriving from all over the ancient world at the moment they emerged from the monumental entranceway to the east.[20]

The statue would also have been a presence for those attending the theater directly below it (fig. 44). Positioned obliquely to the south of the stadium, the goddess stood at the end of an aisle used by theatergoers to reach their seats.[21] Her right arm and the prow of the base both pointed down this aisle toward the stage as well as to the cult buildings beyond. The sweep of the *Nike*'s left arm and body in the other direction could be construed as her embrace of the sanctuary.[22]

In the 1970s, the *Nike* was thought to have been part of a fountain.[23] Although this idea has been largely discredited for the statue's original placement,[24] it may be valid for a later Roman installation. Certainly, sculpture was placed near water, even in Hellenistic times, to create a reflection, and this device was favored by the Romans. In

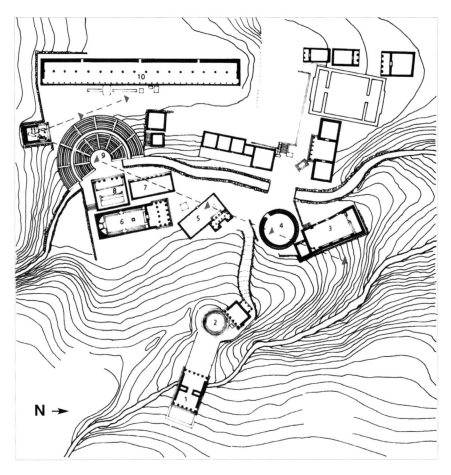

43. Sanctuary of the Great Gods, Samothrace (Archaic-Hellenistic), sketch plan.

1. Ptolemy's propylon
2. Circular meeting place
3. Anaktoron
4. Arsineion
5. Temenos
6. Hieron
7. Votive hall
8. Main altar
9. Theater
10. West hall (stoa)
11. *Nike* fountain

44. Sanctuary of the Great Gods, Samothrace, reconstruction of view from theater to *Nike*.

the garden at New York's Museum of Modern Art, a recumbent female figure—*The River* (1938–43), by Aristide Maillol—is exhibited in just this way (fig. 45).

The six slabs on which the ship base rested diagonally seem to have been carved to resemble rippling waves and contained holes, possibly for the attachment of dolphins, other sea creatures, or landscape elements.[25] Some archaeologists believe the slabs paved the upper of two basins built into the exedra, which were separated from each other by a wall. In this case, water entering the shallower upper basin would have poured down into a deeper basin, foaming like surf around the boulders in it.[26]

The form of the statue itself may, in part, have been determined by its placement, its elongated proportions dictated by an elevated site, necessitating views from below.[27] The less refined drapery of the right side favors viewing of the figure's left side and explains the statue's angled position within the exedra, turned three-quarters to her right.[28]

A sculpture's monumentality is often determined as much by its support as by the work itself: even a small figure on a large pedestal is seen as a monument, whereas the reverse is not always true.[29] Along with the *Nike*'s exalted position within the sanctuary, the statue's massive ship base certainly reinforced its importance. Ships and ships' prows, symbolizing maritime power or naval victories, are known to have supported sculpture as early as the fourth century B.C.: the coupling of a Nike figure with such a base was, however, somewhat unusual,[30] and it made a particularly compelling statement.

With the unearthing of the marble shoulder, neck, and partial breast of a female figure on the island of Samothrace in the spring of 1863, the *Nike* entered the modern world. These fragments turned out to be just three of the more than two hundred excavated over time to which the *Nike* had been reduced. Discovered by Charles-François-Noël Champoiseau, Napoleon III's young, newly appointed interim consul to Adrianopolis (Edirne in present-day Turkey), the statue was delivered to the Louvre a year later, and was painstakingly reassembled as missing pieces were discovered in a series of operations that took almost two decades. As it turned out, Napoleon III never saw the *Nike,* which was largely dismissed at a time when, except for the *Venus de Milo,* only integral works were considered presentable in a museum. By 1869, however, the statue had been described in the museum's catalog of Greek sculpture as exceptional, and it became even more so with the restoration of the wings, parts of the anatomy, and sections of the ship base.

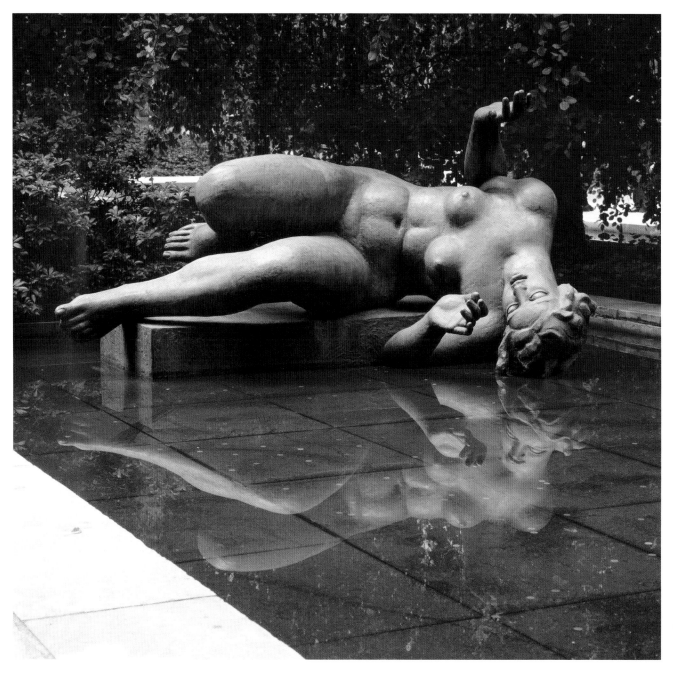

45. Museum of Modern Art, New York (c. 2000): Aristide Maillol, *The River* (1938–43).

46. Louvre, ground-floor plan showing historic statue emplacements.

A. Salle des Caryatides
B. Salle du Tibre
 (now Salle du Parthénon)
C. Daru Stairway
D. Musée des Antiques
 (now Salle des Antonins)
E. Main entrance before expansion
X. *Nike*
Y. *Laocoön*

The Salle des Caryatides, 1866–Late 1870s

The *Nike* made a modest debut at the Louvre in a small area set apart by alternating arches and stylized Corinthian columns at one end of the Salle des Caryatides, named after the four giant female figures, designed by Jean Goujon in 1550, that serve as columns at the other end (fig. 46). The decor today is much as it was in 1866, when the *Nike* was placed approximately where *Mercury with a Sandal* (second century A.D.) now stands, in front of a monumental fireplace surmounted by two large figures, also by Goujon (fig. 47).

For a century before the palace became a museum, the kings of France had used the Salle des Caryatides for their collections of antiquities, described by Christiane Aulanier, in her monumental history of the Louvre, as "a mishmash of badly maintained, badly displayed" small figures, French Renaissance sculpture, copies, and some contemporary pieces.[31] When the *Nike* arrived here, restored only from beneath the breasts and without her identifying wings and ship pedestal, she must have been lost in a jumble of objects that included late Roman as well as Greek sculpture—for the most part poorly restored—and nineteenth-century replicas of both[32] (fig. 48). (The bust and one wing may have been displayed in a nearby vitrine.)

The statue's fragmented condition could have been the reason for its placement in the small, poorly lit space before the fireplace.[33] Like other sculpture in this area, it had to compete with the elaborate Renaissance decor and in particular with the massive fireplace figures. In its favor, this initial installation positioned the statue obliquely on its square plinth, offering the correct three-quarters view of the figure's left side, which was later overlooked.

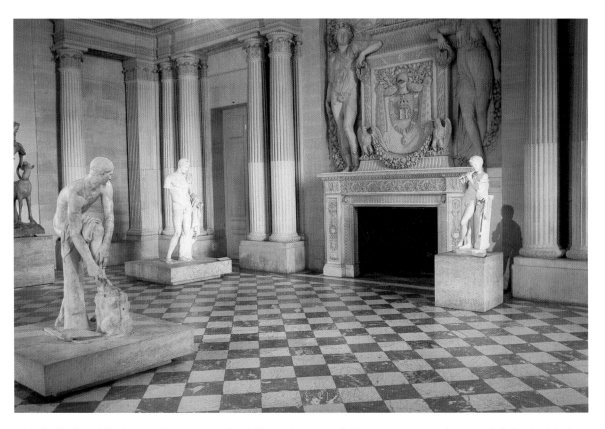

47. Salle des Caryatides, Louvre: *Mercury with a Sandal* (second century A.D. Roman copy of a fourth century B.C. Greek original), facing fireplace in the position where the *Nike* stood.

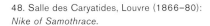

48. Salle des Caryatides, Louvre (1866–80): *Nike of Samothrace*.

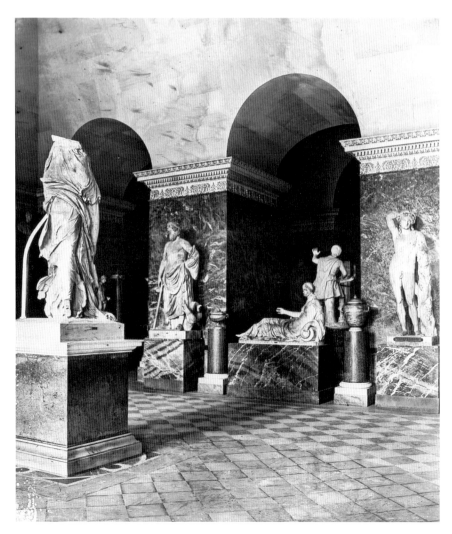

50. Salle du Tibre, now Salle du Parthénon, Louvre (2004).

49. Salle du Tibre, Louvre (late 1870s): *Nike of Samothrace.*

The Salle du Tibre, now the Salle du Parthénon, Late 1870s

The next stop in the *Nike's* ascent within the museum hierarchy was a brief sojourn in the Salle du Tibre, another relatively small area at the end of a long gallery. Placed here more prominently—at the center of a square space—the sculpture also enjoyed better light from the south-facing windows. This part of the Louvre, built under Napoleon I, had walls of deep red marble tinged with gray, an ornate white cornice, and a barrel-vaulted ceiling, all typical of the era (figs. 49, 50).

In the early nineteenth century, strong colors were favorite backgrounds for the calm, rounded forms and pure white tones of contemporary sculpture; instead of providing a similar contrast for the *Nike,* the reddish walls of the Salle du Tibre must have diminished the impact of the sand-colored Hellenistic work. Additionally, the insistent horizontality of the top-heavy cornice would have opposed the figure's elongated sense of flight (fig. 51). Life-size atlantes, male figures serving as supports, at the end wall would have been as inimical to the *Nike* as Goujon's fireplace figures.

51. Salle du Tibre, Louvre: Hibon, after Civeton, *Salles du Héros Combattant et du Tibre* (1826), showing life-size atlantes (now destroyed) at back.

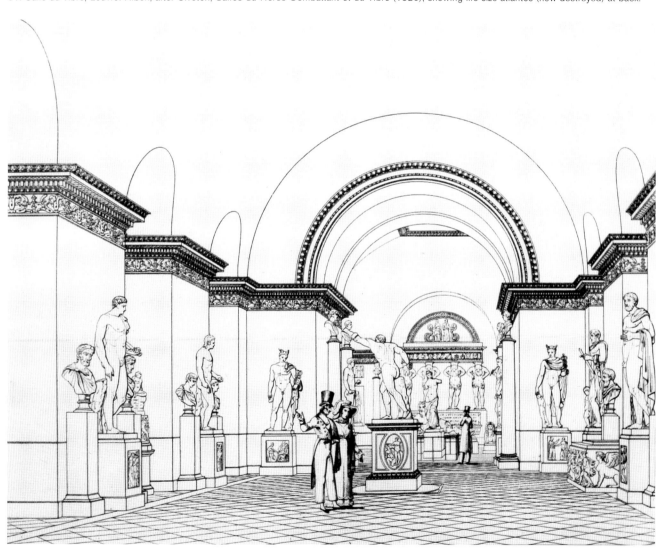

The Grand Stairway I, 1883–1927

In replacing the cultural context for which an object is made, the museum consecrates the object as art and at the same time establishes its relative importance by the way it is installed.[34] Isolation and visual focus denote importance: the greater the masterpiece, the greater its separation from other objects that might compete for attention. A perfect example of the process is the *Nike's* upgrading as restoration gradually revealed the work's potential public appeal as an archaeological masterpiece, something experts had acknowledged from the beginning.

The Louvre's curator of antiquities, Jean-Gaspard-Félix Ravaisson-Mollien, began to work on the *Nike* in 1870, assisted by his son Charles. Having completed the figure from waist to neck, father and son proceeded with the all-important attachment of the wings. Since only one wing had been found, the almost intact left one, it was used to mold a plaster replica of the right wing. After the addition, in 1879, of twenty-nine newly excavated marble blocks from the ship base, the figure, now nine feet tall, was acclaimed as "the department's largest work and one of the most beautiful"[35] (fig. 52).

With sculpture galleries stuffed to capacity after two decades of unusually numerous acquisitions,[36] the Louvre's curators sought a less crowded space to display the *Nike* in all its monumentality. Considerable deliberation led finally to the statue's placement on the skylit upper landing of the museum's grand Daru Stairway.

From the time of the Louvre's transformation into a museum in the late eighteenth century to its 1980 renovation, this wide, multitiered stairway was central to the building's circulation. Linking Napoleon III's massive new Mollien Pavilion with the existing palace, it provided an appropriately processional approach to the most prized possessions in the collections: French and Italian Renaissance painting in two of the museum's choice spaces, the Salon Carré and the Grande Galerie. In choosing the *Nike* to crown this key passageway, the museum conferred unique status upon it.

Isolating the work high above arriving visitors, below one of three skylit cupolas, seems in retrospect to be an imaginative simulation of the monument's appearance in antiquity as many visualize it. The place was chosen, however, more for its generous space than for its elevation.[37] But even this brilliant presentation, hit upon more or less intuitively, had a major flaw: instead of being turned slightly to the right so as to favor a view of the figure's more refined left side, the statue was placed frontally, on axis with the stairway, as it remains to this day.

In 1883, the newly installed monument was not yet what we see now. An attempt to rebuild the upper left arm in plaster was still in place, a triangular chunk of the prow was missing, and the figure stood directly on the ship's fragmentary deck, without the modern stone block that was inserted in 1933. But even more important in terms of

52. Louvre courtyard (c. 1880): *Nike of Samothrace,* with blocks from ship base in process of restoration.

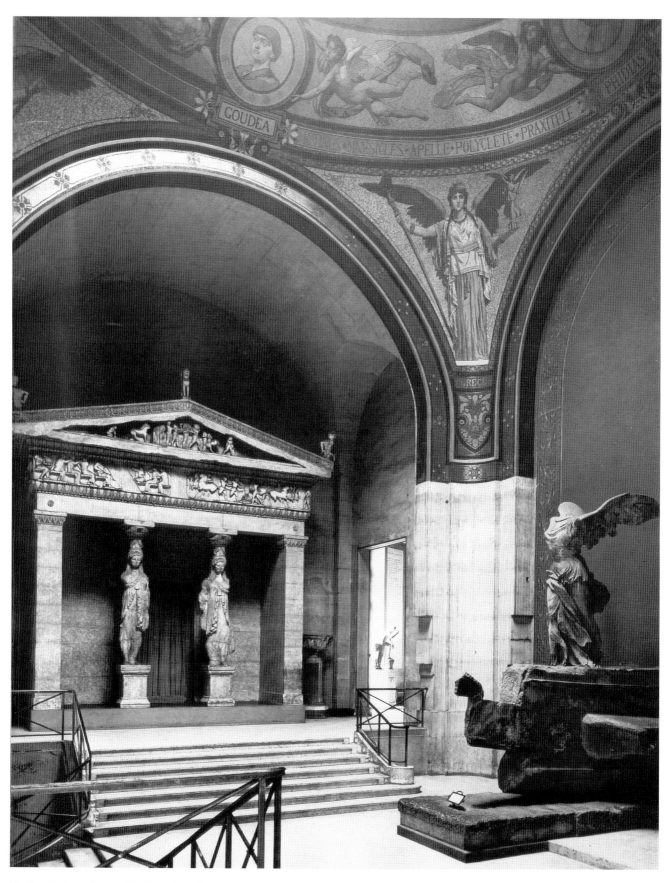

53. Daru Stairway, Louvre (1883): replicated facade of Siphnos Treasury and *Nike of Samothrace*.

installation, the stair hall itself, decorated with the emplacement of the *Nike* in mind,[38] would be all but unrecognizable to viewers today (fig. 53).

To correct what, in the late nineteenth century, was considered the stairwell's unacceptably bare stone, the ceiling was adorned with mosaics that were supposed to convey "a summary of the Louvre's riches and a history of art evoking every school represented in the museum."[39] Each of the area's cupolas displayed an aspect of the program, with antiquity occupying the large cupola directly above the *Nike*.

The mosaics were ridiculed by the press at their unveiling for both the vulgarity of their colors and the inelegance of the representations.[40] Winged figures symbolizing Egypt, Assyria, Greece, and Rome decorated the four pendentives; additional wings flapped above on the backs of cherubim supporting ocular portraits of Cheops, Goudea, Phidias, and Vitruvius.[41] Against a wall of Pompeian red flecked with gold fleurons and rosettes, outlined by a fussy floral border, and competing with the winged figures directly above it, the *Nike* was overwhelmed. Additionally, one of the skylights cast a yellowish light, and the colored glass of a second one, completed in 1897, made matters worse. The new curator of antiquities, Antoine-Marie-Albert Héron de Villefosse, likened the effect to "the last throes of a bright pink bonfire."[42]

Yet Villefosse did not help the presentation: even though he eventually freed the area around the monument of fragments from Samothrace, he filled up other parts of the stairwell with plaster replicas of unrelated finds from Delphi. Compounding the confusion, a life-size model of the facade of the treasury at Delphi dedicated by the island of Siphnos (525 B.C.) occupied most of the east landing, blocking the window behind it and depriving the flying goddess of a source of natural light.

The jumble of ceiling images and reproductions was typical of the time. Until the early twentieth century, museums routinely exhibited reproductions alongside original works of art, often within elaborate decors. Photographs of the installation on the stairway show that such habits seriously compromised the *Nike*'s impact. To a twenty-first-century sensibility, the mosaics and replicas detract from the Hellenistic sculpture, and the proximity of fake antiquities to an authentic one blurs the distinction between real and replica.

The *Nike*'s first appearance on the Louvre's grand stairway proves that position alone does not necessarily establish predominance. Wall and ceiling treatment, nearby displays, and light must reinforce a privileged placement in order for it to be effective. What was considered a showcase installation at the time would fall far short of that designation today.

The Grand Stairway II, 1927–present

Within a few decades of the *Nike*'s move to the stairway, its circumstances deteriorated still further. By 1910, works as diverse as Botticelli frescoes and paintings by the turn-of-the-nineteenth-century artist Antoine Coypel had joined plaster replicas hanging on the stairwell's walls and scattered on the floor.[43]

Shortly before World War I, the museum's painting galleries were rehung, their vertically stacked canvases pared down to orderly horizontal rows. Galleries crowded with sculpture did not all benefit, however, from this reorganization.[44] In particular, the

Nike's presentation remained unchanged until 1927, when a new director, Henri Verne, rethought many aspects of the museum.

Responding to Modernism's new, stripped-down aesthetic, Verne cleared the stairwell of everything except the *Nike;* the walls were relieved of their red paint and the mosaics were painted over to achieve a uniform stone color. The two lateral stairs were moved back to enlarge the principal landing into an area for the *Nike* of approximately the same size as the sculpture's exedra at Samothrace.[45] In 1932–33, the sculpture was repositioned within that area.

Brought forward on the landing by five feet three inches, the *Nike,* framed by an archway, revealed itself gradually to museum visitors walking down the long Daru Gallery toward the stairway: first the ship's prow came into view, then the feet and legs, and finally the torso, in just the way an alighting figure would appear. Moving the statue forward had the added advantage of freeing it from the wall, thereby allowing it to be viewed from all sides.

In the absence of a platform thought to have existed on the ship's deck, a modern concrete block was inserted under the sculpture, with separate plinths supporting the drapery and mantle swag.[46] The front of the ship base was reworked to conform to new research that suggested an upward curve of the prow.[47]

The way viewers saw the *Nike* was the result of more than a half-century of restoration and repositioning, implemented by successive generations of curators. The statue's 1932–33 installation singled it out as one of the Louvre's greatest treasures, the first major moment visitors encountered.

But the first gallery that viewers entered from the museum's main entrance on the Quai du Louvre at that time is no longer the first gallery today (see fig. 46). As a result of the changes in circulation wrought by I. M. Pei's renovation and expansion of the 1980s, the statue lost its preeminence. The new central entrance via the glass and steel pyramid offers paths to three wings, and depending on the choice, visitors may miss the *Nike* altogether. Even those who opt for the Denon Pavilion, where the statue is situated, will come upon it after a much longer walk. One itinerary in fact brings viewers abruptly to the foot of the stairway on which it is displayed. The thrilling processional along the length of the Daru Gallery, which conveyed the illusion of the figure floating down from the sky, has been lost to those who do not deliberately seek it out.

Pei, possibly in reaction to criticism of the entrance atrium at his East Wing addition to the National Gallery in Washington, D.C., where architecture outshone the art placed within, wanted to position the *Nike*—or a replica of it—inside the pyramid, to retain its preeminence at the Louvre.[48] Denied that privilege, both because of technical problems in moving the statue (it weighs more than thirteen tons) and because of the Louvre's current ban on reproductions, the *Nike* has been demoted.

Crowds surrounding the figure attest to its status as a highlight of the collection, comparable in quality to the *Venus de Milo* and the *Mona Lisa.* Those who do not know the former entrance will not miss the more dramatic discovery of the statue it offered, a sacrifice necessitated, according to Louvre curator Marianne Hamiaux, by the need for change, so as to avoid "museumifying the museum."[49]

THE LAOCOÖN

No image could be more different from the *Nike,* with its joyful message of triumph, than the *Laocoön,* with its searing evocation of pain. Nike was a deity, Laocoön a legendary human; the flying female figure is all lightness and freedom of motion, the tortured male nudes are earthbound and constricted; the *Nike* celebrates, the *Laocoön* suffers (fig. 54).

The statues' histories are also quite different. In contrast to the long reconstruction and slow emergence from obscurity and a fragmented condition of the *Nike,* the *Laocoön*—identified by some as the priest of Apollo, by others as a priest of Poseidon, and his two sons—was found nearly intact and quickly hailed as one of the great sculptures of all time. Unlike the *Nike's* halting climb up the museological ladder, the *Laocoön* was hardly out of the ground when its "staging" in the Vatican's Statue Court was being planned with the solemnity due a sacred object. This very staging may have played a part in how the sculpture's missing limbs were replaced.

From the moment the *Laocoön* was discovered on Rome's Esquiline Hill in 1506, its mythological subject was recognized and the sculpture was identified as the marble masterpiece described by Pliny the Elder in the first century A.D. The priest is shown struggling for his life against large sea serpents attacking him and his two sons. Of the many accounts of the myth, the best known is in Virgil's *Aeneid,* according to which Laocoön, in this telling a priest of Poseidon, was destroyed by the gods because he was an impediment to their plan to ruin Troy. The words with which he advised the Trojans against opening the city's gates to receive the wooden horse have become legendary: "Even when Greeks bring gifts / I fear them, gifts and all."[50]

The statue's instant acclaim was partly due to its having the right backers. Attributing the work to three Rhodian sculptors—Hagesandros, Polydoros, and Athenodoros—Pliny had declared it "superior to any painting and any bronze."[51] Upon its discovery, the statue was immediately matched to Pliny's description by Giuliano da Sangallo, the Florentine architect, sculptor, and military engineer, who was in turn seconded by no less than Michelangelo. The *Laocoön* has been revered through the centuries by artists who, to this day, reproduce and reinterpret it in every conceivable medium. The group's ability to convey intense pain never fails to register, but the different contexts in which it has been seen go hand in hand with changing reactions to the work.

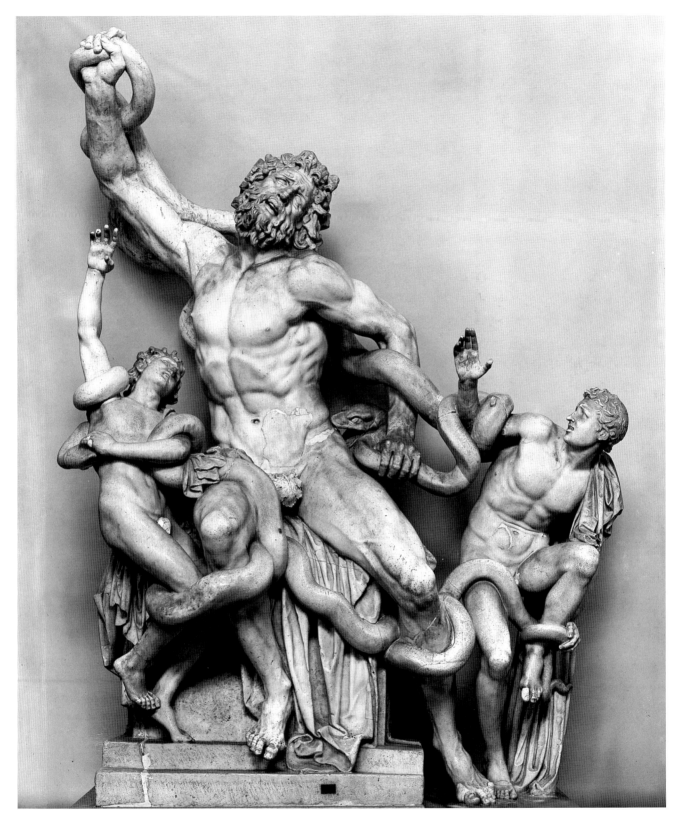

54. Statue Court, Vatican, Rome: *Laocoön,* as exhibited until 1960 with Renaissance-inspired restoration.

55. Bernardo della Volpaia, *Codex Coner*.

A. Belvedere Courtyard
B. Statue Court
C. spiral stair
D. toward medieval palace
E. Belvedere Villa

·P VLCRVM·
VIDERE·
PONTI
·FICIS·

56. Marten van Heemskerck, *Courtyard, Palazzo Medici-Madama, Rome* (c. 1530).

The Statue Court at the Vatican, 1511–1797

The *Laocoön* could not have been reborn into a more receptive environment than that prevailing during the third year of Julius II's papacy (1503–13). Already as Cardinal Giuliano della Rovere, the future pope was one of many passionate collectors of antiquities—albeit wealthier and more powerful than most. Election to the papacy allowed Julius to pursue his interest in the ancient world and to act as patron to the innovative young architects using its vocabulary in new ways and with unprecedented scope.

The Statue Court commissioned by Julius for the Vatican[52] may have been conceived specifically for the *Laocoön*.[53] The court was part of a complex modeled by Rome's leading architect of the day, Donato Bramante, on ancient Roman remains—especially villas—and literary descriptions. The 450-foot-long Belvedere Courtyard connected the popes' medieval palace with Innocent VIII's (1484–92) Belvedere Villa to the north; the small Statue Court filled the awkward space between the courtyard and the villa (fig. 55).

Early collectors of antiquities occasionally displayed them outdoors, as did Cosimo de' Medici in Florence. In the mid-1470s, Cosimo's grandson Lorenzo opened to visitors his own sculpture garden on the Piazza San Marco in Florence.[54] In Rome, by the 1530s, the Medici, the Maffei, and the Sassi were among the families whose palace courtyards were adorned with antiquities (fig. 56).

But what Julius created at the Vatican was quite different from these fifteenth- and early-sixteenth-century statue gardens, in which antique sculpture and inscriptions either were scattered casually among contemporary works or served only as decoration. The deliberate program and carefully designed installation of the Statue Court clearly gave priority over the surroundings to the sculpture itself.

The Statue Court was conceived as a holdover from the *giardino segreto,*[55] a type of intimate walled garden that had served as a retreat for its owners since the Middle Ages. The Renaissance's association of such gardens with cloisters conferred on them a religious aspect in much the same way that trees and sacred groves suggested

57. Marten van Heemskerck, *View of the Belvedere Statue Court* (1532–33), showing *Laocoön* (far left), *Nile* and *Tiber* (center).

sanctuaries to the ancients.[56] In deliberate contrast to the turbulent celebrations, spectacles, and bullfights that took place in the larger and more formal Belvedere Courtyard, the Statue Court was a serene, secluded place of contemplation, its magnificent orange trees recalling the golden apples of Ovid's fabled Garden of the Hesperides. (The latter was in turn considered a pagan counterpart to the Garden of Eden.)[57] The small, square, gardenlike court of approximately 1,300 square feet was bounded by walls of irregular height, as shown in a drawing of the 1530s by the Dutch artist Marten van Heemskerck[58] (fig. 57).

From the beginning, the *Laocoön* was to be the main attraction of the Statue Court, a prominent feature for anyone looking from a window of the Belvedere Villa at the north, as well as for those entering the garden from the villa. Bramante's earliest drawings indicate a rectangular niche for the statue at the center of the south wall, where it was placed in 1511.[59] Like many other fine private collections, the court was open to select visitors, who were given access directly from the street when Bramante's magnificent spiral staircase was completed (posthumously) around 1540.[60] At the northern side of the court, it too placed emerging visitors opposite the *Laocoön*.

Just as niches had been used to enhance statues presented as votive offerings in Hellenistic Greece, the alcoves designed by Bramante also had religious connotations.[61] From the first, they were referred to as "chapels," and the sculpture pedestals as "altars." In the hallowed confines of the Vatican, the Statue Court encouraged a reverential attitude toward the artworks contained in it. Inversely, the secular space of the first purpose-built museums was sanctified—and still is—by the presence of venerable artworks.

A massive pedestal was placed under the *Laocoön,* even though it lifted the priest's and the younger son's faces too high for a full view. The gesture was repeated for the other statues in the court, forcing viewers to look up to the figures from a respectful distance.[62]

In the early Middle Ages, pagan objects were given Christian meanings thanks to

their prominent exhibition by the Church. The giant *pigna* (pinecone) now in the Belvedere Courtyard is an example: a life-affirming symbol of Roman deities, it became a sign of the Church's nucleus when installed in front of St. Peter's in the eighth century.[63] In like manner, when placed in front of the Lateran Palace, bronze antiquities became symbols of Christian victory over idolatry.[64] The Statue Court was part of Julius's continuation of this tradition.[65] Like politicians throughout history, he used art to serve his ambitions, in this case employing a pagan imperialist idea and pagan art to elevate Catholic Rome to the status of the earlier empire and beyond.

As the Hebrew Bible is believed by Christians to foretell the New Testament, so Aeneas was considered by medieval and Renaissance tradition the allegorical personification of the Church. Because Laocoön's sacrifice enabled Aeneas to flee Troy and found Rome, the priest prepared the way for the seat of Christianity. Julius linked himself with the legend recounted by Virgil by inscribing above the entrance to the Statue Court the words spoken by the Cumaean Sybil to Aeneas as he entered the underworld: *O procul este, profani* ("Let the profane stay away").[66]

Julius began in 1508 to have a program prepared for the court directly related to the *Aeneid,* tying together pagan and Christian imagery. A statue of Hercules and Telephos (interpreted as Aeneas and his son Ascanius) together with one of Apollo were joined the next year by the *Venus Felix* and a *Cleopatra* (reidentified as Ariadne in the late eighteenth century), followed in 1511 by the *Laocoön*—all characters mentioned by Virgil.

The concept was amazingly effective. Revered instantly for its formal perfection, the *Laocoön* soon became a symbol of Christian virtues and the greatness of the Romans.[67] The agonized figure of the pagan priest became a model for depictions of Christ's suffering and the martyrdom of the saints. It was no accident that this particular sculpture was so important for the Statue Court: its exhibition there signaled Julius's presentation of pagan antiquities as great works of art in the service of Christianity.

Over the years, the garden was progressively formalized and eventually semi-enclosed. The image of nature was overtaken by that of architecture. Already by the time that Leo X (1513–21) succeeded Julius, two colossal river gods—the *Nile* (appropriately near *Cleopatra*) and the *Tiber*—had upstaged the *Laocoön.*[68] As recorded in the van Heemskerck drawing, it was now these two reclining figures, set opposite one another in reflecting pools in the middle of the court, that greeted visitors arriving from the main entrances at the northeast.

This new arrangement may even have affected the *Laocoön's* restoration. The idea of reconstructing a statue's missing parts apparently first occurred to the sculptor Lorenzetto (Lorenzo Lotti) while redesigning the statue court of Cardinal Andrea Della Valle's Palazzo Valle-Capranica in Rome sometime between 1526 and 1534. In the

58. Cornelis Cort, after Marten van Heemskerck, *Statue Court of the Palazzo Valle-Capranica, Rome,* showing restoration by Lorenzetto.

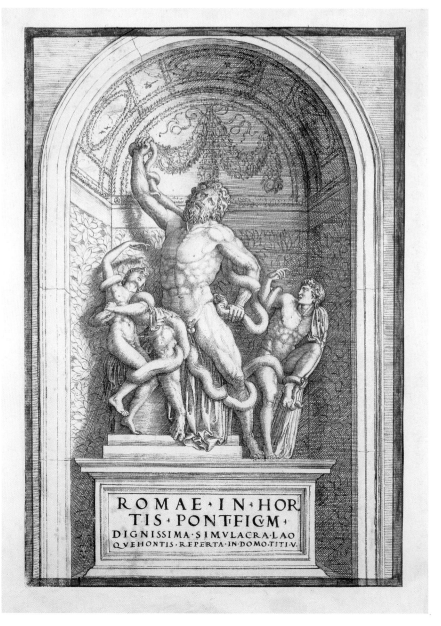

ROMAE · IN · HOR
TIS · PONTFICM ·
DIGNISSIMA · SIMVLACRA · LAO
QVEHONTIS · REPERTA · IN · DOMO · TITI · V.

59. Francisco de Hollanda, *Laocoön* (late 1530s), in Statue Court.

course of this project—directly inspired by Bramante's Belvedere Courtyard[69]—Lorenzetto's re-creation of missing body parts started a trend that would be followed for three centuries[70] (fig. 58).

Crucial to the *Laocoön*'s reconstruction was the priest's right arm. (Also important were the missing right hands of both sons and the problem of how to position the three figures in relation to one another.) Of the many attempts at restoration, the most influential was the one begun in 1513 by Michelangelo's assistant, the Franciscan Giovanni Angelo Montorsoli,[71] who initially drew the priest with a bent arm, like the one now believed to be archaeologically accurate. Mysteriously, the terra-cotta limb he eventually provided

60. Hendrik van Cleve III, *View of Rome* (c. 1545), showing Statue Court, at left.

for the statue was extended in the melodramatic gesture that was repeated in various replicas for four centuries.[72]

Why the sculptor changed his mind is open to conjecture.[73] Possibly, Montorsoli decided to extend the priest's arm because a more compact *Laocoön* would have been almost completely hidden behind the massive *Nile,* with its eye-catching bevy of babies, by then at the center of the court.[74] Or given the width of the barrel-vaulted rectangular recess—compared with the smaller semicircular corner alcoves with canopy-shaped vaults—the artist may have felt a need to fill the space. The shallow, rectangular recess would also have encouraged Montorsoli's High Renaissance vision of a linear, relieflike composition.

There is an argument for an even more three-dimensional configuration that turns the older son ninety degrees, placing him parallel to the right side of the base. Even though the prime view of the group is clearly frontal, all sides of each figure are finished, and their deeper arrangement would oblige the observer to move around the work in order to see the sons' actions, viewing it as an unfolding narrative rather than as a static image.[75]

In the late 1530s, the Portuguese artist Francisco de Hollanda drew the *Laocoön,* as restored by Montorsoli, displayed in a niche painted with plant motifs reminiscent of the glass mosaic decoration often found in antique alcoves (fig. 59). The *Venus* and *Apollo* niches were painted with similarly bucolic trellis and bird motifs. Two corner niches—for *Cleopatra* and the *Tigris*—were nymphaea, artificial re-creations of sacred grottoes dedicated to nymphs.[76] The sound of their splashing fountains was an important part of the garden's sensory environment.[77] At this time, even though the orange grove had been eliminated, the court's casual, irregular walls, floral decorations, fountains, and elaborate loggia still felt like those of an Edenic garden[78] (fig. 60).

Just as even a minor renovation can completely change the character of a museum, altering the building's relationship to its contents, Pirro Ligorio's remodeling, in the 1560s, of the Statue Court's west, south, and southern third of the east walls provided

61. Statue Court, second-story plan (1720–27), with additions by Pirro Ligorio, 1560s.

62. Anonymous drawing (1720–27), showing new stucco facing of west wall of Statue Court by Pirro Ligorio, 1560s.

63. Hendrick Goltzius, *Tiber* (c. 1565), showing, in background, shutters hiding the *Laocoön* in Statue Court.

an altogether different context for the *Laocoön*.[79] Instead of the informality of the villa residence with its serene garden, a more structured arrangement, unified by a new stucco facing, turned the garden into a formal palace courtyard (figs. 61, 62). The new configuration made the *Laocoön* and other statues subsidiary to the architecture, mere ornaments rather than the featured masterpieces of Bramante's presentation.

Even more damaging were the ideological forces of the Counter-Reformation: within less than a decade of the Julian papacy, the statues were branded as "profane idols,"[80] and all but one of the court's several entranceways were closed.[81] Succeeding pontiffs sold or gave away antiquities. Under Pius IV (1560–65), heavy wooden shutters were affixed to many of the court's niches to hide what were considered the most offensive figures—including the *Laocoön* [82] (fig. 63). Censorship of the sculpture marked the beginning of a 150-year period during which the Statue Court was seriously neglected.

The miserable state to which this former garden of Eden had been reduced was described in 1740 by a French visitor: "The small and ugly octagonal court consists of arcades [sic] closed in by large red doors. It looks more like a storage space than anything else. Open the storerooms and in each one, instead of coaches, you'll find an antiquity, and my word, what antiquities!"[83]

From the beginning of the eighteenth century, Rome had been a high point on the Grand Tour, a mandatory stop for artists and cultivated travelers who came from all over Europe to learn the lessons of the ancient world.[84] Responding to the renewed interest in antiquity, Clement XI (1700–21) and his learned counselor Francesco Bianchini brought statues and inscriptions to the Statue Court for safekeeping, without, however, improving its appearance.[85] This scholarly, philological approach to display gradually gave way to a more aesthetic one with the addition by Clement XIV (1769–74) of a loggia to the Statue Court, and his plans for a new museum— eventually realized as the Pio Clementino.

Michelangelo Simonetti's elaborate barrel-vaulted loggia (structurally completed

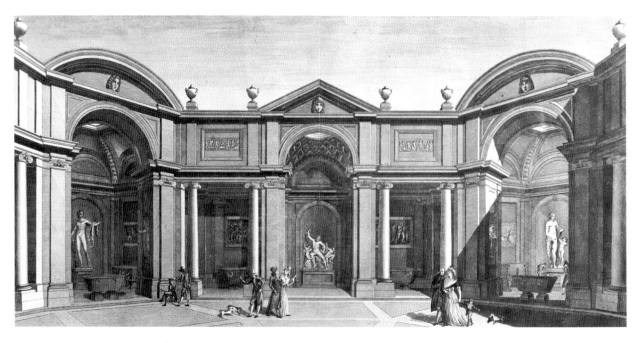

64. Vincenzo Feoli, Octagon Court (completed by Michelangelo Simonetti, 1774), showing the *Laocoön* in alcove of loggia.

in 1774 and still in place), with its greatly enlarged alcoves, or *gabinetti,* altered yet again the nature of the court and its displays: the outdoor space became a partially indoor one, from then on called the Octagon Court.[86] No longer bathed in full daylight, each sculpture was spotlit, so to speak, by natural light that penetrated diagonally from the oculus above together with ambient light from the front of the *gabinetto* (fig. 64).

It was a more inventive arrangement than the unified, linear vista of sculpture lined up against the walls of the adjacent Galleria delle Statue (fig. 65). The *gabinetti* isolated each object in its own intimate enclosure, with a choice of shifting views[87] and a variety of theatrical effects—shading the sculpture in sunny weather, highlighting it on overcast days, and at night, increasing the mystery of torchlit tours whose flickering light seemed to animate the figures.[88] However, the more modern focus on a single object isolated each sculpture and ruled out the dialogue among related artworks that had existed earlier. Furthermore, Simonetti's large, ornate portico overwhelms the *Laocoön,* invariably making it seem much smaller to first-time viewers than its various reproductions suggest.

The mise-en-scène was carried out with the help of Giovanni Battista Visconti, who was in turn influenced by the quasi-religious encounter with antiquity promoted by his contemporary the German archaeologist and art historian Johann Joachim Winckelmann. By identifying and tracing the rise and subsequent degeneration of an idealized classical period (fifth–fourth centuries B.C.), in which he placed the *Laocoön,* Winckelmann established the statue's canonic status. No matter that this dating turned out to be erroneous; Winckelmann's judgment nevertheless made the *Laocoön* and other designated works in the late eighteenth and early nineteenth century equivalent in importance to the Sistine Chapel today.[89]

The German scholar laid the foundations of art history by attempting a systematic reading of art within a historical context.[90] His focus, however, was on individual sculptures, and he had little interest in the subtleties of their display.[91] In this sense, his separation of artworks from their context forecast André Malraux's *Museum without Walls,* in which

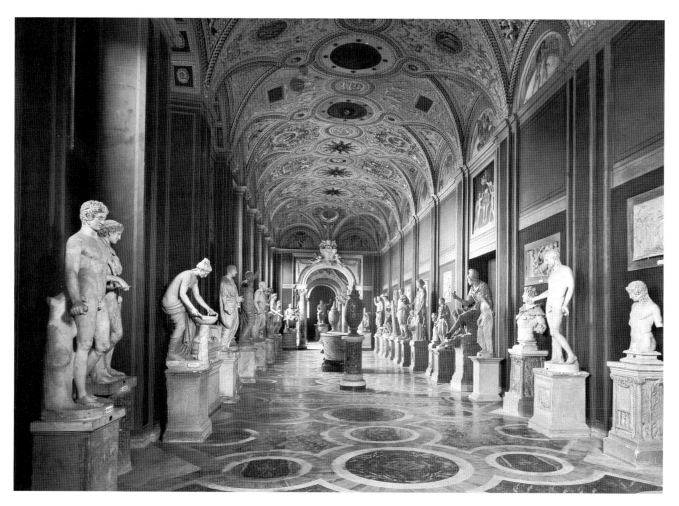

65. Galleria delle Statue, Vatican (completed 1775).

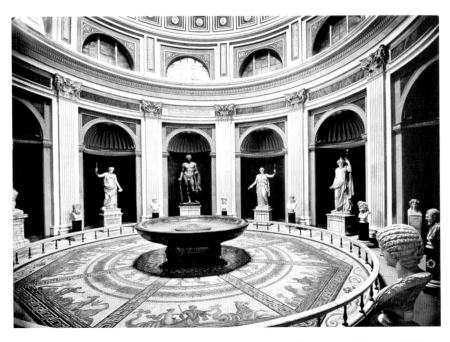

66. Sala Rotonda, Museo Pio Clementino, Vatican (completed by Michelangelo Simonetti, 1784).

the French scholar illustrated artworks abstracted from their installations.[92]

The interiors of the Pio Clementino Museum (and subsequently the Louvre) were to a certain extent inspired by the famous Roman villa of Cardinal Albani, whom Winckelmann served as an adviser.[93] In keeping with aristocratic taste of the day, statues were placed decoratively in pairs according to typology rather than style and in some cases were backed by mirrors that would show them more fully.[94] For museums, it was the Villa Albani's eighteenth-century ceiling paintings, like those of the Villa Borghese Casino, also in Rome, that had particular appeal, coordinating as they did with the ancient sculpture like Technicolor narratives using the same cast of characters.[95]

When Pius VI succeeded Clement XIV in 1775, he continued work on the Museo Pio Clementino in collaboration with Visconti, who, from 1770 until his death in 1784, made every major decision regarding the excavation, acquisition, restoration, and installation of antiquities, including the choice of pedestals and the design of frames and niches.[96] Visconti rejected as inappropriate the use of antiquities for decoration, as in private palaces, and the traditional alignment in rows, as in galleries. Instead, the antiquarian argued for historicized settings that would literally envelop visitors with allusions to antiquity. The Pantheon and Roman baths served as models for the new museum's architecture. Overhead—painted on the ceiling vaults—were mythological allegories; underfoot, Visconti installed authentic Roman mosaics[97] (fig. 66).

Upon its near completion in 1784, the Pio Clementino immediately became a model for museums throughout Europe and the United States. However, the new pope's grandiose ambitions worked to the detriment of the Octagon Court. Whereas for Clement the court was central to the museum, Pius made it into an addendum. To emphasize the Pio Clementino's public nature, Simonetti constructed a large new stairway leading directly to it. Consequently, visitors came to the court last instead of first.[98] Reversal of the circuit and competition from the expanded scale and variety of decors adopted for the museum's rooms completely changed the hierarchy of spaces[99] (fig. 67).

Despite the unquestionable quality of the Pio Clementino's neoclassical architecture,

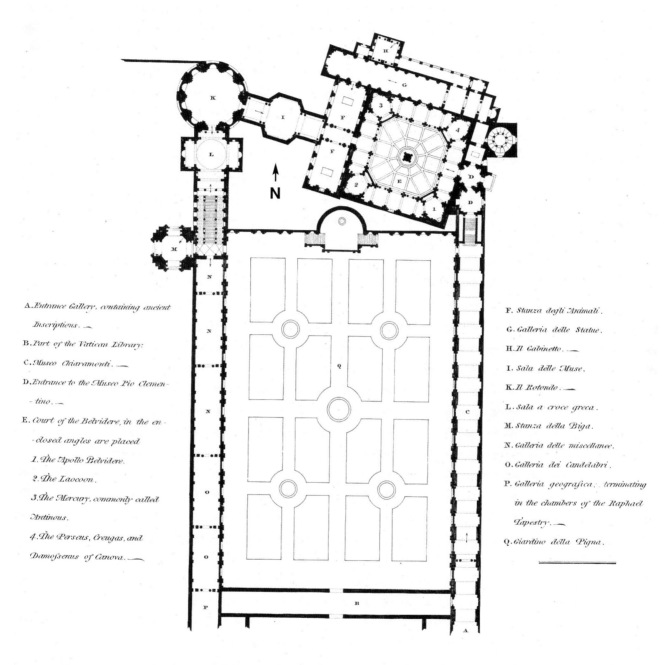

Pl. 1.

Plan of the Museum of the Vatican, Rome.

A. Entrance Gallery, containing ancient Inscriptions.

B. Part of the Vatican Library.

C. Museo Chiaramonti.

D. Entrance to the Museo Pio Clementino.

E. Court of the Belvidere, in the enclosed angles are placed

 1. The Apollo Belvidere.

 2. The Laocoon.

 3. The Mercury, commonly called Antinous.

 4. The Perseus, Creugas, and Damossenus of Canova.

F. Stanza degli Animali.

G. Galleria delle Statue.

H. Il Gabinetto.

I. Sala delle Muse.

K. Il Rotondo.

L. Sala a croce greca.

M. Stanza della Biga.

N. Galleria delle miscellanee.

O. Galleria dei Candelabri.

P. Galleria geografica, terminating in the chambers of the Raphael Tapestry.

Q. Giardino della Pigna.

The dart marks the spot from whence the View is taken.

Drawn by James Hakewill.

10 20 40 60 80 100 200 feet.

Engraved by Harry Willson.

Published as the Act directs, May 1.1818, by John. Murray, Albemarle Street London.

67. Vatican Museum: Plan (after 1772), with Museo Pio Clementino, preceded by Simonetti stairway, at upper left.

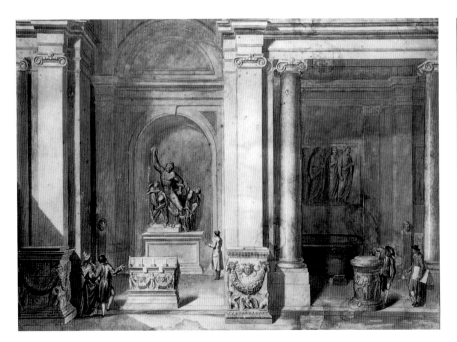

68. A. L. R. Ducros and G. Volpato, *Laocoön, Octagon Court, Vatican* (late eighteenth century), showing multitude of objects in loggia.

69. Octagon Court (early twentieth century): *Laocoön*, with right arm from 1720 exhibited on statue base.

its displays were severely criticized: "They are marked more by luxury than by taste," noted Baron Alexis von Krüdener, a traveler in Italy in 1786.[100] The baron went on to say: "The pope has noticeably increased the collections, putting 'Ex munificentia Pii VI' on each one of them. However, the statues are badly lit and placed in disorder, mixing beautiful, middling, and ugly. Even more shocking, the pedestals bear no relationship to the figures."

Certainly, the *Laocoön* was ill served by the new arrangement. In addition to the problems of its new, overly elaborate setting, the statue was now in a space that was clearly secondary to the museum proper and, consequently, was downgraded by association. Equally troubling was the accumulation of objects around the priestly group: within a few years, what had begun as a museumlike presentation of a few related masterworks became a catchall for everything that did not find a place within the Pio Clementino. Thus, in addition to being dwarfed by the architecture of the loggia, the *Laocoön* was also diminished by the confusing jumble of objects surrounding it (fig. 68). In keeping with the new didactic mandate of a public museum, an unfinished bent arm in marble, discovered at this time and erroneously attributed to Michelangelo, was attached to the *Laocoön*'s pedestal[101] (fig. 69).

The Louvre, 1798–1815

With Napoleon's defeat of the Italian states, the *Laocoön,* along with a hundred of the Vatican's finest artworks, was requisitioned by the French emperor. As Rome had pillaged Greece, so France pillaged Rome; like Julius II, Napoleon used art to establish himself as a new Caesar.

As a museum, the Pio Clementino was seen as a neutral, secularized space, in much the same way as the Louvre, in its new role as a public cultural institution, neutralized the connotations of the treasures of the Old Regime.[102] Napoleon, however, repoliticized art by using his plunder, including the *Laocoön,* to buttress the image of France's military might. For the emperor, art was a trophy, just as costly new acquisitions seem to be for today's competitive museums.

The Italian collections were brought to Paris in 1798 with the pomp befitting an ancient triumphal procession: carts decked with garlands and tricolors were accompanied by cavalry, parading troops, marching bands, and exotic animals.[103] The fact that the *Laocoön,* like other statues and paintings in the procession, was hidden in its traveling case did not deter artists from depicting the work as if it had been on display: represented

70. Antoine Béranger, *The Entrance into Paris of the Works Destined for the Musée Napoléon,* Etruscan-style Sèvres vase (1813), detail showing the *Laocoön.*

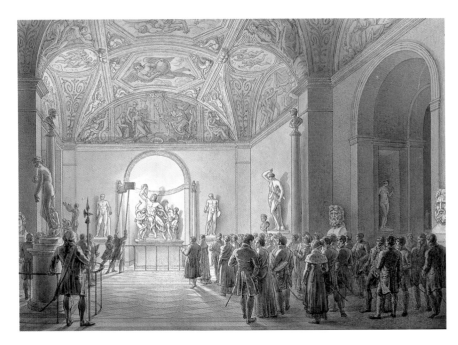

71. Benjamin Zix, *The Emperor and Empress Making a Torchlight Visit to the Laocoön Room at the Louvre* (c. 1800).

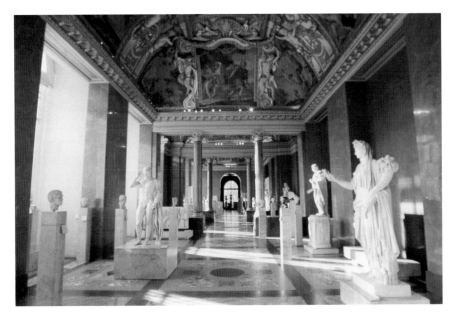

72. Louvre (2004): Window that was covered to create niche for the *Laocoön* at end of enfilade (1800–1812).

on a Sèvres Etruscan-style vase, the heroic priest became a prisoner of war (fig. 70).

One of the revolutionary government's first acts had been the inauguration in August 1793 of the Museum of the Republic, now known as the Louvre. In it, the kings' collections and over five hundred canvases confiscated from royal households and religious institutions were made available to the public on a regular schedule. Sculpture—vastly inferior in quality, and with far fewer pieces—was first displayed in one of the new museum's courtyards.[104] The treasure trove arriving from Italy made clear the need for a grander setting: accordingly, two wings of the Louvre were redesigned to serve as the Musée des Antiques, inaugurated in 1800.

The antiquities occupied a long north-south suite and a shorter space perpendicular to it—formerly the apartments of the Regent Anne d'Autriche, queen to Louis XIII and mother of Louis XIV. The *Laocoön* was the centerpiece of the renovated antiquities galleries, standing at one end of a long enfilade with a new entrance inserted at the other end[105] (see fig. 46). The priestly group was thus once again the focal point for arriving visitors, as it had been originally in the Statue Court (figs. 71, 72).

The arrangement of sculpture in Paris was entrusted to the Italian archaeologist Ennio Quirino Visconti, who had succeeded his father, Giovanni Battista, as director of the Pio Clementino. Having fled Rome after the collapse of the short-lived Italian Republic (1802–5), he was named keeper of the Louvre antiquities by the French government—for whom his political sympathies must have been as important as his professional qualifications. Visconti's presence in both Rome and Paris undoubtedly accounts for some of the similarities between the two museums.

In Rome, Visconti had criticized the *Laocoön's* placement on a high pedestal, observing that it "loses half its beauty placed high, because you can't see the laurel crown . . . or the expression of the mouth. Also, the face of the younger son is lost."[106] In Paris, these considerations were again sacrificed to the most effective showcasing of the statue: on a hefty rectangular pedestal, and within a semicircular niche framed by Corinthian columns. Like other sculpture in the galleries, aligned for the most part against the walls, the *Laocoön* could be seen only from the front. Uncertainty about the statues' dates ruled out the kind of loosely chronological presentation that guided the museum's organization of paintings, and thus it was typology, together with size and symmetry, that for the most part dictated the groupings at the Louvre, as was the case at the Pio Clementino and, indeed, in antiquity.[107] In the absence of labels, the museum published yearly, reasonably priced pamphlets, the *Notices,* enumerating the works in all the collections and identifying the artists and subjects.[108]

As his father had in Rome, Visconti looked to the examples of the Albani and Borghese villas in commissioning ceiling paintings to explicate material in the galleries. At the time, such paintings probably functioned much as explanatory wall texts do today. The decorative program in the vestibule of the Galeries des Antiquités featured the birth and development of sculpture. Four bas-reliefs showed personifications of past artistic cultures, pointing to their masterpieces.[109] Other ceilings' thematic paintings suggested the selection of sculpture in many spaces, even where these paintings were left over from Anne d'Autriche's commissions. For what became the Laocoön Hall (now the Salle des Antonins), however, Giovanni Francesco Romanelli's representations of virtue in honor of the regent, and related gold-leaf stucco figures, were irrelevant to the sculpture.

Placement of what was referred to as the *Adonis* (now called *Meleager*) near the *Laocoön* may have been motivated partly by the blurred distinctions between divinities and superhuman heroes,[110] the subject of most of the statues in this gallery. Reputation also played an important part in the arrangements of the statues. That the *Adonis* as well as the *Discobolus at Rest* were chosen to flank the *Laocoön* may well have been because, at the time, they were all equally coveted. This was also true of the *Venus de' Medici,* placed in the same gallery in 1803 after lengthy diplomatic negotiations to obtain it from the Italians. Exceptionally, the *Venus* was positioned facing a window, with her back to the room; a specially designed turning pedestal allowed views of the sculpture from all sides.[111]

The Laocoön Hall was generously proportioned and filled with daylight from three east-facing windows. However, as in the case of the *Nike,* the reddish walls were not ideal, and the excessive ornamentation of the galleries was compounded by the crowded installation. Henry Milton, a visitor from London in 1815, wrote: "Painted ceilings, gilded figures in relievo, and all the tawdry richness of a state drawing room

are discordant with the severity and dignified simplicity of sculpture."[112]

Dominique-Vivant Denon, the museum's formidable first director, was in constant conflict on just this matter with Pierre François Léonard Fontaine, of the celebrated Percier and Fontaine team of architects appointed by Napoleon to renovate the Louvre. Denon wanted a museum, Fontaine a palace.[113] The distinction was important for the kind of cultivated French person who read Winckelmann's adoring descriptions of Greek sculpture in the translation that appeared almost simultaneously with the German publication of his *History of Ancient Art* in 1764.[114] These people viewed ancient sculpture with new art-historical seriousness, understanding the pieces as esteemed art objects of intrinsic merit rather than as decoration.

Paradoxically, it was while the purloined Italian antiquities were in Paris, where Winckelmann was so widely respected, that his ideas were decisively challenged. Already in the late 1770s, the German painter Anton Raphael Mengs, a close friend of Winckelmann's, had questioned the dating and quality of masterpieces such as the *Laocoön*.[115] Winckelmann's mistaken dating would probably not have come to light at this time had the statues remained in Italy. But in Paris, by the summer of 1807, the sculpture was often compared with the Elgin Marbles, which had just gone on view in London (fig. 73).

To knowledgeable observers who traveled between the two cities, often specifically to see the new displays, it was soon apparent that the work in London was closer to the classic Greek ideal described by Winckelmann as "noble simplicity and calm grandeur" than what they saw in Paris.[116] Even before the Elgin Marbles came on the scene, Visconti had begun to defend his collection by refuting the contention that Greco-Roman copies, such as the *Laocoön,* were inferior to Greek originals. As a dealer today would protect the reputation of his or her stable of artists, Visconti delayed a visit to the Elgin Marbles as long as possible—until 1814—in an effort to stave off the challenge they posed to the statues in Paris.[117]

Although Winckelmann's approach to art history prevailed, his dates did not. Generally accepted as examples of fifth-century-B.C. classical sculpture when they arrived in Paris, the *Laocoön* and other famous works from Italy were eventually recognized as later than the Parthenon sculpture and therefore, by Winckelmann's own criteria, inferior. After its Renaissance and Enlightenment apotheosis in Rome, the *Laocoön* diminished in prestige in Paris as it was dated to a more recent time.

The *Laocoön's* decline corresponded to a new interest in truthfulness as embodied in more lifelike earlier sculptures: the priest's expressiveness was considered inferior to the naturalism of the Parthenon's sculptures.[118] Reinforcing the change in taste were the opposite ways in which the two collections were presented. The unrestored condition and modest temporary installation of the Elgin Marbles reminded Quatremère de Quincy of a sculptor's studio, in a sense recontextualizing them.[119] The presentation responded

73. Park Lane, London (1810): Elgin Marbles.

to a growing preference for artless naïveté and naturalism, antidotes to what began to be regarded as the eighteenth century's artificial schematization and stylization.[120]

With the prospect of their permanent exhibition in the British Museum—a purpose-built museum rather than a renovated palace—the Elgin Marbles were stripped of all decorative connotation. Those assessing them simply ignored their origin as architectural sculpture. Their untampered-with, damaged condition authenticated their archaeological value; fragmented, they encouraged the viewer to imagine them completed, as perfect works. While the statues in the Louvre were presented as potential furniture in a palace, those in London were offered as autonomous art objects, thereby detracting from the former and enhancing the latter.[121]

Downgrading of the Italian antiquities toward the end of their Parisian sojourn did not dampen the enthusiasm of those who traveled to see them, nor would it affect the general public's admiration until later in the century. By then, the classical Periclean period had become firmly established as the qualitative high-water mark for evaluating antique sculpture. The closer a sculpture came to the latter part of the fifth century B.C., the date of the Parthenon sculptures, the higher the value placed on it; conversely, the further away from that time, the lower the value.

Even the spurious way in which France acquired the *Laocoön* and other statues from Italy was blurred by the former country's lofty political rationale. A newly liberated France was freely touted as a worthy guardian for treasures produced in a Greek democracy.[122] As for the English, Henry Milton, for one, dismissed "the crimes of rapine" by which the works were procured from various Italian localities in favor of keeping them. He suggested that his country might buy the collection to increase "the grandeur and dignity of the nation."[123]

This attitude was emblematic of the nineteenth century's fiercely competitive construction of public museums and acquisition of art for them. The new institutions were important symbols of national identity: in them, antiquities formerly associated with a universal humanist tradition were linked with a sense of nationhood.

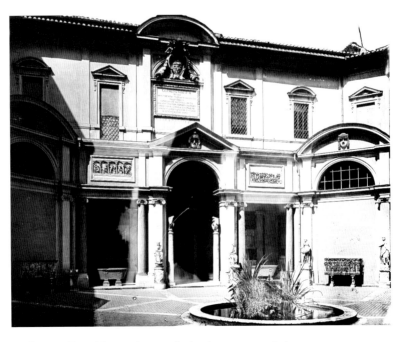

74. Octagon Court (nineteenth century), showing corners sealed.

The Statue Court Redux, 1816–present

Given the high profile of the art plundered by Napoleon, it is not surprising that its restitution was one of the most important issues raised by his defeat. Barely two months after Waterloo in 1815, Pope Pius VII (1800–23) put Antonio Canova, the preeminent sculptor of the day, in charge of recovering works taken from the Italian principalities. Passionately concerned about regaining his compatriots' lost treasures, Canova was the obvious choice for the job.[124]

Already upon his election to the papacy, Pius VII had begun to shore up the Vatican's art holdings, depleted by decades of sales and gifts to increasingly aggressive collectors and by the immense loss of artworks to France. The enterprising pontiff also acquired contemporary art, including two sculptures of the wrestlers Kreugas and Damoxenus and *Perseus Triumphant with the Head of Medusa*, all by Canova, whom he had appointed Inspector General of Fine Arts and Antiquities for life in 1802.[125]

Canova was, of course, sensitive to changing ideas about sculpture and its perception. In both France and England, an increasing range of luxury goods had raised public awareness of materials and fabrication, and viewers were applying this new discrimination to three-dimensional art objects. Whereas previously only small-scale sculpture in bronze or ivory had been subject to close attention, Winckelmann's new value system mandated the same scrutiny for large works as well.[126] It was thanks to close examination of the Elgin Marbles' detail and execution—realistic representation of veins and sinews, together with subtle surface modeling—that they were identified as fifth-century classical work. Other sculptures had to be displayed to satisfy this kind of inspection (as did painting).[127] Furthermore, Canova's out-of-hand dismissal of the idea of restoring the Elgin Marbles largely reversed the centuries-old practice of completing fragmented antiquities with sculpted marble parts (with rare exceptions such as the Belvedere Torso at the Vatican). To accommodate these new viewing practices, and possibly because he too felt that Simonetti's loggia dwarfed the statues in the Statue Court, one of the new inspector's first acts (in 1803) was to enclose the

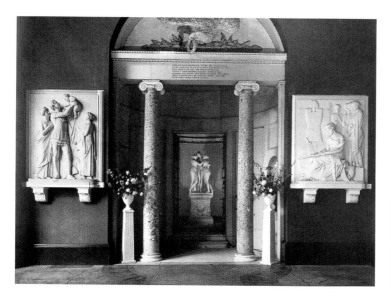

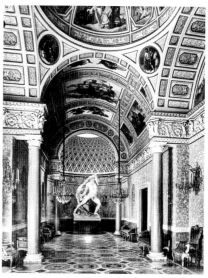

75. Sculpture gallery, Woburn Abbey: Entrance to *Temple of the Three Graces* (architecture completed by Jeffrey Wyatt, 1816), flanked by George Ganad, *Eagle of Jove,* and Francis Chantry, Homeric relief.

76. Palazzo Torlonia, Rome: Canova, *Tribune of Hercules and Lichas* (1796).

four corner alcoves (fig. 74). The measure also protected the fragile plaster replicas that had been substituted for the statues taken to Paris, as well as his own marble *Perseus*.

Shortly before the restitution, the sculptor's ideas about installing two of his own works in private residences prefigured concepts he would use for the Vatican display. He encouraged the creation of two domed, skylit rotundas, one for the *Three Graces* (1815–17) at the sixth duke of Bedford's new sculpture gallery at Woburn Abbey[128] and the other for the monumental *Hercules and Lichas* (1795–1815) at the now demolished Palazzo Torlonia in Rome[129] (figs. 75, 76). The two installations, recalling the dome, oculus, and niches of the Pantheon, were extraordinarily elegant and showed the sculptures in light and from viewpoints that were carefully controlled. The re-creation of a similar design for a public institution was, however, not without problems.

Despite the merits of the contextual setting, a French visitor to the Torlonia Palace complained, "Placed in too narrow a space, the Hercules group cannot be seen from all sides and the spectator has no distance in which to step back from it."[130] The Torlonia installation allowed, at least, a distant frontal view of the sculpture, not available, however, for the *Laocoön* when, upon its return from France in 1815, it was placed in a walled-in corner *gabinetto*.

Although the *Laocoön* was in the same area in which it was first shown over three centuries earlier, its presentation had changed radically. The statue was visible only from a tightly prescribed path, with restricted illumination; long views of the statue from the center of the court were eliminated, as was light from this source. The setting was more like the controlled single trajectory of early Modern exhibition design, which has now been largely rejected in favor of more flexible options. For the sake of symmetry, the *Laocoön* was removed from its dominant position in the court and placed on an equal footing with the sculpture in the other corners, including the contemporary *Perseus*. Just as it was losing its preferred place in the critical hierarchy, the *Laocoön* lost its unique place of honor in the court.

By the middle of the twentieth century, scholars were questioning the installation.

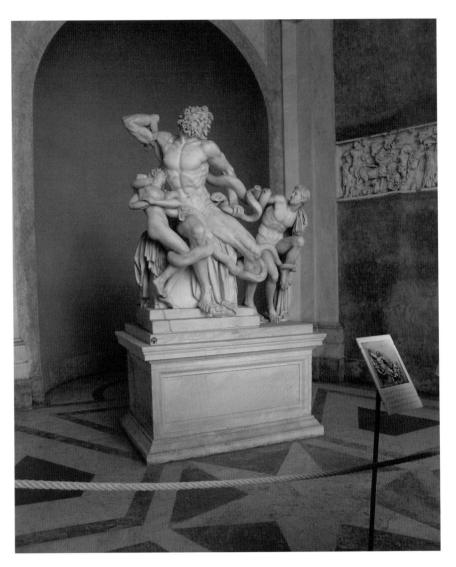

77. Octagon Court: *Laocoön,* as exhibited since 1960.

In part due to rapidly increasing attendance (over a million people in 1950, a Jubilee year),[131] the *Laocoön's* installation was described as "suffocating."[132] In 1959 (in time for the 1960 Olympics in Rome), the blocked-in corners of the Statue Court were opened to reveal the newly restored group[133] (fig. 77; compare with fig. 54). Among the changes that had been made, the so-called Montorsoli arm, this one in plaster, the last in a long line of prostheses, was replaced with a bent arm discovered in 1906 in a Roman sculptor's studio and thought to belong to the original group.[134] The new restoration, by moving the elder son back from the other two figures, also makes the composition more pyramidal. The sculpture was lowered by reducing the thickness of the marble slabs supporting the figures and brought forward to allow viewing from all sides.[135] (Yet it is now roped off and can be seen only from the front.)

To acknowledge the "traditional" *Laocoön,* the one with the outstretched arm that had exerted such widespread influence for four centuries, a plaster copy of it was displayed with the Montorsoli arm[136] (fig. 78). Ironically, the copy ended up in the place of honor, the central, southern niche designed for the original, while the authentic statue remains in a corner niche.[137] The double offering, intended to allow visitors to compare

the two versions,[138] must have been confusing, because in 1985 the plaster replica was removed from the court and is now relegated to a corner of the museum's new entrance area.[139] Replaced beside the original statue's caption by a photograph, the replica of the "old" Laocoön has lost any meaningful relationship with the original.

The Laocoön no longer engages its viewers with the power it once had.[140] Cultivated Romans in antiquity were familiar with the great epic poetry and mythology on which figural representations were based, and which routinely furnished a starting point for learned conversation. Gradually, these meanings were lost as mythic associations eroded in favor of purely aesthetic appreciation.

At present, the Renaissance has upstaged classical antiquity. Circulation through the Vatican Palace and Museums is now focused on the Sistine Chapel, where the paintings of Michelangelo and Raphael are more easily appreciated than classical sculpture. For today's three and a half million annual visitors to the Vatican Museums,[141] the Statue Court is no longer a destination but rather an incidental cluttered passageway leading from one bewildering maze of exhibition spaces to another. As with the Nike at the Louvre, a changed viewing itinerary has demoted the Laocoön from its symbolic preeminence.

Each of the statue's many presentations (including the Louvre) placed it in a niche. For the initial display in the Statue Court, Bramante, like other Renaissance architects, relied on that construct, known from antiquity. But how the Laocoön was displayed then can only be surmised.

78. Plaster replica of Laocoön (c. 1956), current placement.

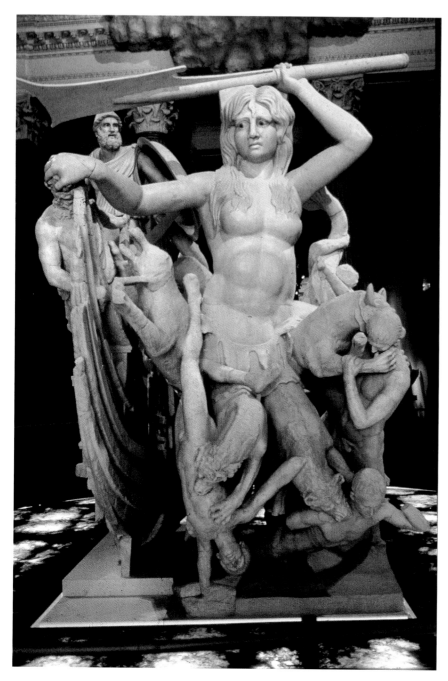

79. *Scylla* group (c. 20 B.C.–A.D. 20), Sperlonga.

80. Bernard Andreae and Baldassare Conticello, grotto, Sperlonga, reconstruction of the general plan.

A. Water basin
B. Fish pond
C. Triclinium island

The *Laocoön* in Antiquity

Apart from Pliny's reference to the statue in the Palace of Titus, nothing is known of how the *Laocoön* was displayed in antiquity. Because the ways in which sculpture was exhibited in the ancient world were as susceptible to changing fashions as they are today, dating is crucial to understanding how an object was first seen. Dating antiquities precisely is, however, no easy matter, and the *Laocoön's* time frame ranges over more than a hundred years, from 50 B.C. to A.D. 70.[142] In addition to providing clues to the statue's first installation, an exact date would clarify whether its artists were creative originators or merely skillful copyists: dating the *Laocoön* to a more recent time would support the contention that the marble was copied from a second-century B.C. bronze masterpiece.[143]

Pliny did not give dates for the three sculptors—Hagesandros, Polydoros, and Athenodoros—to whom he attributed the *Laocoön*. But there is evidence that the first two worked in Rhodes between 60 and 41 B.C.,[144] and some consider the group's eclectic style typical of the first century B.C.[145] There are, however, equally passionate arguments for more recent dates.[146] Beginning with the early dates for the priestly group and working forward in time, three hypothetical settings may be put forward.

If the *Laocoön* was made sometime between 40 and 20 B.C.,[147] it could have been the property of a wealthy citizen, who might have used it as a garden ornament. According to the Laocoön legend, the snakes emerged from the sea to strike down the priest as he sacrificed a bull to Poseidon, and the different levels at which the father's and the older son's feet rest imply that the original support was uneven, possibly wavy, to evoke the shore.[148] If the kind of rocky base so popular at this time did indeed support the sculpture, its associations with water suggest the possibility of the sculpture's placement in a nymphaeum. In such a grottolike setting, perhaps partially veiled by plantings, the statue would have created an element of surprise.[149] Strollers would have come unexpectedly upon the *Laocoön's* drama within a serene, private space, a peaceful outdoor context not unlike the one later devised by Bramante at the Vatican.

A different kind of installation for the statue is brought to mind by a major archaeological discovery in 1957 at Sperlonga, a small seaside town midway between Rome and Naples.[150] In a picturesque natural cave just south of the town, a marble group bearing the names of the three artists with whom Pliny associated the *Laocoön* was found among the wealth of distinguished sculpture that had apparently embellished the large, rocky grotto. The monument is, however, less finely detailed than the *Laocoön*, probably because it was meant to be seen from a distance.[151] It depicts a stirring moment in Odysseus's voyage, when he and his men were attacked by Scylla, a fish-tailed sea

monster[152] (fig. 79). It is is one of four monumental representations of Homeric themes found in and near the grotto, which together form a dramatic tableau vivant.[153]

The cave opens at the foot of a hill beside the remains of a luxurious villa. Its circular water basin is connected with a large pond for prized fish, a costly conceit common to palatial seaside dwellings in antiquity.[154] Just outside the cave's mouth, to the right, there may have been a representation of Odysseus and Diomedes stealing the Palladium (a sacred image of Pallas Athena that ensured the protection of cities); to the left of the cave, an older warrior (possibly Odysseus again) carrying a younger one. A gigantic, inebriated Polyphemus being blinded by Odysseus and his companions is believed to have writhed on a boulder at the back of the cavern within a minigrotto of its own. Most spectacular of all was the *Scylla* group, positioned on a masonry plinth at the center of the basin looking north across the Gulf of Gaeta to the very mountain where Circe is said to have warned Odysseus about the monster (figs. 80, 81).

The cave fits ancient literary descriptions of the one in which Tiberius was nearly killed by a rockfall as he dined there sometime between A.D. 23 and 26.[155] The emperor seems to have adopted a preexisting villa, and the cave decorations may well have been created before his time.[156] Whenever the statues were made and installed, however, the link between the artists of the *Scylla* and the *Laocoön* raises the possibility that the priestly group could, at some time, have enjoyed a similar mise-en-scène.

Socializing and, especially, dining were given high priority among the many pleasures of the Roman aristocracy, and summer heat made the coast's cool caverns a favorite place in which to entertain. Within the fishpond, a rectangular island served as a triclinium, or dining room, from which guests faced the cave and its treasures.[157] Pliny the Younger described diners at his Tuscan villa reclining on couches beside a triclinium pool on which servants floated heavy trays with food in vessels shaped like ships and birds.[158] A century earlier, a similar arrangement may have been in place at Sperlonga.

By the end of the evening meal, customarily starting at three or four in the afternoon, the rays of the sinking sun would have cast a pink glow on the bright-colored statues, in turn reflected in the pool. Musicians, singers, and actors would have performed on the banks of the pond for guests, who could enjoy near and far views of the statues from rock-cut seats at the cave's mouth, from the stairs, and from a path around the basin.[159] Alternatively, for viewers in the back of the cave, the *Scylla* group would have been silhouetted against the entrance.[160]

In the third scenario, the ancient, richly decorated room where the *Laocoön* was found, in what Pliny described as the Palace of Titus (A.D. 79–81), has been identified as the Sette Sale, near the cistern of the later Baths of Trajan (A.D. 98–117).[161] So possibly the baths themselves were among the many places where the *Laocoön* may have stood at different times. Sculpture has been found in the remains of various bath

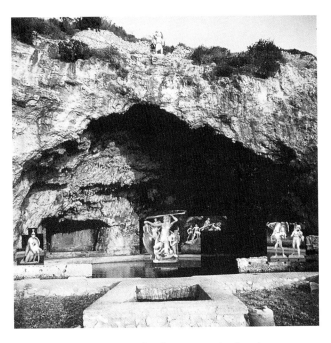

81. Bernard Andreae, grotto, Sperlonga, reconstruction view.

buildings, especially in the central bathing core and palaestrae (enclosed areas at the perimeter of the building).[162] The Baths of Caracalla (A.D. 211–217.) in Rome are the best example of this tradition and also provide the strongest evidence of a program, one that consisted of classical deities, personifications, and ideal types—including a glorification of the youthful male nude—all suggestive of health and pleasure (fig. 82). Additionally, freestanding statues often celebrated Roman military might in a political reminder of the donor and his power.[163]

The multistoried, columned interior walls of bath buildings originated with the *scaenae frons* of late Republican temporary theater buildings, offering stagelike displays,[164] as did, in its own manner, Tiberius's imagined dining cave at Sperlonga. Statues often seem to have been placed against walls or columns, less frequently between the columns and alongside some pools.[165] Water poured from the bases of many niches containing sculpture, or from the sculptures themselves, which were made into fountains by having pipes inserted. Fountains and sculpture both created dynamic effects, introducing an unexpected element into the predetermined, symmetrical spaces.

Trajan reigned more than a century before Caracalla, but by then all the basic architectural components of the large imperial bath type were already in place.[166] The earlier Trajan Baths with which the *Laocoön* is associated may therefore have looked very much like the later Baths of Caracalla. Interiors were as colorful as the statues themselves. Glittering glass mosaics, polished stone cladding, and painted stucco adorned the surfaces; hundreds of statues stood in niches and on bases on the floor.[167] Sculpture was illuminated by abundant natural light from large windows and possibly from skylights, in addition to reflected light from pools and flowing water.

Unique to the Baths of Caracalla is the large number of colossal works (ten known and eight more that can be traced) apparently commissioned for the baths, which included some atypically grisly subjects. These giant marbles, among them the *Farnese Hercules* and the *Punishment of Dirke* (called the *Farnese Bull*), are believed to have enjoyed especially careful installations; even though they are all much larger than the

Laocoön, they suggest possible placements for the priestly group, should it have stood at one time in the Baths of Trajan.

The enormous *Dirke,* for example, may have stood against a wall (its back is less interesting than its other sides), possibly in the apse of a palaestra, thus providing a dramatic climax to the long vista. Or it could have been placed in an exedra or as a centerpiece surrounded by water[168] (as the *Scylla* was at Sperlonga). In the Baths of Trajan, the *Laocoön* would undoubtedly have received an equally dramatic placement.

To conclude these conjectures, let us indulge fantasy still further, hazarding a guess at the effect of these imagined contexts. If the *Laocoön* was secreted within the confines of a small, private nymphaeum, the statue would have been seen from a single viewpoint by one or at most a handful of people at a time. These contemplative conditions might have encouraged an impression of the contained suffering Winckelmann had in mind when he described the priest as groaning rather than screaming.[169] If the group was instead part of a decorative ensemble in a dining cave used by an emperor, the *Laocoön* would have been visible from various vantage points and with a more spectacular range of natural light. Although accessible to more viewers than in the nymphaeum, the statue would still have been in a private space, reserved for an elite audience.

Finally, the sculpture might have stood in the midst of a busy public bath. Next to dining, bathing—with its blend of hygiene and culture—was the most important social activity of the Roman world. The thermae were especially crowded during the mandatory visit before the evening meal, when they were the scene of boisterous activity, with the hawking of food vendors contributing to the general commotion.[170] This raucous context, with its opulent interiors animated by splashing fountains and flooded with natural light, would have highlighted the sculpture's flamboyance—the priest emitting a strident scream rather than Winckelmann's stoic groan. Furthermore, in contrast with the two earlier, natural settings, the formality of the bath's architecture would have emphasized the theatricality of the *Laocoön's* baroque forms.

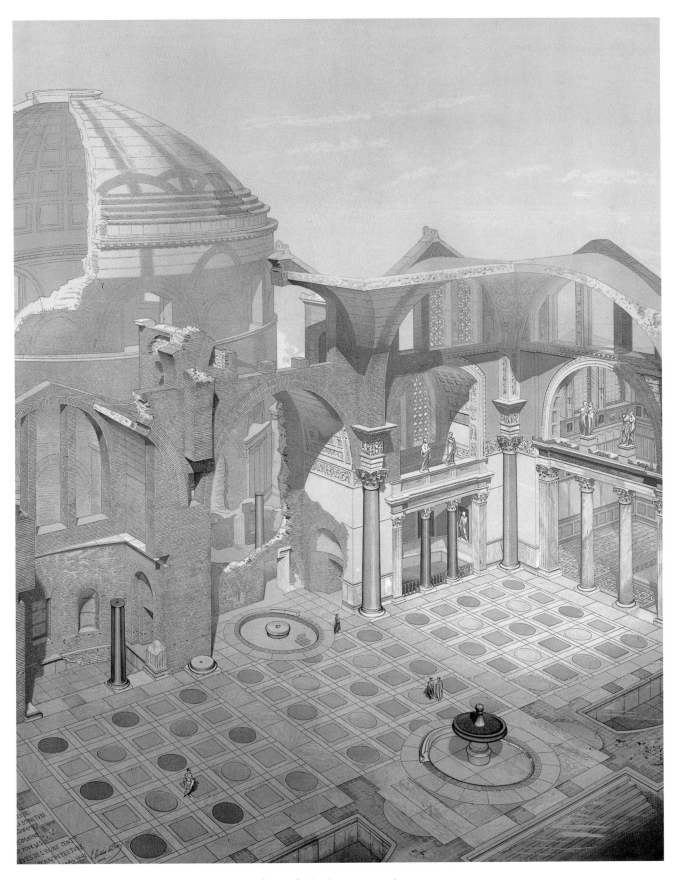

82. Eugène-Emmanuel Viollet-le-Duc, *Baths of Caracalla* (c. 1867), showing reconstruction.

83. Villa dei Papiri, Herculaneum, plan
drawn by Karl Jakob Weber (1758).

A. *Seated Mercury*
B. *Athlete*
C. *Pan and She-Goat*
D. *Drunken Silenus*

THE BRONZES FROM THE VILLA DEI PAPIRI IN HERCULANEUM

For the ninety-some bronze and marble statues discovered at the Villa dei Papiri at Herculaneum, there is far more evidence of an original context than for either the *Nike of Samothrace* or the *Laocoön*. Exceptional circumstances surrounded the discovery in 1750 of this particular site at the ancient Roman town of Herculaneum, which, like Pompeii, was among those buried by the eruption of Mount Vesuvius in A.D. 79. Thanks to the meticulous records kept by Karl Jakob Weber, a Swiss army engineer who was in charge of the excavations, we know that the sculptures (now in the Archaeological Museum of Naples) adorned the semi-outdoor spaces of a palatial estate known as the Villa dei Papiri, after its library of 1,800 preserved papyrus scrolls.[171]

The statues were removed through tunnels, and the villa itself has never been uncovered (although there is a project to do so); therefore knowledge of the whole complex remains partial. However, a plan of the exact locations where the sculptures were discovered and part of the villa, together with the evidence of ancient texts, affords a unique glimpse into aristocratic life in the first century B.C.[172] (fig. 83).

From late Republican times through the fourth century, the spectacular coasts of Latium and Campania were a favorite resort area for wealthy Romans. A former Greek colony, Naples maintained the institutions, leisure, and learning of its origins to such an extent that it was commonly referred to as the "Greek city."[173] The desire to embellish public and private spaces with art, and especially sculpture, was among the most important aspects of this Hellenic tradition.

The avidity with which collectors pursued their interest in Greek objects was evident in Cicero's correspondence in the mid-first century B.C. with his financial adviser and publisher friend Titus Pomponius Atticus; Cicero constantly urged Atticus to find statues in Greece for his villa in Tusculum, about fifteen miles southeast of Rome (and the site of one of Cicero's eight country houses). The remains of several shipwrecks reveal enormous cargoes of just such objects, mass-produced in Greece for the Italian market.[174]

In his instructions to Atticus, Cicero specified locations for which the sculpture was intended rather than the artist, style, scale, material, or subject.[175] Similarly, in his assessment of his acquisitions, Cicero was less interested in the sculpture's quality—or even its appearance—than its effect on the meaning of the place where it stood, its ability to create a specific atmosphere.

Related to the importance of placement was sculpture's role as a memory aid, for rhetoric and just about anything else. This device, long attributed to Cicero, is now traced to the Auctor ad Herennium (the author who wrote to Herennium), who, in the late 80s B.C., is believed to have recommended "a house, an intercolumniation, a corner, an arch, and other things which are similar to these" with which to associate what was to be remembered.[176]

Wealthy Romans were willing to pay a premium for old art and for a distinguished provenance; however, by the late first century B.C., the supply of original classical or Hellenistic sculpture for private consumption had dried up.[177] The Romans' endless emulation of a limited number of Greek models is now attributed to their interest in reinterpretation and continuation of tradition rather than to a lack of creativity.[178] Whatever the reasons for repetitions such as the three (and possibly more) portrait busts of Epicurus and the four fountain figures of Silenus, a Dionysian satyr, at the Villa dei Papiri,[179] personalized installations may have been a way of rendering them less tedious.[180]

The Roman believed by some to have built the Villa dei Papiri was Lucius Calpurnius Piso Caesoninus, whose daughter Calpurnia married Julius Caesar in 59 B.C. Cicero wrote at length about Piso, handing down to us quite a bit about the nobleman's cultural activities. If the cave at Sperlonga shows a first-century setting for monumental sculpture fit for an emperor, the Villa dei Papiri reveals a possibly somewhat earlier one decorated by a fabulously wealthy private citizen.

It is hard to envision the colossal scale on which wealthy Romans lived in the first centuries before and after Christ. The enormous main house of Randolph Hearst's San Simeon is less than a third the size of what has been excavated of Piso's, and even George Washington Vanderbilt's Biltmore—with 250 rooms, the largest private house in the United States—has a footprint of only 72,000 square feet compared with over 200,000 for the partial excavation of only one of the Villa dei Papiri's three levels.

Scale was matched by the richness of marbles and metals, mosaics, and finely painted scenes and decorations, all of which were used to create a series of stagelike

settings. Mosaic patterns seemed to destabilize floors, and designs made ceilings appear open to the sky;[181] similarly, the perspectives and trompe l'oeils of wall paintings blurred the distinction between reality and fancy, between exterior and interior. Painted arches, windows, and colonnades created a series of frames within frames.[182] In this same illusionistic vein, multiple copies of a sculpture, placed symmetrically and often mirrored in water, would have been intentionally disorienting.[183]

Ancient Romans like Piso and Cicero modeled their enclosed gardens on the Greek *gymnasium,* situating decorative sculpture in imitation of the arrangements in such institutions in Athens and Alexandria.[184] What is exceptional about the Villa dei Papiri site is that many of the marble and bronze statues were discovered buried in what are believed to have been the places they occupied when the residence was inhabited: thirty-nine in a three-hundred-foot-long peristyle garden. At the head of a pool stretching almost the entire length of the garden, a beautiful *Seated Mercury,* the usual guardian of the *gymnasium,* was placed together with a pair of youthful athletes.[185] Toward the other end of the pool, a marble Pan copulated with a she-goat, a bronze piglet ran among gods and demigods, and a wantonly drunken bronze Silenus lolled. Dionysiac figures such as these were possibly used by Piso to evoke an earthly Elysium, or paradise,[186] as Pope Julius II would do by other means.

The whole point of having a country villa was to escape from the business and politics (*negotium*) of the city to the relaxation (*otium*) of the country, in much the same way that we use weekend houses today. For the ancient Roman, *negotium* connoted a long tradition of public service;[187] *otium,* on the other hand, was the private pursuit of literature, philosophy, art, and luxurious living after Greek models.[188]

The pairing of marble herms—triangular columns supporting a male head or bust, often detached from a full-length figure—alongside the pool may have illustrated this contrast, often coupling an intellectual figure, such as a famous philosopher or poet, with a political or military leader.[189] The dichotomy opposed Epicureanism, apparently followed by Piso himself,[190] and Stoicism, the two dominant philosophies of the time. Alternatively, the pairings could be seen as complementary, demonstrating the need for both *negotium* and *otium* for a satisfying life.[191]

Vantage points typically figured even more decisively in the placement of objects than they do today,[192] as evidenced at the Villa dei Papiri. According to one theory, at either side of a central pool in the villa's smaller, square peristyle stood five almost life-size female figures,[193] long thought to represent dancers but identified by some as water carriers or Danaids.[194] Together with a sixth, smaller female bronze, the statues seem to have stood in pairs on semicircular projections from the pool. In this configuration, subtleties such as a glimpse of one girl's breast as she fastens her peplos would have been visible only from the entrance, a privileged view afforded arriving visitors.

The Herculaneum Museum, also called the Royal Museum, Portici, 1758–98

Antiquities had been found in the region of Herculaneum as early as the sixteenth century. But excavation of the ancient site began in earnest with Emmanuel-Maurice, prince of Elboeuf, an army general serving under the Austrians who ruled Naples and Sicily briefly after 1707. For several years after the rediscovery of Herculaneum in 1711, Elboeuf made his summer residence near the town of Portici, almost overlying the ancient site. The general underwrote excavations there and eventually smuggled out three statues that ended up in the Dresden collection of Frederick Augustus, elector of Saxony.[195]

In 1738, Charles VII of Bourbon, son of King Philip V of Spain and Elisabetta Farnese, followed Elboeuf's lead by choosing Portici for his summer abode. Charles had been crowned king of Naples and Sicily four years earlier, when it became an independent kingdom. Attracted primarily by the area's hunting and fishing, the king was soon intrigued by its wealth of antiquities.[196] Encouraged by his wife, Maria Amalia Christina—as Frederick Augustus's daughter, she was well versed in the appreciation of ancient sculpture—he sponsored the excavations, eventually conducted by Karl Jakob Weber, that led to the discovery, in 1750, of the Villa dei Papiri.

Unlike earlier treasure seekers, who ignored, or even destroyed, everything but their valuable finds, Weber worked in such a way as to preserve the villa's architecture as well as its art. Under his guidance, site plans were drawn up and meticulous records of find spots were kept. Even the great Winckelmann had at first been indifferent to the exact location in which an object was discovered, information that would eventually make a tremendous contribution toward understanding the object.

All finds were automatically appropriated by Charles and housed in his palace, part of which was open to the public, by special permission and subject to specific conditions (no drawings, for one), as a museum of antiquities known as the Herculaneum Museum. Portici was almost on top of the digs, which provided a constant influx of material, and it was also near Vesuvius. The site thus combined the man-made objects and the natural phenomena that intrigued people at the time. The king's palace became a "must-see" for travelers on the Grand Tour. Goethe, for one, called the Herculaneum Museum "the Alpha and Omega of all antiquities collections."[197]

Winckelmann rushed to the Royal Museum shortly after it opened and returned three times in the 1760s.[198] His attention was caught by several of the bronzes from the Villa dei Papiri—the *Water Carriers* (which he called dancers), the *Drunken Silenus,* the *Dozing Satyr,* and the *Seated Mercury*—which he described as "the most beautiful bronze statues,"[199] a distinction that has endured up to the present.[200] The *Water Carriers* were placed as decorations on the spiral staircase between the building's two levels and may

have looked much as their replicas do now in the Naples Academy of Fine Arts (fig. 84). Other sculptures mentioned by the German scholar were exhibited on specially constructed rocky bases that are still in place.

As remarkable as the quality of the sculpture in the museum at Portici was the diversity of objects shown there. During his second visit, in 1762, Winckelmann noted a mosaic floor in one room, and in another, in addition to sculpture that he had noticed earlier, "the three most beautiful paintings found at Stabia" [sic] were set into a wall.[201] Even more unusual was a room full of the villa's candelabra and kitchen equipment, everyday objects that visitors found intriguing. To many, perfectly preserved grains and vegetables were also fascinating.[202] One observer, Count Friedrich Leopold Stolberg, went so far as to declare the museum the most interesting in Europe because only there could he see furnishings, a child's toy, and—of particular interest to him and to others—two ivory theater tickets.[203] The Pio Clementino contained a larger share of perfect artworks, observed the count, but such works could also be seen in private collections; what for him distinguished the Herculaneum Museum was its revelation of "manners and customs." Indeed, these displays of what is now called material culture are possibly the first example in a museum of everyday objects related to a historic context.

Sculpture, however, was still arranged conventionally, more or less according to type and medium—bronzes with bronzes, marbles with marbles—with no distinction between finds from Herculaneum and from Pompeii. The same was true of wall paintings removed from the buildings they had adorned. Only occasionally was a nod given to the original context, as in the case of relevant portrait busts positioned next to the library. Remarkably, in the mixture of art and household objects, the museum's content was unique, as was its topographical and chronological homogeneity—all coming from the same limited area and all predating the eruption of Vesuvius.

84. Academy of Fine Arts, Naples (2002):
Water Carriers, replicas on stairway.

85. Royal Bourbon Museum, Naples (1816–60): Galleria dei Bronzi.

The Royal Bourbon Museum, Naples, 1816–60

Charles VII of Bourbon, who inherited the vast Farnese collections from his mother, lost no time in transferring the bulk of them to Naples. But not until the end of the century, sometime between 1787 and 1800, did the famous Greek and Roman pieces, the Farnese sculptures, follow. Ferdinand IV, the successor Bourbon king of Naples and Sicily, had had to flee French invaders twice (in 1798 and 1806), taking many artworks with him to Palermo, but it was in fact thanks to Napoleon and his obsession with museum making that Ferdinand's wish for a museum was realized—during the 1806–15 Napoleonic occupation of Naples. At that time, the Villa dei Papiri sculptures began to be added, along with other Bourbon possessions, to several different collections in the Royal Bourbon Museum, lodged in the stolid, early-seventeenth-century Palazzo degli Studi in Naples,[204] where they remain to this day. Once again, as he had done in Rome and England, Canova helped with the project.

The bronzes from the Villa dei Papiri joined nearly a hundred statues from different sites arranged decoratively in the palazzo's Galleria dei Bronzi—a long, ground-level hall with sandy yellow walls and a lofty, vaulted ceiling.[205] The most celebrated pieces stood at the center, beginning with the villa's two *Gazelles,* followed by the *Drunken Silenus* and, after a life-size horse, the *Seated Mercury* (fig. 85). The rows of sculpture were determined for the most part by medium, numbered, and only occasionally labeled; no attempt was made to date objects, which were sometimes still regarded as Greek originals rather than Roman copies.[206] The arrangement resembled other contemporary museums of antiquities such as the Galleria delle Statue at the Vatican and the Louvre Musée des Antiques.

The National Archaeological Museum, 1860–Present

By 1860, the Royal Bourbon Museum in Naples had become the National Archaeological Museum. There, for over a hundred years, the Villa dei Papiri bronzes were shown in rooms decorated in the Pompeian style: a deep band of brightly tinted plaster imitation ashlar encircled the top quarter of the room; the star-studded ceiling suggested a night sky; and the dog-toothed cornice was modeled on the first-style Pompeian wall painting that had adorned parts of the Villa dei Papiri[207] (fig. 86). The statues themselves almost all stood on colorful, custom-made rectangular bases fashioned from ancient marble or imitations thereof. Large south-facing windows provided ample light, but the exhibits were still organized by medium and mixed finds from different sites, with only erratic indication of provenance on captions and wall labels. True to old decorative impulse, the *Water Carriers* were separated into two groups, one at either end of the gallery, and statues alternated with busts along the rear wall.

Only in 1903 were sculptures from other sites removed, at last giving the Villa dei Papiri bronzes rooms occupied by them exclusively[208] (fig. 87). Like the upgrading of the *Nike of Samothrace* at the Louvre, the distinction coincided with a reevaluation of the statues' quality. Even though they were by now acknowledged as multiple Roman copies of Greek originals, the bronzes were nevertheless considered superior to most of the mass-produced objects found at Herculaneum and Pompeii.[209]

But even this new installation failed to reunite the villa's marble sculptures with the bronzes, something that happened only with the current installation, unveiled in 1973 and described as a "recontextualisation."[210] But is this an accurate characterization? For the first time since their excavation, the Villa dei Papiri marble and bronze sculptures are all together, and are shown with papyruses from the villa and with frescoes from other sites. The archaeological correctness of the sculptures' reunion is offset, however, by a stripped-down modern display that lacks the contextual gestures of the museum's earlier, Pompeian-style decor.

In one of the two main galleries, the large bronzes appear to float in space, standing as they do on white blocks that blend into the walls and floors in an expansive room flooded with natural light (figs. 88, 89). The second main gallery contains marbles as well as some bronze sculptures. A large reproduction of Weber's 1758 plan, showing where the statues were found in the villa's garden—for those who make the connection—dominates the first large gallery. The guidebook likewise touches on ideas that influenced the sculptures' selection and placement in antiquity. Still, most visitors encounter the statues as they would Modern art: individual, self-sufficient objects divorced from their original associations.

86. National Archaeological Museum, Naples (late 1800s): Villa dei Papiri bronzes, including *Seated Mercury*, some *Water Carriers*, *Drunken Silenus*, one *Athlete*.

87. National Archaeological Museum (1903 installation): Postcard showing Villa dei Papiri bronzes, including *Seated Mercury*, *Water Carriers*, at back, and *Sleeping Satyr*, in foreground.

88. Villa dei Papiri Gallery, National Archaeological Museum (1973 installation), including *Seated Mercury, Water Carriers, Athletes,* in front of Weber plan, and *Drunken Silenus,* in foreground.

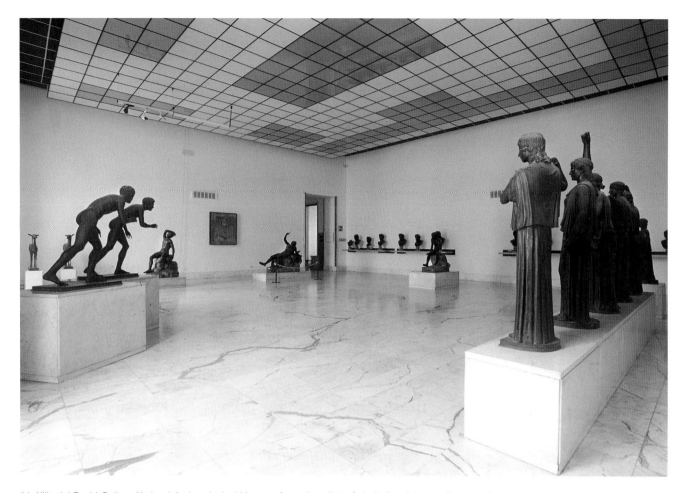

89. Villa dei Papiri Gallery, National Archaeological Museum (1973 installation), including *Athletes, Sleeping Satyr, Drunken Silenus,* by door, *Seated Mercury,* and *Water Carriers.*

The Getty Villa dei Papiri: Context Replaces Content

It was precisely in reaction to such a lack of context that J. Paul Getty created a museum for his collections of art and antiquities, modeled on Piso's villa, in Malibu, California. As the Malibu museum was being constructed, replicas of several Villa dei Papiri bronzes were ordered from the Chiurazzi company, a Neapolitan foundry that has been reproducing antiquities since the 1840s,[211] to create a contextual display distinct from the museum's original pieces. When the present renovation and expansion is completed in 2005, the replicas will be positioned as near as possible to the original find spots, in accordance with current thinking[212] (fig. 90). So twentieth-century copies of works that are themselves Roman copies of earlier Greek models will be seen in a twenty-first-century setting copied from a Roman prototype, parts of which—such as the peristyle garden—imitate Greek precedents.

Admittedly a pastiche of several houses excavated in Campania, the area south of Rome, the villa in Malibu was built to the original scale of the Villa dei Papiri.[213] Many of the ancient villa's decorations were reproduced, and trees, shrubs, and flowers known in antiquity were planted in the Roman manner (fig. 91). Condemned by some as a make-believe Disneyland for art when it opened in 1974, the villa is now championed by scholars, among them Carol Mattusch, the author of a recent book on the Villa dei Papiri and its contents. "I love the idea of the Villa Museum because it brings you back to earth after all the excursions everyone has taken," Mattusch says.[214]

The Greeks and Romans valued copies for their own sake, and many such pieces were signed by the copyist. The Villa dei Papiri's bronze bust of the *Doryphoros* (spear carrier) is just such a copy; it was signed by one Apollonios, whose sculpture, together with a marble copy found at Pompeii, records Polykleitos's over-life-size original.[215] And the Papiri *Doryphoros* was, in turn, one of the favorite models for the eighteenth-century miniature copies avidly sought by travelers on the Grand Tour.

From the time of their discoveries, the *Nike of Samothrace* and the *Laocoön* inspired replicas and reinterpretations that were displayed as proudly as the originals, and the Getty's offering of originals and copies recalls similar groupings of the past at the Louvre and the Vatican. In Paris and Rome, the juxtaposition of replicas with the *Nike* and the *Laocoön* detracted from the originals and proved equivocal; in the Malibu garden, the replicas will be clearly set apart.

Some museum professionals shun historicizing re-creations in favor of less literal settings, such as the one offered by "Treasure Houses of Britain" at the National Gallery in Washington, D.C., in 1985–86. For that show, the museum's legendary exhibition designer the late Gaillard F. Ravenal (assisted by Mark Leithauser, who would succeed him) used devices such as columns, niches, and moldings to suggest, rather than reproduce, historic interiors. Now called an environmental installation, the exhibition

90. Getty Villa, Malibu, California: Working plan of renovated garden (subject to change, 2003).

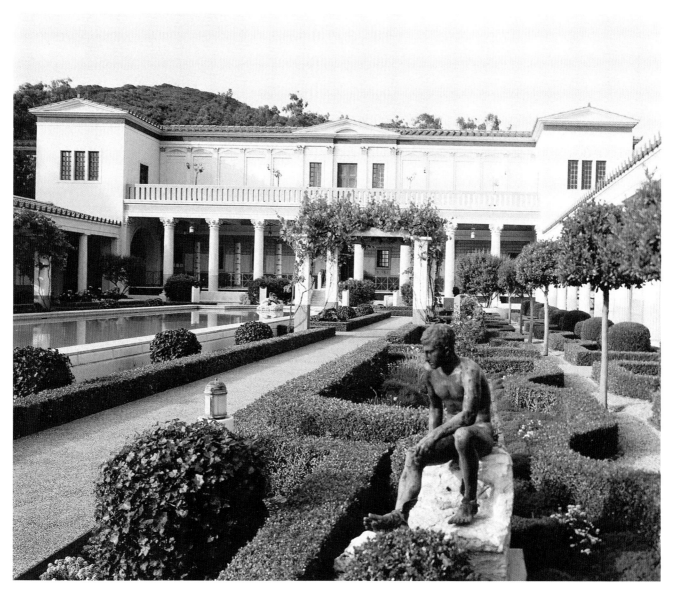

91. Getty Villa: Papiri garden before restoration, with *Seated Mercury*, in foreground.

was as much about display in the stately homes of England as it was about the objects displayed: sporting pictures in dining rooms, antique and contemporary sculpture in sculpture galleries, and paintings hung in multiple tiers.[216]

Some dismiss the possibility of any meaningful creation of a historic context. The literary critic Daniel Mendelsohn insists that any attempt to reproduce Greek tragedy today is "a meaningless exercise in theatrical embalming."[217] Even if the chorus, masks, and other elements of the original staging are re-created, the grand religious and civic ceremonies that were essential to the performances are inevitably missing.

Efforts to remake the historical context of music have met with similar problems. Period instruments, performance techniques, and historic auditoriums are among many elements introduced in the search for authenticity. Here too, experts admit that very little in so-called historical performances is truly historic, since so much depends on contemporary practices.[218] Social, political, scientific, and other conditions change for each era, as do aesthetic ones: what Winckelmann considered restrained classical perfection in the *Laocoön* is today regarded as baroque expressionism.

It is impossible to reproduce a mindset, yet curators often attempt to convey something of the context of an object's production and original setting. A century ago, Wilhelm von Bode, from 1906 to 1920 director general of Berlin's Kaiser-Friedrich-Museum (part of the Museum Island complex currently undergoing a massive renovation and restoration designed by the English architect David Chipperfield), broke the rule of exhibiting by medium. In one part of the complex, at what is now called the Bode-Museum, the innovative director reorganized the medieval, Renaissance, and contemporary collections, mixing painting and sculpture with furniture and other objects from the same period in order to evoke their similar style.[219]

In 1998, New York City's Metropolitan Museum of Art reinstalled its Greek and Roman sculpture collection according to a comparable concept of historic totality. For the first time in this department, mediums are mixed to suggest a cross section of the culture: small bronzes, for example, stand alongside terra-cotta vases. In a further bow to contextuality, the galleries themselves have been restored to their turn-of-the-twentieth-century neoclassical design.[220]

Other than the *Nike of Samothrace,* there are few works whose installation has become intrinsic to them; in fact, reproductions of the *Nike* are often placed so as to recall the Louvre setting. At the beginning of the twentieth century, a *Nike* replica crowned the Art Institute of Chicago's new grand stairway, itself modeled on the Louvre's. And during World War II, the Metropolitan Museum invoked the Goddess of Victory's original meaning by placing her reproduction at the head of its own grand stair (figs. 92, 93).

Curiously, as the original *Laocoön* lost its privileged position in the art-historical hierarchy, allusions to it as a symbol of suffering continued to proliferate, and in a reversal

92. Art Institute of Chicago (1906): *Nike of Samothrace*, replica.

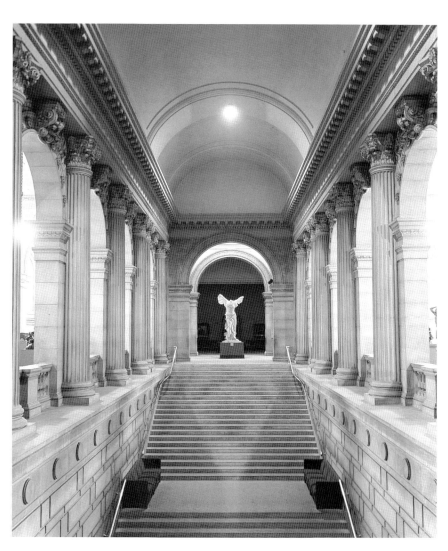

93. Metropolitan Museum of Art, New York (1942 or 1944):
Nike of Samothrace, replica.

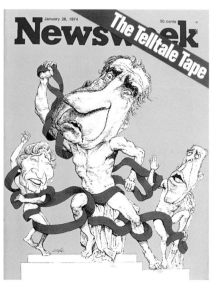

94. Illustration, *New York Times*,
September 15, 2001.

95. Robert V. Engle, *Newsweek* cover,
January 28, 1974.

of the usual precedence of authenticity over imitation, appropriations of the *Laocoön* have become more meaningful than the original. On September 15, 2001, four days after the destruction of the World Trade Center, the *New York Times* used the statue to illustrate an article on representations of pain in art.[221] At the time of the Watergate scandal, a *Newsweek* cover cartoon showed President Nixon and two cronies bound in audio tape.[222] A December 17, 1990, *New Yorker* cover depicted Christmas shoppers ensnared by snakelike gift-wrap ribbons (figs. 94–96). The image of the bound figure has assumed a life of its own, apart from its physical manifestation in the sculpture. The Getty replicas of the Villa dei Papiri bronzes in their replicated setting in Malibu could follow the same pattern and prove more meaningful to the general public than the abstracted originals in Naples.

Whatever their shortcomings, historical re-creations have long held an irresistible appeal. The famous villa constructed by the emperor Hadrian (117 B.C.–A.D. 38) in Tivoli, a few miles east of Rome was, like the Villa dei Papiri, modeled on Greek antecedents. Additionally, however, a make-believe Egypt is thought to have been one of its many extravagances.[223] Not only did architectural elements and water canals possibly refer to the ancient city of Canopus and the Nile, but in addition to Egyptian originals, some sculpture found at the site suggests that the emperor commissioned Egyptian-style statues as well.[224] Hadrian's stage set for fake and authentic Egyptian sculpture anticipated by almost two thousand years John D. Rockefeller Jr.'s re-creation (and partial restoration) of Colonial Williamsburg, Virginia.

The virtual Grand Tours featured in nineteenth-century panoramas were considered more desirable than the real thing by many because they saved time and expense.[225] Today's visitors to Disneyland enjoy similar miniversions of European landmarks, as do guests at Las Vegas hotels, for North American and European sites. The complete fabrication of an environment has become increasingly popular among preservationists, for example, the full-scale reproduction of prehistoric cave paintings at Lascaux in France (opened in 1983) and at Altamira in Spain (opened in 1999). All of these re-creations, including the Getty Villa, substitute fiction for fact and, in so doing, replace content with context.

Dec. 17, 1990

THE NEW YORKER

Price $1.75

96. R. O. Blechman, *New Yorker* cover, December 17, 1990.

Art or Archaeology

How Display Defines
the Object

Sigmund Freud's arrangements in the famous Berggasse apartment he occupied in Vienna clearly defined his attitude toward the objects he collected with such passion (fig. 97). The forest of Egyptian and other small ancient sculptures that invaded the psychoanalyst's orderly workrooms reminded one of his friends not of "a doctor's office but rather of an archaeologist's study." Freud himself declared that the Louvre's Assyrian and Egyptian collections had for him "more historical than aesthetic value." And he compared his uncovering of layer upon layer of the human psyche to archaeological excavation.[1]

In the eighteenth and nineteenth centuries, ancient Egypt was considered a primitive forerunner of Greek and Roman art.[2] Consequently, Egyptian artifacts were presented in museums as archaeology, lined up in vitrines according to material and function. The walls of Egyptian galleries were typically decorated with paintings and architectural details based on those found in tombs and temples (fig. 98). Gradually, in the twentieth century, another kind of display emerged: artlike installations in anonymous white spaces typical of museums of Modern art and of commercial art galleries (fig. 99).

In contrast with the variety of indoor and outdoor contexts in which Greek and Roman sculpture has been presented, Egyptian art is typically seen within a museum. Owing to the ambiguous nature of the artifacts, these can be museums of natural history, science, or fine arts. Wherever it might be, the Egyptian department is almost invariably the public's favorite, with special appeal for children, for whom specific displays are sometimes mounted.[3] One example is Chicago's Field Museum, where visitors are invited to clamber through the reconstruction of a pyramid containing authentic objects. The emphasis is on easily understood information about ancient burial customs rather than on appreciation of the objects themselves.

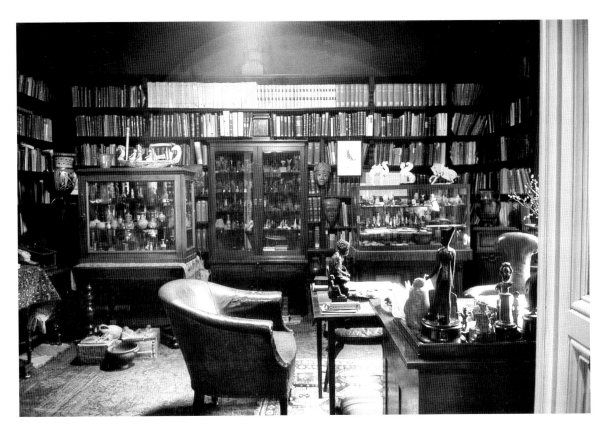

97. Sigmund Freud's study, Vienna (1938).

For ancient Egypt, as for other ancient cultures and for ethnographic collections generally, display can actually define the nature of the artifacts. When grouped together by material or type, and related to a particular environment, objects are seen as archaeological evidence of a lost civilization. Mounted on individual pedestals, like Modern sculpture, and removed from any kind of historical reference, the same objects become fine art.[4]

The exhibition "Egyptian Art in the Age of the Pyramids" originated in Paris in the spring of 1999 and traveled that fall and early in 2000 to New York City and Toronto. In each of the three venues, different presentations of approximately the same objects defined the objects as either art or archaeological finds.

At the Grand Palais, Paris's nineteenth-century exhibition hall, the curator Christiane Ziegler, who directs the Louvre's Egyptian Department, created an exotic stage set. Vast, dimly lit spaces evoked the mystery of ancient tombs; a thin layer of sand lined the bottom of showcases; color and decorative motifs alluded to the landscape and architecture of ancient Egypt; the crowded grouping of objects recalled the disorder in which they were found. The mise-en-scène thus referred both to the objects' original settings and to the conditions of their discovery, defining them as archaeological.

Dorothea Arnold, Ziegler's counterpart at the Metropolitan Museum in New York, adopted an altogether different approach. Historical allusions were minimized in favor of sparse, neutral settings that made little attempt to change the basic character of the museum's galleries. Consequently, the objects were defined as timeless works of art, as they were at Toronto's Royal Ontario Museum, albeit with concessions to popular taste regarding display.

Curators, who normally avoid flamboyant gestures, which can soon appear

98. Egyptian Gallery, British Museum, London (c. 1900).

outmoded for permanent installations, often seize the opportunity of a temporary show to do just the opposite. Pulling out all the stops, they create extravagant fantasy settings. For "Egyptian Art," Ziegler did just that at the Grand Palais, where she was freed from the strict rules forbidding video and other exhibition techniques considered incompatible with the ingrained Louvre style. Conversely, her counterparts in New York and Toronto operated more as they would have for a permanent installation. Comparison of the different settings in the traveling exhibition, and of these settings with the objects' permanent installations, reveals the advantages and disadvantages of the different approaches.

The legacy of ancient Egypt presents several paradoxes. First of all, concealment in tombs or in the innermost precincts of temples was intrinsic to the artifacts for which today's museums seek maximum exposure. Second, the Egyptian language had no word for art as we conceive of it today. Nor was there a word for religion, or for piety or belief,[5] to which the culture's creative energies were devoted. Figural representations—of gods, kings, and lesser mortals—were looked upon as living incarnations of their subjects. What mattered were the rituals—among them feeding, clothing, applying cosmetics, and participating in processions—connected with the priests' initial conferring of life on these figures and their subsequent maintenance as living entities. Similar rituals prevailed for customs regarding the afterlife. Theological principles or writings, although they did exist, were less significant.[6]

Secrecy was of paramount importance. For more than a thousand years (2700–1550 B.C.), the kings of Egypt were buried deep under impenetrable pyramids served by nearby temples. The king's coffin was protected by a sarcophagus, whose lid was sealed, as was the door to the burial chamber. In or near the mortuary temple or chapel, in which priests and a few select visitors worshipped, was the serdab, a room for statues of the deceased, which was also sealed.[7] The extraordinary array of objects buried with the monarch to serve him in the afterlife was intended for his eyes alone. It was in fact the search for ever greater secrecy that led, in the New Kingdom

99. Egyptian Museum, Munich (2004).

(1550–1070 B.C.), to the replacement of pyramids with rock-cut royal tombs set in a valley removed from the mortuary temple.[8]

Access to temples and the riches they contained was protected by massive enclosure walls, pylon barriers, and fortified gateways.[9] Of the many priests who served the largest temples, few were allowed into the innermost chambers, and only on special occasions did the populace penetrate the outer courtyards and ceremonial halls. Generally, the most sacred interiors of all temples were completely dark; only during rituals did torchlight reveal the brilliant colors of reliefs, the bright hues and shimmering gold of sculpture, and the gilded surfaces of doors, shrines, and cult vessels.[10]

Because knowledge was power, its possession was promoted while its content was kept secret. Even for those priests who knew how to read, texts were made intentionally obscure, and initiates were limited in what they were allowed to see. To ensure this exclusivity, a set of rules and practices known as decorum controlled all means of visual representation.[11]

The restrictions on who could see the artifacts included another paradox. Even though they were visible—if at all—to only a chosen few, statues, paintings, and reliefs were carefully juxtaposed with hieroglyphs that functioned in part as wall labels do in contemporary museums. Hieroglyphs on the statues themselves might be compared with museum captions; they usually identified not the artist but the figure represented and, occasionally, the action taking place.[12] Longer "wall texts" included requests for offerings, hymns, and the deities' pronouncements. The texts were essential to the balanced composition of each scene and assumed the presence of a viewer even when they were concealed from the living.

Hieroglyphs are small pictures that can be simultaneously phonetic—representing sounds—and logographic—standing literally or metaphorically for an object or an idea.[13] Sculpture and painting were the hieroglyph's logographic, or ideographic, component.[14] Written both vertically and horizontally, hieroglyphs were generally designed to be read from right to left. The primary orientation of hieroglyphs and figures in two-dimensional

100. False Door Panel of Rahotep from his tomb chapel at Meidum (Fourth Dynasty), limestone, 31.1 inches high, with hieroglyphs at top facing viewer's right (as does the figure they identify) and other hieroglyphs representing offerings and their recipient.

RAMSES III FOLLOWING THE BARK OF SOKAR IN PROCESSION
SECOND COURT, SOUTH WALL

RAMSES III FOLLOWING THE SYMBOL OF NEFERTEM CARRIED IN PROCESSION
SECOND COURT, SOUTH WALL

101, 102. Painted wall reliefs, Temple of Ramses III, Medinet Habu (Twentieth Dynasty), showing ceremonies of feast of Sokar.

103. Painted wall relief, Temple of Ramses III, Medinet Habu, showing statue of Min carried in Min festival.

art was to the right.[15] A series of hieroglyphs concluding with the venerated dead person's name can end with a large-scale representation—a wall painting, a relief, or a freestanding sculpture—that functions as the determinative of the name (fig. 100). These large representations normally face the viewer's right, and toward the phrase they complete; hieroglyphs on the sides of statue bases usually face in the same direction as the sculpture (see pages 119, 120). This integral relationship between Egyptian art and writing is unparalleled in any other culture.

A major exception to the restrictions upon viewing sacred art was the elaborate processions that marked Egypt's numerous religious festivals. For these popular events, attended by an exuberant population celebrating with abundant quantities of beer, sacred statues were removed from their shrines in the temples' inner sanctum and paraded around the temple, through the city, and sometimes beyond. But even then, statues were usually at least partly concealed within a portable shrine.[16] Although the extraordinary pomp of Egyptian processions anticipated aspects of Greek ceremonies (see page 48), sculptural display was only rarely a part of the former.

According to New Kingdom records, the monarch's outings from the royal palace during these festivities to perform rites in one or two temples were elaborate spectacles in which the king, preceded by his bodyguards, was sometimes carried on a *palanquin,* or litter, and followed by members of the elite. During the festivals, as for all cult rituals, the king, often represented by a priest, served as the intercessor between heaven and earth.[17] The gods, embodied in their statues, also left their permanent residences to visit other temples, in processions whose richness seems to have surpassed even the king's.

For the festival of falcon-headed Sokar, the funerary god of Memphis, the deity's statue was moved on its own boat (held by a four-legged frame on a litter); the god was either concealed within a closed chapel or visible within an open chapel (both representing a sarcophagus).[18] In a depiction of the procession in Rameses III's Medinet Habu temple in Thebes, Sokar is accompanied by other gods, hidden on their

respective litters, and by the king, a multitude of priests, royal princes, courtiers, and dignitaries (figs. 101, 102). Another wall sequence at Medinet Habu represents the elaborate festival procession of Min, the ancient fertility god, visible to all while en route[19] (fig. 103). These New Kingdom reliefs most likely portrayed aspects of festival ceremonies that had been in place for some time.[20]

Even when a processional statue was not visible, it interacted with the crowd as an oracle, making affirmative and negative movements in response to questions addressed to it. Festival processions were a kind of performance art, temporarily transforming the city itself into an artwork.[21]

Hidden icons were likewise part of the Christian tradition throughout the Middle Ages and the Renaissance. The famous image of the Savior was kept locked in a cupboard of the Lateran's Holy of Holies, the pope's private chapel, to which only an elite corps of the clergy had access. The icon, concealed in a silver case, was removed from its sanctuary just once a year in order to visit a painting of the Virgin at Santa Maria Maggiore.[22]

In the 1400s at Impruneta, a small town six miles outside Florence, a sacred image of the Madonna produced such hysteria when it was exposed in processions that the image had to remain covered most of the time. The practice of concealing holy images might be said to continue in today's religious processions, as is evident in the throngs that obscure the image of Our Lady of the Rosary at Fatima in Portugal[23] (fig. 104).

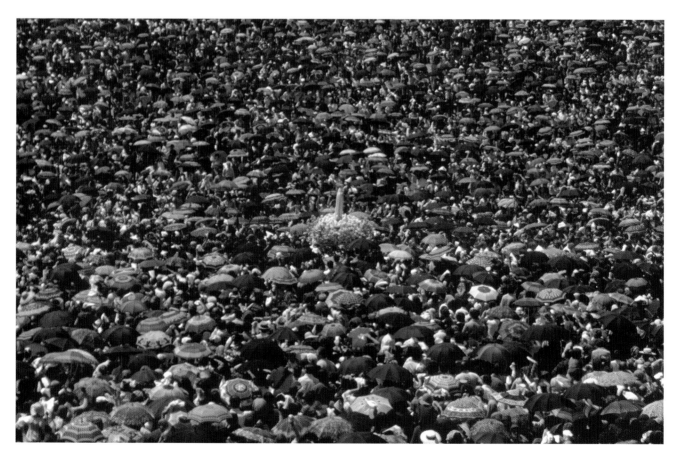

104. Pilgrims at Fatima, Portugal (c. 1980).

EGYPTIAN ART IN THE AGE OF THE PYRAMIDS

The parallel between today's religious processions and those of ancient Egypt is surely not high in the consciousness of modern viewers. And yet only such a procession would recall the context in which the public originally had access to much of this art. Given the impracticality of the scenario, museums are faced with the same conflict between mystery and sensitivity to viewers that characterized the art of ancient Egypt.

The different ways in which curators in Paris, New York, and Toronto chose to present the exhibition "Egyptian Art" greatly influenced the viewers' perception and understanding of what was being shown. Objects conveyed a different message not only in each of their three temporary installations but also with respect to their permanent installations, further attesting to the power of placement.

At the Met, Dorothea Arnold, curator in charge of the Egyptian Department, explained her approach to the display of objects whose effectiveness depended originally on their being hidden. "We are modern people and this is a museum; we're not reconstructing," she stated.[24]

Christiane Ziegler, at the Grand Palais, sought, on the contrary, to re-create the atmosphere of Egypt, with its distinctive colors and light. She wanted background hues for objects that had little color of their own, notably those of white limestone whose original paint had largely disappeared.[25] Her use of the deep ochre and bright blue associated with the Egyptian landscape influenced her selection, as indeed it had Egyptian art.

In Paris and New York, the exhibition occupied approximately the same amount of space (19,000 square feet on two levels in the former, 22,000 on one level in the latter), but the space was apportioned differently. At the Grand Palais, large galleries contained a dense array of objects; at the Metropolitan, for the most part, small areas gave more space to fewer objects.

Jean-François Bodin, the architect who designed the Grand Palais installation, used, in addition to color, decorative motifs suggested by Ziegler, such as a papyrus frieze, lotus images, and pylon forms. Small sculptures stood on the glass covering sand-lined showcases, thus suggesting an archaeological excavation.[26]

Such an allusion to the conditions of discovery had been used for the landmark "Treasures of Tutankhamun" exhibition at the Metropolitan in 1978. Organized in commemoration of the fiftieth anniversary of Howard Carter's discovery of the famous tomb of "King Tut," as it was popularly known, the blockbuster show featured the excavation itself, simulating the tomb's outer walls and juxtaposing objects with life-size enlargements of photographs of them taken for the Met by Harry Burton at the time of their discovery.

Bodin shared Ziegler's approach to temporary exhibitions as theater—"must-see events" that attract a more sophisticated, local audience as well as one-time tourist groups, which constitute 70 percent of the attendance for the permanent collection. As recently as ten years ago contextual re-creations were unthinkable to those in charge at the Louvre, deemed inappropriate to a museum of painting and sculpture. However, the taboo against conjuring up aspects of a civilization has been shattered by the remarkable success of the Louvre's renovated Egyptian galleries (opened in 1997), half of which were conceived as thematic, contextual displays.

The earliest surviving pyramids were built during the Old Kingdom (2649–2150 B.C.), a high point of Egyptian culture, and "Egyptian Art in the Age of the Pyramids" was the first comprehensive presentation of work from this period ever to take place. Although investigation of the Old Kingdom has been ongoing since the mid-nineteenth century, in the 1980s and 1990s accelerated research produced revolutionary new dates for the era's nonroyal artifacts. Objects previously thought to have been made in the Sixth

Dynasty (c. 2323–2150 B.C.) were redated to the Fourth Dynasty (2575–2465 B.C.), making clearer their link with royal works of that period. The new dating of nonroyal objects made the Old Kingdom appear far more diverse artistically than had been thought; in fact, it emerged as the time when conventions were being established that would govern Egyptian art for three millennia.[27] Ziegler's prime intention for the Grand Palais exhibition was "to allow the public to discover the Old Kingdom as the source of Egyptian art with art forms other than the pyramids with which it is commonly associated."

The principal theme of "Egyptian Art" was the relationship between royal and nonroyal objects, the prime focus of the Paris installation. To highlight comparisons between the two categories of objects, those made for the king were grouped at the right side of each gallery, those commissioned by high officials at the left. Wall labels were kept to a minimum, and instead the colors of the walls themselves provided a guide: ochre for royal, blue for nonroyal.

In New York, the Metropolitan Museum's installation conveyed a different message. Isolated on spotlit pedestals, the same objects were presented as high art in an abstract setting. Instead of the Grand Palais's bright-colored walls, Arnold chose mostly gray—for her, the most neutral background color. Variations in tonality, and occasionally a different color, were used primarily to avoid monotony. Alternating levels of ambient light in the Met's galleries contrasted with the overall darker Grand Palais display, where halogen jewel lights placed in the vitrines lit small objects. The ambient lighting of most of the displays in New York was generally more successful than the Paris spotlights, which were often directly overhead and thus cast shadows on the sculpture. As the Met's designers explained, "We are presenting the room as well as the objects, and light is the glue that holds it together."[28]

Arnold was true to her word about not reconstructing: instead of re-creating Metjetji's tomb (as at the Paris and Toronto installations), she merely alluded to it with the strategic placement of reliefs and wall paintings from the tomb. Context was merely hinted at: a low portal and a gabled corridor ceiling referred to ancient Egyptian architecture; black walls in one gallery and dark brown in another, with appropriately somber lighting, evoked tomb interiors. Because royal and nonroyal objects were often presented sequentially, in one gallery after another, rather than opposite each other, as they were in Paris, connections between the two kinds of objects were less obvious.

Although the Royal Ontario Museum (ROM) in Toronto is known for natural history and archaeology rather than for art, a senior curator, Krzysztof Grzymski, followed the Metropolitan's art-oriented approach, with some variations. To attract the public, imagined by the museum's director as resistant, the exhibition was designed with the audience rather than the objects in mind: the curator wanted to evoke "a more romantic Egypt" than the Met's. Bright yellow and dark purple were selected for the walls, not because of any relevance to Egypt but because the designers believed these warm tones would be appealing.[29]

The most surprising of Grzymski's accommodations of the public was the insertion into a corner of the Fifth Dynasty room of a mini-exhibition of vintage photographs: "Canadians on the Nile." The display, in a small cul-de-sac, of material that was completely at odds with the rest of the show broke the narrative flow; it would have benefited—as would the show itself—if it had been seen in an independent space.

A series of ninety-degree turns each introduced a long vista of a major object. This common museum practice is the same kind of "subjective guidance" that was used for World's Fair exhibits in the 1930s. Referred to in museum parlance as a "weenie," the configuration entices viewers, leading them through a show, and establishes a theme

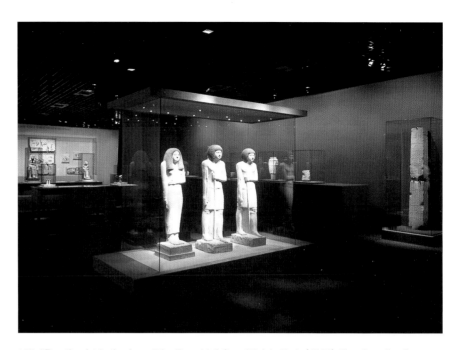

105. "Egyptian Art in the Age of the Pyramids," Grand Palais, Paris (1999): Two *Standing Sepas,* painted limestone, 65 and 66 ½ inches high, and *Standing Nesa,* painted limestone, 60 ½ inches high (all Third Dynasty).

for all the displays in one area.[30] Photographs of the pyramids and quotes from pyramid texts introduced each section, together with explanations on banners; wall labels were kept relatively brief (in Canada, they must be in French as well as English). Pyramid texts, inscribed on the walls of royal burial chambers of the later Old Kingdom, provide incantory spells that are of special service to the dead king in his voyage to the celestial realm. These otherworldly statements were a nice counterpoint to the mundane banner texts. Even without the thirty-four objects loaned by Cairo's Egyptian Museum to Paris and New York, and with the space allotted to it cut almost in half (on two levels, as in Paris), the Toronto show remained effective. Attendance, at 350,000, was the highest of any exhibition in the museum's history.[31]

Two Standing Sepas and the Standing Nesa, All Third Dynasty (c. 2649–2575 B.C.)

The three life-size painted-limestone statues that greeted visitors to the exhibition in the Grand Palais are the oldest known examples of large Egyptian nonroyal sculpture[32] (fig. 105). The representations of Sepa, a priest and important government official, and his companions, like other statuary at this time, embody both archaisms and innovations. The figures' rigidity, their lack of a clearly modeled neck, their oversized shoulders and thick legs would eventually be abandoned. But artistic rules already firmly established at this time explain the similarities among the three: their frontality, gender-specific attire, formal pose, and timeless youth. These, together with the faces' idealism and impassivity, embodied conventions that would remain in place for the next three thousand years.[33]

In the midst of the show's first room, Sepa stood on a low blue plinth; at his right was a slightly larger version of the same standing male figure. In turn, at their right, Nesa, a comparable female statue, may have been Sepa's wife.[34] The three were protected by a large, freestanding transparent vitrine.

The stunning trio of iconic figures, spotlit in a darkened gallery, met eye to eye

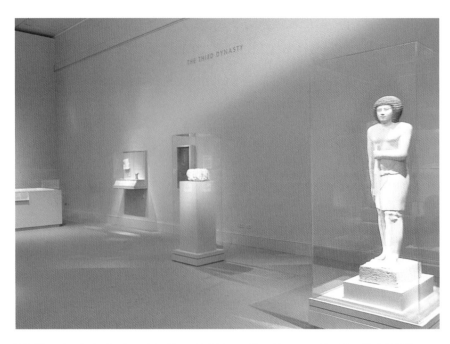

106. "Egyptian Art in the Age of the Pyramids," Metropolitan Museum of Art, New York (2000): *Standing Sepa,* painted limestone, 65 inches high.

107. "Egyptian Art in the Age of the Pyramids," Royal Ontario Museum, Toronto (2000): *Standing Sepa,* long view.

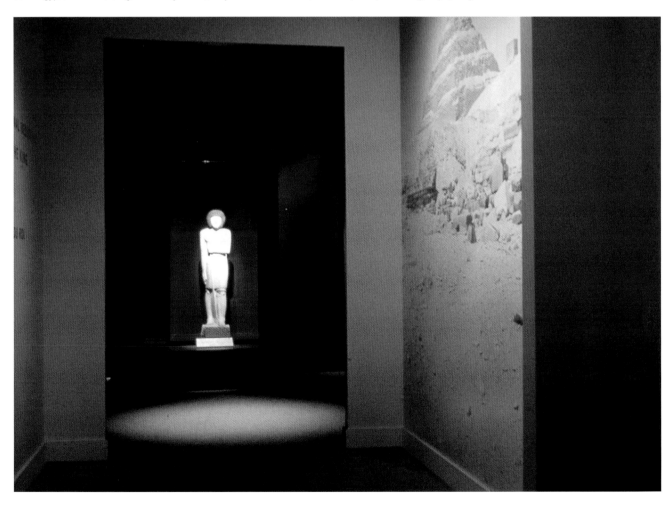

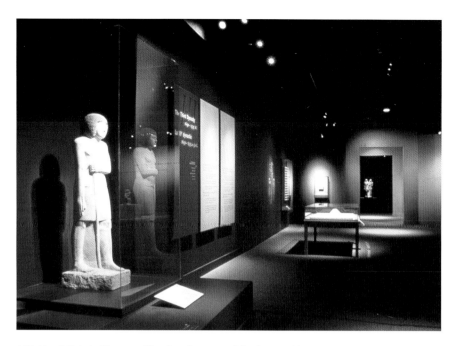

108. Royal Ontario Museum: *Standing Sepa* near didactic materials.

visitors entering the Grand Palais exhibition. As dramatic as the statues were, the profusion of objects with which they shared this large space detracted from their potential impact.

All three statues belong to the Louvre, and only in Paris were they presented together, because the larger Sepa and the Nesa were considered too fragile to travel. In New York, the single Sepa was lifted off the floor and placed on a higher plinth before a wall (fig. 106). Viewers saw the sculpture standing alone against this neutral background with no competing displays in their field of vision. In comparison with the Grand Palais display, the idea that setting apart an object connotes importance worked in favor of the Met's single figure.

In Toronto, major pieces were showcased in the same spirit as in New York. Grzymski explained that "Every section had its icon, and Sepa was the one for the Third Dynasty that began the show." Seen from afar, the effect was maintained, but as viewers approached the key figure, an array of banners and an intrusive caption distracted from the work (figs. 107, 108).

Remarkably, the single figure in New York and Toronto was just as forceful as the three statues together in Paris. Conceptually, three similar figures might be expected to be more imposing than one, but Sepa provided one of many instances of the Paris installation's emphasis on overall effect at the expense of individual objects.

By isolating the statue, the installations in New York and Toronto offered an archaeological bonus as well. The tops of the bases of all three statues bear raised relief inscriptions: these do not face the viewer but are placed sideways, to be read from front to back, and are most likely meant to be seen from the right side.[35] The right-profile view of the statues is in any case the most important, since it shows both legs.[36] This vantage point was possible only if museum visitors could approach the right side of each statue. When the three figures stood together with one Sepa in the middle, the right sides of two statues were necessarily more difficult to see.

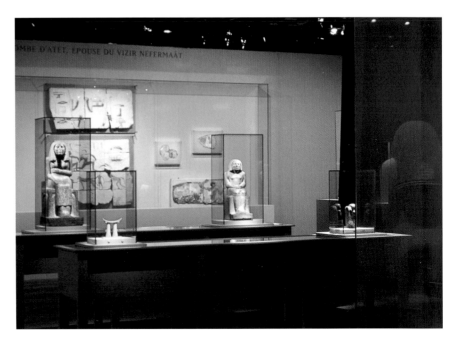

109. Grand Palais: *Princess Redjief Seated,* basalt, 32 ¾ inches high, and *Ankh Seated with Hands Clasped,* gray porphyroid granite, 24 ⅝ inches high.

Ankh Seated with Hands Clasped, Ankh Wearing Two Feline Pelts, and Princess Redjief Seated, All Third Dynasty

Compared with the elegant, elongated Sepa figures, the stocky bodies of two male figures of Ankh, a priest of Horus, conform rather naively to the cubic block from which they were cut. For these two representations, as for their female counterpart, the Princess Redjief, the lower part of the cube is a backless seat, on three sides of which the simple outline of an arch charmingly imitates bentwood stools of the period[37]—distant ancestors of the forms used by Thonet in the mid-nineteenth century. Inscriptions on the *Seated Ankh*'s knees—an archaic placement that soon gave way to hieroglyphs on bases[38]—identify him. These are oriented toward the viewer: from front to back for his titles on the right leg, from back to front for his name on the left one.[39] *Princess Redjief Seated* is a more realistic and more powerful work than her two companion Third Dynasty figures.[40] She is identified by raised relief inscriptions on the top front of the pedestal.

Plexiglas protective coverings aside, both granite Ankhs and *Princess Redjief* were displayed at the Grand Palais in a nice relationship with tomb reliefs (even though they were unrelated) in a vitrine behind them (fig. 109). Furthermore, all three sculptures stood on tablelike showcases thinly lined with sand (not visible in the illustration). The statues were thus seen against a sandy background and in conjunction with wall reliefs in a subtle evocation of the archaeological conditions in which they were found.

Contrasting with the scattered placement of the three figures in Paris, the sculptures were grouped on a platform next to one another on low individual pedestals in New York and Toronto (figs. 110, 111). At both museums, the installation allowed no mistaking the statues' designations as major masterpieces. Unlike the Sepa display, here the three figures together were more arresting than any single one. The generous amount of space allotted to the display in New York and Toronto plus illumination that created a bright pool of light for the entire installation—sculptures, pedestals, and platform—called special attention to the figures. The Metropolitan further emphasized their importance by placing them at the center of the first gallery, where they were framed by the portal

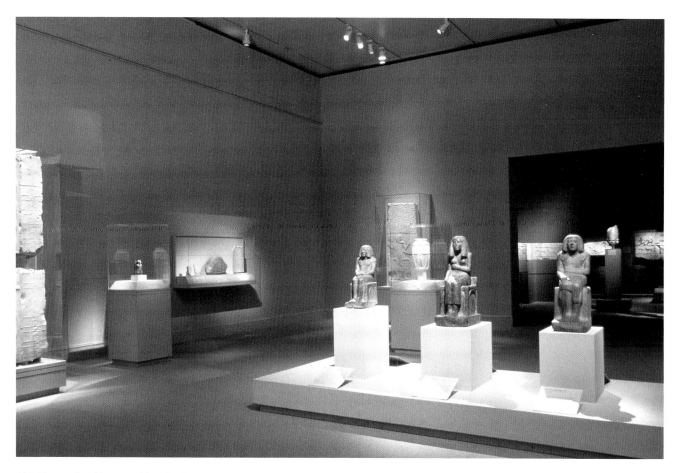

110. Metropolitan Museum of Art: *Ankh Wearing Two Feline Pelts,* grano-diorite, 31 ⅛ inches high, *Princess Redjief Seated,* and *Ankh Seated with Hands Clasped.*

leading to the darkened next room. Arnold says that, throughout the show, instead of emphasizing context, she tried to highlight connections. She certainly succeeded in doing this for the Ankh statues and Princess Redjief, where grouping the three sculptures facilitated comparison of their shared characteristics. In Toronto, a similar arrangement was only slightly less effective because a wider plinth under the pedestals distanced viewers from the figures.

Of the two Ankhs, the larger is considered the more refined, despite the less daring, pre-canonical bent left arm.[41] An added attraction is the realism of the panther skins over the figure's legs and across his upper body, where the pelts are held in place by toggles. A single hind paw hangs over the priest's left knee, with another beside his right calf; a tail dangles by his left leg. What may be the toes of front paws protrude coyly from beneath the shoulder toggles.

111. Royal Ontario Museum: *Princess Redjief Seated, Ankh Wearing Two Feline Pelts,* and *Ankh Seated with Hands Clasped.*

The skins and toggles identify the wearer as a priest. The hard stone used for both Ankh sculptures was available only by order of the royal house, so these may have been created by royal artisans. If they were royal commissions, it is possible that they were kept in temples rather than tombs, which would explain the relatively high placement of the inscriptions on both statues. Located not on the base but on the knees of one and the shoulder toggles of the other, the inscriptions would have been read more easily by the temple priests. At the time, placement of a nonroyal statue in a temple rather than in a tomb ensured its continued participation in the cult of a god or king, so these small figures may well have participated in Egyptian ceremonial processions.

112. *Hemiunu Seated,* limestone with remains of paint, 61 ¼ inches high, 24 ¼ inches wide, 41 ¼ inches deep (Fourth Dynasty).

113. Metropolitan Museum of Art: Reserve Head, limestone, 11 ⅞ inches high, MFA, Boston, in foreground, with two additional Reserve Heads visible, at back right.

Reserve Heads, Fourth Dynasty (c. 2575–2465 B.C.)

At the Metropolitan Museum, the figure of Hemiunu, a massively obese seated man, drew visitors into the first of the exhibition's larger spaces (fig. 112). This sculpture is among the few exceptions to the ancient Egyptian convention of avoiding individual characteristics in favor of standardized formulas for the depiction of humans. The hyperrealistic representation of this aging high official, who is believed to have directed construction of the Great Pyramid, dominated one end of the gallery, at the center of which were four Reserve Heads (fig. 113).

Reserve Heads are among the most intriguing of all Egyptian artworks.[42] Perhaps the abstraction of these hairless, bodiless, staring portraits makes them particularly appealing to contemporary viewers; perhaps it is the mystery surrounding their purpose and original location. The thirty-one heads that have been excavated up to now, almost all at Giza, are carved in limestone and date mostly from the Fourth Dynasty.[43] Their fabrication as independent body parts defies the Egyptian belief that funerary figures had to be complete in order to be effective, and the strange mutilations evident on most of them have never been conclusively explained. Found for the most part in shafts or burial chambers rather than in the associated offering chapel where sculpture was usually placed, the heads may have originally stood on the floor in front of the sarcophagus.[44] These considerations were taken into account in all three installations, where viewers looked down on the heads.

In New York, a single Reserve Head, from the Museum of Fine Arts in Boston, was shown alone. Three others—from the Phoebe Apperson Hearst Museum of Anthropology in Berkeley, the Kunsthistorisches Museum in Vienna, and Boston's MFA—shared a second vitrine. In Paris and Toronto, all four heads were shown together in a single vitrine (figs. 114, 115).

Singling out a Reserve Head was a stroke of genius at the Met. Nearly a foot in height, it is larger than the other three heads and the only specimen with none of the intentional damage typical of these portraits.[45] Also distinctive is the face's resemblance

114. Grand Palais: Four Reserve Heads, limestone, including Reserve Head, 10 ⅞ inches high, Vienna; Reserve Head, 10 ½ inches high, Berkeley; Reserve Head, 11 ⅞ inches high, MFA, Boston; Reserve Head 10 ⅜ inches high, MFA, Boston.

115. Royal Ontario Museum: Four Reserve Heads.

to Egyptian representations of Nubians. But even more important for this exhibition, the face's features—high cheekbones, fleshy cheeks, and round, wide-set eyes—are closer to those of royal statues than are the features of the others. It has even been compared specifically with a famous statue of King Khafre in the Egyptian Museum in Cairo.

Arnold says, "One of the wonderful things about changing exhibitions is that you can make people see things differently." Her placement of this particular head before the others did just that, in one of only a few instances in the display that accentuated its theme of royal and nonroyal relationships.

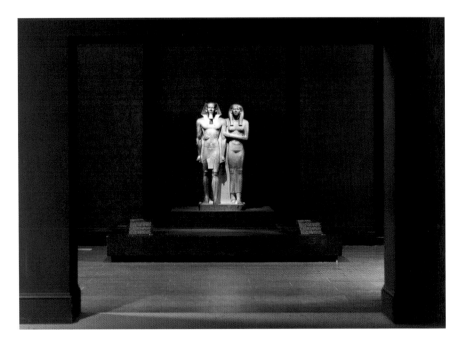

116. Metropolitan Museum of Art: *King Menkaure and a Queen,* graywacke with remains of paint, 54 ¼ inches high.

King Menkaure and a Queen, Fourth Dynasty

Boston's magnificent four-and-a-half-foot-high graywacke (a grainy, gray stone) statue of King Menkaure and a queen (his principal wife) provides the clearest illustration of the different concepts governing the "Egyptian Art" exhibitions. Not only is this one of the most refined sculptures shown, but it was already an acknowledged masterpiece at the time of its creation in the Fourth Dynasty.[46] The statue was found in a thieves' hole in the valley temple associated with the king's pyramid.

At the Metropolitan, a double podium made the statue of the royal couple appear even larger than it really is; dramatic spotlighting and strategic placement further emphasized the dyad's importance (fig. 116). The couple stood in a small room, made tenebrous by black walls and extremely dim ambient light, on axis with a low, wide portal suggestive of Egyptian architecture. To approaching visitors, Menkaure and his queen appeared to stand in the room alone, brilliantly highlighted against the dark background; only upon entering the space did viewers perceive a substantial sculpture of the king and two female figures at the far left and two fragments—the king's head and the head and hindquarters of an animal deity—to the far right. Everything about the statue's presentation— its central location, raised position to appear life-size, highly theatrical illumination, and even its framing by the only low doorway in the circuit—paid homage to its status.

The ROM tried to achieve a similar effect by placing *King Menkaure and a Queen* at the end of an enfilade, spotlit in a relatively small, darkened space (fig. 117). The designer preferred purple to black as a background, setting off the statue's dark-hued stone. Although the sculpture was effective when seen at a distance, the effort to showcase it was compromised—as were other objects in the show—by distracting didactic materials, especially the multicolored banners (fig. 118).

In Paris, rather than being displayed as a qualitative high point of the exhibition, *King Menkaure and a Queen* was used to make an especially strong point about the show's royal/nonroyal theme (figs. 119, 120). In a radical departure from the old-fashioned way in which the queen holds her left arm across her midriff—a throwback

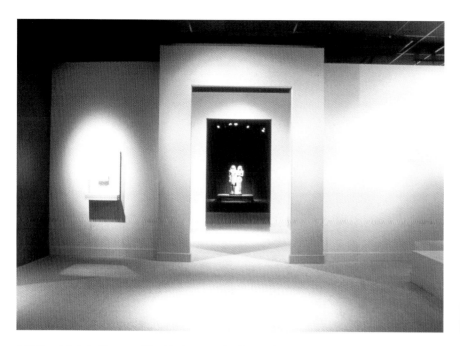

117. Royal Ontario Museum: *King Menkaure and a Queen*, long view.

118. Royal Ontario Museum: *King Menkaure and a Queen* near didactic materials.

119. Grand Palais: *King Menkaure and a Queen,* in far right background.

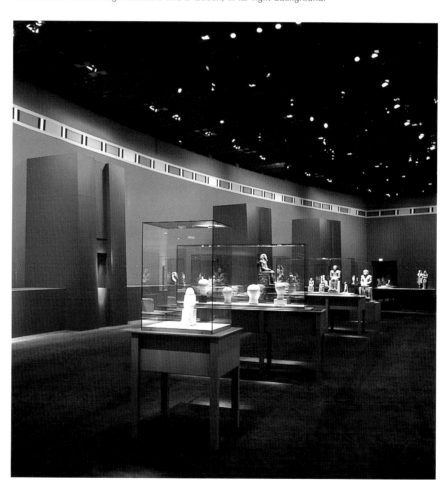

to the posture of Third Dynasty figures like the Sepa—her left hand is placed affectionately on the king's arm and her right arm encircles his waist. This restrained demonstration of intimacy was one of many imaginative leaps made at this time[47] and portrayed most spontaneously in the Old Kingdom; it conferred on the royal pair a new humanity and became a model for private statues. Given Ziegler's intentions, it was logical to place the statue near a number of nonroyal pairs that repeat the gesture, both in standing and sitting positions.

Logical, yes, but was it effective in terms of presentation? Perhaps not. Ziegler herself admits the shortcomings of this particular installation. Instead of signaling the statue's exceptional quality, its placement made it seem no more important than the nearby array of smaller, inferior pieces. In hindsight, the curator felt that the dyad's display was diminished by what she considers a common fault of today's ever-expanding exhibitions: there are just too many objects for the public to absorb.

For an installation guided by the theme of archaeological discovery, the Grand Palais display had another problem as well. *King Menkaure and a Queen* was found standing alone against the wall of a thieves' hole, probably thrown there by plunderers after the Arab conquest.[48] Placing it with other objects in one of the exhibition's largest spaces belied the conditions of its discovery.

Pair Statue of Katep and Hetep-Heres Seated, Fourth Dynasty

Among the nonroyal sculptures displayed near the Menkaure dyad in Paris was one of a seated man and wife, Katep and Hetep-Heres (fig. 120). The wife's affectionate encircling of her husband's back and her hand clasping his waist clearly mimic the royal couple's gesture. Other couples in this pose were placed near the dyad.

The Metropolitan Museum devoted two galleries to sculptures of married couples, separating the royal and the nonroyal. These two galleries embodied remarkably well the designers' attempt to create what they called "episodes" within the show by varying the illumination and wall tonality. Visitors passed from the dark, tomblike area in which the large, royal, hard-stone statues were exhibited, without protective coverings, to the brightly lit, neutral, gray setting in which small limestone sculptures were shown in vitrines, for the most part individually, but in the case of *Katep and Hetep-Heres Seated* as part of a threesome (fig. 121). The presentation made clear the similarities between different examples of nonroyal statuary. However, relationships with the royal figures were more difficult to spot because the two types were no longer side by side.

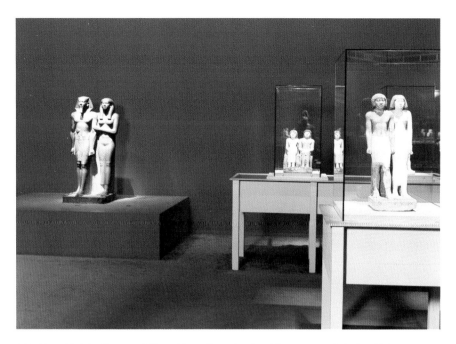

120. Grand Palais: *Katep and Hetep-Heres Seated,* painted limestone, 18 ¾ inches high, in middle ground, with *King Menkaure and a Queen,* at left, *Iai-Ib and Khuaut,* at right.

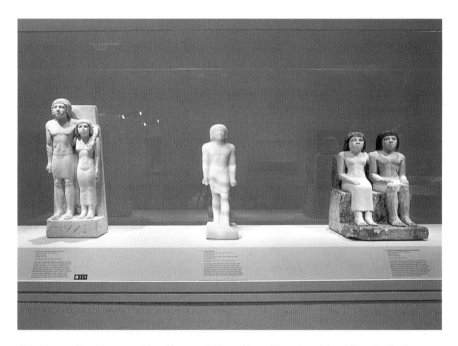

121. Metropolitan Museum of Art: *Katep and Hetep-Heres Seated,* at right; *Prince Ba-Baef Standing,* Egyptian alabaster, 19 ⅝ inches high (Fourth Dynasty), in center; *Memi and Sabu Standing,* limestone with remains of paint, 24 ⅞ inches high (Fourth Dynasty), at left.

122. *Seal Bearer Tjetji as a Young Man*, painted wood, 29 ¾ inches high.

123. *Seal Bearer Tjetji in Middle Age*, acacia wood, 33 ⅞ inches high (Sixth Dynasty).

Seal Bearer Tjetji as a Young Man, Sixth Dynasty (c. 2323–2150 B.C.)

One delicately carved wooden figure of a standing male nude included in "Egyptian Art" is identified on its pedestal as the Seal Bearer Tjetji (fig. 122). The sculpture is believed to have been made in the reign of Pepi I or Merenre I for a rock-cut tomb at the necropolis of El-Hawawish at Akhmim.[49] A fragment from the tomb, a wooden sculpture of Tjetji in middle age (fig. 123), and two representations of a similar male nude, Meryre-Ha-Ishetef, likewise at two different stages of life, were also in the show. All of these artifacts, representing the last period covered by the exhibition, were displayed in the final gallery in all three venues. How the respective curators conceived this arrangement is revealing.

In the Grand Palais installation, Tjetji as a young man and the older Tjetji, wearing a long, aproned kilt, were placed near each other as they might have been in a tomb. The two figures stood on a podium flanked by the same kind of showcase used throughout the exhibition; jewelry, in one, and small figures, including the two Meryre-Ha-Ishetefs, lay on a thin layer of sand with an array of objects that also alluded to the mortuary purpose of the material.

For these precious objects, all found in tombs, Dorothea Arnold at the Met wanted the dark walls—in this case, brown—and dim light of the gallery to evoke a treasurylike environment (fig. 124). She separated the figures rather than grouping them together, as in Paris, and showed them on individual pedestals. Each intensely spotlit wood or alabaster figure provided a dramatic moment in an "episode."

For the exhibition in Toronto, Grzymski explained, "We wanted to leave people with a bright, upbeat feeling, not something tomblike." To avoid associations with death and darkness, contextual and art-historical considerations were set aside, and Tjetji and his companions were brightly lit in their individual displays in order to give the public a happy ending (fig. 125).

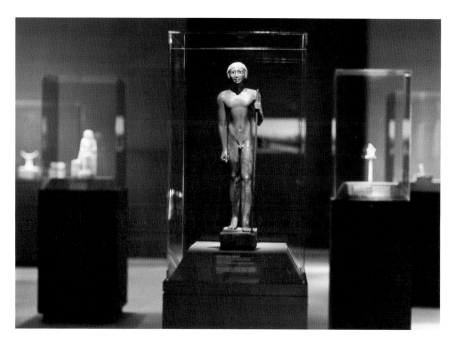

124. Metropolitan Museum of Art: *Seal Bearer Tjetji as a Young Man.*

125. Royal Ontario Museum: *Seal Bearer Tjetji as a Young Man,* at back; *Seal Bearer Tjetji in Middle Age,* at left.

126. Grand Palais: Vitrine in the form of a pyramid.

The Pyramid

The single greatest achievement of the Old Kingdom was the pyramids in which most of Egypt's kings and many of their queens from the Fourth to the Sixth Dynasties were interred. Beginning in the Third Dynasty with King Djoser's Step Pyramid, the use of stone, instead of more perishable building materials such as brick, wood, and reeds, made the development of these architectural wonders possible. Even though few pyramids have survived as standing monuments, their form is undoubtedly the image most commonly associated with ancient Egypt. The exhibition title "Egyptian Art in the Age of the Pyramids" was not only appropriate historically, but its familiar way of designating the Old Kingdom captured the public's imagination.

As might be expected, pyramid complexes were represented by large models in all three venues: the stepped forerunner of the pyramid built for King Djoser at Saqqara; the true pyramid complexes of Kings Khufu, Khafre, and Menkaure at Giza in the Fourth Dynasty and of King Sahure at Abusir in the Fifth Dynasty. Less predictable were the ways in which the Paris, New York, and Toronto curators adapted the pyramid image to their respective purposes. At the Grand Palais, a transparent pyramidal showcase was used for stone fragments inscribed with famous "pyramid texts"; at the Metropolitan, a photograph of the Great Pyramid at Giza at the entrance to the exhibition was followed later in the show by an outline of that pyramid with a drawing of the museum superimposed on it to indicate relative scale; in Toronto, the smaller image of the pyramids reflected the ROM's more modest stance (figs. 126–128).

Just as the pyramids defined the Old Kingdom, the curators' use of their form defined their intentions. In Paris, the pyramidal vitrine was consistent with settings designed to evoke ancient Egypt. In New York, the Metropolitan Museum's use of its building to convey scale placed the self-referential imprimatur of High Art on the exhibition. The somewhat impressionistic pyramid image in Toronto, like the display's unconventional colors and strange photographic digression, conformed to the idiosyncratic presentation.

127. Metropolitan Museum of Art: Relative scale of the Great Pyramid of Khufu at Giza and the Metropolitan.

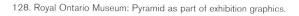
128. Royal Ontario Museum: Pyramid as part of exhibition graphics.

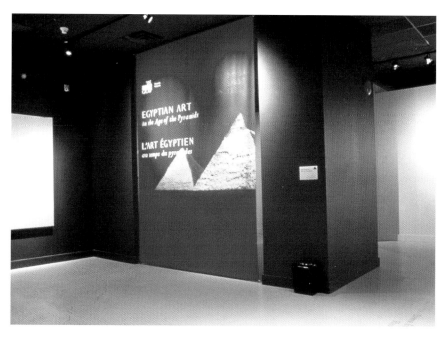

SOME PROS AND CONS OF THE THREE EXHIBITIONS

Over and above the stage set for the royal/nonroyal theme at the Grand Palais, Christiane Ziegler wanted to convey a broader message: that "the Old Kingdom was remarkable not just for its architecture but for other art forms as well." To refute the common notion of Egyptian art as static and unchanging, she selected objects that would demonstrate how styles evolved in succeeding periods.

Compare, for example, the slender, nude Sixth Dynasty *Tjetji as a Young Man* and the monolithic Third Dynasty Sepa and Ankh figures (see figs. 105, 109, 122). The faces of Tjetji and related wooden statues are far more expressive than those of the impassive Sepa and Ankh figures. Tjetji's face, in particular, is illuminated by large, inlaid eyes, in white limestone and obsidian, mounted in copper cells. By contrast, the painted eyes of the Sepas, of which traces remain, are more primitive.

The bodies of the early and later figures also demonstrate considerable development. The nudity of the Tjetji group is a novelty attributed by some to a change in thinking about figures that were not meant to be seen by the living.[50] Whereas the limestone bodies of the Sepa group have been simplified to the fewest possible planes,[51] Tjetji's wood carving has been refined—his neck clearly delineated, the hands and toes finely carved, the legs slimmed down and separated. The Sepa sculptures show the priest with one leg advanced and holding a thin staff; but the impression is static because a stone slab joins the two legs and the staff is carved into that slab. Tjetji's position is more realistic: he strides vigorously, and his staff, similar to Sepa's, is thrust forward, disengaged from his body in the more natural gesture of his left arm, which is bent but extended in front of him, as the softer material allows. Fourth Dynasty statues such as *King Menkaure and a Queen* mark an intermediate stage in these changes with their innovative expression of affection (see fig. 116).

To what extent was the average museumgoer conscious of these developments? It is easy to see stylistic distinctions between individual pieces, but in the contexts of the exhibitions, with over two hundred objects (slightly fewer in Toronto), comparisons were more difficult to make. The Met's "King Tutankhamun" of 1978 included only fifty-five objects, exhibited for the most part in relatively small spaces, and there was no mistaking its theme: the miracle of archaeology and the opulence of its discoveries. "Egyptian Art in the Age of the Pyramids" had a more sophisticated agenda that required a careful reading of the catalog in conjunction with attentive viewing of the exhibition. What did those who made the usual rapid circuit of galleries offering several hundred objects come away with?

In the Grand Palais, the color coding of each gallery into royal (ochre) and nonroyal (blue) areas highlighted comparisons between these two categories and thus overshadowed the stylistic differences between eras. The Met and the ROM, with less visual emphasis on the theme of royal and nonroyal, made stylistic differences more apparent, focusing on individual objects or, at most, on two or three similar objects, rather than on large categories.

To demonstrate more fully the complexities of developing styles, it would have been necessary to prompt other comparisons, for example, the red quartzite *Head of King Djedefre* with the graywacke *King Khafre Seated* (fig. 129). None of the show's installations made this contrast clear. If these two works had been placed more obviously in relation to each other, the greater refinement of the red quartzite head, made possibly as many as thirty years before the graywacke full figure, would have been more evident. Next to the skillfully rendered features of King Djedefre's face—the receding chin line, high cheekbones, and depressions under the eyes[52]—King Khafre appears clumsy. Unexpectedly, for a later work, the large figure is carved with less sensitivity, and his face is impassive compared with the expressiveness of the earlier figure.

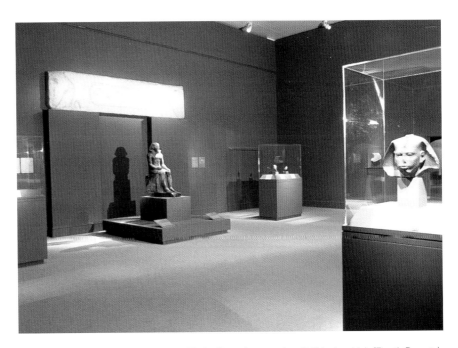

129. Metropolitan Museum of Art: *King Khafre Seated,* graywacke, 47 ¼ inches high (Fourth Dynasty), at left; *Head of King Djedefre,* red quartzite with remains of paint, 10 ⅜ inches high (Fourth Dynasty), at right.

The two sculptures offer an interesting contextual contrast as well. Djedefre's head is believed to have belonged to a sphinx, and so would have been seen in the open, in full daylight. The *King Khafre Seated* is one of more than twenty similar statues that were lined up between, or against, granite pillars in a hall of the king's valley temple at Giza. Even though such sculptures benefited from daylight passing through the windows, they were perhaps intentionally simplified because they were seen in an interior and as part of the architecture. Yet by showing the King Khafre under the cast of a lintel from the temple complex, the Met called more attention to it than to the superior Djedefre head, placed simply on a pedestal.

The conceptual nature of the presentation in New York was evident even outside the exhibition proper. At the entrance, a small Cycladic sculpture and a Mesopotamian, Early Dynastic figure, representing civilizations contemporaneous with the Old Kingdom, signaled a more intellectual approach than those provided by the videos that were shown in Paris and Toronto. Granted, at the Met these artifacts stood near an enormous contemporary color photograph of the Great Pyramid at Giza, chosen by Arnold "to get the public's attention immediately." But to most people, the meaning of the juxtaposition was probably obscure. In words that might be applied to the exhibition itself, Arnold said, "It was a picture of reality rather than a romantic evocation."

If the Grand Palais offered a "romantic evocation" of ancient Egypt and the Metropolitan emphasized the "reality" of timeless art, with the ROM mounting an exhibition that was a compromise between the two, which concept was the most successful? A look at a few of the exhibition objects in their permanent installations reveals some pros and cons of the different approaches.

There is no doubt that the Grand Palais's "romantic" presentation was more theatrical, and therefore more inviting to the average museumgoer, than the more austere installation at the Met. From the moment visitors entered "Egyptian Art" in Paris, they were immersed in an exotic ambience of subdued lighting, ancient Egyptian decorative motifs, and richly colored walls. As captivating as this setting was for many

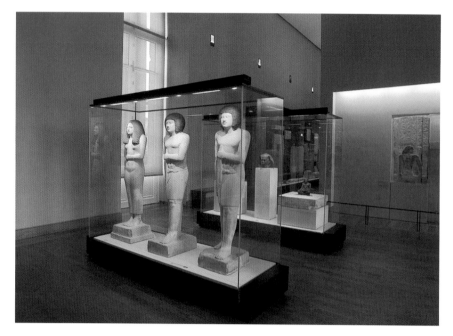

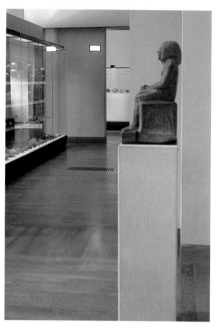

130. Louvre, Paris: *Standing Sepas* and *Standing Nesa,* permanent installation.

131. Louvre: *Ankh Seated with Hands Clasped,* permanent installation.

(myself included), it struck others as gimmicky and inimical to serious viewing.

The tomblike darkness, for example, throughout the Grand Palais installation (and used intermittently in all three venues) did not facilitate examination of the objects. Purists insist that even if a sculpture originally stood in darkness, it is less important to be reminded of this than to see each chisel mark.

Comparison of the temporary display of the Sepa and Nesa figures at the Grand Palais and their permanent installation in the Old Kingdom galleries of the Louvre illustrates the point. At the Louvre, the figures, presented in the same freestanding, transparent vitrine as in the show, are bathed in the ample daylight that streams in from floor-to-ceiling windows on both sides of the gallery. The permanent displays are seen in relatively small areas with pale blue walls—a less distracting background than the elaborate paraphernalia of the temporary show (fig. 130).

A similar comparison between the Grand Palais and the Louvre displays holds true for the *Ankh Seated with Hands Clasped.* Placed on a pedestal at shoulder height near the Sepa statues in the Louvre, the Ankh enjoys the same abundant natural light and serene background. Examination of the small sculpture is also greatly facilitated by its placement, higher than in any of the three temporary shows, and by the absence of the protective covering used at the Grand Palais (fig. 131).

King Menkaure and a Queen offers another contrast that favors the statue's permanent installation. Not even the more "realistic"-minded curators at the Met and the ROM could resist staging this bravura piece spotlit in a darkened space. At its home in the Boston Museum of Fine Arts, the sculpture is far better illuminated in a skylit gallery. Another advantage of the permanent installation in Boston is the sculpture's situation on a freestanding plinth, which enables viewers to walk around it and see it from all sides (fig. 132).

At the MFA, however, *King Menkaure and a Queen* loses the star status it enjoyed while traveling. Among the extraordinary array of Old Kingdom masterpieces in its home gallery, the sculpture takes second place to the monolithic seated figure of King Menkaure

132. Museum of Fine Arts, Boston: *King Menkaure and a Queen,* at left, and *King Menkaure Seated,* at center, permanent installation.

133. Museum of Fine Arts: Four Reserve Heads, at left, left center, and far right, permanent installation.

that greets visitors at the gallery's entrance and commands their attention. Only after stepping forward and turning left does a museumgoer see the dyad. (In the museum's new, expanded building, *King Menkaure and a Queen* will be the focal point of a gallery.) But there is no doubt that, in its permanent display, details such as paint remnants and tool marks on the unfinished lower bodies are far easier to see than in any of the show's temporary installations.

Boston's Museum of Fine Arts offers a similar advantage for the six Reserve Heads in its collection (fig. 133). Each one is presented on its own relatively high pedestal as

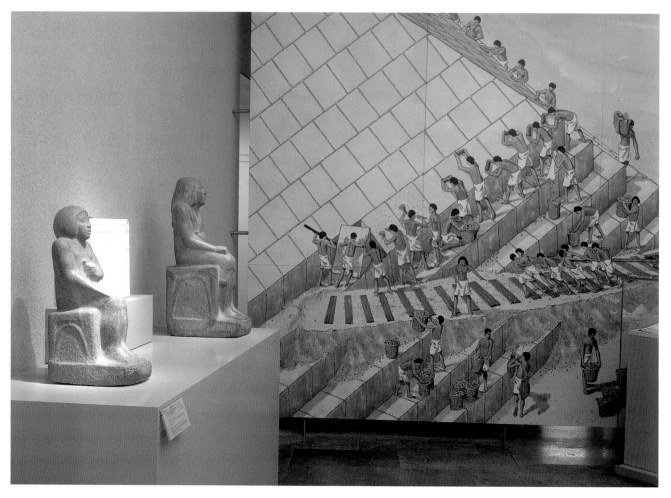

134. Rijksmuseum van Oudheden, Leiden: *Ankh Wearing Two Feline Pelts* (second from left), permanent installation.

an individual masterpiece—as a modern sculpture would be. At eye level, in a blend of ambient natural light and artificial spotlighting, the heads are given more prominence, and are more easily examined, than when grouped together.

Rita Freed, chief curator of the Boston museum's Egyptian Department, explains, "Each head is unique, and we don't want to lose their individuality."[53] This is exactly what happened in the traveling show. Two of the heads from Boston and several others standing on the same plinth (with one fortuitously singled out at the Met) looked more like wig stands than sculpture. This unfortunate effect was even more pronounced in Toronto, where the vitrine containing the heads was inserted into a wall with a large red banner overhead and intrusive captions below (see fig. 115).

Despite such compromises, temporary displays often provide real benefits. For all the clarity of its permanent presentation, the Louvre's *Ankh Seated with Hands Clasped* could easily be overlooked, tucked as it is into a corner beside the entrance to a study gallery of terra cottas (see fig. 131). The Ankh's placement on a prominent, freestanding plinth with two other cubelike sculptures at the Met and the ROM—allowing all-around views—focused attention on an object that even frequent visitors to the Louvre might miss.

In its usual abode at the Rijksmuseum in Leiden, the larger *Ankh Wearing Two*

135. Egyptian Museum, Turin: *Princess Redjief Seated,* permanent installation.

136. Egyptian Museum: *Princess Redjief Seated,* detail of permanent installation.

Feline Pelts also fails to command attention (fig. 134). The museum's Ancient Egyptian section is organized according to a simple narrative that guides visitors by means of a key figure for each period. For the Old Kingdom, that figure is the Scribe, so the Ankh is shunted off to a dimly lit corner of the gallery, taking second place to the less important Fifth Dynasty figure. Besides its poor placement and illumination, the Ankh is overshadowed by a recent floor-to-ceiling wall painting of a pyramid under construction.

The visits of the Louvre and Leiden Ankhs to the United States and Canada are today's equivalent of those figures' transportation in ancient processions from their own temples to other sanctuaries. Just as the dynastic rituals brought the sculptures out of the dark and into the daylight for all to experience, the sculptures' temporary display conferred importance on them and gave them a vastly expanded audience.

Princess Redjief Seated needed no such promotion: in her usual installation at Turin's Egyptian Museum, the half-life-size figure is the undisputed highlight of the first gallery (fig. 135). Yet this sculpture benefited in other ways from its temporary displays, especially at the Met and the ROM, where it was shown uncovered.

In Turin, the statue is the first thing an observer sees upon entering a vaulted room in Guarino Guarini's magnificent Baroque Palazzo dell'Accademia delle Scienze, which now houses the Egyptian Museum. On axis with the entranceway, the statue is framed by a pair of facing concave vitrines that funnel visitors toward it. The sculpture is further framed by the portal to the gallery behind it. In an effort to make the statue a destination rather than simply a circulation marker, the museum director, Anna Maria Donadoni Roveri, resorted to the unusual—possibly unique—solution of surrounding its lower portion with curved glass (fig. 136).

Whenever possible, curators rely on the sturdiness and heaviness of stone sculpture for its own protection, eschewing intrusive coverings so that materials and carving can be fully appreciated. In Turin, the viewer loses the advantages of seeing the figure directly. The shaped-glass cylinder is especially distracting because its curvature creates reflections; the princess was seen to greater advantage with no such protective layer in the New York and Toronto displays.

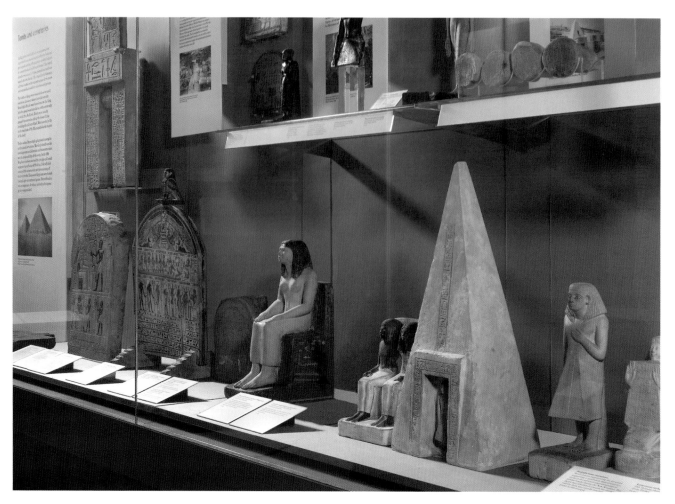

137. British Museum: Vitrine with empty space where *Meryre-Ha-Ishetef* usually stands in for *Seal Bearer Tjetji as a Young Man; Nofretmin* (Old Kingdom, c. 2300), to left of empty space; pair statue of a man and wife, limestone (Eighteenth Dynasty, c. 1500 B.C.), to right.

138. Louvre: *Seal Bearer Tjetji in Middle Age,* permanent installation.

The most compelling argument in favor of temporary exhibitions is provided by *Seal Bearer Tjetji as a Young Man.* At the British Museum in London, to which it belongs, the sculpture was left homeless when its gallery was destroyed in the late 1990s to make way for Norman Foster's renovation of the Great Court. At almost two and a half feet in height, the sculpture is too tall for the new vitrines in the renovated Old Kingdom funerary galleries, so a smaller piece from the same period, *Meryre-Ha-Ishetef,* takes its place (fig. 137). Even were this showcase able to accommodate the young Tjetji figure, it could go unremarked in the display's crowded arrangement, and he would be visible only from the front. The young Tjetji therefore depends entirely on special exhibitions for public display.

Although the statue of the middle-aged Tjetji that accompanied the "younger" one in "Egyptian Art" is on permanent display at the Louvre, it too was more visible in its temporary installations. Deemed of insufficient quality to merit an individual display in the Louvre's Old Kingdom galleries, this Tjetji shares a vitrine with other carved-wood figures (fig. 138). The temporary placements highlighted the sculpture and allowed a fuller appreciation of it.

Which installation best served these objects, whose worth originally decreased in proportion to their visibility? The archaeological vision of Paris or the fine-art approach of New York and Toronto? In evaluating the different phases of three exhibitions that enjoyed equal critical and popular success, it is important to remember that some design decisions were dictated by practical matters such as security, light sensitivity, and circulation. At the Grand Palais, for example, a last-minute security decision mandated covering all small sculpture with transparent cases,[54] and as noted, the lights in the cases often cast shadows that obscured the facial features. Stringent security rules in Toronto also necessitated more covers for the sculpture than in New York.

The Grand Palais's Egyptian-style decor was dismissed by some as simple-minded ersatz, demeaning to the serious tone of the exhibition. But the setting was offered in the same spirit as the Metropolitan Museum's permanent display of reproductions, made in the first third of the twentieth century, of ancient Egyptian wall paintings. The Met's renderings record the paintings of actual Theban tombs, whereas the Grand Palais's Egyptian motifs were invented; nevertheless, both evoke a context. It is difficult to imagine equivalent replicas in other parts of the Met's hallowed galleries, but the popularity of the Egyptian reproductions has earned them walls in two rooms in a department hard-pressed for space.

The Egyptian departments of other distinguished institutions, such as the Kunsthistorisches Museum in Vienna, have also retained mood-setting reproductions. In Vienna, nineteenth-century Egyptian-style wall paintings testify to the importance

139. "Ramses the Great," organized by the Museum of Natural History at Fair Park, Dallas, Texas (1989): Introductory theater.

of such imagery in creating an intelligible context for a culture as different from ours as that of ancient Egypt. Whatever their shortcomings in terms of authenticity, the re-creations give immediacy to objects that can otherwise seem remote.

An extreme in this respect was the film that prepared visitors for the 1989 "Ramses the Great" exhibition in Dallas, Texas. Screened at the entrance to the show, the film addressed the relationship of mythology to the life and art of ancient Egypt. The movie was intended to disorient visitors, to transport them beyond their everyday environment and make them aware of the unfamiliar customs that produced the objects they would see. At the end of the presentation, the screen dissolved, so to speak, opening up to the first gallery (fig. 139).

At the opposite end of the spectrum is the permanent display at Cairo's Egyptian Museum, where no concessions are made to the public (fig. 140). Opened in 1902, and considered by many the mother of all Egyptian museums, the Cairo museum has extensive holdings that are packed into a grand Beaux-Arts building in what appear to be the original display cases. And yet, in the opinion of some visitors, these dusty and badly lit installations provide the most exciting viewing experience of all. The very effort it requires to see the objects encourages a feeling of discovery reminiscent of the archaeologist's adventure—a sensation that has all but disappeared from more sophisticated displays. It remains to be seen whether Cairo's current reorganization will preserve this element of surprise. (As part of the project, a new museum of antiquities, arranged according to computer guidelines, is planned within a theme park and shopping complex at Giza.)

As a descendant of the culture that produced its incomparable treasures, the Cairo museum is *hors concours:* other displays of ancient Egyptian art cannot compare. Different approaches to the exhibition of this art are difficult to assess. Given the secrecy that surrounded the art of ancient Egypt, any setting created for it is necessarily contrived. Whether the objects are presented as archaeology or as art, the decision brings its own assets and liabilities.

140. Egyptian Museum, Cairo: Great Hall, with large seated figures of King Amenhotep III and his queen Tiye, at center.

Jackson Pollock

How Installation Can Affect Modern Art

For modern art—in its broadest definition, from the Renaissance to the present—
the artist's own preferences can help determine how the work should be presented.[1]
Hans Namuth's extensive still photographs and documentary films of Jackson Pollock
in his studio show that he worked on extremely large canvases in a relatively small space,
deliberately juxtaposing large and small paintings (fig. 141). For his exhibition at the
Betty Parsons Gallery in 1950, the artist maintained a similar relationship between the
paintings themselves and the space they occupied, something he also did for his
installation of an oversized painting in the home of Ben Heller. A comparison of
installations of Pollock's largest canvases, which I call the mural-size canvases, in museum
exhibitions with his own placements reveals a vulnerability to the conditions of display
similar to that for earlier art.

　　Curatorial decisions about display affect art in much the same way as directorial
decisions affect a motion picture. Just as a screenplay is interpreted by the director, an
artist's work depends on the curator's presentation of it. Andrew Sarris, in discussing
his *auteur* theory in relation to film, points out that, in the 1950s, the moviegoing public
was largely unaware of Fellini or Bergman, since audiences were generally ignorant of
the director's function.[2] That is no longer true today, and museum curators are emerging
from a similar anonymity, in some cases even upstaging the art. For Sarris, the *auteur*'s
role can be as subtle as an actor's slight hesitation within the film or as noticeable as an
innovative technique or radical interpretation.

　　The curator's hand is also visible in varying degrees. Like a film director, who works
with a studio, actors, a cinematographer, technicians, and a producer, a curator heads
a team. The museum director is the studio head, deciding when and how (financially) a
given project can take place; the institution's development staff is the producer, allocating
financial and human resources; the exhibition designer is the cinematographer; and

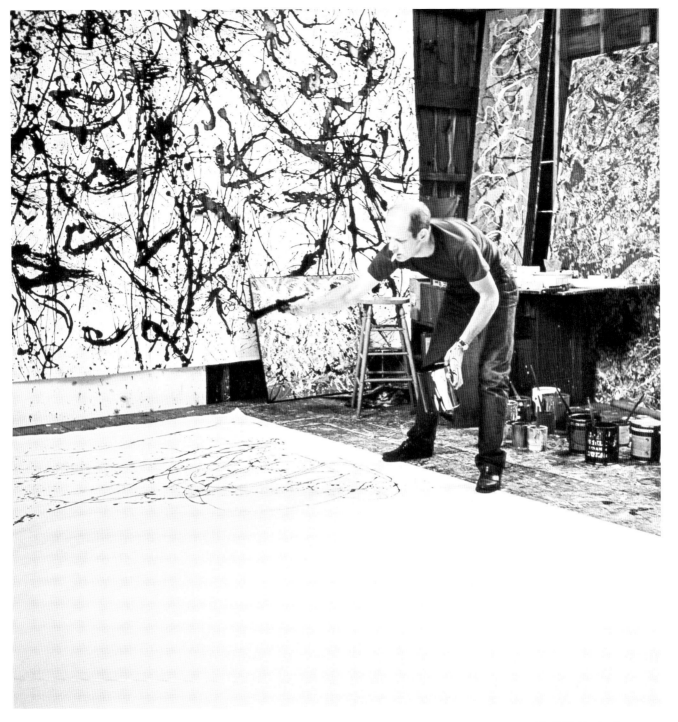

141. Jackson Pollock in barn at Springs, Long Island (1950): juxtaposition of small and large paintings, including *Number 32, 1950; Number 6, 1950/(Autumn Landscape); Number 7, 1950; Out of the Web: Number 7, 1949.*

conservators who determine conditions of light, climate control, and security are the film technicians. If the screenwriter's success depends on all of these in addition to a director and actors, the impact of an artist depends on the team guided by a curator. Like film directors, curators are concerned with style, technology, and message.

Jackson Pollock's widely publicized and mythologized personal life, his premature death at the age of forty-four in a car accident, his critical acclaim, and the astronomical prices commanded by his paintings in recent decades have made him an American icon, and the brilliance of his art is therefore perceived as immutable. However, it becomes apparent on seeing his revolutionary, mural-size paintings in different venues that the work is highly sensitive to its presentation.

For Pollock's paintings, we have a clear model of the way the artist wanted his work to be seen, as we do not for antiquities such as the *Laocoön*. When curators departed from this ideal in their exhibitions of his work, the paintings have had a different, often weaker, impact.

JACKSON POLLOCK

Pollock was born in Cody, Wyoming, and lived there briefly before moving with his family to Arizona and then to California, where he attended the Manual Arts High School. In 1930, at the age of eighteen, he came to New York, where he studied with Thomas Hart Benton at the Art Students League. The dark, brooding landscapes and awkward figures that he began to exhibit in 1934 were strongly influenced by Benton's and Albert Pinkham Ryder's paintings of American scenes. He went on to experiment with Expressionism, Cubism, Mexican art, and Surrealism. Only late in 1946 did he free himself from these American and European antecedents with his breakthrough "all-over" style.[3]

This style is first evident in paintings such as *Shimmering Substance* and *Eyes in the Heat,* part of the *Accabonic Creek* (1946) and *Sounds in the Grass* (c. 1946) series executed after Pollock and his wife, the artist Lee Krasner, moved from Manhattan to Springs, Long Island, in November 1945. The paintings reflected Pollock's heightened awareness of nature in a more lyrical abstraction and brighter palette, which replaced the violent, figurative Expressionism and somber colors of the early work.[4] Thanks to the now legendary pouring technique—made familiar to a broad public by the actor/director Ed Harris in the 2000 film *Pollock*—this style reached its fullest development between 1947 and 1950, when the artist's prolific output included the mural-size paintings for which he is best known. Although popularly referred to as "dripping," the artist's linear effects are more accurately described by Francis V. O'Connor as "pouring."[5]

A few artists had experimented with pouring pigment onto a horizontal canvas, but Pollock alone developed this method into a pictorial innovation as well as a style of his own,[6] eventually resorting also to squeezing, pushing, smudging, and throwing paint, and even applying it with a turkey baster.[7] Since all these devices were used on canvases

laid flat on the floor, Pollock struggled with the problem of displaying them vertically.[8] Compounding this problem was the artist's assertion that he worked "in" the painting as he moved around it, clearly an impossibility for the viewer. That the work itself was unlike anything ever seen before was a further complication.

The pouring method—paint propelled onto canvas at different speeds and by means of different gestures—produced a homogeneous field that suggested a new kind of space. First described by Krasner as "unframed space,"[9] and subsequently by the artist Allan Kaprow, who said, "The entire painting comes out at us ... right into the room,"[10] this visual phenomenon has been much discussed. Michael Fried revised his early concept of Pollock's "opticality" (1965) in order to accord more importance to the materiality of Pollock's surfaces.[11] The homogeneous field he had described is in fact sometimes cut out of the canvas (as in *Out of the Web: Number 7, 1949*) and sometimes embedded with a variety of objects, ranging from sand and pebbles to crushed glass and cigarette butts (for example, *Full Fathom Five,* 1947). The art historian Meyer Schapiro felt that the recurrent criticism of Pollock's all-over painting for being merely a series of decorative, repetitive patterns was due to a lack of awareness of its extraordinary complexity: "Only from a distant view, which loses sight of the intimate personal qualities of the surface and execution and all the passion and fantasy within the small areas, can one mistake the ornamental aspect for the essential trait of the whole."[12]

An equally important aspect of Pollock's work was addressed shortly after his death by Kaprow. Kaprow followed the lead of Harold Rosenberg in seeing Pollock as an "action painter,"[13] whose work forecast the happenings and installation art that he and his colleagues were interested in. However critics interpreted Pollock's work, they agreed that the large paintings should be seen in small spaces. For Kaprow, that meant "a medium-sized exhibition space with the walls totally covered by Pollocks."[14]

In a rare statement about his working method, Pollock described his own painting as "energy and motion made visible,"[15] an assertion deemed so revealing by his first biographer, B. H. Friedman, that he adapted it for the title of his book.[16] In a more recent study, Michael Leja relates Pollock's expression of the unconscious and the primitive to cultural forms prevalent in the United States between the 1930s and the 1950s, such as jazz, *film noir,* and Modern Man literature,[17] all of which tried to impose order on chaos to cope with a world that, in the atomic era, suddenly appeared out of control. For Leja, the Abstract Expressionists' embodiment of this dynamic produced tensions of order/disorder and control/uncontrol.[18] In the case of Pollock, I would add figure/abstraction, conscious/unconscious, action/contemplation, appropriation/invention. Pollock used his new ways of handling paint to create a turbulent art that embodied the energy and movement he was striving to express.

All too often Pollock installations have dissipated this energy. A measure of the difficulty in presenting the work is the number of unusual ideas that have been proposed

for its installation over the years: they range from an architect's project using mirrors opposite the paintings in a roofed, open-air pavilion to a museum curator's decision to suspend them overhead, floating free in space. The size and nature of Pollock's work present special challenges and elicit distinct responses from those installing it.

From an early age, Pollock was intrigued with big mural painting. By the end of his life, he had produced only twelve mural-size poured paintings,[19] but they have received as much attention as all the rest of his work combined. In June 1930, while he was still at art school in Los Angeles, he traveled with his brother Charles to Pomona College in Claremont, California, to see a new fresco there by José Clemente Orozco. That fall, in New York, the young man registered in Thomas Hart Benton's class at the Art Students League. In the years that followed, Pollock watched Benton painting the New School of Social Research murals and saw Diego Rivera painting murals on movable wall panels at the New Workers' School. He was also aware of Rivera's mural for the RCA Building at Rockefeller Center, which, because it included a portrait of Lenin, was destroyed in 1934 by the client.[20] By 1936, he and his brother Sande were working with spray guns and airbrushes, using unorthodox materials such as Duco (an industrial enamel paint) on May Day floats in David Alfaro Siqueiros's "experimental workshop" at 5 West Fourteenth Street.[21]

Only two of Pollock's existing mural-size paintings were commissions. The only one not in the poured technique, *Mural* (1943), was for his dealer Peggy Guggenheim, the niece of Solomon R. Guggenheim and a passionate collector in her own right; the other, in 1950, was for Marcel Breuer's Bertram Geller house in Long Island.[22] Such commissions provided the opportunity for the artist to create site-specific work, something he clearly welcomed. As early as 1930, he was making studies for murals intended for a settlement house in Greenwich Village,[23] and Krasner asserted that he always aspired to get his work into architectural settings.[24]

The problem of how to display Modern art so that it did not appear merely as decoration was very much in the air at midcentury, as witnessed by a symposium held at the Museum of Modern Art in New York in March 1951, called "How to Combine Architecture, Painting, and Sculpture." On that occasion Mark Rothko declared, for himself and, in his words, "for some of my contemporaries," that "I paint large pictures to be very intimate and very human."[25] Differences in the nature of Rothko's and Pollock's work necessarily produced different effects. Rothko's serene, contemplative paintings tend to create a sense of enclosure, as they do in the room devoted to several of them at the Phillips Collection in Washington, D.C., and at the Rothko Chapel in Houston; Pollock's ebullient rhythms extend beyond the canvas. Each, however, clearly wanted to envelop the viewer in a spatial environment of his own creation. Yet Pollock's installations of his paintings in accordance with this concept of intimacy were often discounted in museum exhibitions.

THE STUDIO IN SPRINGS, LONG ISLAND

Hans Namuth took two hundred black-and-white photographs and made two documentary films of Pollock at work in the summer and fall of 1950 in the barn he used as a studio.[26] The second film, made with Paul Falkenberg, in color, was in part filmed from beneath a glass panel on which Pollock was painting, now known as *Number 29, 1950*. Namuth's photography was a major factor in defining the artist's work as "action painting."

In the introduction to a collection of the stills, Barbara Rose suggests that Namuth photographed Pollock as he would have stalked a wild animal: stealthily tracked, the artist, in his rhythmic movement, conveyed a sense of untamed energy.[27] A dancelike ritual was just one part of a painstaking process that involved long periods of contemplation, for which the canvas was nailed to a two-by-four and lifted to the studio wall so that Pollock could study each phase of the pouring process; it was then often finished on the floor with great deliberation.[28]

The barn's working space was approximately twenty-two feet square—about the size of a modest living room and barely four feet wider than Pollock's Eighth Street Manhattan studio, in which he painted *Mural,* his first mural-size canvas. The Springs studio had a much higher ceiling and a good north window: according to Krasner, her husband worked only in daylight[29] (fig. 142). Nevertheless, the studio's dimensions were barely sufficient for canvases that could be over seventeen feet long. The farthest the artist could step back from a picture he was working on was about twenty feet—not coincidentally, the distance at which the mural-size canvases come into focus. From a greater distance they can appear unresolved, and at closer range it is difficult to apprehend them in their entirety. Remarkably, twenty-two square feet was the size of the room at the Betty Parsons Gallery where Pollock installed his mural-size paintings in 1950.[30]

Pollock's scale is the arc of his reach. In this sense there is no distinction between small and large works: the signature gesture consistently creates the same rhythms whatever the size of the canvas.[31] Over time, the barn presented what seemed to be an arrangement of finished paintings and works in progress, as if one canvas were guiding the conception of another,[32] with small or medium canvases often standing next to, or in front of, large works. This contrast in scale left an indelible impression on at least one visitor to the studio: for Carroll Janis, taken as a child to the barn in the early 1950s, by his father, Sidney (who eventually became Pollock's dealer), the juxtaposition of works of different sizes remains his predominant recollection.[33] The studio evidently contributed to the reactions of other visitors, who professed astonishment at the awesome impact of the large paintings in their modest setting.

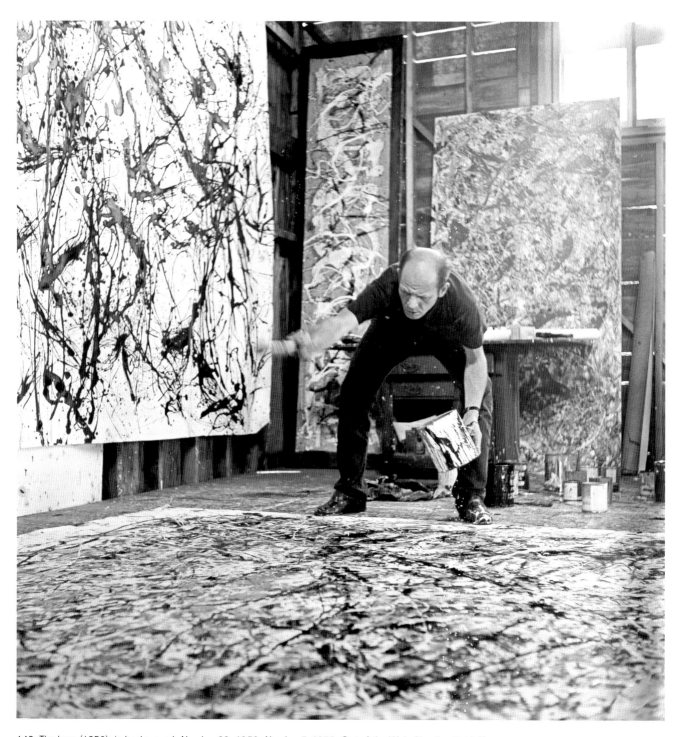

142. The barn (1950): in background, *Number 32, 1950; Number 7, 1950; Out of the Web: Number 7, 1949.*

A SITE-SPECIFIC COMMISSION

Pollock had executed the first and widest of his large canvases in his Eighth Street studio—eighteen feet square, with a ten-foot ceiling—before his move to Springs.[34] In his application for a Guggenheim Fellowship in 1947, he cited *Mural* (signed and dated 1943) as a precedent for the new mural-size painting he wanted to do instead of the easel pictures that he considered "a dying form."[35] The work, atypical in its arresting sequence of curved lines, loosely suggestive of stick figures marching rhythmically across the surface, was painted conventionally, with brushes on a canvas in the vertical position. Nevertheless, its size (7 feet 11 ³/₄ inches by 19 feet 9 ¹/₂ inches) raises questions about its placement similar to those raised by the later mural-size poured paintings.

Created for the ground-floor entrance hall of the apartment building at 155 East Sixty-first Street (now demolished), where Peggy Guggenheim lived, *Mural*'s presence in a communal passageway made it public, even though the smallness of the space—approximately thirteen and a half feet wide and thirty-five feet long[36]—was closer to the dimensions of a residential interior. The painting (given to the University of Iowa by Guggenheim and now in its permanent collection) thus marks a transition between the public murals that Pollock had studied—by artists like Orozco and Benton—and his own later, private mural-size work.

Guggenheim had asked Pollock for a canvas that would entirely cover one wall of the entrance hall (figs. 143–45). In her autobiography, the collector describes the artist's inability to hang the canvas because it was too large, a problem allegedly solved by Marcel Duchamp's trimming eight inches off the end.[37] According to Guggenheim, Pollock's distress over the problem was so great that he walked naked into a party going on in her apartment, three stories up.[38] The Duchamp story is discredited by the presence on the canvas of all four unpainted tacking edges, proof that the painting was never trimmed;[39] furthermore, Francis O'Connor argues convincingly that the difficulties came from the canvas's being too short rather than too long.[40]

Soon after receiving the commission, the artist measured the entrance hall wall as 8 feet 11 ¹/₂ inches by 19 feet 9 inches. But the canvas he painted on was 8 feet ¹/₄ inch at its tallest by 19 feet 10 inches at its longest.[41] That it was almost a foot shy of the ceiling is evidenced by the curved molding attached to stretcher bars placed around it as a frame, and an extra molding at the top attached to the ceiling, which together brought it to the proper height (a device contrived, according to Guggenheim, by Duchamp and a "workman").

The entranceway's nine-foot ceiling, short walls perpendicular to the painting at either side of it, and dependence on artificial light (a small window provided scant illumination) were not so different from conditions at the Betty Parsons Gallery,

143. Peggy Guggenheim entrance hall, 155 East Sixty-first Street, reconstruction perspective: *Mural* (1943), at right.

144. Peggy Guggenheim entrance hall, plan.

where Pollock would create his dramatic installation of 1950. Among the differences from the Parsons space, however, was the lobby's narrow width, which limited viewing of *Mural* to a distance of thirteen feet at most. Seen this close up, the painting must have looked slightly blurred, and it would have extended beyond the viewer's peripheral vision. Although Guggenheim invited those who visited exhibitions in 1945 at her Art of This Century Gallery at 30 West Fifty-seventh Street to come to Sixty-first Street to see *Mural,* she had apparently always intended the work to receive its full public exposure in the gallery.

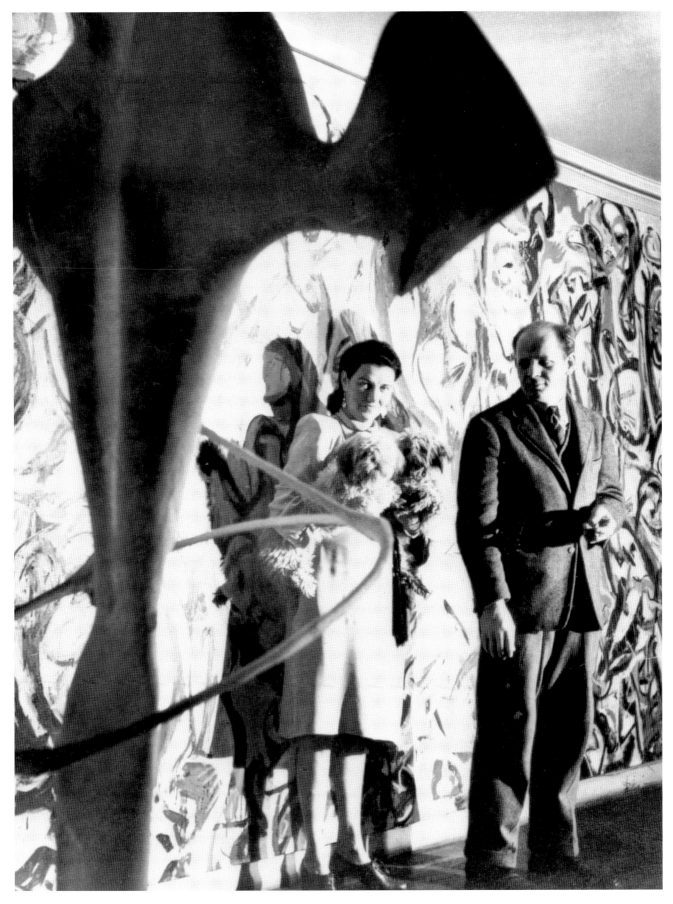

145. Peggy Guggenheim and Pollock before *Mural* in entrance lobby of her apartment building (1946).

146. Art of This Century, 30 West Fifty-seventh Street, approximate plan.

GALLERY INSTALLATIONS

Art of This Century

In 1943, Guggenheim had signed a contract with Pollock and given him his first solo show. Her Art of This Century gallery was a unique enterprise begun the year before as a museum in which her personal collection was to be permanently on view with a small area reserved for changing exhibitions.

Karole Vail, Guggenheim's granddaughter, described her as "good at accepting advice and acting quickly on it;"[42] Guggenheim was helped in her enterprise by a number of prominent art world figures, including Marcel Duchamp, Piet Mondrian, Howard Putzel, Herbert Read, James Johnson Sweeney, Alfred Barr, and her husband, Max Ernst. It was, in fact, thanks to Duchamp and Putzel that the gallery showed Pollock. To combine and renovate two adjacent top-floor lofts on Fifty-seventh Street—each about twenty-five feet wide and ninety feet long—for her purpose, Guggenheim hired the Viennese artist/designer Frederick Kiesler, who produced one of the most distinctive settings ever made for the exhibition of art (fig. 146).

Occupying a good part of the west side of the rectangular doughnut configuration was the Abstract Gallery, where turquoise-colored canvas was bound with rope, saillike, to a metal armature to hide the walls and windows; paintings by Kandinsky, Mondrian, and Léger were attached to cloth tapes and ropes stretched in triangular configurations from the ceiling to the floor (also turquoise).[43] On the east side, concave wooden panels formed a tunnel-like space for the Surrealist paintings of Ernst, Miró, and Matta, among others, which were all affixed to baseball bats that protruded from the panels at different heights. In contrast to the brightly lit Abstract Gallery, this darkened area had spotlights that rose and fell in sync with the sound of a moving train. North of the Surrealist Gallery was the so-called Kinetic Gallery, in which reproductions of works by Duchamp were visible through a peephole when the viewer turned a wooden wheel and works by Paul Klee were displayed on a moving belt.

147. Art of This Century, Daylight Gallery with Painting Library.

148. Art of This Century, computer approximation of 1947 Pollock exhibition, view from east side of Daylight Gallery toward entrance.

Facing north to Fifty-seventh Street was the temporary exhibition space, the Daylight Gallery, where Pollock's work was shown (fig. 147). It was characterized by light flooding through large picture windows, tempered by transparent, gauzy curtains.[44] In contrast to the quirkiness of the permanent installations, "there were no shenanigans" in the temporary exhibition space, according to Virginia Admiral, who exhibited there.[45]

Clement Greenberg, one of Pollock's first and most ardent supporters, described Art of This Century's galleries, with the exception of the Surrealist room, as "crowded and scrappy."[46] They had an intimate quality that was worlds away from the cavernous spaces of the next generation of Manhattan galleries, which began to take over commercial lofts in SoHo in the late 1970s.

Jimmy Ernst, Max's young son, sat at a desk just inside the entrance while Guggenheim positioned herself at the northwest corner of the Daylight Gallery. Both mingled freely with visitors, most of whom they knew, in what was then a close-knit world of artists and initiates in a handful of galleries (almost all on the East Side of Manhattan). Adding to the homey atmosphere were shabby walls, a scattering of folding stools with bright blue canvas seats, and a number of biomorphically shaped plywood objects designed by Kiesler as multipurpose easels, storage units, and seats. Greenberg wrote that the decor "creates a sense of exhilaration and provides a relief from other usually over-upholstered or over-sanitary museums and galleries."[47] Its small scale—Robert Motherwell described it as "tiny"[48]—and informality were also reminiscent of many artists' studios.

Only informal photographs document exhibitions in the Daylight Gallery, where Pollock and most of the artists who became part of the New York School were shown.[49] These photos, the building itself, and the testimony of artists associated with the gallery[50] and of some of the individuals who helped Guggenheim install exhibitions[51] have provided clues for a computerized re-creation of the 1947 Pollock exhibition there, his fourth and last at Art of This Century (fig. 148).

By this time, a painting library had been eliminated, and contemporary art was being presented in the fifty-foot-wide Fifty-seventh Street side.[52] The Daylight Gallery had

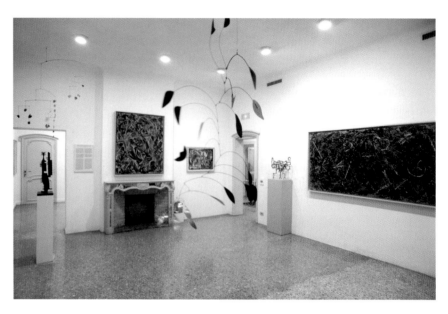

149. Palazzo Venier dei Leoni, Venice, where Peggy Guggenheim lived from 1948 to 1979.

plain white walls and painted rough wood floors; its space was partially interrupted at the center by a floor-to-ceiling panel perpendicular to the outside wall. Canvases were hung conventionally: close together and in relation to a fixed horizontal line. Guggenheim was influenced by the tendency of Alfred Barr at MoMA to alternate large and small as well as horizontal and vertical works,[53] as demonstrated by her installation of the Pollock Room in the basement of the Palazzo Venier dei Leoni in Venice, her home from 1948 until her death in 1979 (fig. 149).

In the fall of 1946, in preparation for the exhibition of *Mural* at Art of This Century, to open in January 1947, the painting was removed from its original site. The walls of the Daylight Gallery all seem to have been a few inches shy of the necessary space, and indeed, it is not clear whether the painting actually appeared in the show.[54] In any case, the gallery would have offered the ample natural light, low ceiling, and approximate viewing distance of the artist's eighteen-foot-square Manhattan studio.[55]

In 1947, however, *Mural* was included in MoMA's "Large-Scale Modern Paintings" exhibition. The second largest painting in the show, it was seen in very different conditions from those of either Pollock's workplace or Art of This Century (fig. 150). On a dark background and lit artificially, it hung between Joan Miró's small *Animated Landscape* (1927) and Rafael Moreno's *Paradise* (1943). Nearby and perpendicular to *Mural* was Léger's *Composition with Two Parrots* (1935–39), the largest work in the show. Colored walls, canted partitions, and dramatic spotlighting were typical of the museum's installations at this time and were often effective. But in this case, highlighting the canvas and placing it on a dark ground beside other works was treating it like the easel paintings Pollock was trying to transcend. Not until MoMA's 1967 retrospective was *Mural* installed in accordance with the artist's conception[56] (see fig. 179).

Restored and relined by its current owner, the University of Iowa, *Mural* now has irregular edges and blank canvas showing at top and bottom.[57] In the Sculpture Court of the university's Museum of Art, its position on a wall far too big for it, with too much viewing space in front of it (fig. 151), diminishes its impact as seriously as did the cramped conditions of its installation in Guggenheim's entrance hall.

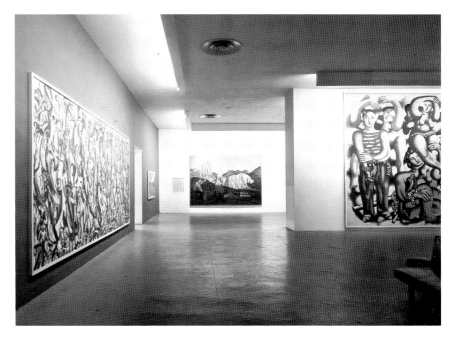

150. "Large-Scale Modern Paintings," Museum of Modern Art, New York (1947): Pollock, *Mural* (1943); Joan Miró, *Animated Landscape* (1927); Balthus, *The Mountain* (1937); Fernand Léger, *Composition with Two Parrots* (1935–39).

151. Museum of Art, University of Iowa: Robert Motherwell, *Elegy to the Spanish Republic No. 126* (1965); Pollock, *Mural* (1943).

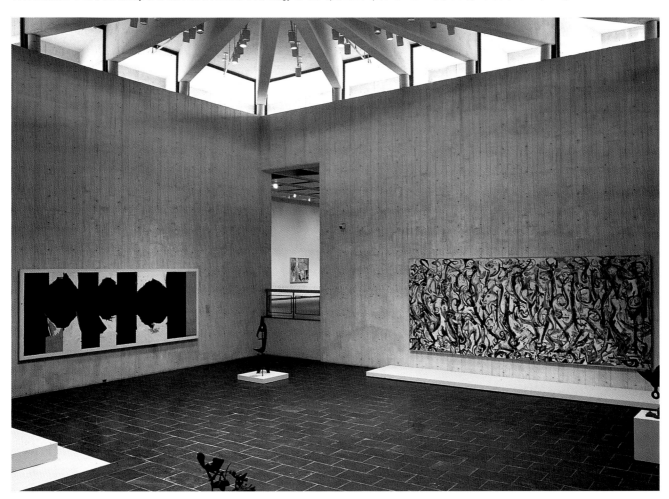

Betty Parsons, a Museum Project, and a Church

By 1948, Peggy Guggenheim had decided to close Art of This Century and return to Europe, relinquishing the representation of Pollock to Betty Parsons. Like Guggenheim, Parsons was a socialite with all the right art-world connections, but she was also an artist with her own convictions about how to show the cutting-edge work she favored. They were quite different from Guggenheim's.

Just two blocks east of Art of This Century, on the fourth floor of 15 East Fifty-seventh Street (now demolished), Parsons had two contiguous spaces of unequal size, each smaller than Art of This Century's Daylight Gallery. In contrast to the alternately theatrical and informal atmosphere of Guggenheim's enterprise, the Parsons Gallery was a reverential shrine to art, a windowless, spotlit temple, with its own "hushed and mysterious mood."[58] Stripped of all architectural embellishment (except for the baseboard), the walls—with the exception of the black wall at either side of the entrance—were painted white, and all seating was banished.

Oversized canvases were always hung unusually low to give the feeling of walking right into them, thereby making them more accessible. Undoubtedly to compensate for the absence of daylight, paintings were flooded with strong light from overhead troughs.[59] Judging from viewers' reactions, the absence of natural light at Parsons did not detract from Pollock's work. Clement Greenberg remarked that the metallic pigment in *Phosphorescence* (1947), exhibited in 1948, made the painting "almost too dazzling to be looked at indoors."[60] And critical responses the following year specifically mentioned the aluminum and silvers,[61] which do not stand out unless properly illuminated.

Like Art of This Century, the Parsons Gallery avoided the slick look of most galleries and museums: the rough, splintered floor was like a farmhouse kitchen's and the walls were painted only once a year. According to Jock Truman, who worked at the gallery from 1961 to 1976, it too "was like the extension of a studio."[62]

Parsons's installations had a particular grace to them.[63] One of her devices was to enlist the help of her artists to install a show: Barnett Newman (who played an advisory role for Parsons similar to that of Duchamp for Guggenheim) hung a Clyfford Still and an Agnes Martin show, among others, while Rothko hung a Newman show.[64] Pollock had asked Parsons, for his first exhibition with her in January 1948, to let his friend the sculptor Tony Smith design floating panels on which to affix the paintings. The method had been used earlier for Gerome Kamrowski's paintings, with as many as twelve small canvases on each side.[65] However, Pollock was already working on fairly large pictures, and most of the sixteen paintings in his exhibition (including *Lucifer,* 1947, forty-one inches by eight feet nine and a half inches) were too big for such a presentation, so they were hung on the walls with the help of Herbert Matter, Newman, Smith, and Still.[66]

For his third solo show at Parsons (the second in 1949), in November and December,

152. Pollock and Peter Blake at the Betty Parsons Gallery with model of Ideal Museum (1949).

153. Ideal Museum, re-created model.

Pollock turned to the architect Peter Blake, who had recently been named curator of architecture and industrial design at MoMA. Blake was one of many people who had been bowled over by the artist's Long Island studio: with the sun streaming in, he recalled "a dazzling, incredible sight—like the Hall of Mirrors at Versailles. Despite the modesty of the barn, the place was majestic."[67] Blake was convinced that, compared to its impact in the studio, "the work looked constricted in a conventional gallery; its movement, transparency, and translucency required a different setting." His feeling in the barn of being "surrounded by paintings on the floor and walls that reflected each other in a magic series" (and whose aluminum paint reflected light) reminded him of the neoclassical Reform Club in London, designed by Charles Barry in 1841, where mirrors at each turn of the arched stairway create a series of reflections. With this in mind, the young architect designed for an *Architectural Forum* series what he called "the Ideal Museum," a fifty-by-one-hundred-foot Miesian structure open at the sides (figs. 152, 153). (The model, which did not survive, was later re-created at the Pollock-Krasner House in Springs.)[68] Unframed paintings were to stand like walls at right angles to floor-to-ceiling mirrors that would reflect them to infinity. Blake planned to have glass and mirrors instead of walls so that there would be a sense of "the paintings defining space, not the other way around," and indeed, the critic Arthur Drexler declared the project to have reintegrated painting and architecture so that the painting *was* the architecture.[69] Besides the impracticality of an open-air museum, it is questionable whether reflecting the paintings ad infinitum would have in fact enhanced the works.

154. Tony Smith, project for a Catholic church (1950–51).

The model of the museum project (which remained unbuilt), with replicas of Pollock's paintings and three paint-splashed wire-and-plaster sculptures, was displayed at the Parsons show, billed as "Murals in Modern Architecture: A Theatrical Exercise Using Jackson Pollock's Paintings and Sculpture by Peter Blake." The title captured the architectural context intended by the artist for his large canvases and the dramatic nature of Blake's proposed presentation. Despite the exhibition's ambitious title, the actual installation was not unusual.

Pollock contemplated yet another setting for his work in the summer of 1950: a Roman Catholic church to be designed by Tony Smith at the behest of Alfonso Ossorio, a friend of both artists (fig. 154). An architect before he took up sculpture, Smith believed Pollock's large-scale works, like those of Newman, Rothko, and Still, required special viewing conditions—"unframed and uncrowded in uncarpeted space"—so that the painting could be experienced by "getting into it." At one point he suggested in-depth shows of these artists in a circus tent or a parking lot.[70]

Wrightian in plan, the church was to have consisted of a series of interconnecting hexagons elevated on pillars one story above ground. Eleven stained-glass clerestories, approximately three by seventeen feet, in two of the six-sided cells would presumably

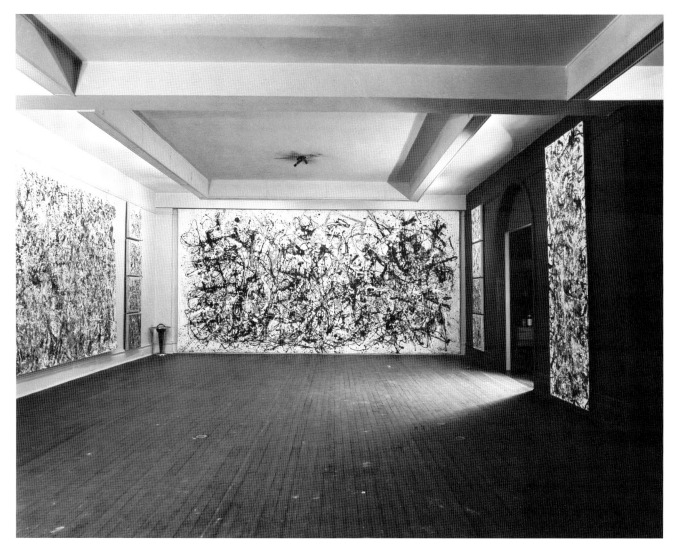

155. Betty Parsons Gallery, New York (1950): *Lavender Mist: Number 1, 1950; Autumn Rhythm: Number 30, 1950,* with four small canvases at either side; *Number 27, 1950.*

have been based on paintings by Pollock.[71] In addition, six of his canvases were to be installed—one existing work, *Lucifer* (1947), and five new commissions.[72] Krasner's recollection of the project, as reported by Rosalind Krauss, was that Pollock's six canvases were to have been mounted, or perhaps suspended, to form a freestanding hexagon.[73] In such an arrangement, the canvases would have read as the walls of an open-roofed aedicula within the building. The absence of walls in Blake's Ideal Museum opened the space outward to the landscape; the Smith/Pollock configuration instead enclosed the art. The effect would have been similar to that of the enveloping environment Pollock created at Parsons that fall.

For this fourth show at Parsons, in November–December 1950, Pollock, with the help of Smith, installed his own paintings[74] in an arrangement that has since served repeatedly as a model. Not only were the paintings shown among the artist's greatest masterpieces, but the effectiveness of the installation has never been surpassed. His three largest canvases of that year—*Autumn Rhythm: Number 30, 1950; One: Number 31, 1950;* and *Number 32, 1950*—were mounted flat on the walls without stretchers to emphasize their mural quality and to show the full extent of the canvas as it had been painted on the floor.[75] On the walls at either side of *Autumn Rhythm,* so-called miniatures

(about twenty-two inches square) were stacked four high in two totemlike arrangements that recall some of Pollock's early Indian-inspired compositions such as *Male and Female* of c. 1942 (fig. 155). Another large canvas, *Lavender Mist: Number 1, 1950* hung beside one of these stacks. As in the studio, work of such different sizes juxtaposed in this manner made the large paintings look larger and the small paintings smaller,[76] a dramatic effect that was intensified by the room's packed quality.

Pollock seems to have painted specifically for the space. *Autumn Rhythm* and *One: Number 31, 1950* (both more than seventeen feet long) filled the two end walls, while *Number 32, 1950* (fifteen feet long) fit into a shallow setback (fig. 156). The three tallest (nearly nine feet high) just barely fit between floor and ceiling; only the slightly smaller *Lavender Mist: Number 1, 1950* and *Number 28, 1950* had a few inches of breathing room. Opposite *Lavender Mist,* Pollock hung *Number 27, 1950* vertically, despite a signature and date at the lower right of its horizontal position. Besides echoing the verticality of the arrangements of the small canvases, this positioning gives the painting a vitality and coherence it lacks when positioned horizontally. (Nevertheless, until the Whitney Museum of American Art's millennium exhibition, "The American Century: Art and Culture, 1950–2000," curators have respected the signature in their orientation of the canvas.) More than fifteen years later, Allan Kaprow described the Parsons exhibition: "When [Pollock's] all-over canvases were shown at Betty Parsons gallery around 1950, with four windowless walls nearly covered, the effect was that of an overwhelming *environment,* the paintings' skin rising toward the middle of the room, drenching and assaulting the visitor in waves of attacking and retreating pulsations."[77]

William Rubin, MoMA's chief curator of painting and sculpture from 1967 to 1988, has compared the intimacy of the mural-size pictures with that of Monet's large late paintings. Like the French Impressionist's mural-size works, Pollock's preserved the intimacy of easel painting (as do the large canvases of other New York School artists). At the same time, these artists replaced the traditional idea of the representational easel painting as a window with the conception of a canvas that has become a wall, displacing rather than embellishing architecture.[78] As Monet's *Water Lilies* (1916–26) have surrounded the viewer at the Orangerie in Paris, they constitute a world in themselves.[79] Pollock's paintings at Parsons created a similar world.

The Parsons space approximated the residential scale for which the large works were intended,[80] and again, the dimensions of its largest gallery approximated those of the artist's studio. The analogy was not lost on visitors to the exhibition. Lillian Kiesler, Frederick Kiesler's widow, recalled that "the paintings looked just as good as in the barn,"[81] and Rose Slivka, a critic, remembered feeling "totally surrounded, like blanketed, in Jackson's intensity. It just took you over."[82]

It was after the artist's second show at Parsons, in January–February 1949, that

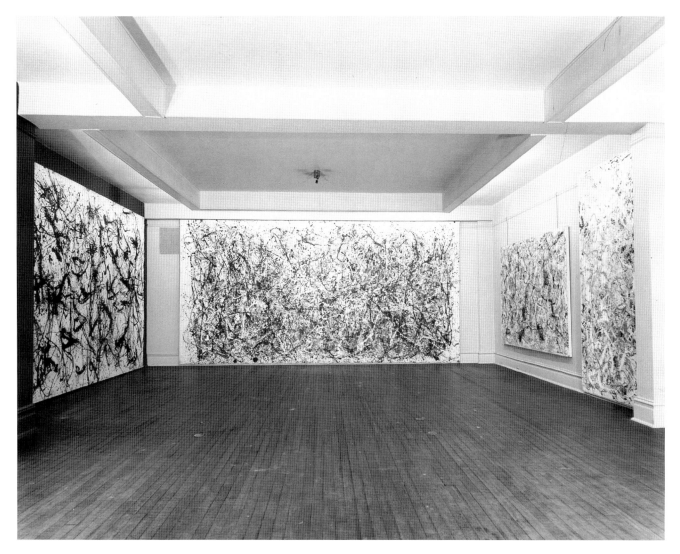

156. Betty Parsons Gallery (1950): *Number 32, 1950; One: Number 31, 1950; Number 28, 1950; Number 2, 1950.*

Life magazine published its cover story "Jackson Pollock: Is He the Greatest Living Painter in the U.S.?"[83] And the November–December show also received generally favorable reviews. Nevertheless, the paintings Parsons offered in 1950 did not sell. Just how radical the work was at the time is revealed by the young Jasper Johns's reaction to *Number 29, 1950,* the painting on glass: "It looked like something from another planet; it had nothing to do with anything I was involved with. It seemed to lack any sense of order."[84] Paradoxically, this exhibition of what are now considered Pollock's greatest achievements marked the beginning of the end of his career. Beset by problems, including the death of a doctor he had depended on and the pressures of making the films with Namuth, he lapsed into alcoholism, which had plagued him since adolescence.

In November and December of 1951, Parsons mounted her fifth and last Pollock exhibition: sixteen black-and-white semi-figurative paintings, five watercolors and drawings, and a portfolio of six prints.[85] Once again, despite favorable critical reaction to the show—at the time, Greenberg called it "a newer and loftier triumph"[86]—the work did not find buyers.[87] By September of the following year, Pollock had left his dealer for the more commercially minded Sidney Janis, whose gallery then adjoined Parsons at 15 East Fifty-seventh Street.

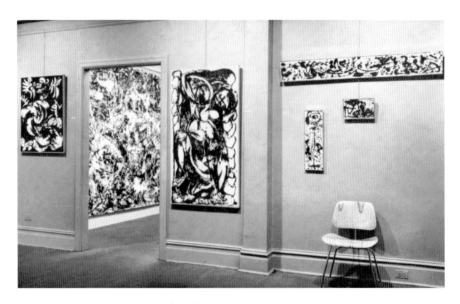

157. Sidney Janis Gallery, New York (1952): *Number 9, 1952: Black, White, Tan; Convergence: Number 10, 1952,* through doorway; *Number 5, 1952; Triptych* (1952).

Sidney Janis

Unlike the stripped-down temporary exhibition spaces at Art of This Century and Parsons, the apartmentlike setting of the Janis Gallery retained its original moldings.[88] Having switched to this more high-powered dealer, Pollock was reputedly unhappy that his new representative did not invite the artist's participation in his installations.[89] In fact, photographs of the first exhibition with Janis in November 1952 reveal a mannered clustering of canvases, an arrangement popular in the 1940s and 1950s, which almost certainly would not have appealed to an artist anxious to avoid decorative associations[90] (fig. 157).

During the next three years the increasingly troubled Pollock produced little, and for what should have been his annual exhibition of new work at the end of 1955, Janis was forced to resort to a mini-retrospective. Always wishing to show as much as possible, the dealer hung *White Cockatoo: Number 24A, 1948* on the ceiling (apparently with Pollock's approval)[91] (fig. 158).

Having suffered the problems of installing the 1943 *Mural,* Pollock had finally realized an ideal installation of his mural-size paintings at the 1950 Parsons show. Later, when he was struggling with Janis's display techniques, a private setting allowed him once again to carry out his own ideas about how the mural-size works should be seen.

158. Sidney Janis Gallery (1955): *White Cockatoo: Number 24A, 1948,* on ceiling; *Search* (1955); *Totem II* (1945); *Flame* (1934–38).

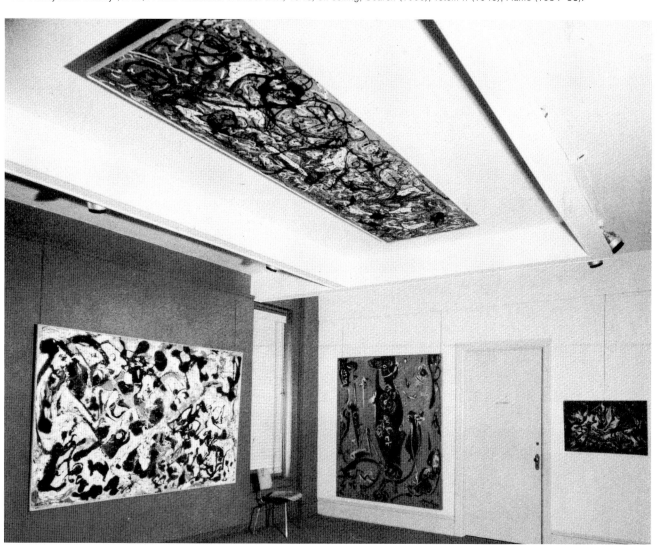

RESIDENTIAL INSTALLATIONS

Ben Heller

Ben Heller, a businessman and art collector, acquired his first Pollock in 1954 after visiting the artist's studio. With the help of Ileana Sonnabend, an art dealer and a friend of Pollock's, Heller selected a whopper: *One: Number 31, 1950* measured 8 feet 10 inches high by 17 feet 5 ½ inches long. The collector remembers that he and Pollock moved the huge canvas from Long Island to the city, where together they decided how to install it. Heller's apartment at 280 Riverside Drive was as challenging as Peggy Guggenheim's entrance hall had been.[92] Because the canvas was a few inches too tall for Heller's ceiling (8 feet 7 ½ inches), he had a stretcher made with half rounds at the top and bottom around which the excess canvas was rolled and stapled. Consequently, the picture filled the wall vertically and horizontally, as the largest paintings had at the 1950 Parsons exhibition.

With a growing number of acquisitions, including Asian and African sculpture as well as a second mural-size Pollock, *Blue Poles: Number 11, 1952* (6 feet 11 inches by 16 feet), the smaller *Echo: Number 25, 1951,* and large canvases by other artists, Heller eventually moved to a bigger apartment. He gutted and rebuilt a space at 151 Central Park West to accommodate the largest paintings and provide an appropriate setting: walls were removed to make an open living-dining area, moldings were eliminated, and lights were sunk into a dropped ceiling and into recesses at the juncture of ceiling and walls.[93] Paintings were hung from the recesses, which were painted black to give the impression that they continued above the ceiling. To provide a neutral setting, walls and furniture were beige or white, with only an occasional gray or putty-colored accent.

One: Number 31, 1950 was placed at one end of the living area on a wall-like panel the same size as the painting itself a few inches in front of the true wall, allowing it to be installed to its full size on a new stretcher. *Blue Poles* hung opposite it on a floating panel (figs. 159, 160). The whole arrangement recalled Pollock's 1950 Parsons exhibition, except that *Blue Poles* was substituted for *Autumn Rhythm;* in addition to *Echo,* works by Rothko, Still, and Newman were hung on the side walls; and African and Ancient Eastern objects were also displayed.[94]

Kirk Varnedoe, who became director of the Department of Painting and Sculpture at MoMA in 1988, has pointed to Pollock's deep assimilation of primitivism throughout his career:[95] the fundamental energies of tribal art are intrinsic to Pollock's work and make juxtapositions of the two particularly apt. Without achieving the uniquely Pollock environment of Parsons, Heller's room had the same intimacy, and the installation promoted a dialogue between compatible art objects.

The late Annalee Newman remembered that "everyone wanted to see Ben Heller's

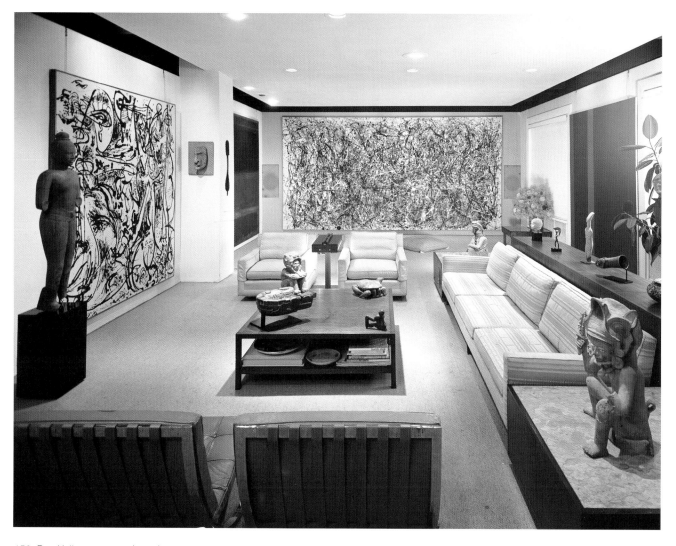

159. Ben Heller apartment (1960): Pollock, *Echo: Number 25, 1951;* Mark Rothko, *Four Darks in Red* (1958); Pollock, *One: Number 31, 1950;* Barnett Newman, *Adam* (1951–52).

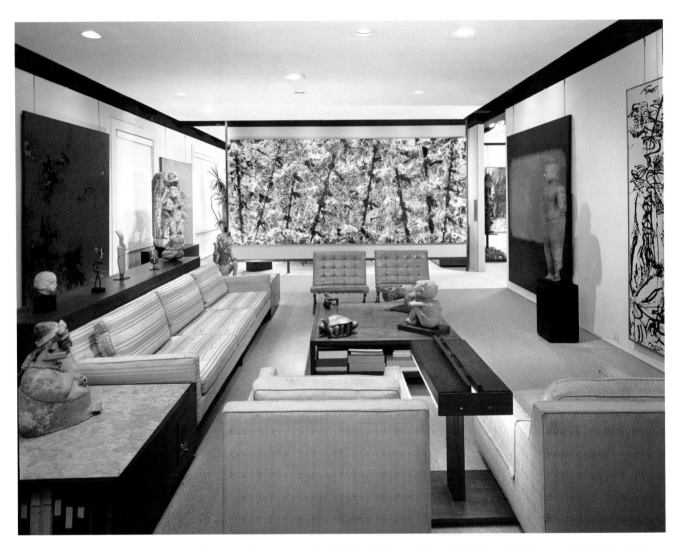

160. Ben Heller apartment, New York (1960): Clyfford Still, *Still '49;* Mark Rothko, *Yellow and Green* (1954), partially obscured; Pollock, *Blue Poles: Number 11, 1952;* Rothko, *Browns* (1957); Pollock, *Echo: Number 25, 1951,* partially visible.

apartment; it was so beautiful."[96] And Rothko, Heller remembers, called it "the Frick of the West Side."[97] Heller himself is convinced that "art looks best at the artist's studio, next best in a home, then a gallery, then the museum. In the studio you see art with the artist's other works, in the light the artist painted in. In a museum there is a lack of intimacy; you can't focus; paintings aren't lit individually. The museum operates as a Frigidaire."

Those who might question this assertion have but to compare the way *One: Number 31, 1950* and *Blue Poles* looked in the collector's home with the way they looked at the California Palace of the Legion of Honor in San Francisco, one of many venues for a traveling exhibition of the Heller holdings initiated by MoMA in 1961. At the Legion of Honor in 1962, the paintings were shown in a gallery far too big for them that did not provide the tight architectural framing they need (fig. 161). Long walls with a number of paintings hung on them are always problematic (see pages 234–37), and this was certainly the case for *Blue Poles*. Additionally, the rambling space put too much distance between the two large Pollocks and other paintings, isolating them from one another. Incidentally, Heller's opinion of museum viewing did not prevent him from selling the two large Pollocks to museums. *One: Number 31, 1950* went to MoMA and *Blue Poles* went to the National Gallery of Australia in Canberra.

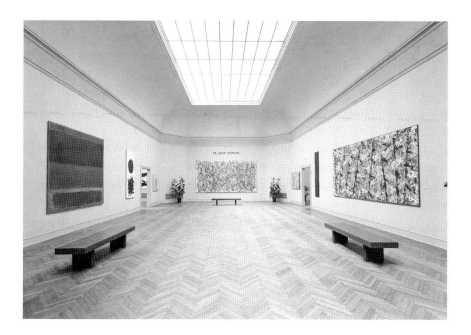

161. "The Collection of Mr. and Mrs. Ben Heller," California Palace of the Legion of Honor, San Francisco (1962): Mark Rothko, *Four Darks in Red* (1958); Adolf Gottlieb, *Burst* (1957); Phillip Guston, *Zone* (1954); Pollock, *One: Number 31, 1950;* unidentified painting; Barnett Newman, *Queen of the Night* (1951); Pollock, *Blue Poles: Number 11, 1952.*

Alfonso Ossorio

Born in the Philippines to a wealthy family and educated in England and the United States, Alfonso Ossorio decided at an early age that he wanted to be an artist. It was to this end that he acquired Pollock's work. His purchase of Pollock's *Number 5, 1948* from Betty Parsons the year it was painted was the first in a collection of contemporary painting that he drew on for his own work.

Ossorio and Pollock first met to discuss the restoration of *Number 5,* which had been damaged in transit from the gallery to the collector's home on Macdougal Alley in Manhattan. The meeting took place at Springs, and Ossorio was so captivated by this part of Long Island that he rented a house there for the summer of 1949. Eventually he bought his own magnificent property, the Creeks, in Wainscott, and moved there permanently in 1952.

The two artists' spontaneous friendship is less surprising than their different personalities and painting styles might suggest. Both had roots in Surrealism, and both looked to the native art of their respective countries as sources for their own work. Additionally, their shared interest in primal beginnings, science and myth, the irrational and the grotesque informed their art. To these, Ossorio added a deep religiosity and a flamboyant homoeroticism.

Urged on by Pollock, Ossorio traveled to Paris in 1949 to meet Jean Dubuffet, with whom he developed a close relationship: within two years the French artist published his interpretive study *Les Peintures Initiatiques d'Alfonso Ossorio.*[98] Dubuffet's interest in Art Brut (the work of the insane, the criminal, and the culturally marginalized) became, in turn, another resource for Ossorio, who in 1952 agreed to what was to be a decade-long display at the Creeks of Dubuffet's extensive Art Brut collection. At about the same time, Pollock introduced Ossorio to Clyfford Still, whose paintings Ossorio added to his collection.[99]

Ossorio bought *Lavender Mist* the moment he saw it at Pollock's Parsons exhibition in 1950,[100] initially installing it on a single wall in the main entrance hall of the Creeks. The area's relatively small size and less-than-nine-foot ceiling were ideal for the canvas: *Lavender Mist* and other Pollocks were seen in conjunction with Dubuffet and, elsewhere, with Ossorio's own works, pointing up affinities and contrasts among the three (fig. 162).

By the late 1960s, *Lavender Mist* had been moved to the much larger music room, where it hung alone on a twenty-foot-high wall (fig. 163). Under the influence of Ossorio's partner, Ted Dragon, the home's early sparseness had given way to a dense clutter of objects, including Oriental rugs, birdcages, and potted plants. Surprisingly, visitors to the house at this time do not recall the overdecorated interior as distracting. In fact, the multitude of objects may have helped compensate for the overscaled wall. The installation's strongest asset seems to have been the natural light, which enhanced *Lavender Mist*'s exceptionally delicate colors.[101] Additionally, the short flight of stairs leading down to the room would have provided dramatic multilevel views of the painting.

162. The Creeks, Alfonso Ossorio home, Long Island (1950): Ossorio, *Untitled* (1951); Jean Dubuffet, *Francis Ponge Jubilation* (1947); Pollock, *Lavender Mist: Number 1, 1950,* in entrance hall; Dubuffet, *Les Petits Yeux Jaunes* (1951).

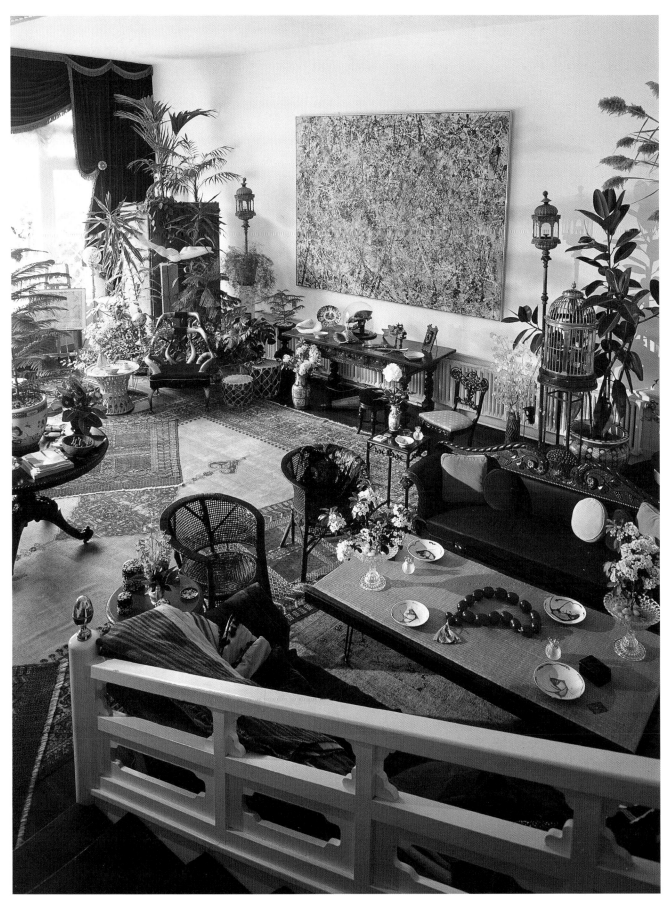

163. The Creeks (late 1960s): *Lavender Mist: Number 1, 1950,* in Music Room.

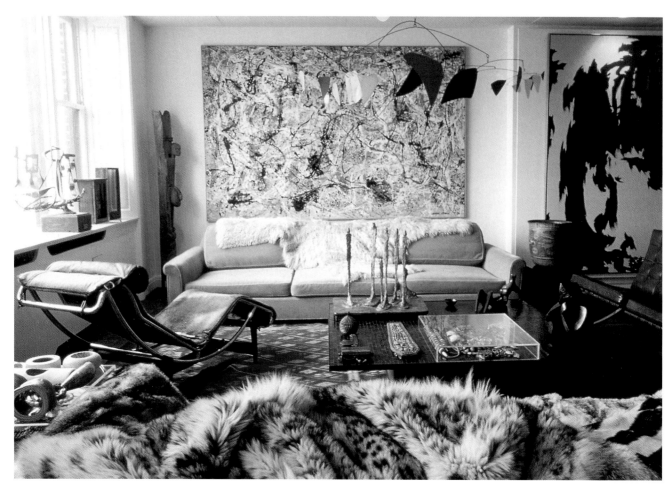

164. Muriel Kallis Newman apartment, Chicago (1990s): Pollock, *Number 28, 1950;* Clyfford Still, *Untitled* (1947-H).

Muriel Kallis Newman

Like Ossorio, Muriel Newman began to surround herself with art as a painter rather than as a collector. Her interest in European masters in the late 1940s switched in the next decade to the work of the New York School, which soon dominated her Chicago apartment. But seeing her own work alongside that of other artists was discouraging for Newman; she remembers, "Abstract Expressionism was an innovation like I'd never seen before: I had nothing to say as an artist after that experience."[102]

Newman eventually decided that collecting and installing art was the next best thing to making it. Her artistic instincts served her well: she installed Pollock's *Number 28, 1950* on a recessed wall perfectly proportioned to its large size (fig. 164). Not only was the painting contained within its architectural setting, but it hung perpendicular to north-facing windows, which provided optimum light for its silver pourings.

MUSEUM EXHIBITIONS

Private collectors and gallery directors are for the most part free of the museum's mandate to teach a lesson, nor are collectors and galleries competing for massive attendance. They can therefore be more relaxed than museums about security and circulation. Former museum director Walter Hopps describes the different experiences of a museum and a gallery in musical terms: "Gallery space is like chamber music. Betty Parsons was an interesting example: you walked in and within two minutes you had surveyed what was in the room. A solo show there was like a grand chord—very different from walking from room to room in a museum."[103] Shortly after Pollock's death, shows of selected work, one at MoMA in New York and one presented in London and at a Rome museum—among other venues—were like gallery exhibitions. Later, larger exhibitions—at MoMA in 1967 and 1998, the Pompidou Center in 1984, and the Tate Gallery in 1999—were more institutional and contributed to a change in the effect of Pollock's mural-size paintings.

MoMA, 1956–57

In the fall of 1956, a show planned by MoMA as the first in a series devoted to artists in midcareer became a memorial when Pollock died on August 11 of that year. In the last three years of his life, Pollock was increasingly agitated and erratic; he drank heavily and was emotionally disturbed.[104] The historian and critic Sam Hunter, who had been teaching at UCLA and working on a book about Pollock, recalls an interview with the artist at Springs in 1954: "He was drinking beer and was blasting a new hi-fi. He was wild and very unhappy."[105] It was no surprise to those who knew him that he lost control of the car he was driving to a party at Ossorio's, an accident that proved fatal.

The MoMA exhibition was curated by Hunter, whose rigorous selection captured the artist's spirit. Like Pollock himself, who in a 1950 interview had declared, "I'm just more at ease [painting] in a big area than I am on something 2 x 2,"[106] Hunter favored the artist's oversized canvases. More or less echoing Clement Greenberg's assertion that abstract painting "became trivial when confined within anything measuring less than two feet by two,"[107] Hunter declared scale to be everything. "The lyric sublimation of the large paintings is awesome," he said. "Pollock struggled with the small ones, but they don't do it for you. Only when you expand it do you get into subliminal space." He therefore included only two small paintings (both less than three by three).

Furthermore, because the exhibition was planned for the "Work in Progress" series, Hunter showed very few of the pre-1946 semi-representational paintings. The concept suited the curator's aesthetic prejudices against 1930s realism and in favor of abstraction. He remembers, "[Harold] Rosenberg's essay on action painting influenced everyone. It never occurred to me to include the 1930s work: the Pollock exhibition was sort of a campaign to exert the dominance of the New York School."

Given Hunter's preferences, the exhibition was more like a commercial gallery's offering of masterpieces. While his stated intention was to "cover the development of Pollock from *She Wolf* (1943) and *Pasiphaë* (c. 1943) through Surrealism to a kind of Existential Art," it was clearly the late work that interested him. More than half the thirty-five canvases he chose to exhibit were painted between 1947 and 1950, for Hunter, as for many, the period of "Pollock's most critical and exciting artistic contribution." Six of these were mural-size paintings.

In 1956, the ground-floor gallery MoMA devoted to Pollock was approximately its original size of 3,600 square feet. Spur walls for additional hanging within this modest area created roomlike settings. With help from Smith, Krasner, and Greenberg, Hunter chose the paintings and hung them chronologically and asymmetrically, interspersing them with three watercolors, four 1930s drawings he discovered in the artist's studio, and two later drawings. Pollock's great classic works were introduced by only seven of the early figurative paintings.

After hanging the mural-size *Number 1A, 1948* and *Number 1, 1949* next to each other, Hunter made what he called "a shrine of great pictures" with the same four large canvases that had been shown so effectively at Parsons six years earlier. *Lavender Mist* and *One: Number 31, 1950* were positioned perpendicular to one another, with *Number 29, 1950* between them supported by poles a few inches from the wall (fig. 165). Two mural-size paintings followed in the next space, also at right angles to one another: *Autumn Rhythm* and *Number 32, 1950* (fig. 166). To create a change of pace, a few of the museum's walls were painted black and one an "elephant gray." Dark walls, among a number of lighter ones, can highlight a display, causing viewers to pause. Because of the blacks in *Autumn Rhythm,* it was chosen to hang alone on one of the black walls, with the black-and-white *Number 32, 1950* on the gray wall perpendicular to it.

Although without the dramatic contrasts in scale of the 1950 Parsons installation, the juxtaposition of a medium-size canvas with very big ones emphasized the proportions of each. The proximity of the large works of the same period, executed in the same inscriptional language, was meant to bring Pollock's dematerialized color into the viewers' space and achieve an enveloping effect similar to that of the Parsons show. The intention succeeded, at least for one reviewer: "Entering the rooms in which the large paintings from 1947 to 1950 hang, one cannot help feeling that flow of spirit, the rustling, murmuring … intensity of many of the lyrical 'dripped' single paintings, the sealike rhythms which are sustained from one canvas to the next."[108]

From the time of his first one-man show at Art of This Century in 1943, which was reviewed by *Art Digest* under the title "Young Man from Wyoming,"[109] Pollock had been portrayed as a lawless cowboy. Although he was in fact never such a figure, the image fitted his limited education and impulsive personality, and the artist went out of his way

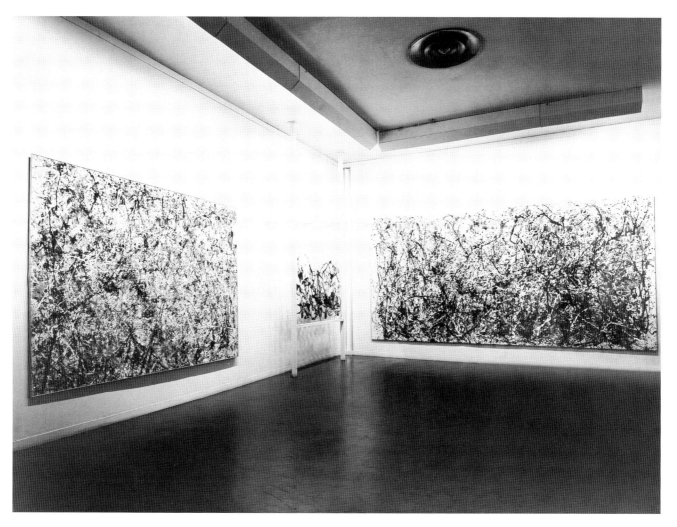

165. "Jackson Pollock," MoMA (1956–57): *Lavender Mist: Number 1, 1950; Number 29, 1950, One: Number 31, 1950.*

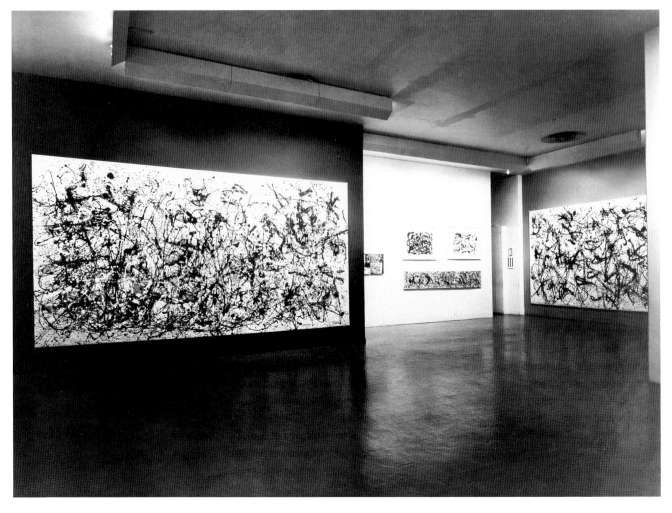

166. "Jackson Pollock," MoMA (1956–57): *Autumn Rhythm: Number 30, 1950;* two drawings of about 1951 above
Number 10, 1949, in next gallery; *Number 32, 1950.*

to cultivate it: wearing cowboy boots and capitalizing on his inarticulateness, he promoted himself as a tough western bad guy.[110] The ferocity of the early figurative work shown at MoMA suited the image, in much the same way that van Gogh's emotional instability is linked with his art. Reviews of Pollock's first exhibitions referred to him and his painting as "volcanic,"[111] "a disciplined American fury,"[112] "surcharged with violent emotional reaction,"[113] and having "a ravaging, aggressive virility."[114] His New York School contemporaries were also labeled "wild,"[115] but Pollock appeared more so, and the 1956 exhibition reinforced the image.

Hunter's brief text for what was essentially a thirty-five-page illustrated checklist clearly expressed the impact he wanted the exhibition to have. Key words echoed those of earlier reviews: "conflict," "unexampled savagery," "violent combat."[116] And while Hunter conceded that time subdues even the most radical art, he left viewers with the image of a vibrant, innovative talent. In its selective choice of works and its dynamic groupings, MoMA's first Pollock show must have generated a vibrancy similar to that of Pollock's studio, and comparable to his early gallery shows and to Heller's apartment. Without resorting to the macho photographs of the artist that were to become an intrinsic part of later Pollock exhibitions, this one left visitors with the image of an explosive genius.

Whitechapel Art Gallery, 1958

In 1957, Frank O'Hara, a poet and a friend to the artists of the New York School, served as a guest curator of a Pollock show, sponsored by MoMA's International Circulating Exhibitions Program, which traveled from the São Paulo Biennial to seven cities in Europe. Among these, the installations at the Galleria Nazionale d'Arte Moderna in Rome (March 1–30, 1958) and at the Whitechapel Art Gallery in London (November 5–December 7, 1958) were outstanding. At the Whitechapel, the exhibition came closer to the effect of explosive innovation achieved by Hunter at MoMA than did the more decorative Rome installation, although the former took place later.

Basing his choices loosely on the museum's 1956 exhibition, O'Hara retained *Number 1, 1949, Number 32, 1950* and *One: Number 31, 1950;* he added *Blue Poles* and dropped *Number 1A, 1948, Lavender Mist* and *Autumn Rhythm.* Keeping about half of the other paintings shown by Hunter, O'Hara also selected additional canvases, ending up with six fewer paintings than the 1956 exhibition. Among the works he included were early and late canvases (together with more than twice as many drawings and watercolors); his choices effectively transformed the earlier memorial at MoMA into a modest retrospective. The difficulty of obtaining loans for a traveling exhibition and the costs of such an exhibition may have influenced its smaller size; in any case, its twenty-nine canvases and as many works on paper were considered sufficient to represent the oeuvre of a leading artist in this pre blockbuster era.

In Europe, a local curator hung the show at each stop, in most cases, with remarkable indifference to presentation. At the Hochschule für Bildende Künste in Berlin, for example, canvases hanging on temporary partitions were viewed against the glare of daylight (fig. 167). The lack of interest in exhibition design then characteristic of most art institutions made the London and Rome installations all the more remarkable.

The Whitechapel has functioned as a nonprofit *Kunsthalle* since its founding in 1901. Only slightly larger (approximately 4,500 square feet) than the 1956 MoMA space, and interrupted by four slender columns and one short wall near the back, the Whitechapel was more like a commercial gallery of the period than a museum. As installed by Bryan Robertson, the gallery's director, with the architect Trevor Dannatt, Pollock's work had a greater sense of scale in the contained and somewhat fussy interior than it did in open, unarticulated museum spaces.[117]

Four white cinder-block walls, each approximately five and a half feet high, radiating from the center of the rectangular gallery—making what the architect called "a Mondrian in three dimensions"—determined the exhibition's design (fig. 168). The two long walls, offset from but parallel to one another, and two shorter ones perpendicular to them were obviously influenced by Mies van der Rohe, and to some degree by Russian Constructivism, in this heyday of European Modernism. The relatively low partitions subtly suggested a

167. "Jackson Pollock 1912–1956," Hochschule für Bildende Künste, Berlin (1958): *Summertime: Number 9A, 1948; Portrait and a Dream* (1953); *Number 32, 1950.*

168. "Jackson Pollock 1912–1956," Whitechapel Art Gallery, London (1958): Plan showing spatial divisions, with entrance at bottom.

path through the space and allowed interesting juxtapositions of the work. Furthermore, the walls' sturdy masonry conveyed a feeling of permanence compared with the flimsy temporary panels on which canvases were then routinely mounted.[118]

Dannatt reinforced his design with fabric overhead and carpeting on the floor. Strips of white muslin were stretched in a taut zigzag from the entrance to the back of the gallery, covering the central portion of the ceiling, to reduce the twenty-foot height. A cross axis was created by a broad strip of carpeting that ran the width of the gallery at its midpoint. Entering the Whitechapel, the visitor had his or her gaze directed by one of Dannatt's long walls and the jagged ceiling strips to *Number 32, 1950,* hanging on the back wall, more than sixty feet away (fig. 169). Though the painting was the farthest from the entrance, its size and strength, reinforced by the exhibition design, immediately commanded attention.

Inclined skylights at either side of the gallery provided the sole source of natural light; when daylight alone was insufficient, spotlights directed upward on vertical supports created ambient illumination. Under the skylight to the right of *Number 32, 1950,* in an alcove between the gallery's back wall and a short parallel wall, *One: Number 31, 1950* was placed perpendicular to that major work (fig. 170). Instead of hanging on the wall, *One: Number 31, 1950* was supported horizontally by two narrow boards in front of a wall covered with black fabric. Floating the canvas in this way reinforced the painting's elusive space. At a right angle to it, the small *Number 5, 1950* hung on the short wall. Facing the large painting, a long low bench with inset lights invited a pause.

Canvases were presented chronologically beginning with the wall to the right of the entrance, where an angled wood-board panel broke the display's rectilinear configuration to signal the importance of the painting hanging on it, *Male and Female* (fig. 171). For Robertson, the totemic figures of this early work from about 1942 prophesied the verticals of *Blue Poles,* painted ten years later, which he hung on the skylit wall directly across the room, where the exhibition came to an end (fig. 172).

Among the various installations of Pollock's work, only the Whitechapel's addressed the question of background textures. Robertson and Dannatt were concerned that painted walls might detract from the complex surfaces of Pollock's canvases. Their use of fabric on the ceiling and behind several canvases was intended to dissolve surfaces. As a background for some paintings, closely woven white muslin was finely pleated into a texture likened by Robertson to "the underbelly of a mushroom." *One: Number 31, 1950* was hung against pleated black matte fabric.

Paintings were affixed at approximately the same height to the freestanding walls and the permanent walls, with lively, asymmetrical alternations of different shapes and sizes. Placed in close proximity within the gallery's constricted space, the work radiated violence and energy, creating what one critic described as "Baroque dynamism."[119]

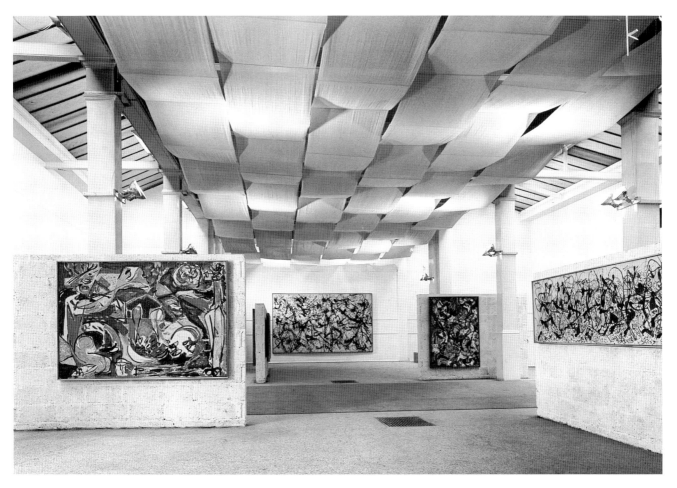

169. "Jackson Pollock 1912–1956," Whitechapel Art Gallery (1958): *The Key* (1946); *Number 32, 1950; Four Opposites* (1953); *Summertime: Number 9A, 1948.*

170. "Jackson Pollock 1912–1956," Whitechapel Art Gallery (1958): *Number 32, 1950; One: Number 31, 1950; Number 5, 1950; Number 1, 1949.*

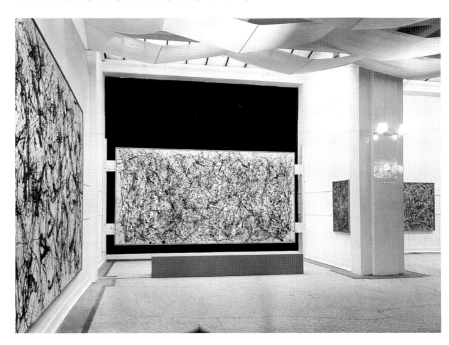

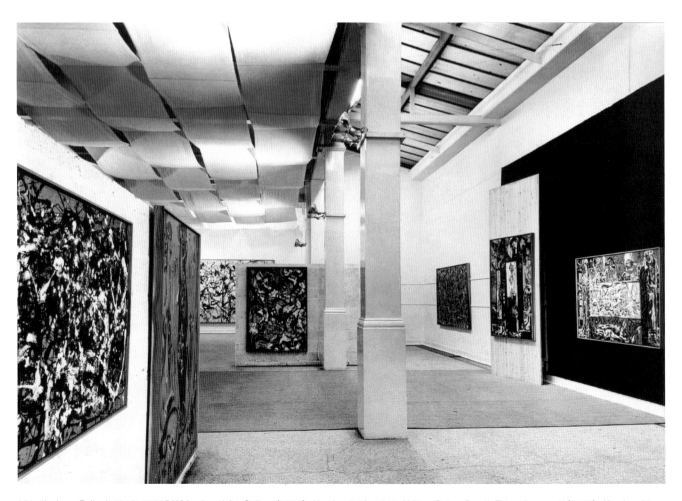

171. "Jackson Pollock 1912–1956," Whitechapel Art Gallery (1958): *Number 25A, 1948: Yellow Ochre Scroll; Totem Lesson II* (1945); *Number 32, 1950,* partially obscured; *Four Opposites* (1953); *Sea Change* (1947); *Male and Female* (c. 1942), on angled panel; *Guardians of the Secret* (1943).

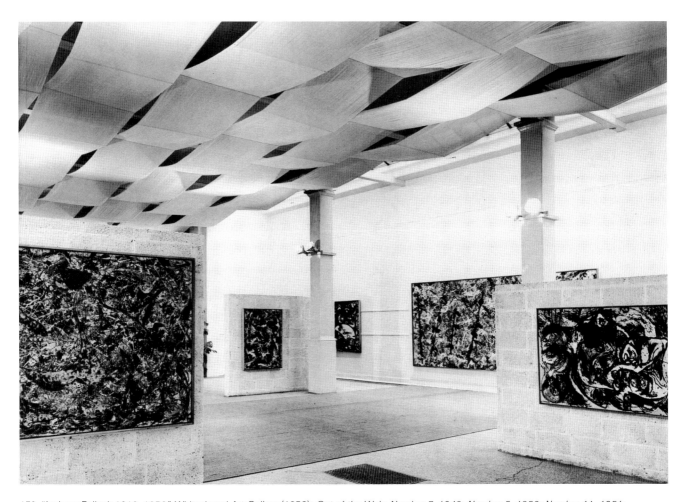

172. "Jackson Pollock 1912–1956," Whitechapel Art Gallery (1958): *Out of the Web: Number 7, 1949; Number 5, 1950; Number 11, 1951; Blue Poles: Number 11, 1952,* partially obscured; *Number 8, 1952.*

Galleria Nazionale d'Arte Moderna, 1958

Earlier in 1958, the same canvases had been presented quite differently in Rome. There, in contrast with the Whitechapel's grounding of the work, the curator Giovanni Carandente lifted many of the paintings overhead.[120] His understandable effort to convey Pollock's novelty produced some curious effects.

Amid Italy's highly politicized cultural scene in the 1950s, even left-wing critics with a prejudice against abstraction agreed that Pollock's was a radical departure:[121] his nonreferential abstraction was entirely different from Italian conceptual or geometric abstraction.[122] For Carandente, the American artist's canvases represented such a complete transformation of painting that he felt a conventional installation would be inadequate. He remembers: "I thought the paintings didn't need walls because they were like walls themselves. I started thinking of some of Pollock's declarations—'My painting does not come from the easel . . . the painting has a life of its own.' So I decided to use the museum's very large rooms in an unconventional way . . . floating canvases freely in space so they could breathe."

The method worked best for *One: Number 31, 1950*. Standing on two small blocks and almost imperceptibly supported at the back by parallel horizontal wires, with no other art behind it, the painting was truly wall-like (fig. 173). A bench placed about thirty feet from the canvas suggested an optimal viewing point. Canvases suspended from the ceiling also had a startling dynamic: *Summertime* (1948) passed through a doorway in defiance of the room's boundaries; *White Cockatoo* (1948) and *Out of the Web* (1949) hung diagonally across a recess in the wall (figs. 174, 175). In a further departure from convention, the exhibition's sequence was not strictly chronological.

Floating effects had been achieved for art exhibitions before by means of poles, partitions, and at Art of This Century, floor-to-ceiling tapes and ropes, but actually dangling canvases on wires seems to have been a novelty. The device was later adopted by others. James Johnson Sweeney, a friend of Carandente's who attended the Pollock exhibition in Rome, used the method at the Museum of Fine Arts in Houston, where he served as director from 1961 to 1968. It was employed mainly for special exhibitions of twentieth-century painting, and solely in the Cullinan Hall gallery, Mies van der Rohe's 1958 addition to the museum. Suspending paintings from the ceiling provided one possible solution to the problem of exhibiting art in Mies's wall-less spaces; the method was also used at the Nationalgalerie in Berlin, another Mies design, from the time the museum was inaugurated in 1968 until the mid-1970s (figs. 176, 177).

In the Rome exhibition, contrasts between paintings hung on the walls near floor level, at eye level, and overhead carried asymmetrical installation to the extreme. And as in the case of some other Pollock museum exhibitions, at the Galleria Nazionale

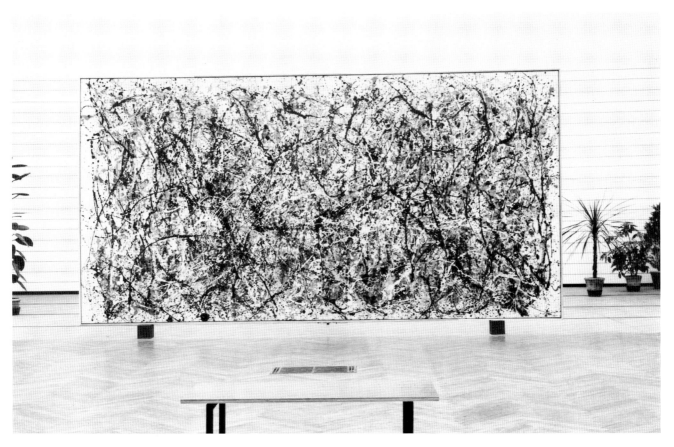

173. "Jackson Pollock 1912–1956," Galleria Nazionale d'Arte Moderna, Rome (1958): *One: Number 31, 1950.*

174. "Jackson Pollock 1912–1956,"
Galleria Nazionale d'Arte Moderna (1958):
Summertime: Number 9A, 1948,
above *Guardians of the Secret* (1943).

175. "Jackson Pollock 1912–1956,"
Galleria Nazionale d'Arte Moderna (1958):
Unidentified painting, partially obscured;
White Cockatoo: Number 24A, 1948, partially
obscured; and *Out of the Web: Number 7,
1949; Blue Poles: Number 11, 1952;
Echo: Number 25, 1951,* partially obscured.

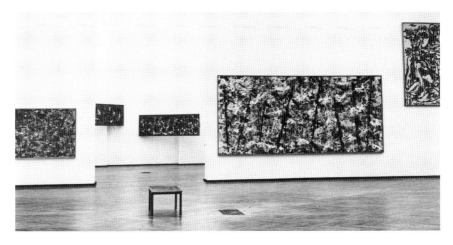

176. "The Heroic Years: Paris 1908–1914," Museum of Fine Arts, Houston (1965).

177. "Matta," Nationalgalerie, Berlin (1970).

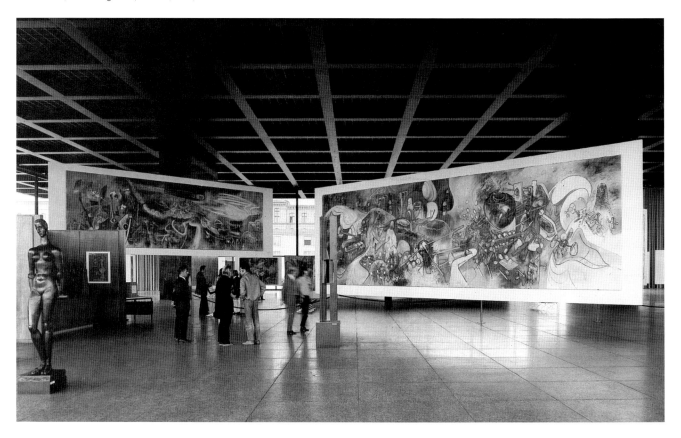

d'Arte Moderna the paintings struggled against overscaled spaces. A scrim lowered the thirty-foot-high ceilings by approximately half, but vast walls remained problematic for mural-size canvases hanging alongside other work. Skied as it was, *Number 32, 1950* lost its relationship with the floor, an essential ingredient to the successful presentation of Pollock's large canvases. Even the presence nearby of two much smaller works did not compensate for the painting's loss of tension (fig. 178). *Blue Poles* fared only slightly better at eye level (see fig. 175). One advantage of the Rome museum was the diffused daylight in which all the paintings were seen. Skylights almost entirely covered the roof of the 1911 building, providing ample natural illumination in the top-floor galleries.

The presentation evidently worked for Peggy Guggenheim, who, after visiting the exhibition, singled out the largest canvases as extremely moving.[123] And for one critic the show had a powerful impact: Marcello Venturoli, who until then had accepted the left-wing party line against abstraction, declared his complete conversion, persuaded by the Pollock exhibition that "painting has no need of external points of reference."[124] The paintings had prevailed over the shortcomings of their installation.

178. "Jackson Pollock 1912–1956," Galleria Nazionale d'Arte Moderna (1958): *Number 32, 1950; Number 22, 1951; Number 14, 1951.*

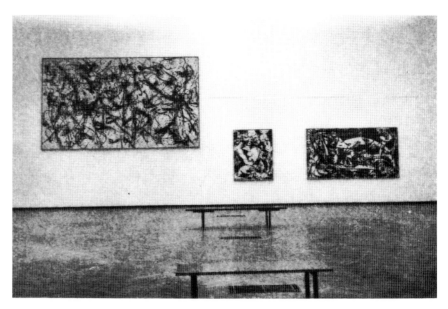

MoMA, 1967

A Pollock retrospective in 1967, ten years after the artist's death, called for a more analytical perspective. According to his own account, William S. Lieberman, MoMA's director of the Department of Prints and Drawings, wanted to demonstrate how the artist arrived at his masterpieces as well as to display the masterpieces themselves.[125] To accomplish this, he began the selection with work of a decade earlier than that in the museum's "Work in Progress" show: ten of Pollock's Mexican and Bentonesque paintings illustrated his origins. Horizontal series paintings were included, such as an untitled black-and-white polyptic (1950), in which the artist made one painting after another on a long canvas rolled out on the floor, like the frames of a film. Lieberman also displayed eighty works on paper, just about tripling the number of objects shown in the previous exhibition.

Like Hunter, Lieberman showed six mural-size canvases, adding one to Hunter's selection of oversized, classic pourings to re-create the group shown at Parsons in 1950. He began the exhibition with a spectacular presentation of *Mural* on a freestanding white panel in ambient artificial light (fig. 179). Here, the work was installed for public viewing in a manner more in accordance with Pollock's interest in an alternative to easel painting than it had been in MoMA's 1947 installation (see fig. 150).

By 1967, MoMA had begun a program of expansion, and the Pollock retrospective was installed on the ground level in Philip Johnson's East and Garden Wings. Lieberman solved the problem of mounting the show in two adjoining structures by positioning the late *Portrait and a Dream* (1953) at the end of the early work in the East Wing on a freestanding panel (fig. 180). Like the polyptic of 1950, this is a serial painting. The left side is occupied by a suggestive abstraction and the right side by what could be a self-portrait; the large horizontal canvas marked the transition from representational to abstract work. The installation, which broke the chronology and gave prominence to a painting sometimes dismissed as inferior, was extremely controversial at the time.[126] Compared with the 1956 display (fig. 181), however, the

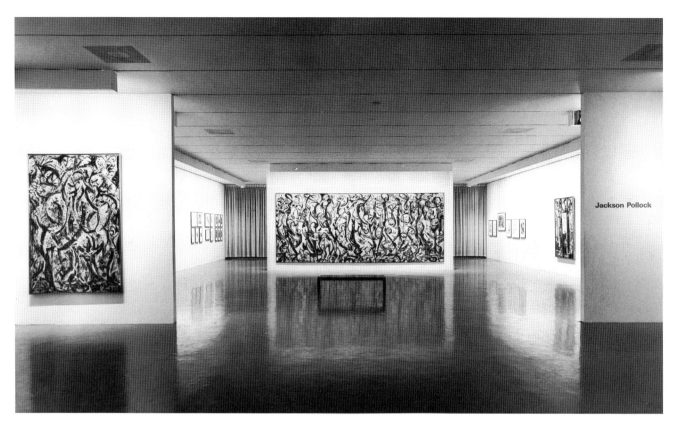

179. "Jackson Pollock," MoMA (1967): *Gothic* (1944); *Mural* (1943); *Male and Female* (c. 1942).

180. "Jackson Pollock," MoMA (1967): Two 1943 gouaches; *White Angel* (1946); *Portrait and a Dream* (1953); *The Blue Unconscious* (1946); *The Night Dancer* (1944); untitled mixed media (1945).

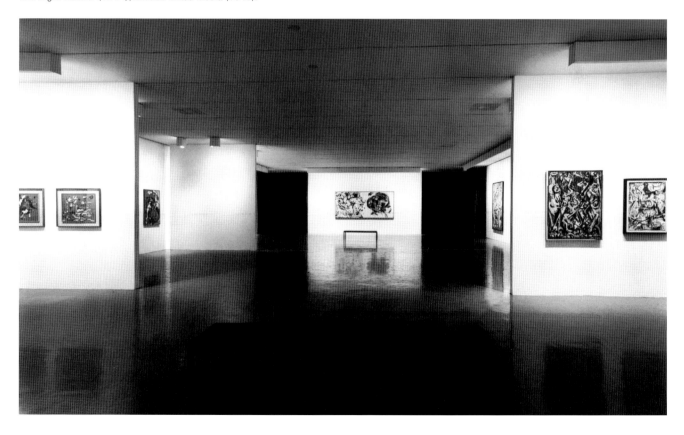

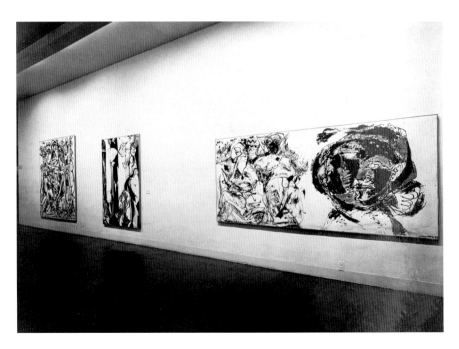

181. "Jackson Pollock," MoMA (1956): *Echo: Number 25, 1951; Easter and Totem* (1953); *Portrait and a Dream* (1953).

picture was shown to better advantage, and its scale and black-and-white abstract side prepared viewers for the first of the large poured canvases, *Number 32, 1950,* in the Garden Wing.

In fact, that painting was visible at the end of the corridor connecting the two buildings (fig. 182), where a mural collage of Namuth's photographs of the artist at work linked the exhibition's two parts. *Number 32, 1950* was followed by *One: Number 31, 1950* (fig. 183). Unlike the earlier exhibition's placement of the large paintings at right angles to one another, making it easier to see them together, the first two mural-size canvases and *Lavender Mist* were hung sequentially, on parallel spur walls. *Autumn Rhythm* followed on a side wall, thereby depriving it of the more dramatic impact of a frontal presentation. Fragmented in this manner, the work lost the enveloping effect of the museum's earlier display (figs. 184, 185).

As in the 1956 exhibition, dark backgrounds (deep brown) were interspersed with light ones (cream, closer to the beige backgrounds preferred by Barr).[127] But color was used more to differentiate distinct series—for example, a room of small 1948 and 1949 canvases—than to punctuate the rhythm of a visit (fig. 186). Lieberman also made his installation as asymmetrical as possible, repeatedly disrupting the hanging line with an object that was higher than the ones at either side of it and randomly juxtaposing horizontal and vertical works. As he said, "If you hang symmetrically, people look at the arrangement instead of the individual works; asymmetry keeps the viewer's attention." Also helping to create diversity, the curator admits to what he calls "cheating" on the lighting with the use of ice-blue and rose filters to soften some illumination.

Convinced that Pollock's drawings were the key to understanding his paintings, the curator used them as a leitmotif of the presentation.[128] A large gallery near the beginning of the circuit was devoted to works on paper, including sketchbooks exhibited publicly for the first time. Many other drawings were hung in the same galleries as the paintings, an unusual arrangement, since the viewer had to step forward to inspect

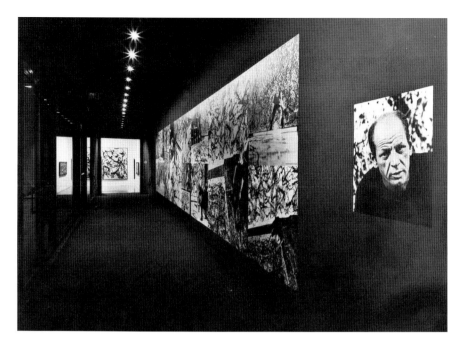

182. "Jackson Pollock," MoMA (1967): *Number 32, 1950,* at back in Garden Wing.

183. "Jackson Pollock," MoMA (1967): *Out of the Web: Number 7, 1949; Number 27, 1950; One: Number 31, 1950; Number 32, 1950.*

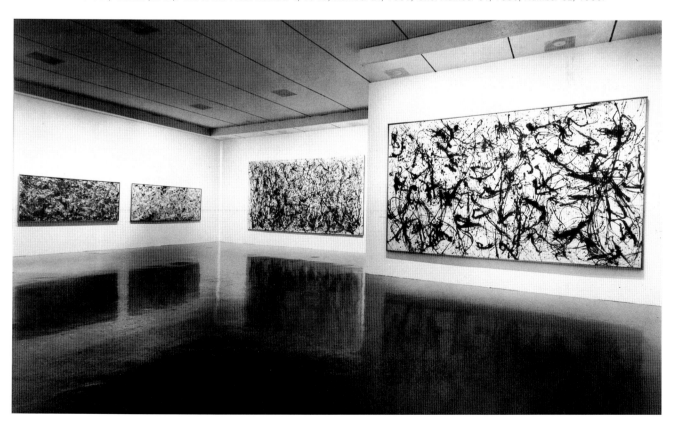

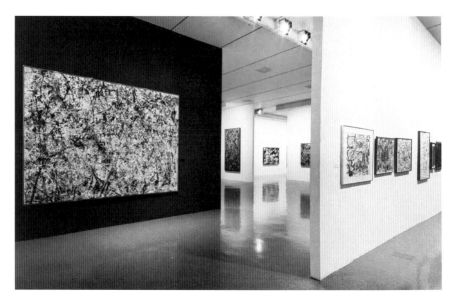

184. "Jackson Pollock," MoMA (1967): *Lavender Mist: Number 1, 1950; Sleeping Effort* (1953), in next gallery; oil paintings on paper, at far right.

185. "Jackson Pollock," MoMA (1967): Oil paintings on paper; *Echo: Number 25, 1951; Number 28, 1951; Autumn Rhythm: Number 30, 1950.*

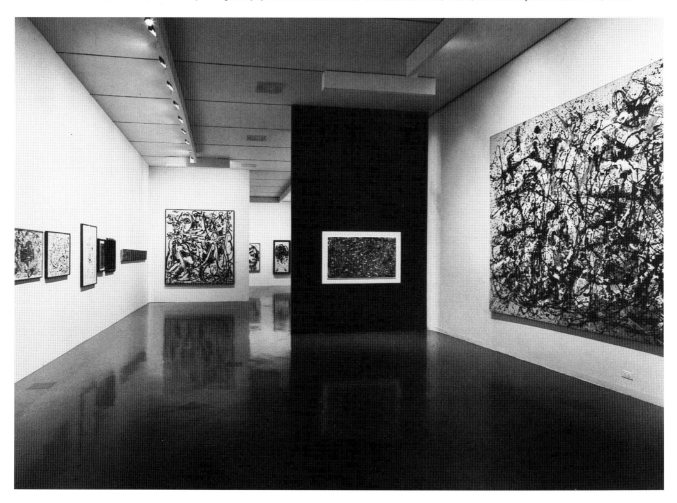

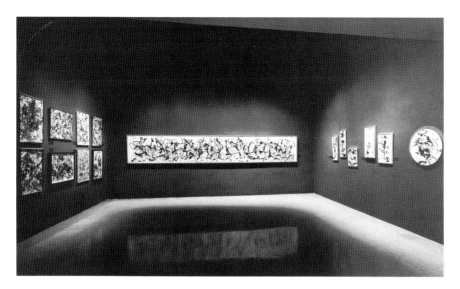

186. "Jackson Pollock," MoMA (1967): *Summertime: Number 9A, 1948,* at center, with canvases from 1948–49 on either side.

187. "Jackson Pollock," MoMA (1967): *White on Black* (1949); *One: Number 31, 1950;* unidentified drawing; *Vortex* (1947).

small works on paper and backward to see large canvases. Conservators usually prefer to show drawings in separate spaces with dimmer lighting. Lieberman's thoughtful mix of drawings and paintings demonstrated to the public that Pollock's pourings were the product of careful conceptualization rather than mindless automatism. The juxtaposition of *One: Number 31, 1950,* for instance, with a drawing was basically a lesson in the artistic process (fig. 187).

Despite a layout that allowed visitors to bypass some of the peripheral material, one artist had a telling reaction to the extensive display. Mel Bochner said, "Seeing a great deal together makes seeing anything difficult."[129] The show's 172 objects were a lot for an audience to take in—especially an audience that had not yet been exposed to the blockbusters of the decades to follow.

On the one hand, the exhibition, together with its 148-page catalog (including Francis O'Connor's seminal chronology of the artist's life), provided new insights into Pollock's work. On the other hand, the curator's didactic intentions reined in the explosive quality of the paintings. In the words of *Time* magazine, the show made Pollock into "something many artists dread more than being controversial: he has become an institution."[130]

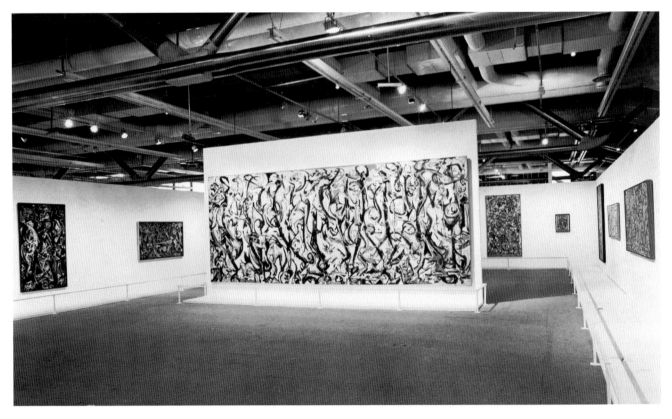

188. "Les Chefs d'Oeuvre de Pollock," Pompidou Center, Paris (1982): *Ceremony* (c. 1944); *Night Visit* (c. 1944); *Mural* (1943); *Enchanted Forest* (1947).

Pompidou Center, Paris, 1982

For an exhibition at the Pompidou Center fifteen years later, billed as "Les Chefs d'Oeuvre de Pollock," the curator Daniel Abadie selected sixty-five paintings in an equitable sampling of styles and sizes. (Drawings were not included because of another show organized by MoMA, "Drawing into Painting," seen in Paris just three years before.) In its restriction to the most prized work, the exhibition resembled the one organized by Sam Hunter at MoMA in 1956.

Abadie was particularly concerned about the presentation. Initially he had projected a full-scale mock-up of Blake's Ideal Museum, a plan that he had to abandon because of insufficient funding. He had also hoped to do away with labels but was not allowed to. So attentive was Abadie to the show's aesthetics that he even insisted on replacing the museum's shabby chairs with two of Mies's elegant Barcelona benches.[131]

The installation was to some extent a product of the museum's architectural innovations. Upon its completion in 1977, the Pompidou, designed by Renzo Piano and Richard Rogers, radically altered conventional thinking about museums. In particular, the building's enormous size—like that of the converted industrial structures it resembled— encouraged a leap in the scale of exhibition spaces generally and is often a liability to the art shown there and in similar venues (see pages 242–49).

A passionate Pollock enthusiast, Abadie devised a series of galleries that would present the artist as persuasively as possible to a public that might be resistant.[132] To convey a sense of the man and the context in which he worked, an initial room offered the Namuth and Falkenberg film together with personal memorabilia; flanking spaces showed paintings by Pollock's contemporaries in Europe and the United States. The exhibition proper began with two galleries of early material, the second dominated by

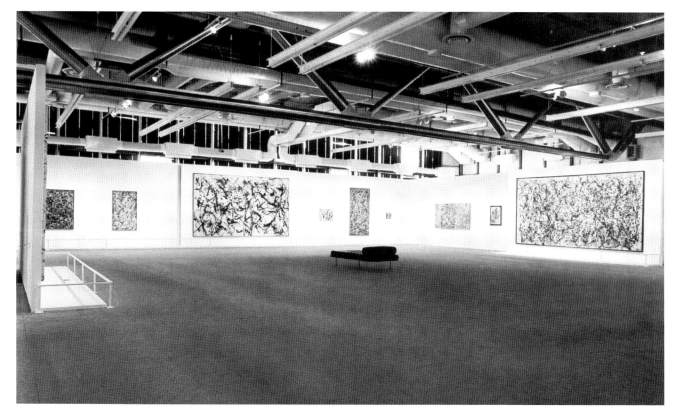

189. "Les Chefs d'Oeuvre de Pollock," Pompidou Center (1982): *Sea Change* (1947); *Number 3: Tiger, 1949; Number 32, 1950; Number 5, 1948,* flanked by two small unidentified paintings; *Number 31, 1949;* unidentified painting; *One: Number 31, 1950.*

Mural on a central freestanding panel reminiscent of the fortuitous 1967 MoMA installation (fig. 188; see fig. 179). On axis with the first gallery and clearly visible from it, the large canvas announced at the outset the large poured paintings of the third gallery, what Abadie called the *salon carré*—a reference to the Louvre's grand space of the same name.

In the five years since the building's completion, little advantage had been taken of the huge, uninterrupted spaces, which Abadie regarded as an ideal setting for the exhibition's four mural-size masterpieces: *One: Number 31, 1950, Number 32, 1950, Autumn Rhythm,* and *Lavender Mist* (figs. 189–91). At the time of the Pompidou's inaugural "Paris–New York" exhibition, Abadie had discovered that *One: Number 31, 1950* was too big to display at Pollock's first solo show in Paris, in 1952, at the small Studio Facchetti.[133] That problem may have influenced the curator's decision to create the huge temporary *salon carré* for the mural-size paintings and for a great many smaller works. Measuring approximately seventy by ninety feet, this vast gallery was made possible by the extraordinary flexibility of the museum's design (that is, before it was permanently partitioned in 2000).

For these largest canvases, the curator wanted room enough to accommodate what he called "the painter's breath" and to convey a physical sense of his invention of something new. In planning the installation, Abadie kept in mind a lesson he had learned from the critic and curator Thomas Hess, who, some years earlier, in the course of hanging a Barnett Newman exhibition in Paris's Grand Palais, had cautioned him that "it is a mistake to put big pictures in big galleries because it makes the pictures look small. Large Newmans are like large Pollocks, the size of the back wall at Betty Parsons (minus about ten inches at either side), where they are powerful."

Taking heed of Hess's advice, for each one of the four mural-size canvases in the

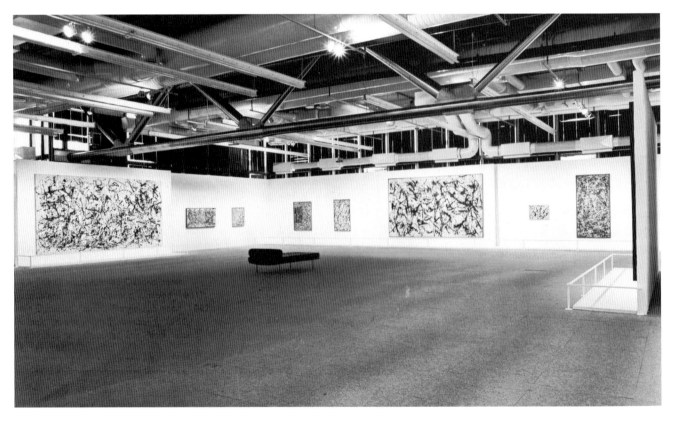

190. "Les Chefs d'Oeuvre de Pollock," Pompidou Center (1982): *Autumn Rhythm: Number 30, 1950;* unidentified painting; *Eyes in the Heat* (1946); *Sea Change* (1947); *Number 3: Tiger, 1949; Number 32, 1950;* unidentified painting; *Number 5, 1948.*

salon, Abadie built a detached panel, about a foot and a half wider than the canvas, that was placed approximately two feet in front of the area's peripheral walls. Thus, in the curator's words, "Each painting was reframed on the larger wall, each with its own space; only the disjunction between the white panel and the white wall marked a difference between the two."

The mural-size paintings selected by Abadie had been hung together at Parsons in 1950 (with, additionally, *Number 28, 1950*), but placed opposite one another in the exploded proportions of the *salon carré,* the experience of them changed completely. When the large paintings were viewed initially across this broad expanse, the framing purpose of the panels was lost, as were the paintings' surfaces—so essential to appreciation of the works. And the room's size posed another problem as well: to fill its long walls, a total of eighteen canvases were shown in it. Even with such generous spacing, the effect, one critic said, was of "everything coming at you simultaneously like scattered shot."[134]

The architecture had other disadvantages. In contrast to the visual foil provided by the Whitechapel's opaque ceiling cover, the jumble of beams and ducts below the Pompidou's ceiling was distracting. In the exhibition's smaller spaces, this service system was directly overhead and therefore less noticeable, but seen in broad perspective for seventy feet or more, the full expanse of the entangled metal tubes proved intrusive. This kind of exposed service structure, common in renovated industrial spaces, can serve as a foil for Pop Art and for installation pieces, but it competes with and defeats the serenity, and intimacy, in which work of the New York School is seen at its best.

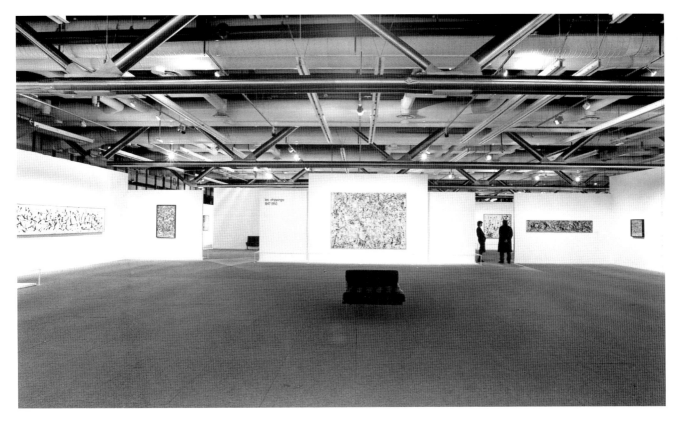

191. "Les Chefs d'Oeuvre de Pollock," Pompidou Center (1982): *Summertime: Number 9A, 1948;* unidentified painting; *Lavender Mist: Number 1, 1950; Number 10, 1949.*

Following the climactic *salon,* a small gallery presented what Abadie described as "the smaller vision": several medium-size black poured paintings of 1951[135] (fig. 192). A slightly larger last gallery was the only space that was wide rather than long, a shift in orientation that reflected the different style of the late canvases within. Without *Blue Poles,* which was not allowed to travel, the exhibition ended with *Convergence: Number 10, 1952* (fig. 193).

Abadie's accomplishment in bringing together so many of Pollock's finest works was undeniable; the critic Peter Schjeldahl wrote that the main gallery was "a Grand Canyon moment, utterly heroic and exalted."[136] However, presenting the mural-size work in a vast, open space drastically altered the artist's intentions.

The curator's two major aims for the Pollock exhibition were to challenge what he saw as overemphasis on the poured paintings and to take full advantage of the museum's new open spaces. Like some other Pollock scholars, especially those who approach the work from a Jungian point of view,[137] Abadie saw figuration throughout the oeuvre, making all parts of it equally important for him. His selection of almost the same number of works from the early, middle, and late periods would have reinforced this idea had the display of the classic poured canvases not so completely upstaged everything else. Ironically, the largest space contradicted Abadie's goals by signaling the poured paintings as the most important work and at the same time detracting from their fullest potential. In this subordination of Pollock's overall achievement to the mural-size paintings, the Pompidou show anticipated one at MoMA in 1998; what in Paris was called "the painter's breath" in New York became the "beating heart."

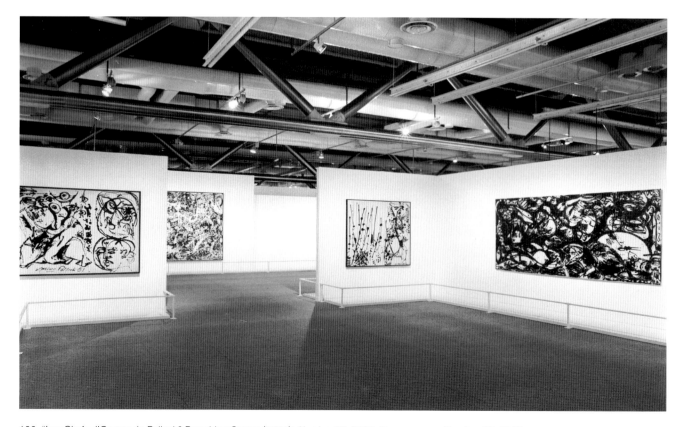

192. "Les Chefs d'Oeuvre de Pollock," Pompidou Center (1982): *Number 27, 1951; Convergence: Number 10, 1952,* partially obscured; *Number 7, 1951; Number 11, 1951.*

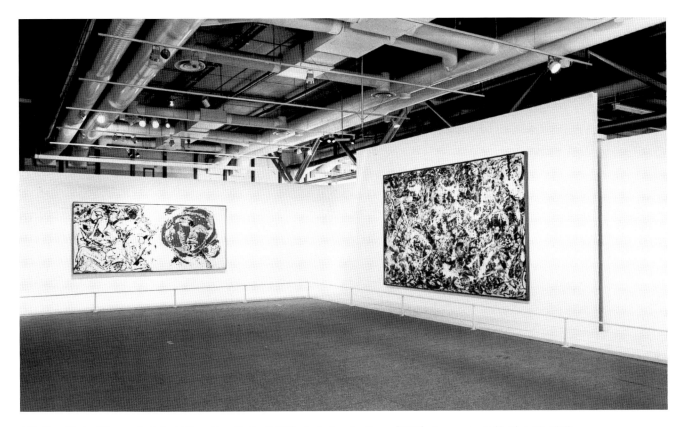

193. "Les Chefs d'Oeuvre de Pollock," Pompidou Center (1982): *Portrait and a Dream* (1953); *Convergence: Number 10, 1952.*

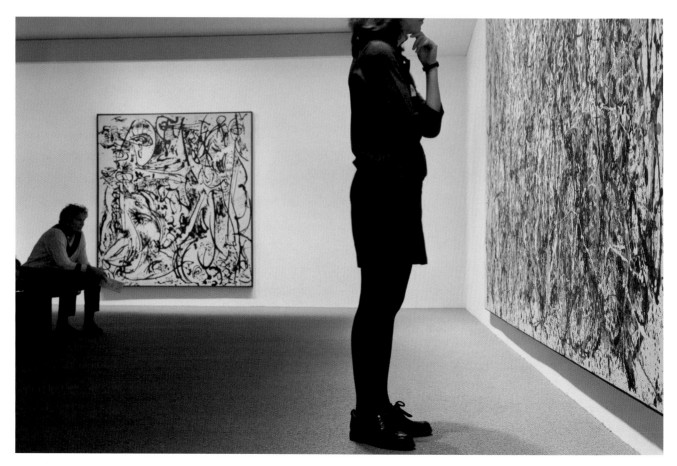

194. Joseph and Sylvia Slifka Room, MoMA (2000): *Echo: Number 25, 1951; One: Number 31, 1950.*

MoMA, 1998

The thirty-some years separating MoMA's two Pollock retrospectives dissipated all controversy about an artist whose paintings are now given pride of place in major museums around the world. Nor was there much left to reveal about the art, which had been included in hundreds of exhibitions and described and analyzed in innumerable articles and books (including a Pulitzer Prize–winning biography by Steven Naifeh and Gregory White Smith, which relied heavily on earlier publications). Faced with this tremendous accretion of material as well as with the legacy of the two previous MoMA shows, the curator, Kirk Varnedoe, assisted by Pepe Karmel, adopted the popular formula of a narrative. It was a completely different presentation from that of the Tate Gallery in London, the exhibition's second and final venue, where curators favored an aesthetic rather than a didactic approach.

Varnedoe said that he envisaged Pollock's development as "a fabulous story—from the compression and tensions of the early pictures to his great breakthrough of one huge painting after another in the summer of 1950."[138] For the curator, the painter's discovery and development of pouring was "one of the most radical innovations in the development of twentieth-century art." He wanted to convey this story, "pacing the experience of Pollock's life to deal with this climax ... without bogging down in less consequential aspects of it."

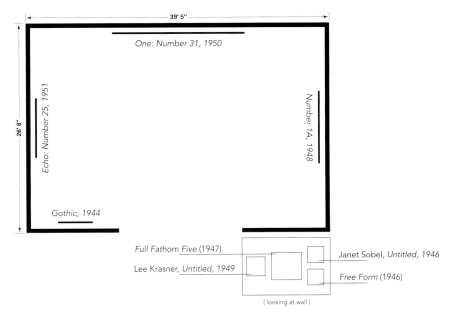

39' 5"

26' 8"

One: Number 31, 1950

Echo: Number 25, 1951

Number 1A, 1948

Gothic, 1944

Full Fathom Five (1947)

Lee Krasner, *Untitled, 1949*

Janet Sobel, *Untitled, 1946*

Free Form (1946)

(looking at wall)

195. Joseph and Sylvia Slifka Room, MoMA: Plan (1992).

For the 1984 reopening of MoMA, after its second major expansion, Rubin had created an installation tailor-made for the prized *One: Number 31, 1950.* In the Joseph and Sylvia Slifka Room, measuring about forty by twenty-seven feet, he hung the picture alone on the longest wall, opposite the entrance (fig. 194). A single medium canvas, *Echo* (1951), was placed on the room's short wall at the left; the larger *Number 1A, 1948,* on the short wall at the right. Facing *One: Number 31, 1950, Gothic* (1944) hung on the wall to the left of the entryway; on the wall to the right were a small Krasner, *Untitled* of 1949, Pollock's *Full Fathom Five* (1947), and a little Janet Sobel, *Untitled* (1946)—donated to the museum by Rubin—above Pollock's *Free Form* of 1946[139] (fig. 195). When he succeeded Rubin as director of the Department of Painting and Sculpture, Varnedoe lifted the ceiling of the so-called Pollock Room to eleven and a half feet and positioned Barnett Newman's mural-size *Vir Heroicus Sublimus* (1950–51) in the preceding gallery, on axis with—and in Varnedoe's words, in "a yin-yang relationship" with—*One: Number 31, 1950.*

The Pollock Room became a model for the 1998 Pollock retrospective. The placement in a relatively small room of one large and other different-size canvases was as near to ideal as possible, given the spatial requirements of the expected attendance. The gallery's twenty-seven-foot depth mimicked the artist's studio in terms of an optimum viewing distance for the largest work; hanging on a plane by itself, the wall-like quality of the canvas was respected; and as in the studio, small pictures (*Free Form,* the smallest of the Pollocks, measures 19 ¼ by 14 inches) reinforced the scale. Furthermore, the earlier Pollocks, the canvases by Krasner and Sobel, and the Newman nearby established a rich context for the featured painting.

For the retrospective, Varnedoe wanted to show three mural-size masterpieces in a chapel-like gallery similar to the permanent Pollock Room. He intended to again position *One: Number 31, 1950* on the wall facing the entrance; two other mural-size pictures—*Number 32, 1950* and *Autumn Rhythm,* on loan from other museums— would hang at either side.[140] When the curators realized that this arrangement would

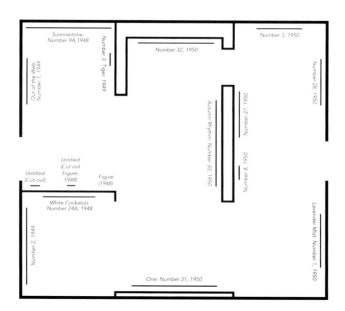

Figure labels (clockwise from upper left):
Summertime: Number 9A, 1948
Out of the Web: Number 7, 1949
Number 3, Tiger, 1949
Number 32, 1950
Number 3, 1950
Number 28, 1950
Autumn Rhythm: Number 30, 1950
Number 27, 1950
Number 8, 1950
Lavender Mist: Number 1, 1950
Untitled (Cut-out)
Untitled (Cut-out Figure, 1948)
Figure (1948)
White Cockatoo: Number 24A, 1948
Number 2, 1949
One: Number 31, 1950

196. "Jackson Pollock," MoMA (1998): Gallery of mural-size 1950 paintings, plan.

cause a circulation bottleneck, they opened up the room into what became the show's largest gallery; more than four thousand square feet, it contained the five large canvases of 1950 first shown at Parsons, among other major poured paintings (fig. 196).

The space was divided in half by means of a freestanding panel, creating two areas each slightly shallower than the Pollock Room. *Autumn Rhythm* hung on the panel at center stage between *Number 32, 1950* on the closest wall, to its left, and *One: Number 31, 1950* on the wall to its right (fig. 197). *Lavender Mist* (1950) and *Number 28, 1950* were visible in the adjacent space (fig. 198). The depth of each of the two areas was an ideal twenty-one feet, but their greatly increased width (fifty-four feet) isolated *One: Number 31, 1950* on the long wall farthest from *Autumn Rhythm*. The arrangement lost the intimacy of the Pollock Room as well as its contrast of small canvases. Nevertheless, this large gallery was a dramatic climax within the narrative: what Varnedoe called "the beating heart of the exhibition."

As an introduction to these poured canvases, seven galleries displayed thirty-seven pre-1947 paintings, ten more than in the 1967 exhibition; in two rooms of their own were a number of drawings and secondary oils from this period. It was a painstaking demonstration of the artist's anguished search for a vocabulary of his own.

One of the most important decisions faced by the curator of an exhibition devoted to a single artist is how much to include. For specialists, more is always welcome, but showing work that reveals the artist not at his or her best can alter a reputation, as can even good work shown to excess. The 1998 show was a bravura performance in terms of the curators' knowledge and ability to obtain elusive material scattered around the world, but the very wealth of objects—225 works, including 127 paintings—and the way they were presented dissipated Pollock's energy.

The extensive presentation of Pollock's early work revealed fascinating connections with later paintings—*Untitled (Self-Portrait)* of about 1931–35 anticipates *Portrait and a Dream* (1953), and the eye motif introduced in *Head* (1938–41) recurs repeatedly, as, for example, in *Birth* (1941), *Eyes in the Heat* (1946), and *Ocean Grayness* (1953).

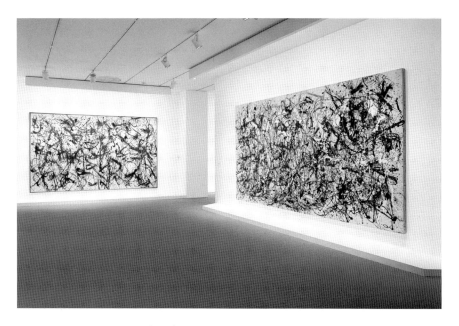

197. "Jackson Pollock," MoMA (1998): *Number 32: 1950; Autumn Rhythm: Number 30, 1950* (*One: Number 31, 1950* was on the wall at right).

198. "Jackson Pollock," MoMA (1998): *Lavender Mist: Number 1, 1950; One: Number 31, 1950* (*Number 28, 1950* was to the left of *Lavender Mist*).

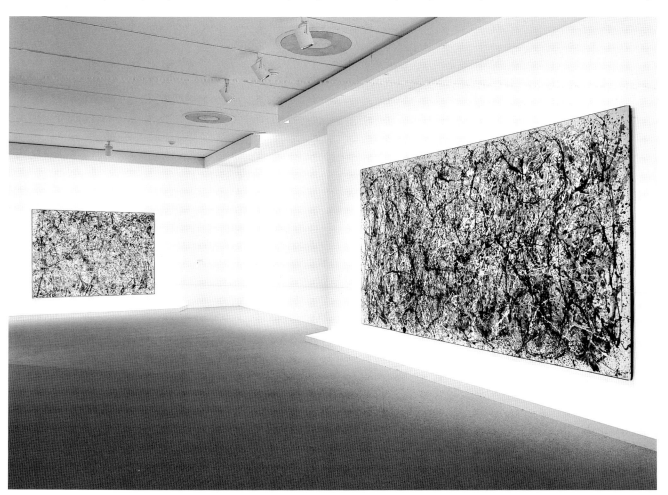

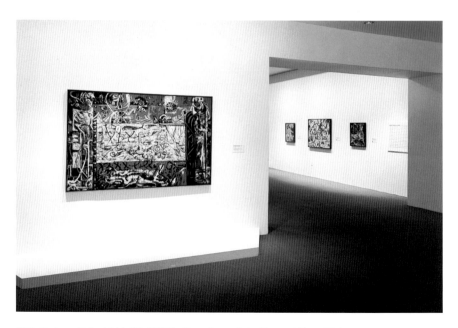

199. "Jackson Pollock," MoMA (1998): *Guardians of the Secret; Water Birds,* between two *Compositions with Pouring* (all 1943).

But the exhaustive display museumified Pollock. Repeatedly, a medium-size central canvas was positioned with a smaller work at either side (fig. 199); the triptych arrangement was repeated by similar groupings of a medium-size painting at either side of a portal with a larger work visible beyond. This was the case for *Number 1A, 1948,* which was flanked by *Enchanted Forest* (1947) and *Cathedral* (1947) in the preceding gallery[141] (fig. 200). The installation's classical symmetry subdued Pollock's baroque exuberance, and some canvases—*Lucifer* (1947), for example—lost their punch hanging alone on walls too long for them.

If making *Number 1A, 1948* the center of a triptych was not an ideal arrangement, its placement did serve the narrative. Like a good Hollywood director building a film's suspense, Varnedoe used this stunning painting to offer a taste of things to come before briefly interrupting the action with a study passageway in which little works on paper and on masonite hung at one side. *Number 1A, 1948* forecast the exhibition's climactic assembly of classic poured paintings.

A small gallery following Varnedoe's major display contained only five of the thirty-seven black poured paintings executed on unsized canvas between 1951 and 1952; with the exception of *Echo* (1951), no major canvas of this period was included. In the next gallery, *Blue Poles* (1952) was positioned as a kind of finale, almost encouraging visitors to bypass the artist's last works hanging in the gallery behind it (fig. 201). While the output of Pollock's later years is uneven, it includes important pictures such as *Portrait and a Dream* (1953) and *The Deep* (1953), but the display at MoMA gave them secondary status, a presentation of which many artists were critical. Frank Stella, for example, said, "The great was great, but the end [of the career] is great too, because Pollock is struggling to get around his very best painting."[142]

Before the late works, the museum offered a re-creation of the Springs studio (fig. 202). Varnedoe was justified in his wish to convey to the public what he described as "one of my most powerful experiences: the barn's small size, and the mundane nature of its space in contrast to the transcendent pictures." Great pains were taken

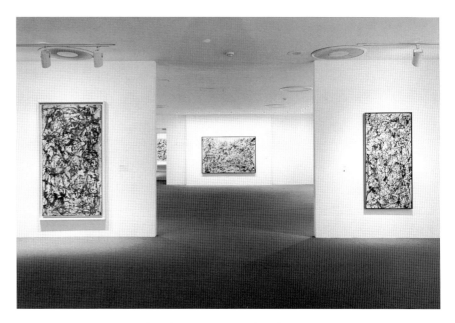

200. "Jackson Pollock," MoMA (1998): *Enchanted Forest* (1947); *Number 1A, 1948; Cathedral* (1947).

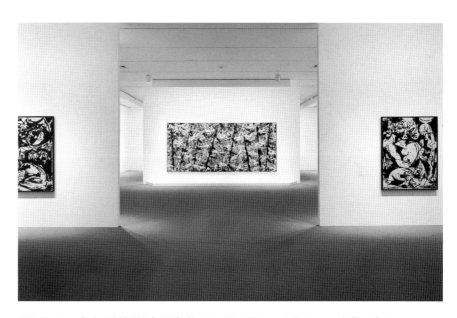

201. "Jackson Pollock," MoMA (1998): *Number 18, 1951,* partially obscured; *Blue Poles: Number 11, 1952; Number 22, 1951.*

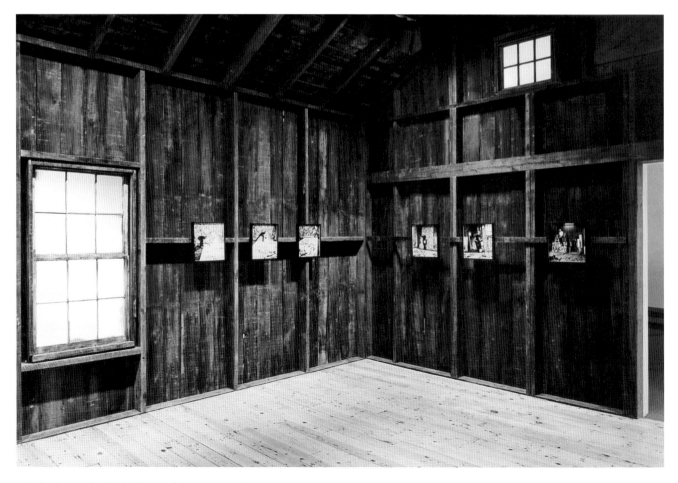

202. "Jackson Pollock," MoMA (1998): Re-creation of Springs studio.

to approximate the experience of the artist's workplace, right down to the size, color, and texture of the barn's boards.[143] Instead of trying to re-create the floor's evocative paint splatters, Jerry Neuner, the exhibition designer, placed a photograph of the floor at the entrance to the replica. All of this was effective. But Namuth's photographs of Pollock at work were hung on the walls of the replicated studio to lure the public into the space, compromising a true sense of the barn's space and function.

Just as the studio's artful disarray was sanitized and made into a gallery for Namuth's photographs, Pollock's frenzied output was neatly ordered to conform to the institutional setting. Even though the museum's ethereal ambient light robbed Pollock's metallic paints of their full sheen,[144] the work was breathtakingly beautiful—perhaps too beautiful, considering that the paintings had been made as a renegade expression in defiance of accepted norms. Francis O'Connor called the exhibition "a work of art in itself, excluding anything that would have intruded on its utopian perfection."[145]

If the 1967 show at MoMA began the institutionalization of Pollock, the 1998 show completed the process. In this tremendously successful exhibition[146] within the hallowed precincts of the museum's white walls and carpeted floors (to ensure neutrality and quiet), the paintings were strictly ordered according to a didactic narrative; their energy was harnessed by the classical configurations of their hanging and by lighting that calmed their radiant silvers. Altogether, it thoroughly tamed the wild young man from Wyoming.

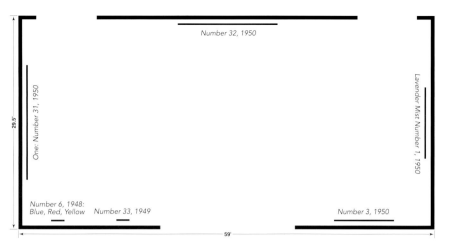

Number 32, 1950

One: Number 31, 1950

29.5'

Lavender Mist Number 1, 1950

Number 6, 1948:
Blue, Red, Yellow　*Number 33, 1949*

Number 3, 1950

59'

203. "Jackson Pollock," Tate Gallery, London (1999): Gallery of mural-size 1950 paintings, plan.

Tate Gallery, 1999

For the exhibition's reincarnation at the Tate Gallery (now the Tate Britain) in London, where it opened in March 1999, MoMA's approach was rejected. In the words of Tate director Sir Nicholas Serota, "We wanted to ensure that each work spoke for itself rather than as a link in a narrative."[147] Consequently, the hang was achronological and asymmetrical, and the output of different periods was given equal importance.

Underpinning the different concepts was the different architecture: MoMA featured an artificially lit linear plan (part of the Cesar Pelli renovation of 1984); the Tate has flexible skylit modules (completed in 1979 by Llewellyn-Davies, Weeks, Forestier-Walker and Bor). Overall, the exhibition benefited from the Tate's natural light; the classic large paintings, however, suffered in bigger spaces.

Following New York's example, the Tate showed the mural-size poured canvases in two contiguous double-module galleries, but in a different configuration (figs. 203, 204). *Number 1A, 1948* hung in the first space, followed in the next one by four mural-size canvases and two small ones from 1948 and 1949. *Number 32, 1950* took the central position occupied at MoMA by *Autumn Rhythm,* which did not travel; *Lavender Mist* and *One: Number 31, 1950* were on the side walls. Flanking a portal were the large *Number 3, 1950* at the right and the diminutive *Number 33, 1949* and *Number 6, 1948: Blue, Red, Yellow* at the left.

Each of the Tate's modules is twenty nine and a half feet square; with two modules used together the wall on which *Number 32, 1950* appeared alone was about forty-five feet long (the remaining space was devoted to portals); the double gallery measured approximately 1,750 square feet compared with the two areas of about 1,100 square feet each in New York. And as in the other galleries, the hanging area was nearly sixteen feet high—a plane too vast to provide a framework for the painting, which appeared unanchored. If space between pictures handicapped their interplay at MoMA, the even larger Tate space isolated them completely.

The exhibition's London curator, Jeremy Lewison, also took the 1950 Betty Parsons exhibition as a model for contrasts in scale when he hung *Number 33, 1949* and *Number 6, 1948: Blue, Red, Yellow,* both less than two feet high and just over two and a half feet wide, at right angles to *One: Number 31, 1950* in the double module.[148] Too distant from the large paintings to interact with them, these small works were even more diminished by the gallery's proportions than the large canvases. They looked like postage stamps. Two modules were joined in only one other gallery, also containing

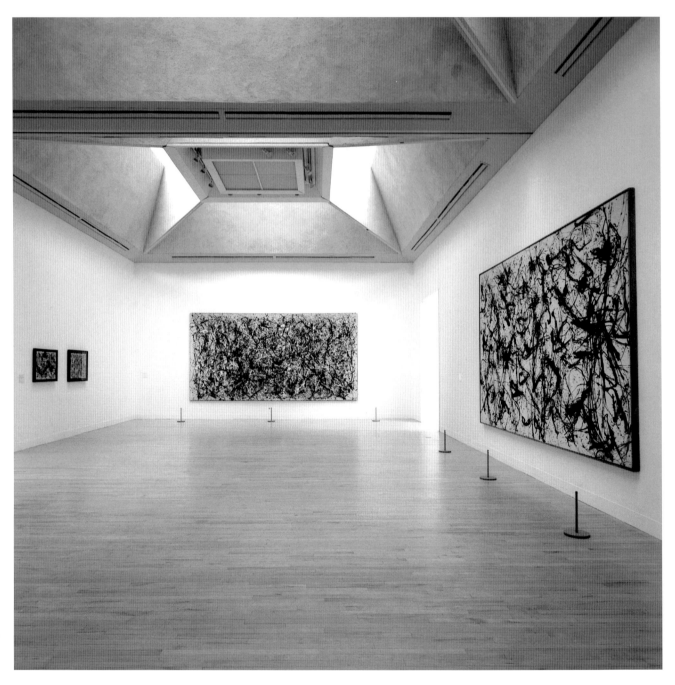

204. "Jackson Pollock," Tate Gallery (1999): *Number 33, 1949; Number 6, 1948: Blue, Red, Yellow; One: Number 31, 1950; Number 32, 1950.*

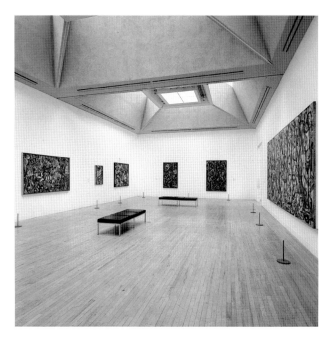

205. "Jackson Pollock," Tate Gallery (1999): *Pasiphaë* (c. 1943); *The Teacup* (1946); *The Key* (1946); *Troubled Queen* (c. 1945); *Gothic* (1944); *Mural* (1943).

an oversized canvas, the 1943 *Mural* (fig. 205). The rest of the exhibition was shown in single-module spaces, with smaller proportions better suited to the artworks.

The Tate compensated for problems in scale with abundant natural light. Seeing the paintings in daylight prompted curator and critic David Sylvester to say that after fifty years of viewing Pollocks, he felt he was seeing them for the first time.[149] For him, natural light made many works more luminous—*One: Number 31, 1950* and *White Light* (1954), for example. It also enhanced the shimmer of aluminum paint, which was not in evidence at MoMA.

In contrast to MoMA's categorical organization of the work, the Tate positioned paintings to point up their similarities. A looser chronology permitted mixing canvases painted in different styles, as in the case of the Surrealistic *Stenographic Figure* (1942) hung catty-corner with one of the first pourings, *Untitled (Composition with Pouring II)* (1943), to highlight their shared colors (fig. 206). At MoMA, *Stenographic Figure* had hung with early representational paintings; the Tate's arrangement suggested Pollock's indecision as he experimented with different approaches at approximately the same time—a theme that returned at the end of the London exhibition. Also to show links between different styles, *Mural* (1943) was hung in the same gallery as two paintings from the later *Accabonic Creek* series of 1946, which marked Pollock's new direction toward brighter colors and a more lyrical all-over technique.

Without the constrictions of a narrative, there was no hierarchization of the work in London. The addition of a major piece, *Number 11, 1951,* enhanced the selection of black poured paintings of 1951–53. This series, hung more tightly than other installations in a single-module gallery, was particularly striking at the Tate (fig. 207).

Instead of conveying the image of an artist burned out immediately after achieving his greater masterpieces, as MoMA did, Lewison's installation presented the final years of Pollock's life as consisting of two distinct phases, two vigorous attempts to relaunch a stalled career. The first, which began in 1951, saw a return to the figure in a series of works consisting of poured black paint; the second, from 1952 onward,

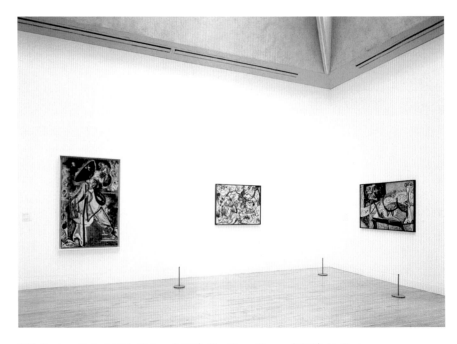

206. "Jackson Pollock," Tate Gallery (1999): *The Moon Woman* (1942); *Untitled (Composition with Pouring II)* (1943); *Stenographic Figure* (1942).

saw him revert to the successful formula of poured abstraction and, simultaneously, pursue a further exploration of figuration. For the curator, Pollock's career was a series of beginnings with sharp ruptures. Consequently, the last paintings were presented not as a sad decline but as a new beginning: Pollock's attempt to recapture the energy of his earlier groundbreaking poured paintings alongside the exploration of new possibilities for figuration.

In the two final galleries, *Portrait and a Dream* (1953) was centered on an end wall in the first, on axis with *Blue Poles* in the second; both were given more dramatic presentations than at MoMA (figs. 208, 209). Here, pictures that were downplayed, or could even have been missed, in New York—among them *Ocean Grayness* (1953) and *The Deep* (1953), as well as *Portrait and a Dream*—were given the same status as the classic paintings.

Of all Pollock's work, *Blue Poles* is the most controversial. Its authorship (with a suggestion of participation by Tony Smith and Barnett Newman)[150] has been questioned, as has its merit. In a good example of the power of display, the Tate's strategic positioning of the canvas was a strong endorsement. As the sculptor Richard Serra has said, "*Blue Poles* was downgraded by MoMA. It's garish and upsetting, but it's as good as any great German Expressionist painting."[151]

The MoMA installation followed the didactic tradition established by Alfred Barr at the museum's outset: it offered a single-minded, linear presentation. For the general public, MoMA's chronological narrative probably illustrated the artist's stylistic evolution more clearly than Lewison's presentation did. The latter was, however, a closer reflection of the way an artist works: toying with different ideas at different times rather than taking clearly defined, sequential steps. The Tate's wall labels encapsulated the contrasting approaches of the London and New York curators. Whereas MoMA's explanatory texts reinforced the exhibition's message, the Tate's merely offered reactions to the work from Pollock's contemporaries, thereby inviting viewers to draw their own conclusions.

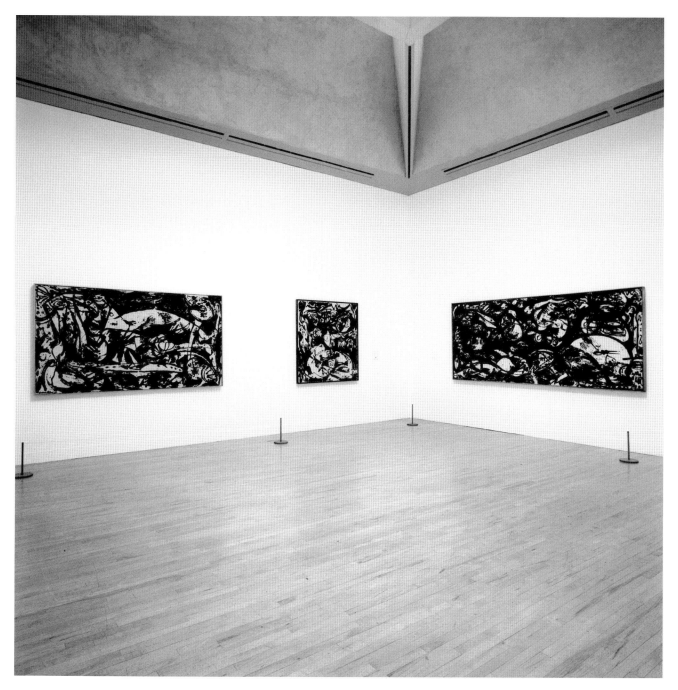

207. "Jackson Pollock," Tate Gallery (1999): *Number 14, 1951; Number 18, 1951; Number 11, 1951.*

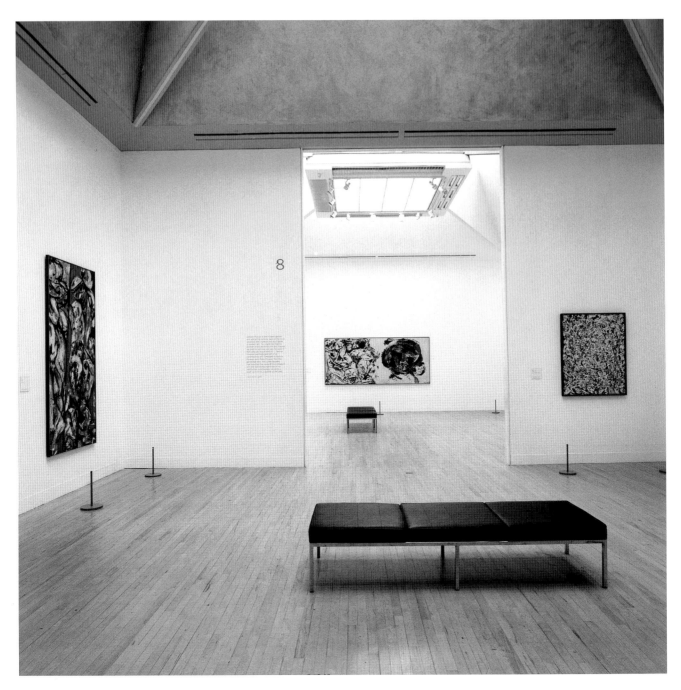

208. "Jackson Pollock," Tate Gallery (1999): *Ritual* (1953); *Portrait and a Dream* (1953); *White Light* (1954).

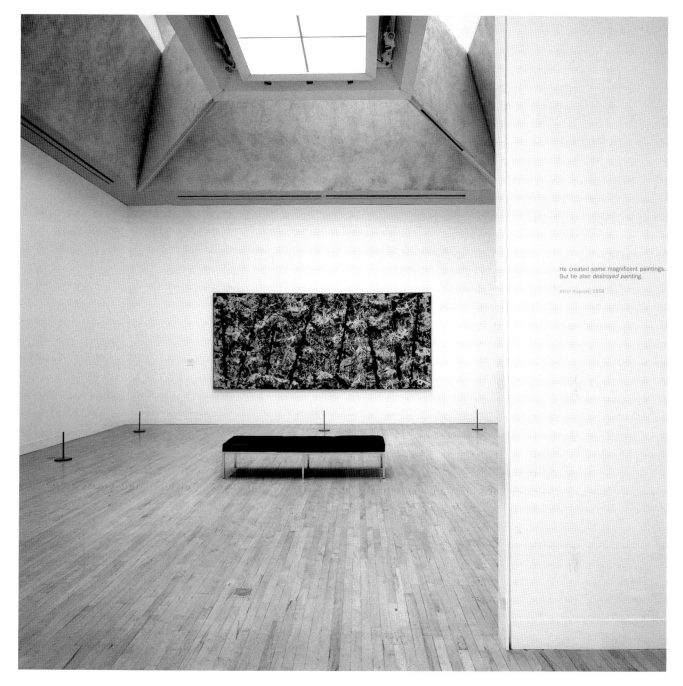

He created some magnificent paintings.
But he also *destroyed painting.*

Allan Kaprow, 1958

209. "Jackson Pollock," Tate Gallery (1999): *Blue Poles: Number 11, 1952.*

DIFFERENT IMAGES OF AN ARTIST

The ideal of the artist's studio as a model for installation was particularly relevant for Pollock: not only is there abundant evidence of the powerful impact produced by his paintings in the Springs barn, but the artist's contribution to arrangements at the Parsons Gallery and in the Heller residence echoed the barn's tight setting and close juxtaposition of differently proportioned canvases. The architectural projects designed by Blake and by Smith for Pollock's work likewise envisaged contained settings for the mural-size canvases.

In each case, viewing was encouraged from a distance of twenty feet or slightly less—the depth of Pollock's work space both in his Manhattan studio and at Springs. Seen in this context, a painting would convey the artist's vision of it as "energy and motion made visible." A viewer must be positioned this close to the canvas to apprehend the "force field" created by Pollock's rhythmic energy of line, the emotional factor of his color and shifting metallic reflections.

William Rubin stated, "The monumental Old Master picture expressed collective values" and "The [new] large American pictures [are] private and contemplative," reflecting his conviction that unlike the distance needed to appreciate public mural art of the past, intimacy was required for viewers of the new abstract mural art. Rubin even went so far as to call the presence of large, abstract paintings in museums—rather than in the apartments of owner-collectors—a cultural compromise, because vast institutional spaces discourage close-up scrutiny and their audience is a collectivity rather than a restricted few.[152] In many instances, today's enormous museum spaces make the viewing conditions desired by artists difficult to realize.

Pollock's preferences were taken into account for the Pollock Room inaugurated at MoMA in 1984. Throughout its several expansions, the museum has maintained the Modern vocabulary and (even in several levels of the 2004 expansion) residential scale of its initial architecture (1929). In these similar spaces, the differences between MoMA's three Pollock exhibitions are particularly revealing.

In 1956, MoMA's sampling of masterpieces presented a new kind of abstract art that appeared to have blazed full-blown from the artist's hand. By 1967, the more inclusive demands of a retrospective froze paintings in a didactic framework that subdued the explosive genius. The 1998 blockbuster museumified Pollock: a lengthy introduction to the great poured canvases classified them in an archival-like context, as did the neat compartmentalization of distinct phases of the production; post-1952 work was written off as inferior—a fulfillment of Greenberg's late-1960s judgment.[153] At the Tate, many of the same paintings that had been shown at MoMA told the altogether different story of an artist cut off at the height of his creativity.

Exhibitions can be primarily educational or aesthetic, either purpose necessarily including aspects of the other. The key curatorial decision—what an exhibition is supposed to convey to the public—determines a long line of subsequent decisions about how to present the art. In contrast to the single overriding idea of each of MoMA's three Pollock exhibitions—abstraction, drawing, and pouring—the Tate, like Frank O'Hara in his selection for MoMA's International Circulating Exhibitions Program, focused on the way the work looked; in both cases, the aim was subject to highly personal interpretations. A similar aesthetic influenced the Pompidou show.

No installation can completely re-create the vibrancy of an artist's workplace, the excitement of a commercial gallery's introduction of a new talent, or the thrill of living with art. But even with the compromises required by today's museum culture, each of the institutional exhibitions discussed here dazzled with boundless riches and intriguing new insights. The price exacted by their compromises and by departures from the artist's intentions was the loss of the paintings' full potential.

Placing Art

A friend remarked to me recently that "We dress for the season and for the event; what works for one doesn't necessarily work for the other. The same is true for art: paintings need their own dress."[1] This same point was made over a century ago by John Wanamaker, the department store owner (see pp. 30–31), but what looked good to him most probably would not to us. A review of how art has been displayed in various eras is a powerful reminder of how quickly styles change. Even judged by the apparently simple criterion of making an artwork look good, the aesthetics of placement are subject to the prejudices of the moment.

In the late 1970s, Richard Rogers and Renzo Piano, the architects of the Pompidou Center in Paris, described the new institution not as a museum but as a center of "information and entertainment."[2] Conversely, Alanna Heiss, a pioneer of alternative viewing spaces and currently director of MoMA's P.S. 1 in Long Island City, wants the museum gallery to "make you feel as if you're in the presence of God."[3] Upon completion of the Schaulager (viewing depot) in Basel, Switzerland, in 2003, Maja Oeri, president of the project's sponsoring Emmanuel Hoffmann Foundation, said her rule is "to exhibit with love."[4] It is precisely the coexistence of these different values that keeps objects alive, in the opinion of Christian Witt-Dörring, a curator at the Museum für Angewandte Kunst, known as MAK, in Vienna. He feels, "If we couldn't see the same objects differently at different times, they would die."[5]

It follows that installations attempting to convey a given idea as absolute will run into trouble, as in the case of overly didactic presentations that inhibit subjective reactions. The "Matisse-Picasso" exhibition, for example, seen at the Tate Modern in London in spring 2002 and subsequently at the Grand Palais in Paris and at MoMA Queens, juxtaposed the artists' work in ways that often diminished individual pieces in order to prove that the two painters influenced each other. In all three of its venues, the exhibition's overall purpose seemed to have been to suggest a competition between the two masters.

If the artist's studio has so often been taken as a model for exhibition spaces, it is in part because it is free of such absolutes. The artist/writer Patrick Ireland/Brian

210. Bank installation by Donald Judd (1989–90), Chinati Foundation, Marfa, Texas: Claes Oldenburg, maquette for *Monument to the Last Horse;* Judd, untitled painting (1961); Frank Lloyd Wright, stained-glass window for Martin House, Buffalo; seventeenth-century Russian refectory table; table (c. 1991) and chairs designed by Judd.

O'Doherty points out that art objects in the studio are "esthetically unstable; they have not yet determined their own value."[6] The studio's often messy evidence of the artistic process, with its sources of inspiration and remains of success and failure, is thus free of the conceptual baggage imposed by other contexts.

By the same token, when artists curate a show, they are almost invariably guided not by a didactic purpose but by a sensual and emotional response to the art. Shows organized by artists, such as MoMA's "Artist's Choice" exhibitions (begun in 1989) and the Boston Museum of Fine Arts's "Connections" series (begun in 1990), were primarily about the experience of looking and only secondarily about learning from that experience.

Throughout the twentieth century, artists have criticized conventional museum displays. Among these objections are Daniel Buren's essays about the energy lost by an art object when it leaves the studio[7] and the Minimalist Donald Judd's transformation of nearly an entire town for exhibition purposes. In Marfa, Texas, Judd's Chinati Foundation/La Fundación Chinati offers his own work and that of others in a lived environment (fig. 210).

The early years of the twenty-first century bring their own questions to discussions of the museum context. Art as entertainment is contested by many together with the related trend toward ever more spectacular museum architecture. While the latter suits some art, it does not suit all art, and in today's wide variety of museums there is often a lack of harmony between container and contents. The need to coordinate this relationship is all too often ignored—by those commissioning new museums, those renovating and/or expanding existing museums, and those in charge of museum programming.

The most basic aspects of art display—the length, texture, and color of walls, the choice of frames for paintings and pedestals for sculptures, how labeling is best handled, the space's scale, the quality of light, and how the works are placed in relation to each other—are the foundations for any permanent or temporary installation. There are no rules for placing art, but assessment of these elements of display in various museums suggests some basic guidelines.

WALL TEXTURE

The first installation at the Musée d'Orsay in Paris of Edouard Manet's *Olympia* (1863) exemplified the way a painting is affected by the texture of the wall behind it. The contrast between it and the previous installation was striking, as was *Olympia's* altered relationship to other paintings.

Olympia is no stranger to adversity. Remaining unsold until 1888, Manet's revolutionary depiction of a nude courtesan staring brazenly at viewers from a reclining position on her bed was acquired by the French government thanks solely to the efforts of Claude Monet, who raised a subscription for its purchase. But even as the property of the state, *Olympia* was first relegated to the secondary Musée du Luxembourg, to be given a place of honor in the Louvre only in 1907.[8]

From 1947 on, the painting was shown at the newly created Museum of Impressionist Painting in Paris (fig. 211). The museum was housed in a modest two-story structure known as the Jeu de Paume, named after the court tennis for which the former orangery was remodeled by Napoleon III. In 1947, the building, which had served as an exhibition hall since the beginning of the twentieth century, was turned over to the Louvre's Impressionist collections, for which it was divided into relatively small galleries. In one of these, *Olympia* enjoyed a privileged placement on a wall to herself at the far end of a rectangular room, a privilege that set her apart from the many other paintings on adjacent walls. The picture actually seemed to grow larger as a viewer moved down the long gallery toward it.[9]

In 1986, *Olympia* was moved to a new Paris museum, the Musée d'Orsay, which brought together artworks executed between 1848 and 1914 and owned by the French state. The Italian architect Gae Aulenti renovated an 1898 train station for the new facility, dividing the vast ground-level space with heavy masonry structures reminiscent of ancient Egypt. Between these partitions is a stunning, wide central hallway, the full height of the skylit structure, in which sculpture is exhibited.

Paintings are instead shown in small, low-ceilinged, enclosed spaces in the Egyptian-style constructions at either side of this nave. In one such room, from 1986 to 2004, *Olympia* shared a wall to the left of the entrance with other Manets (fig. 212). No hierarchical distinction was made between these paintings, all of which hung at the same height. Visitors confronted the work immediately, without the preparatory long view provided by the previous installation. In place of the Jeu de Paume's beige linen wall covering and parquet floors were pink stone-block walls and grayish stone floors.

The soft materials of the Jeu de Paume tempered the reflection of light, allowing the painting's colors to shine forth, while the new museum's hard surfaces reflected excessive overhead electric light onto the painting, dulling and flattening its colors. The older museum's fabric-covered walls provided an unobtrusive, homogeneous background;

211. Jeu de Paume, Paris (c. 1947–86): Edouard Manet, *Olympia* (1863).

at the Orsay, prominent masonry joints and unsightly hanging holes were distracting, and heavy ceiling beams broke up one side of the space. Even the Jeu de Paume's discreet door surrounds and kickboard contributed to a sense of intimacy that is missing at the Orsay, where, Brian O'Doherty comments, "The Manets look like an unmade bed; they look as if they were on their way somewhere."[10] Forced out of what was to a generation of viewers *Olympia*'s flattering "dress," the painting was suddenly thrust into something hideously unbecoming.

The Musée d'Orsay represents a major rethinking of the very idea of a museum. Rather than offering a conventional story of the nineteenth century, it is intended to present a historic context with all its contradictions.[11] The Orsay was conceived as a museum of all the arts, with painting, drawings and prints, sculpture, architecture, decorative and applied arts, photographs, and early film placed in close proximity. Official, academic art—albeit with fewer examples—is intermixed with and accorded the same importance as work of the Impressionists and other innovators of the time.

This approach creates a supreme irony in relation to Manet and the academic painter Thomas Couture. Not only was Couture Manet's teacher for six years, but

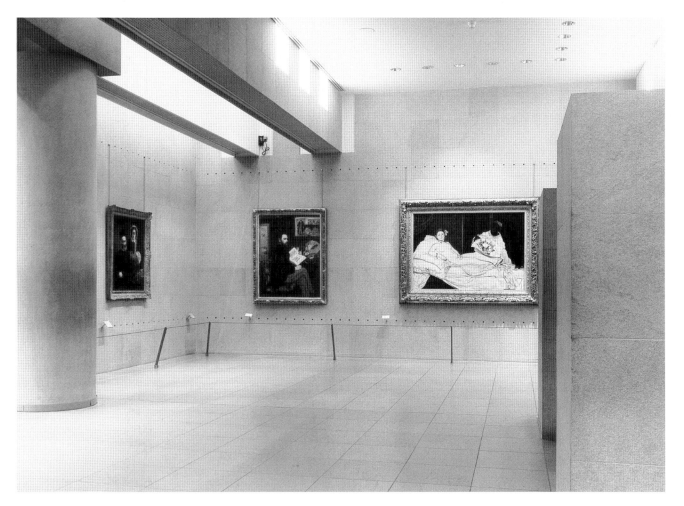

212. Musée d'Orsay, Paris (c. 1986): Edouard Manet, *Olympia* (1863).

Couture's model Victorine Meurent posed for *Olympia* (and for other works by Manet, including *Déjeuner sur l'Herbe*).[12] While Couture's conventional pictures were shown as a matter of course at the Salons, Manet had to struggle to gain admittance for his more daring submissions. When *Olympia* was finally accepted, at the Salon of 1865 in the Palais de l'Industrie (now replaced by the Grand Palais), such was the furor over what was considered the work's "vulgarity" that steps were taken to protect it from vandalism: the canvas was moved so high on the wall that the black cat at the lower right became almost invisible.[13] In a perverse echo of history, *Olympia*'s downgraded installation at the Orsay[14] was countered by the place of pride given to Couture's bombastic *Romans of the Decadence* (1847); the enormous picture reigns as the only painting in the museum's magnificent central hall of sculptures.

The Orsay's first director, Françoise Cachin, dismissed criticism of this arrangement by insisting that Couture's picture reads as part of the decor, its painted sculptures echoing those of the central aisle.[15] And a member of the director's founding team insisted that positioning the Couture—dismissed by many as an example of formulaic, or *pompier,* art—across the aisle from paintings by Courbet that had been rejected by

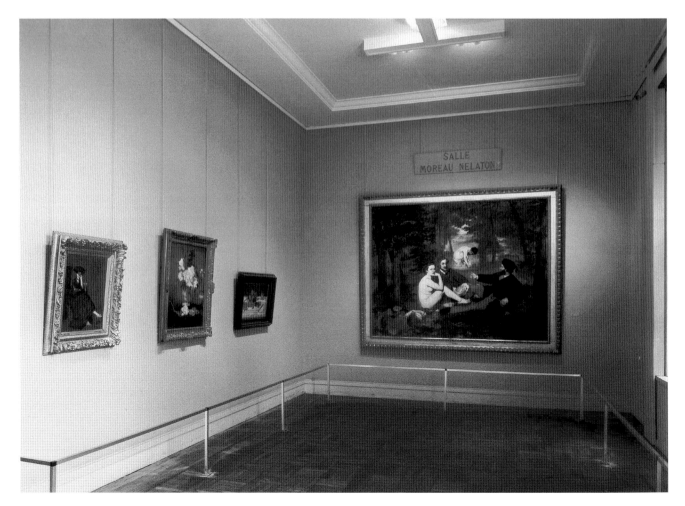

213. Jeu de Paume (c. 1947–86): Edouard Manet, *Déjeuner sur l'Herbe* (1863).

Salon juries called attention to contradictions the museum wanted to reveal.[16] But these explanations do not justify the way in which *Romans of the Decadence* is favored by a uniform pale beige plaster background while the Manet had to struggle against stone blocks. As Kirk Varnedoe said, "Orsay assassinates the richest part of French culture: it's the revenge of Bougereau."[17] The new director of the Orsay, Serge Lemoine, appointed in 2002, is reportedly rethinking many of the museum's installations[18]: by 2004, *Olympia* had recovered some of its former stature, placed alone on a red wood panel that masks the masonry wall.

Manet's *Déjeuner sur l'Herbe* (1863) fared slightly better, even though the painting, part of the Moreau-Nélation donation, was separated from the artist's other work. At the Jeu de Paume, this problem was solved by placing the *Déjeuner* with other Manets in a room adjacent to the rest of the donation (fig. 213). At the Orsay, the Impressionists of the Moreau-Nélation donation hung in a skylit top space two levels away from *Olympia* and additional Manets; there, the *Déjeuner* was shown alone on its own centrally placed panel, which was faced in pale ochre *stucco veneziano* (trowel-textured plaster replacing a background that was similar to the Couture's). The installation at least retained for the

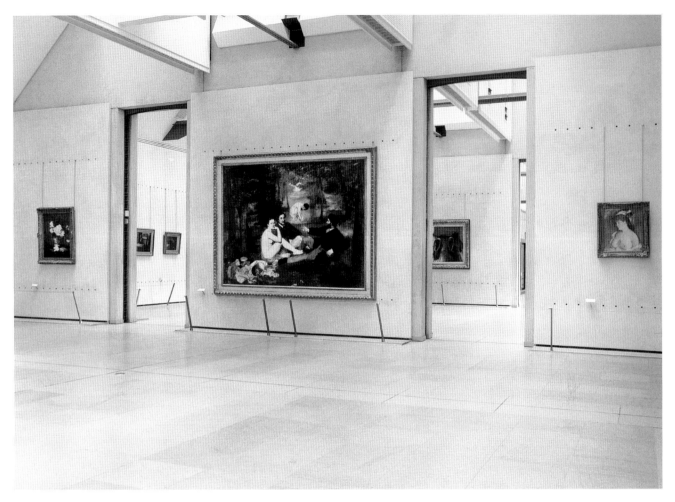

214. Musée d'Orsay (c. 1986): Edouard Manet, *Déjeuner sur l'Herbe* (1863).

Déjeuner the status that it, like *Olympia*, enjoyed at the Jeu de Paume (fig. 214). However, the stark overhead natural light—harsh even for Impressionist paintings that thrive on tempered daylight—was even harsher on Manet. The more subtle illumination of the older museum was a sad loss. Now the Moreau-Nélation donation is in ground-floor galleries, and the *Déjeuner* benefits from more evenly controlled light. Additionally, it is nearer *Olympia* and, like that work, hangs on a colored wood panel, in this case brownish green. The new placement of the *Déjeuner* is, however, less commanding than before.

In general, hard masonry surfaces provide a less sympathetic background for paintings than fabric-covered or plaster walls. The severe stone walls in churches and cathedrals—a common setting for Old Masters—were offset by lighting that was much gentler than the illumination of today's museums. John Walsh, director emeritus of the J. Paul Getty Museum in Brentwood, points out that in modern light conditions, stone heightens the dissonance between time-worn objects—the painting and its frame—and the walls on which they are displayed. Seen against fabric or plaster, colors appear brighter; fabric has the added advantage of dampening sound.[19] Walsh makes a further distinction between the homogeneous pigmentation of walls painted in matte vinyl latex

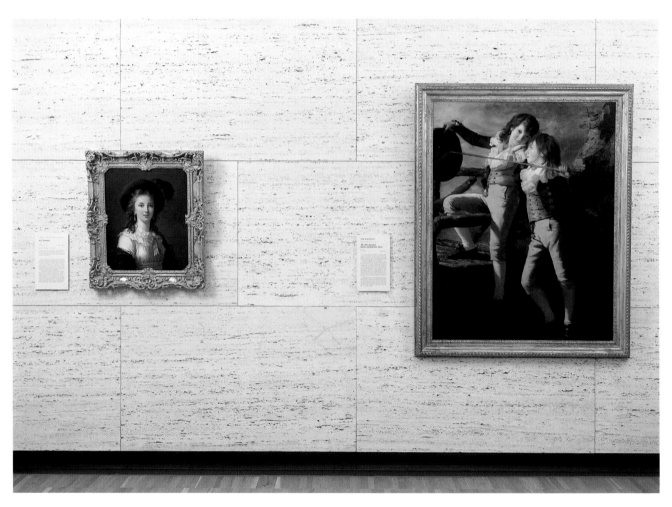

215. Kimbell Art Museum, Fort Worth (2004): Elizabeth Vigée-Lebrun, *Self-Portrait* (c. 1781); Henry Raeburn, *The Allen Brothers* (early 1790s).

applied with a roller and the texture of costlier stippled or glazed walls, which have a more desirable translucent quality.

In this respect, even Louis Kahn's famous Kimbell Art Museum in Fort Worth, Texas (1966–72), is less than perfect. There is no question as to the consummate beauty of the building's space, with its extraordinary control of natural light, and the harmony of its materials—structural concrete with white oak and travertine for walls, paneling, and floors. Each gallery is defined by segmental concrete vaults that split at the top; light is reflected from metal diffusers in the openings and bounces off the underside of the vault, gently illuminating the painting and sculpture displayed below. The system registers an awareness of passing clouds and other meteorological changes, a refreshing alternative to the current tendency in museums—for instance, the nearby Modern Art Museum of Fort Worth by the Japanese architect Tadao Ando—to homogenize daylight.

The Kimbell's stone walls pose a problem, however, for paintings characterized by fragile forms and colors, such as eighteenth-century French works. Compare, for example, Elizabeth Vigée-Lebrun's *Self-Portrait* (c. 1781) at the Kimbell, seen against a stone background, and a group of eighteenth-century French paintings at the Wallace Collection

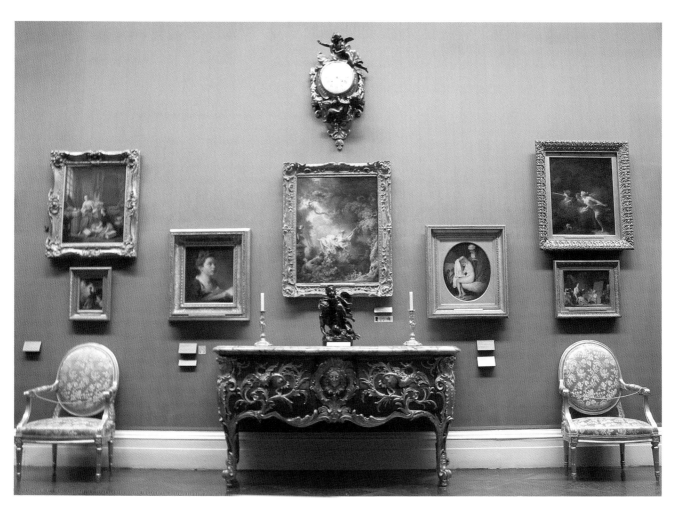

216. Wallace Collection, London (2004): Jean-Honoré Fragonard, *The Swing* (c. 1767), at center, with Fragonard, *A Young Scholar* (c. 1773–76), at left, and Jean-Antoine Watteau, *La Toilette* (c. 1716–17), at right; furnishings of the same period.

in London (figs. 215, 216). Olive-green fabric at the latter institution provides a soft texture that complements the delicacy of the art. (The curators plan to further refine the presentation by substituting a pastel fabric more in keeping with wall coverings of the period.)[20] Furthermore, the two installations exemplify the difference between a traditional museum and a home museum. At the Wallace, below the three central paintings stands a bombé chest on which are two candlesticks and a small bronze, Jean-Jacques Caffieri's *Cupid Banishing Pan;* above the paintings hangs a gilt bronze clock. All of the same period, furnishings and art share the same ornate vocabulary, thus conjuring up a holistic vision of this moment in time. To purists who object to such arrangements, because the furniture impedes close examination of the paintings, I would reply that this is the manner in which the paintings were seen originally.

Like Kahn, the Swiss architect Peter Zumthor is a master of light. At the Kunsthaus in Bregenz, Austria (1997), natural and artificial light are combined both by the structure of the building—a light box is inserted between each of its exhibition levels—and by a series of ceiling filters. The result is a diffused illumination that would be perfect for paintings—except that the raw concrete walls of the Kunsthaus absorb light and the

gray terrazzo floors reflect it (fig. 217). The building works well for media other than oil on canvas: James Turrell's light sculpture, exhibited at the Kunsthaus's inauguration, is a good example.

Possibly the most ill-considered material to be used as a background for art in recent memory is the Cor-Ten steel of the Guggenheim/Hermitage in Las Vegas (opened in 2001 and scheduled to close in 2005). This small museum (7,660 square feet), to one side of the entrance to the Venetian Hotel on the Strip, was designed by the Dutch architect Rem Koolhaas to show masterworks from the New York Guggenheim and the St. Petersburg Hermitage. The architect's exceptional skill with building materials, evident in many of his other structures, makes his choice of Cor-Ten for the walls and for the thick movable panels that divide the space into four galleries all the more surprising.

The steel panels hover slightly above blond wood floors and stop short of the ceiling, giving the walls a sense of weightlessness. Capped by the folded planes of a maple ceiling, the space fits Koolhaas's description of it as "a jewel box"[21] (fig. 218).

An architectural "jewel box" perhaps, but not a jewel box for art. In "Masterpieces and Master Collectors," the Guggenheim/Hermitage's inaugural exhibition of forty-five late-nineteenth- and early-twentieth-century paintings, every work was intersected by a prominent expansion joint or seam. The interference of these lines—even more disturbing than masonry joints—was secondary, however, to the distraction of the leathery brown walls themselves. As the sculptor Richard Serra has amply demonstrated, rolled industrial Cor-Ten steel plate is a beautiful material in its own right: when rusted, the metal's surface assumes a sensual quality, with hues in amorphous shapes and tonal variations reminiscent of abstract painting. Koolhaas hoped that the velvety look of the waxed, rusted-steel walls would replicate, in a modern idiom, the richly colored textiles against which paintings are seen at the Hermitage, but it simply did not work.[22] In addition to the distraction of its varied surface, the steel soaked up light. What at first appears to be deficient illumination is in fact caused by the nature of the wall.

Paintings were affixed to the metal by means of powerful steel magnets. A tremendous amount of time and expense went into extensive conservation research to determine that the magnets posed no potential hazard to the artworks.[23] The paintings would have looked infinitely better in a less overbearing presentation.

The Guggenheim/Hermitage in Las Vegas was inspired by the Bellagio Gallery of Fine Art, inaugurated in 1998 by Steve Wynn, then the owner of the Italian Renaissance–style resort hotel. When Thomas Krens, the director of the Guggenheim Museum in New York, learned that in the Bellagio's first eight months half a million people had paid twelve dollars apiece to see the fifty Impressionist and contemporary paintings exhibited there, he decided he could do the same, but better.[24] Both ventures were unusual in offering high art to a public lured primarily by the prospect of gambling and popular entertainment. Krens described the situation in terms of a religious conversion: "If you're in the missionary business, you go where the heathens are. This is what we did in Las Vegas."[25]

217. Per Kirkeby exhibition, Kunsthaus, Bregenz, Austria (1997).

218. "Masterpieces and Master Collectors," Guggenheim/Hermitage Museum, Las Vegas (2001).

Wynn's installation was as funky as Las Vegas itself (fig. 219). In a dark, two-thousand-square-foot space, the paintings were dramatically spotlit against walls covered in black velvet. Bright patterned carpeting matched the garishness of the casino and hotel just beyond the gallery doors, recalling that environment within Wynn's display. The setting appears as High Kitsch. Still, perhaps partly thanks to Julian Schnabel's use of black velvet as a background in several of his paintings, it is possible to accept the wall material; walls and carpeting could be considered part of a harmonious ensemble.

Instead of embracing Las Vegas as Wynn did, Koolhaas excluded it. His exquisitely elegant space is a veritable stronghold against kitsch, insulating the genuine masterpieces from the strip's make-believe. Krens described the Guggenheim/Hermitage as "an undecorated box of classic proportions within the complete inauthenticity of Las Vegas." Since the gallery/museum is in a hotel where escalators whisk visitors upstairs to Venetian-style canals, complete with gondolas and piped-in renditions of "O Sole Mio," it is hard to fault the architect in his bid for authenticity. Unfortunately, in achieving his architectural goal, he sacrificed the art.

219. Bellagio Gallery of Fine Art, Las Vegas (1998): Pablo Picasso, *Portrait of Dora Maar* (1942) and *Seated Woman* (1949).

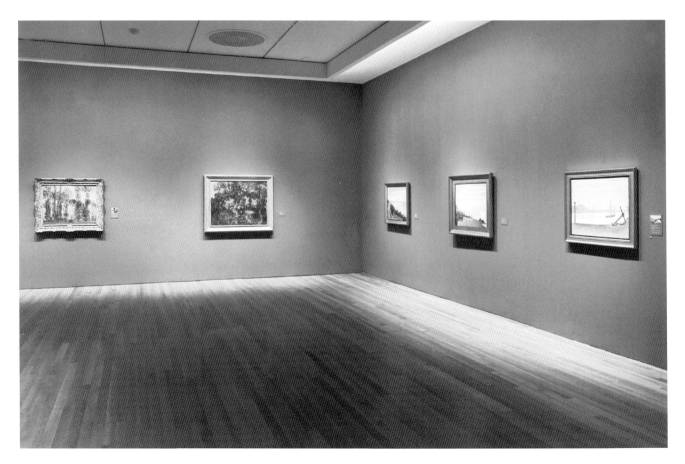

220. "Modern Starts: Changing Visions: French Landscape, 1880–1920," Museum of Modern Art, New York (1999–2000).

WALL COLOR, FRAMES, LABELS

At the end of 1999 and throughout the millennial year, MoMA installed three cycles of exhibitions—"MoMA 2000"—that temporarily revised the placement of its holdings as radically as the Musée d'Orsay's initial permanent installation had for those of the French state.[26] In the first cycle, "ModernStarts," "Changing Visions: French Landscape, 1880–1920" was one of several exhibitions for which the museum introduced strong wall colors instead of its signature "white cube" galleries[27] (fig. 220).

A number of MoMA's most luscious paintings—by Monet, Cézanne, Van Gogh, and Picasso, among others—were hung on colored walls, as were those of the Impressionists and Post-Impressionists. Dark colors were modeled after art dealers' galleries and collectors' homes at the turn of the twentieth century. Against muted chocolate brown, gray, and deep green, the extraordinary hues favored by these *plein air* painters were more intense than when viewed on white walls, which, because of their greater brightness, lessen color values.[28]

In a further departure from their usual display, the curator Magdalena Dabrowski replaced the paintings' modern strip frames with traditional gold surrounds more like their original frames. Instead of outlining the pictures within flat strips, the high profile of the older type of frame created a *repoussoir* effect that gave the pictures added depth.

The *plein air* painters were known for moving their easels outdoors to depict specific familiar scenes, and most wall labels included reproductions of vintage photographs of those scenes. The practice of supplementing painting exhibitions with photographs began as early as 1904, when, for the Salon d'Automne, Cézanne's dealer Ambroise Vollard included twenty-seven photographs of the artist's canvases, thereby doubling the number of works on display.[29] Alfred Barr continued the practice at MoMA in the 1930s and 1940s, occasionally including in his captions photographs of works related to the ones on exhibition.[30]

Many of these same devices were used to make an exhibition more intelligible by Gary Tinterow, curator of "Manet/Velázquez: The French Taste for Spanish Painting" (2003) at the Metropolitan Museum. The exhibition originated at the Musée d'Orsay, and despite some significant differences in the selection of paintings at the two venues— some alternative Manets in New York as well as more Spanish paintings, and a gallery of nineteenth-century American artists also affected by Iberian art—the point of the exhibition at both museums was to demonstrate why French artists such as Corot, Courbet, Manet, Degas, and Renoir chose to replace Raphael's idealism with the realism of Velázquez, thereby paving the way for Modernism. Thanks to its distinctive installation, the Metropolitan conveyed this idea much more clearly than did the Orsay.

The influence of Spain can be traced to two exhibitions of Spanish Baroque art at the Louvre in the first half of the nineteenth century. The Spanish school was practically

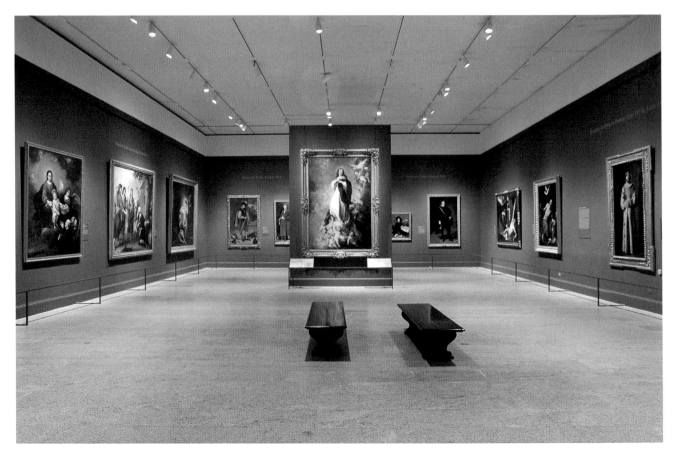

221. "Manet/Velázquez: The French Taste for Spanish Painting," Metropolitan Museum of Art, New York (2003): "Spanish Painting in France in the Eighteenth–Nineteenth Centuries."

unknown in France until the first show, from July 1814 to September 1815, of art plundered by Napoleon during his Iberian campaigns (and restituted after his demise). Upon becoming king of France in 1830, Louis-Philippe took advantage of political unrest in Spain to purchase paintings there, creating a collection whose display from 1838 to 1849 returned to the Parisian public the kind of Spanish art that had briefly tantalized it a quarter of a century earlier. (Upon Louis-Philippe's death in 1850, the collection was returned to the king's heirs.) Manet (1832–83) was too young to have seen either exhibition, but so great was their influence on French art that he was prompted to visit Madrid in 1865, a trip that proved inspirational.[31]

To underscore the important role of the two historic shows, Tinterow arranged the Metropolitan's galleries to suggest how French artists saw the displays at the time. First, an immense gallery with ruby-red walls was titled "Spanish Painting in France in the Eighteenth–Nineteenth Centuries" (fig. 221). Two galleries later, another equally spacious hall, this one painted emerald green and labeled "Galerie Espagnole at the Louvre," referred to the later exhibition (fig. 222). Both included works that had actually appeared in the Louvre exhibitions.

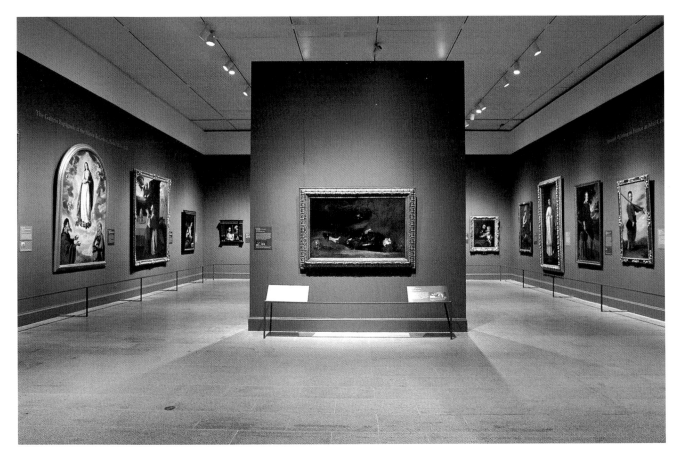

222. "Manet/Velázquez: The French Taste for Spanish Painting," Metropolitan Museum (2003): "Galerie Espagnole at the Louvre."

At the Musée d'Orsay, without the distinct division of spaces, color coding, and prominent titling adopted by the Metropolitan, the complex political, historical, and aesthetic influences on nineteenth-century French artists were more difficult to grasp. In the Orsay's awkward, mostly low-ceilinged, temporary exhibition galleries (in the train station's former buffet), the paintings were hung in spaces that flowed into one another; no visual guidelines indicated what was seen in the earlier and later nineteenth-century exhibitions (figs. 223, 224).

Geneviève Lacambre, the exhibition's French curator, opted for a subdued background in deference to the religious nature of the older works, many of them painted for churches. And indeed, in Paris, against uniformly putty-gray partitions, the Spanish paintings appeared darker, their religious nature emphasized.[32]

At the Metropolitan, photographs included in the wall labels helped viewers to understand particular points, as they had for MoMA's "French Landscape." (In Paris, few photographs were included.) Many of the labels for Spanish art included images of nineteenth-century French paintings that facilitated comparisons. Tinted the same color as the walls, and in some cases mounted on both sides of the work to

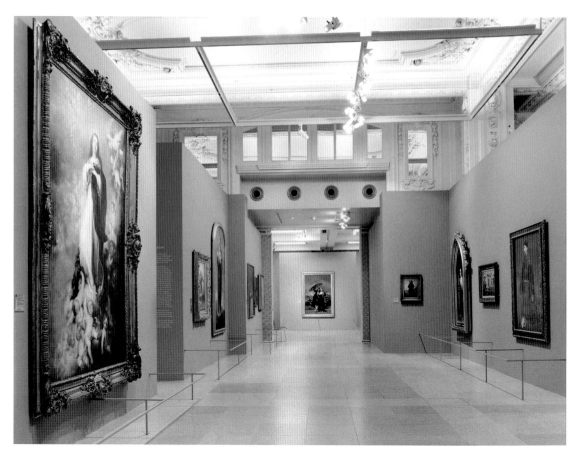

223. "Manet/Velázquez: The French Taste for Spanish Painting," Musée d'Orsay (2002–3).

accommodate viewers, the Met's labels were relatively unobtrusive.

The Metropolitan's installation flattered the paintings, and was easier to understand than the display in Paris. It facilitated appreciation of the relationship between different schools and conveyed a clear idea of how the later works came about.

Although labels are essential to a thematic exhibition like "Manet/Velázquez," there is a growing trend toward eliminating them altogether. Bernice Rose, a former senior curator at MoMA, says, "Curators hate the moment of installation when labels go on the walls. They're ugly, but people need them, and they complain when the labels are not big enough to read."[33]

The English writer and critic William Feaver banned labels from the Lucian Freud retrospective that he organized and installed at the Tate Britain (2002). He concedes, "Labels are okay for a permanent collection, but they're not on art in homes, and it's not from information that you get to know a painting"[34] (fig. 225).

The Dia Art Foundation is one of several institutions that espouse the idea of an unmediated one-on-one experience of art. Objects at the Dia's most recent museum in Beacon, New York—seventy miles north of Manhattan—like those in the foundation's

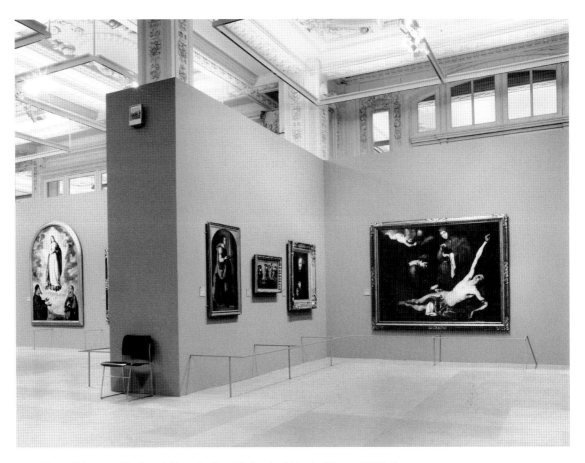

224. "Manet/Velázquez: The French Taste for Spanish Painting," Musée d'Orsay (2002–3).

other exhibition spaces, are identified on laminated information sheets available at the entrance to each gallery, a strategy that has been adopted by a number of institutions. Because the serene aura of the Minimalist work exhibited at Dia:Beacon is particularly susceptible to distractions, being able to view it without visual intrusions such as wall labels is a special treat, as in the case of Robert Ryman's *Vector* series (fig. 226).

Labels are also banned from the broadly eclectic collection of archaeological, tribal, Modern, and contemporary art exhibited at the Museum Insel Hombroich near Düsseldorf, Germany, opened in 1987 (fig. 227). The museum's founder, the real-estate developer and collector Karl-Heinrich Müller, wanted to create "a living place for artists to interact without any bureaucracy." To accomplish this, he asked an artist, Erwin Heerich, to design a series of pavilions, which were installed with the help of other artists. Labels and Acoustiguides are excluded, because Müller wants visitors to remember the objects rather than their explanations.[35]

Eliminating wall labels can be liberating, encouraging a more personal, and often more sensual, viewing. For example, many small paintings in galleries installed between 1731 and 1734, as well as the landscapes by Gaspard Dughet in the so-called Poussin

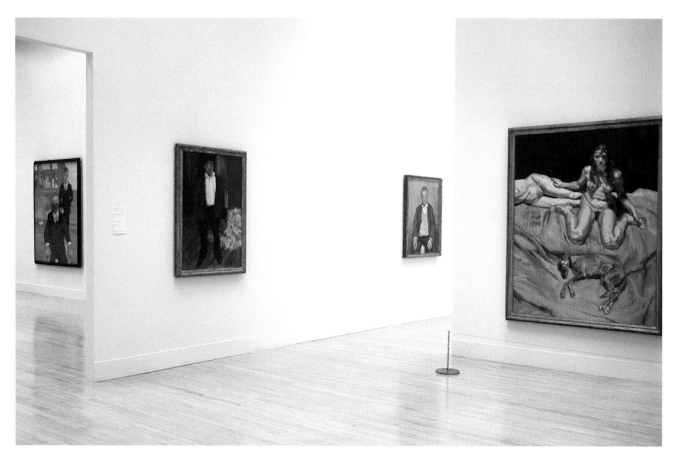

225. "Lucian Freud," Tate Britain, London (2002).

Room, at the Galleria Doria Pamphili in Rome are still seen without labels, as they were before the palace became a museum (see fig. 35). But this is not a practice espoused by the education departments in most major museums.

Sometimes labels are as big as the works they describe, as in the case of a charming little Watteau at the Kimbell in Fort Worth, which was recently upstaged by its explanation (fig. 228). For temporary exhibitions, labels are typically used to chop the catalog into bite-size snippets that reduce the objects to text illustrations. And labeling can be carried to absurd extremes: for the Tate Modern's inaugural exhibitions, there was a general introductory text for each room and a text for each work plus an additional text for some works by a prominent cultural figure (not to mention the Acoustiguide's explanations).

226. Dia:Beacon, New York (2003): Robert Ryman, *Vector* series (1975–97).

227. Orangerie, Museum Insel Hombroich, near Düsseldorf (1987): Khmer heads.

228. Kimbell Art Museum (2003): Jean-Antoine Watteau, *Heureux age! Age d'or* (1716–20).

WALL LENGTH

In addition to its material and color, a wall's length plays an important role in determining how an artwork on it is perceived. The fortunes of one of MoMA's most famous paintings, Picasso's monumental *Demoiselles d'Avignon* (1907), offers an example. Shown on an excessively long wall in "Composing with the Figure" (part of "ModernStarts"), the impact of *Demoiselles* was greatly reduced.

The picture is one of MoMA's signature canvases, and its display has changed over time. Picasso's first title for the work was *The Avignon Brothel,* and even if the subject no longer surprises, the nude figures' hostile angularity, the grotesque masklike faces, and the provocatively widespread legs of one retain their original shock value.[36] Since its acquisition by MoMA in 1939, the painting has been displayed prominently, usually alone and tightly contained by a short wall. In 1984, when MoMA reopened after a lengthy expansion and reinstallation, William Rubin had moved *Demoiselles* to a freestanding wall panel at the center of a gallery (fig. 229). While the new central placement retained—even emphasized—the Picasso's prominence, the surrounding installation detracted from its effectiveness. Just before *Demoiselles,* and partially obstructing it, was a lateral wall panel with Picasso's more traditional *Boy Leading a Horse* (1905–6); the pairing was obviously meant to illustrate the artist's stylistic leap in just one year. At either side of the space beyond *Demoiselles* were the collection's first Cubist paintings, which the Picasso appeared to introduce. Thus a great painting was reduced to a lesson in art history.[37]

When Kirk Varnedoe took over the Department of Painting and Sculpture, he reestablished the painting's full impact. To accommodate what appeared to him as the folding out of the picture's flat planes, he provided the wider embrace of a solid wall instead of the freestanding panel. But even more important was his choice of paintings to hang near *Demoiselles*. Instead of making Picasso's picture an introduction to Cubism, he positioned it across from André Derain's expressionistic *Bathers* (1907), suggesting an explosive exclamation point of different styles heading in many directions at once[38] (fig. 230).

Despite their differences, both Rubin's and Varnedoe's installations reinforced an image of *Demoiselles* as what Picasso's biographer John Richardson calls "the greatest icon of the Modern movement."[39] This prominence was undone in a section of "ModernStarts." John Elderfield, named MoMA's chief curator of painting and sculpture in 2003, originally intended the painting to dominate the show's initial gallery, along with two other monumental figural compositions, Francis Picabia's *I See Again in Memory My Dear Udnie* (1914) and Henri Matisse's *Piano Lesson* (1916).[40] When these three canvases were deemed too big for that space, they were moved to a long wall in the second gallery: on one side of the Picasso was *Piano Lesson,* on the other *I See Again*

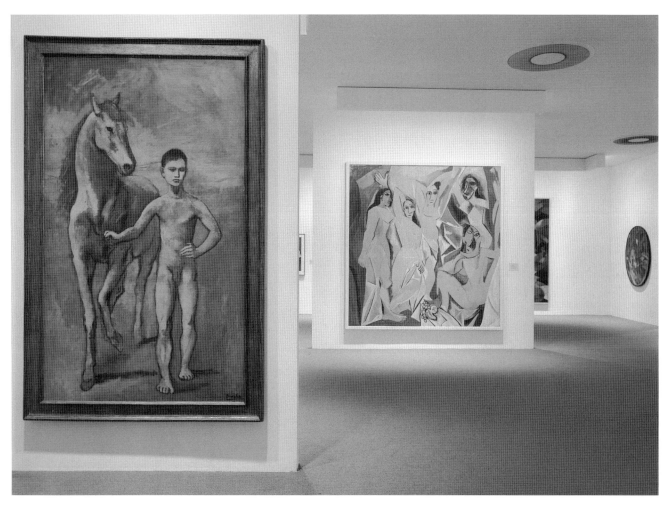

229. MoMA (c. 1984): Picasso, *Boy Leading a Horse* (1905–6) and *Les Demoiselles d'Avignon* (1907).

230. MoMA (c. 1993): Picasso, *Les Demoiselles d'Avignon* (1907); André Derain, *Bathers* (1907).

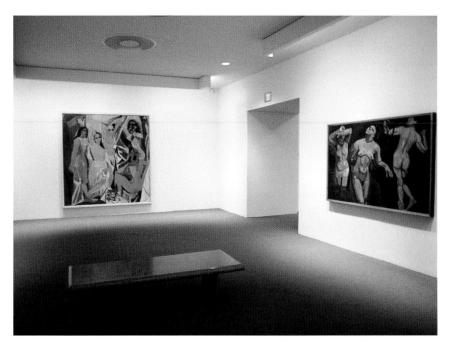

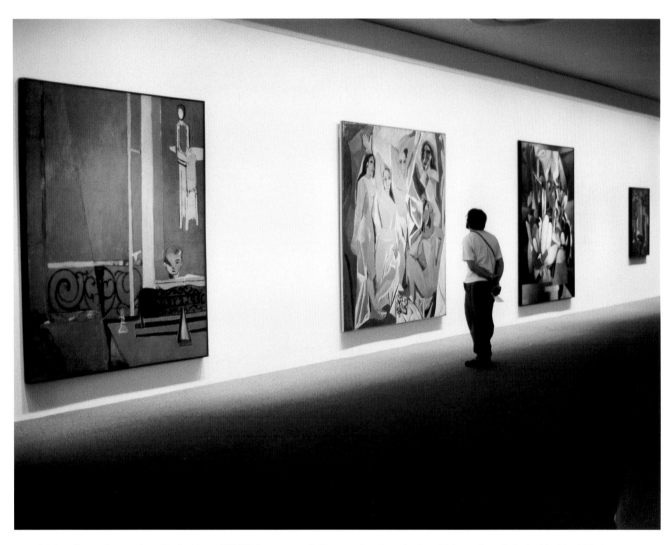

231. "ModernStarts: Composing with the Figure," MoMA (1999–2000): Picasso, *Les Demoiselles d'Avignon* (1907), flanked by Henri Matisse, *Piano Lesson* (1916), at left, and Francis Picabia, *I See Again in Memory My Dear Udnie* (1914), at right.

in Memory My Dear Udnie. Fernand Léger's equally large *Three Women* (1921) was added, together with two smaller canvases, and several sculptures were scattered at either end of the wall (fig. 231).

Elderfield says that this long, relatively narrow gallery was inspired by the intermissions promenade at Charles Garnier's Paris Opéra, a puzzling choice for a space that was supposed to accommodate stationary viewers rather than people promenading at the opera.[41] In addition, the string of six canvases was one of the many millennium presentations criticized by Frank Stella, who says, "A cardinal rule of picture hanging is that three in a row is a loser, because you can't read three in a row, whereas pairs usually work."[42] (Philip Johnson goes even further, preferring one picture per wall.)[43] Stella was without question justified in describing the long row of paintings and nearby sculptures as "a terrible installation: like Swiss cheese with only the holes."

Long walls in contemporary buildings are usually difficult to hang. In contrast to the rich articulation of surfaces in older structures—the Louvre's Grande Galerie comes to mind—Modern architecture is unadorned. At the Louvre, window alcoves, columns, pilasters, and decorative moldings relieve the walls' enormous expanse (fig. 232). The need for such articulation was acknowledged early in the museum's history: in 1799,

232. Grande Galerie, Louvre, Paris (2004).

high marble columns and stelae to support busts were added to the Grande Galerie to relieve its monotony.[44] Without this kind of framework, objects displayed on excessively long walls often appear lost in space.

At the Pulitzer Foundation for the Arts in St. Louis, Missouri, designed by Tadao Ando, the proportions and natural illumination of the elegant main gallery define architecture at its best—but its long wall presents a challenge. A monumental stairway interrupts the 170-foot-long wall at one end, reducing the hanging area by about a third (fig. 233). What remains is still difficult to fill satisfactorily. Twenty-four and a half feet in width and height, the main gallery is much larger than the museum's other two exhibition spaces; but the latter, while they are easier to install, do not enjoy the extraordinary plays of daylight for which the architect is justly famous. In St. Louis, it was the artist Ellsworth Kelly who mastered the exacting space with an installation of his own work (fig. 234). Kelly chose squarish, similarly scaled paintings, avoiding large horizontal rectangles that would mirror the shape of the long wall. He also broke the wall's rectilinearity by grouping the works instead of spacing them at regular intervals.

When Josef Paul Kleihues's skylit addition to the Hamburger Bahnhof Museum für Gegenwart in Berlin was unveiled in 1996, the long walls (263 feet) proved extremely problematic (fig. 235). A former railroad station built in the nineteenth and early twentieth century, the Hamburger Bahnhof had, since its 1988 renovation, provided plausible galleries for exhibiting the extensive contemporary art collection of Eric Marx. But the new wing was a study in installation problems: two dauntingly long walls defined an excessively high and relatively narrow forty-six-foot-wide space. On these vast planes, large works appeared more like a series of billboards in a desolate landscape than art in a museum gallery. As at MoMA's "ModernStarts," paintings were presented in what amounted to an overscaled corridor; both of these lengthy spaces encourage movement through them instead of creating a sense of place for pause and reflection.

233. Inaugural exhibition, Pulitzer Foundation, St. Louis (2002): Richard Serra, *St. Louis III* (1982); Philip Guston, *Edge* (1976); Roy Lichtenstein, *Sleeping Muse* (1983); Andy Warhol, *Mao* (c. 1973), Roy Lichtenstein, *Temple of Apollo* (1964); Andy Warhol, *Self-Portrait* (1967).

234. "Selected Works by Ellsworth Kelly from St. Louis Collections," Pulitzer Foundation (2003): *Chartres, Yellow Panel with Curve* (1992); *Untitled* (1987); *Dark Gray, White, Gray* (1980); *Black, Yellow Orange* (1970).

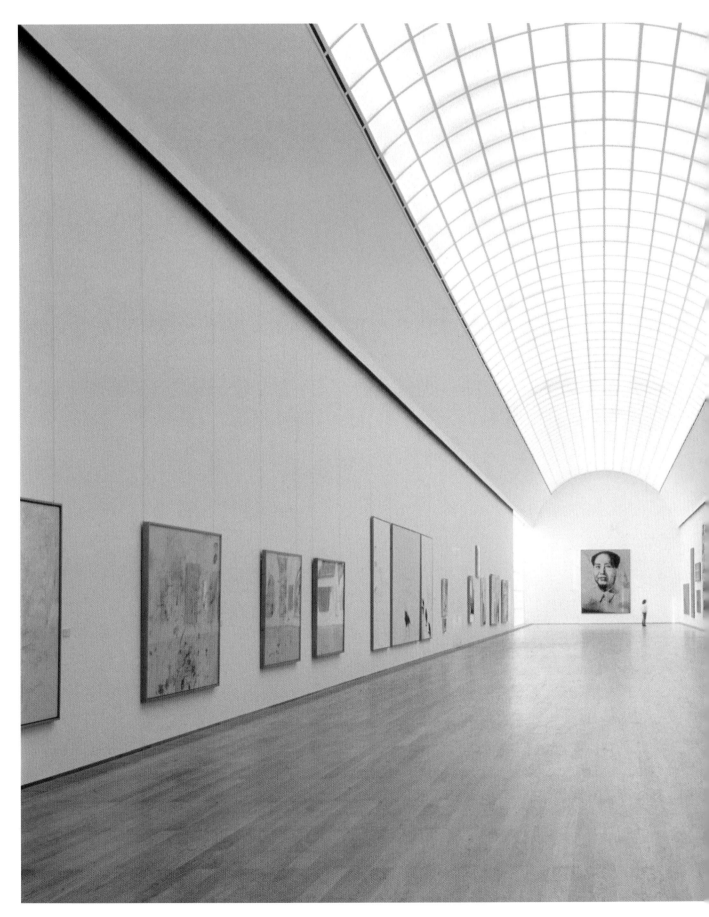

235. Hamburger Bahnhof Museum für Gegenwart, Berlin (c. 2003).

SCALE

As so many installations of Jackson Pollock's mural-size paintings demonstrate, wall height, like wall length, has a powerful effect on the work. The wall on which Pollock's *Mural* hangs at the University of Iowa's Museum of Art is an egregious example of this disparity of scale (see fig. 151).

The relative scale of art and the space in which it is seen is one of the most acute problems in displaying art today. The proliferation of large artworks since the late 1940s has spawned the misguided notion that bigger exhibition spaces are better. In older museums such as the Kunsthistorisches Museum in Vienna, richly articulated architecture gives large galleries a human scale and provides a context for their contents; comparable spaces in a great many new museums and commercial galleries consist of enormous, bare white boxes that often overwhelm the art. The effect is similar to what would take place if chamber music were performed in a rock concert arena. By the same token, cramming oversized paintings into spaces designed for much smaller work, as is routinely the case at the New York Guggenheim, is like hearing rock in a chamber hall.

This one-size-fits-all approach shortchanges not only many artists producing small and even medium work—the subtle wall hangings of Richard Tuttle and the delicate portraits of Elizabeth Peyton, for instance—but those producing large work as well. Harald Szeemann, an independent curator known, among other things, for his stewardship of Documenta in Kassel (1972) and of the Venice Biennale (1999, 2001), states flatly, "Art cannot survive in huge buildings."[45]

Ancient Greece provided a compelling lesson in scale that, remarkably, can be experienced today. In 1931, an exact replica of the Parthenon was erected in Nashville, Tennessee. In 1990, the city added a painstaking re-creation of the monumental chryselephantine statue of Athena Parthenos (Virgin) that originally stood in the temple cella[46] (fig. 236).

The original thirty-eight-foot-tall gold-and-ivory representation of the goddess by Phidias, completed about 437 B.C., was a fitting tribute to the patron deity of the Athenian state. Worshipped as a symbol of patriotism, religion, wisdom, and wealth, the statue achieved wide renown and was copied for centuries, in smaller versions and on coins, jewelry, and seals; it is thanks to these reinterpretations, as well as ancient texts, that the lost sculpture is known to us.[47]

The colossus was placed not in the middle of the temple interior but close to the front, where it was tightly framed by a colonnade that *reduced* the space the statue occupied. In Nashville, at forty-one feet ten inches, the statue comes within a foot of the ceiling beams. Like the original, it is surrounded by a colonnade. And for the six-foot-four-inch replica of the Nike statue held in Athena's right hand, the upper tier of the

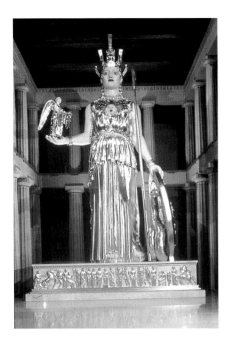

236. Alan LeQuire, *Athena Parthenos* reproduction (1990), Nashville.

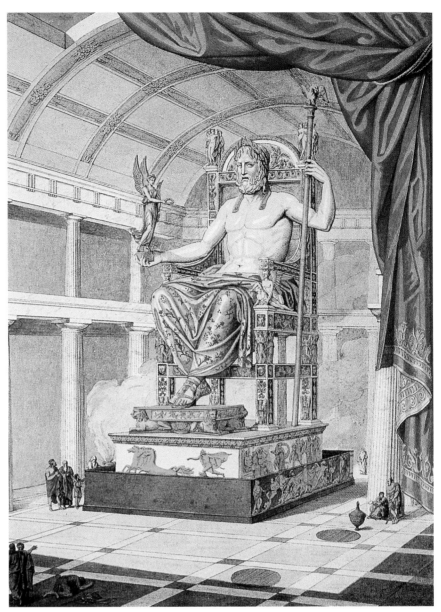

237. Quatrèmere de Quincy, *Temple of Zeus, Olympia* (1815).

colonnade's two levels provides a frame within this frame: when observed straight on, the Nike's feet are at the level of the architrave of the columns' first order. The *Zeus* completed by Phidias shortly after the *Athena* must have appeared even more constricted within its temple at Olympia, owing to the narrower naos in which it was placed and its seated position[48] (fig. 237). For Roman commentators of the second century B.C., this statue in particular raised admiration of art to the level of religious experience, so powerful was its effect.[49]

Cult activities (among them sacrifices and other offerings, accompanied by prayer) were not necessarily among the tremendously diverse uses of various ancient Greek temples; only the idea that prayers were especially effective when said in front of a statue in a temple provided a reason for entering the building.[50] Therefore, although entrance to the temple was probably limited to a privileged few, it may have been more usual for the public to see the statues from the exterior through the temple's entrance portal. When the *Athena* replica in Nashville was seen this way, one observer reported, "The statue seemed to jump out through the open doors; it was truly awesome."[51] Unfortunately, the temple re-creation is compromised by the flatness of the surrounding landscape.

The *Athena Parthenos* was celebrated as a miracle because of the precious, gleaming materials from which it was made and its skillful carving as well as its unusual size. Despite obvious differences, the contemporary abstract sculptures of Richard Serra share some of these characteristics with the classic figurative statue. Serra's *Torqued Ellipses* (1996–2001) are acclaimed for their unusual industrial material, the heroic means of their fabrication, and their scale.

The materials of both the classic and the contemporary sculptures undergo transformations in the aging process. The *Athena's* ivory was regularly rubbed with tinted, and possibly even perfumed, waxes to enhance her coloration and sheen;[52] oxidation, and in some cases oiling, of the Cor-Ten steel of the *Ellipses* produces shades of velvety orange-brown in a variety of configurations. And to an even greater degree than the *Athena,* whose scale is immediately conveyed by features such as her enormous feet, the *Torqued Ellipses* need to be framed by a defined space.

In order to experience the forms, material, and tricks of light in Serra's work, the viewer must enter the sculpture through a slit in its wall and follow its disorienting maze. These behemoths, at forty tons each, with walls that rise as high as thirteen feet, transcend traditional Modern sculpture, becoming something more akin to architecture. Indeed, Serra has said that the pieces are predicated not so much on sight as on the body's movement through them—the definition of the *promenade architecturale* essential to Le Corbusier's concept of architecture.[53]

Serra attributes the inspiration for the series to his visit in the early 1990s to

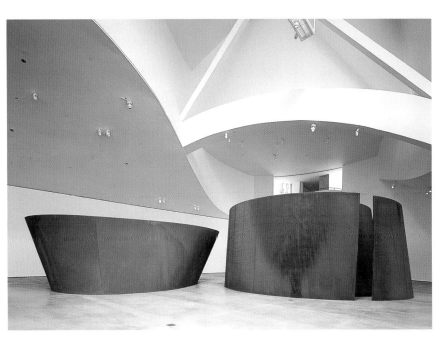

238. Dia, New York (1997–98): Richard Serra, *Torqued Ellipses* (1996–97).

239. Guggenheim, Bilbao (1999): Richard Serra, *Torqued Ellipses* (1996–99).

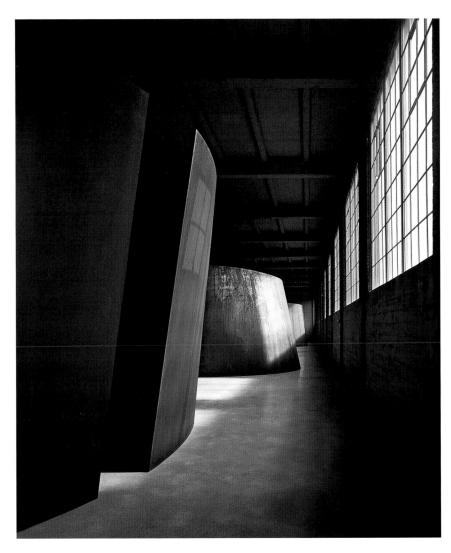

240. Dia:Beacon (2003): Richard Serra, *Torqued Ellipses* (1996) and *2000* (2000).

Borromini's Church of San Carlo alle Quattro Fontane in Rome, where an oval dome rises from a similar elliptical space. With the help of computer technology developed in the office of the architect Frank Gehry, the sculptor overlapped ovals and ellipses, twisting them in elevation, creating in some a double ellipse with a second form within the outer wall. Applying the same concept, using the same material, and working at the same scale, he produced pieces that have their own distinct characters and effects.

At the Dia Foundation's single-story warehouselike space in Manhattan (renovated by Richard Gluckman), across the street from Dia's main museum, the intensity of three of the *Torqued Ellipses* was palpable. The sculptures were exhibited there, from September 1997 to June 1998, within a space big enough to walk around each one yet tight enough to provide a framework (fig. 238). The sculptures were seemingly wedged into the space just a few feet below the dark wooden roof beams, and each one felt like a powerful coil about to snap. Serra (despite his reservations about the ceiling height) said of the installation: "The outside of the form reads better, its definition is clearer in relation to a vertical plane than it would be in relation to a flat open landscape. You immediately see the five-foot overhang of *Torqued Ellipse I* because of the wall next to it." At the Dia exhibition, the work was illuminated only by skylights, achieving a wide range of light and shadow within each sculpture as well as a variety of effects on the exteriors.

The series was less effective at Frank Gehry's Bilbao Guggenheim (1999), where it was presented with Serra's long Cor-Ten steel *Snake* (1996), part of the museum's permanent collection (fig. 239). Seen in a gallery bigger than a football field (the architect has continually advocated the use of stub walls in this space), with ceilings too high to relate to the sculptures, too much space around them, and walls that echoed their curves, eight *Torqued Ellipses* lost some of the tautness achieved by the three in New York.

At Dia's new Beacon museum, two *Torqued Ellipses* and a torqued spiral, *Untitled 2000,* are squeezed into a space so constrained that it restricts distant views of the individual pieces (fig. 240). However, the lack of space around the pieces encourages movement through them, and they come off far better than other large sculpture at Beacon. John Chamberlain's chunky, crushed car-part sculptures (spanning three decades), for example, appear skimpy placed at regular intervals in an oversized space (fig. 241).

If large sculptures like these benefit from being visually contained, for smaller work the need to maintain scale is even greater. Two collections of turn-of-the-twentieth-century Austrian art, one in New York City and one in Vienna, illustrate the point.

The Neue Galerie in New York, inaugurated in 2001, is housed in a mansion designed by Carrère and Hastings, the architects of the nearby Henry Clay Frick mansion. This small museum, devoted to German and Austrian fine and decorative art from 1890 to 1940, was founded by the collector and cosmetics heir Ronald Lauder and his friend

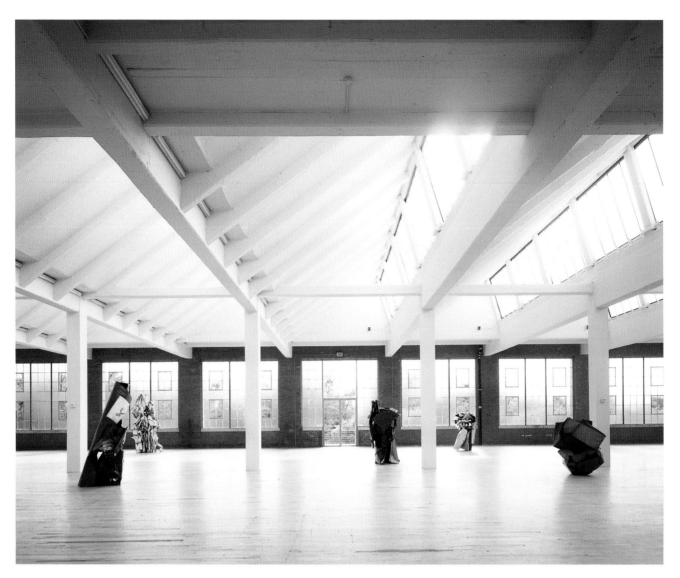

241. Dia:Beacon (2003): John Chamberlain crushed car-part sculptures (1967–97).

of thirty years the late Serge Sabarsky, an art dealer and curator. The New York–based architect Annabelle Selldorf renovated the 1914 house, retaining what was left of its dark wood paneling and colorful marble mantels, which, together with the domestic scale of the rooms, make an ideal setting for paintings of approximately the same era— by Egon Schiele and Gustav Klimt, among others—and furnishings by contemporaneous designers such as Josef Hoffmann and Adolf Loos (fig. 242).

A similar, if much larger, collection (including African and Oceanic art) acquired by the Viennese ophthalmologist Rudolf Leopold and his wife, Elisabeth, opened in Vienna in 2001. The Leopold Museum is part of a complex known as the MuseumsQuartier, itself completed in 2001 on the site of the Baroque imperial stables, a stone's throw from Gottfried Semper and Carl von Hasenauer's facing pair of elegant Beaux-Arts buildings for the city's art history and natural history museums.

The selection in the early 1980s of Vienna's historic district for the project—one of the largest cultural complexes in the world—set off twenty years of heated debate between preservationists and modernists. Two architectural competitions ended with the winning firm, Ortner & Ortner, drastically redesigning its winning entry—one possible reason that the end product of all this effort is so disappointing.

Dr. Leopold, who acts as director of his museum, reputedly worked with the architects on the design of the galleries, so it is all the more unexpected to find cavernous ground-level rooms that completely dwarf the medium and small works exhibited in them. At the Neue Galerie, Klimts and Schieles are actually more impressive than stronger work by the same artists in the Leopold Museum because they are seen in galleries intimately related to them instead of in the impersonal, oversized spaces in Vienna (fig. 243). Just as the most beautiful gown looks dreadful if it doesn't fit, great art is diminished when seen in spaces that are too big—or too small—for it.

242. Opening exhibition, Neue Galerie, New York (2001): Gustav Klimt,
The Dancer (c. 1916–18), at center.

243. Leopold Museum, Vienna (2003): Paintings by Koloman Moser (1912–16),
above a stool and two chairs designed by Josef Hoffmann.

LIGHT

Of all the interrelated factors bearing on perception of an object, the most pervasive is light, since it ultimately determines the success or failure of an installation. Light quality provokes passionate reactions. The distinguished Renaissance scholar Sir John Pope-Hennessy is said to have moved to Florence from his longtime residence in New York City to see artworks in the light in which they were created. The Israeli-French painter Avigdor Arikha compares seeing any painting in artificial light to "drinking a great wine whose bouquet has evaporated."[54]

The importance of light for art was understood already in antiquity. Phidias, for both his *Athena Parthenos* and his *Zeus,* erected workshops at the two sites with the same dimensions and orientations as the naoi for which the statues were intended.[55] The sculptor was thus able to work in spaces that had the same scale and lighting conditions as the interiors in which the statues would be seen.

Recent discoveries suggest that in Greece in the sixth century B.C., a number of temples had skylights made of Parian marble tiles, a material that was translucent, like alabaster.[56] The sculptor Byzes of Naxos is thought to have invented the translucent marble roof sometime after 600 B.C., and it would certainly have been in use by the middle of the next century, when marvelous new cult images, like those by Phidias, required proper illumination to be appreciated.

To do justice to these masterpieces, temples whose interiors had been dark were opened up by means of skylights and windows. At the Parthenon, the *Athena Parthenos* most likely received some light from facing windows, but since they were screened by the temple's peristasis columns, the semitransparent ceiling must have been a more important source of illumination. Light from above would, in turn, have been reinforced by reflections from a pool of water in front of the goddess. (Humidity from the pool also helped to preserve the sculpture's ivory.)

Standard glazed skylights have evolved, in recent decades, into a variety of sophisticated systems, usually incorporating louvers to adjust light levels and supplemented with artificial illumination that often controls color. Some of these work well, as at the Museum Abteiberg in Mönchengladbach, Germany (1982), designed by the Austrian architect Hans Hollein, and the J. Paul Getty Museum in Brentwood, California (1997), designed by Richard Meier. Yet art often looks best in spaces that rely primarily on natural light unaided by technology.

Dia:Beacon is a case in point. The museum occupies a former Nabisco box factory, built in 1929, that was renovated under the direction of Robert Irwin, an artist whose primary medium is light, with the architectural firm Open Office. The sublime light quality is largely due to the structure's twenty-five thousand square feet of north-facing shed skylights, numerous clerestories, and some windows through which

244. Carlo Scarpa, addition to Canova Gipsoteca, Possagno, Italy (1957).

245. Renaissance bronze gallery, National Gallery of Art, Washington, D.C. (2004): small, mostly bronze, sculptures in showcases, with Jacopo Sansovino, *Madonna and Child* (papier maché and stucco, c. 1550), at center.

daylight penetrates, without ever flooding, almost a quarter million square feet of gallery space.[57] Irwin picked floor textures (maple in some places, concrete in others) and a wall color (ever so slightly off-white, ever so slightly textured) compatible with this exclusively natural illumination.

Dia:Beacon's primary focus is on Conceptual, Minimal, and Earth art; separate galleries are devoted to individual artists who in many cases helped install their own work. The arrangements are not perfect, but the light is. A tough test of its quality is posed by the easily missed subtleties of whiteness in Robert Ryman's *Vector* series (see fig. 226). The panels are barely differentiated from the wall on which they hang by narrow, unpainted sides, light yellowish wood on the left and redwood on the right. Thanks to the play of natural overhead light on the painted surfaces, every detail of the panels, which seem to float apart from the plane to which they are affixed, is evident.

In another gallery at Dia:Beacon, windows provide sidelight to exceptionally dramatic effect for Serra's *Torqued Ellipses* and *Untitled 2000*. Depending on the time of day, light hitting the sculptures horizontally is completely blocked by their outer walls, casting parts of the interiors into total obscurity. Traditional sculpture poses different problems. Overlighting, for one, makes marbles appear deathly white—like Ivory soap—and can distort bronzes. Generally, sculpture is favored by natural light, ideally with sidelight

balancing overhead illumination. For the plaster-cast models at the Canova Gipsoteca in Possagno, Italy, Carlo Scarpa combined horizontal and clerestory light with stunning success in his 1957 addition to the museum (fig. 244).

Bronzes are even more difficult to present satisfactorily. Three exhibitions—two permanent and one temporary—illustrate some of the issues. At the National Gallery of Art in Washington, D.C., a Renaissance bronze gallery, one of several newly renovated spaces for sculpture, presents small objects in horizontal showcases (fig. 245). The display is a good example of the replacement of touch by sight in museums generally.[58] Denise Allen, a curator at the Frick Collection, says, "Half of these objects' reason for being was the pleasure of handling them, feeling their weight, balance, and touch; missing this part of the experience is like trying to look at a painting in the dark."[59]

Apart from the initial compromise of seeing these objects under glass, which obliterates their surfaces, the displays are extremely successful. Tall windows in a corner gallery facing north and west provide ideal sidelighting for the sculptures. They are easy to see in predominantly natural light that avoids the violent highlights and shadows of spotlights. Additionally, mixed in with the bronzes are several objects in different media, such as painted and glazed terra cotta, which establish a dialogue between the sculptures. The uniform scale and color of this cohesive collection could easily give the impression that its components all look alike, an effect the installation neatly avoids.

The Renaissance bronzes at the Getty Museum are a different size and a completely different type from those at the National Gallery, each one a medium-size masterpiece meant to be seen alone. The problem is therefore just the opposite of the one posed for small sculpture: distance and isolation rather than proximity and touch are needed. But the extraordinarily graceful *Mercury* (1570–80), which probably stood alone in the middle of a room, and the imposing *Neptune* (c. 1600–1620), which may have crowned a fountain, are seen amid other objects of equal importance without leaving the viewer space enough to stand back from each one (fig. 246). Furthermore, they are dwarfed in a twenty-foot-high room. (The National Gallery's room is twelve feet high to the cove rising above.) In its favor, the display enjoys good natural light from a four-foot-five-inch-square clerestory window, and the bronzes are presented without protective glass.

What can happen to bronzes illuminated solely by bright overhead spotlights was demonstrated by the display of modern sculptures in "Unique Forms of Continuity in Space," a segment of MoMA's temporary millennium exhibitions (fig. 247). Philip Johnson aptly described the effect of hot spots on the shiny bronze protuberances as a display of "tits and ass."[60]

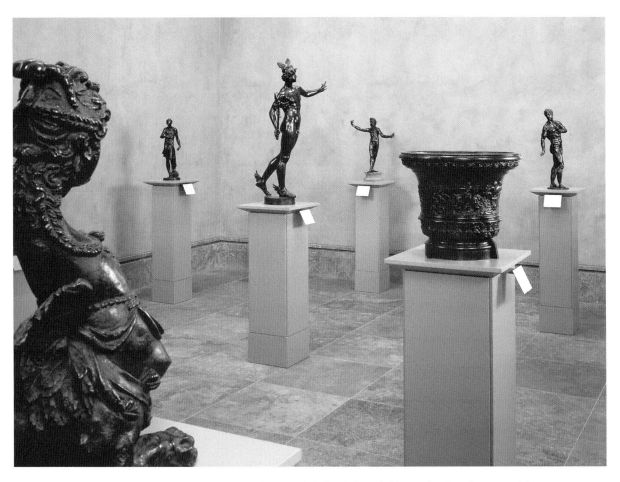

246. Renaissance bronze gallery, J. Paul Getty Museum, Brentwood, California (2004): *Mercury* (1570–80), at center left; *Neptune* (c. 1600–20), at far right.

247. "ModernStarts: Unique Forms of Continuity in Space," MoMA (1999–2000): Auguste Rodin, *Three Shades* (1881–86), in foreground.

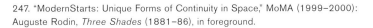

JUXTAPOSITIONS AND THEMATIC INSTALLATIONS

The display of sculpture in "ModernStarts" was part of MoMA's bold experiment in rethinking the installation of its permanent collection. Atypically, materials from the museum's different departments were mixed—paintings and drawings were shown with photographs and video art or with design. And in an even more radical gesture, arrangements of chronology, style, and school were abandoned in favor of themes as a guiding principle.

In 1936, Alfred Barr established a genealogy of Modern art on the jacket of his book *Cubism and Abstract Art;* it began with Cézanne and led to Cubism, Constructivism, and Abstraction. This linear narrative of styles, movements, and individual accomplishments assumed a Darwinian supplanting of one species by its improved descendants. Barr's genealogy served as gospel for the better part of the twentieth century, not only for MoMA but for many other institutions.[61] The thematic arrangements of the museum's millennium exhibitions facilitated a number of alternatives to Barr's single story line.

The transformation of MoMA's galleries was for some informative and stimulating: critic and curator David Sylvester, for one, claimed he appreciated fully Cy Twombly's *Four Seasons* (1993–94) only when he saw the canvases hanging opposite Monet's *Water Lilies* (c. 1920) in "Seasons and Moments," one of the 1999–2000 shows.[62] Others, like the artist Frank Stella, felt, "If a different way of looking at things is no good, what's the point?"

One of Stella's objections was to the installation of "Things," where Modern masterpieces hung on intense blue-green walls beside figurative murals commissioned from the British artist Michael Craig-Martin. He also deplored the juxtaposition of older paintings with contemporary photography. In his opinion, such pairings were an unfortunate gimmick to make the paintings more accessible. In fact, Stella felt the juxtaposition succeeded only in "demeaning the collection and making great art look bad."[63]

Among the many drastic departures from the norm in the millennium exhibitions were the multiple paths, which contrasted with the museum's first, Bauhaus-influenced installations, such as the ones designed there in the late 1930s by Herbert Bayer. In those, visitors were firmly guided by directional shapes and footsteps painted on the floor. Earlier exhibitions in Germany were even more emphatically unidirectional, employing military-style spoken commands to move visitors in the desired direction.[64] In true Post-Modern fashion, "MoMA 2000" left it to museumgoers to decide which theme to explore next, allowing them to make their own aesthetic connections.

Chronology as a method of organization has the advantage of putting together works of similar sensibility that tend to reinforce one another and highlight artistic developments. As Sylvester's and Stella's reactions indicate, departures from this

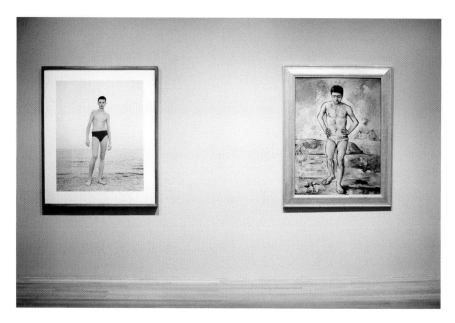

248. "ModernStarts: Actors, Dancers, Bathers," MoMA (1999–2000): Rineke Dijkstra, *Odessa, Ukraine. 4 August 1993* (1993); Paul Cézanne, *Bather* (1885).

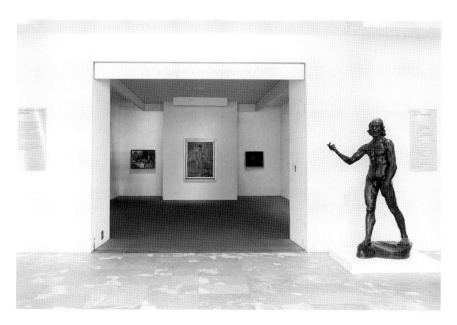

249. MoMA (c. 1993): Cézanne, *Bather* (1885), on panel at center; Auguste Rodin, *St. John the Baptist Preaching* (1878–80).

convention can have mixed results. Art lovers were shocked by the degree to which one of MoMA's most famous paintings, Cézanne's *Bather* (1885), was diminished by the presence beside it of Rineke Dijkstra's photograph of a boy in a bathing suit, *Odessa, Ukraine. 4 August 1993,* in "ModernStarts" (fig. 248).

John Elderfield had a compelling rationale for showing the Modern masterpiece with a contemporary photograph that is still open to critical judgment.[65] Apparently, Cézanne himself, when he created the *Bather,* looked to a photograph, *Standing Model.* This anonymous image of about 1860–80 (which was hung in the next gallery) bears a striking similarity to the painting: both show a young man with one leg extended back and hands placed casually on the hips, a pose that derives from classical Greek sculpture and from academic exercises. Elderfield wanted to demonstrate the formal similarities between the Cézanne and the photographs, and the interrelationship of different mediums and different times.

The curator also intended to challenge the painting's gradual idealization in its previous installations. William Rubin had removed *Bather* from a row of paintings and installed it as the first work visitors saw upon entering the Post-Impressionist galleries. So that there was no mistaking its importance, Rubin positioned Rodin's *St. John the Baptist Preaching* (1878–80) just outside the gallery, with the sculpture's outstretched arm pointing to the Cézanne. The gesture, together with the figure's long stride, implied the beginning of a sequence.

Kirk Varnedoe, Rubin's successor as MoMA's chief curator of painting and sculpture, carried the message even further: while the placement of *Bather* and *St. John* remained the same, the painting was given a new freestanding panel, created by moving forward part of the wall on which it had hung with other paintings (fig. 249). Presented in this manner, *Bather* was even more arresting: rather than the first step in a narrative, the picture became an emphatic emblem of MoMA's painting and sculpture collection.

In many ways, "ModernStarts" was a dry run for the reinstallation of the permanent collections at MoMA, which reopened in November 2004. Galleries in the museum's new building, by the Japanese architect Yoshio Taniguchi, offer multiple paths that present to viewers many unconventional arrangements (such as separating the works of an artist) and some mixing of media. Like Rubin and Varnedoe, Elderfield too has imposed his imprimatur on the museum: *Bather* and *Demoiselles d'Avignon,* for instance, have lost some of the emphasis they enjoyed previously with their positions alone on a partition and a wall, respectively; both now share walls (in the case of *Demoiselles,* a bit too long for optimum hanging) with several others canvases.

The new arrangement is, however, less radical than the one adopted for "ModernStarts," in which Elderfield succeeded almost too well in extracting the *Bather* from its exalted connotations: pairing the weighty nineteenth-century symbolic figure

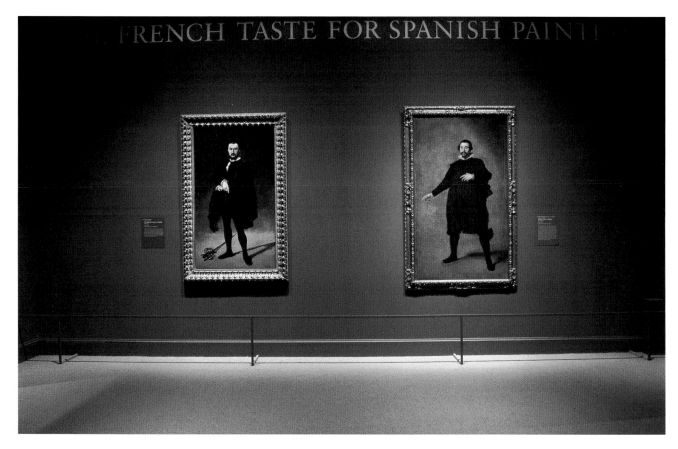

250. "Manet/Velázquez: The French Taste for Spanish Painting," Metropolitan Museum (2003): Edouard Manet, *The Tragic Actor (Rouvière as Hamlet)* (1865–66); Diego Velázquez, *Jester Pablo de Valladolid* (c. 1632–35).

with the late-twentieth-century realistic adolescent in *Odessa* did the Cézanne a tremendous disservice. While both images are highly formalized modern statements that derive from a classical tradition, the photograph is about a bather, whereas the painting is about painting.

As Elderfield points out in the exhibition catalog, Cézanne used the same colors for the landscape and the figure: both are horizontally banded surfaces that lead the eye back and forth, causing the viewer to perceive them as if reading a text. Dijkstra's photograph, on the other hand, shows an awkward and vulnerable, as well as overtly sexual, individual. Both figures were posed artificially by the artists, but the real-life quality of the contemporary adolescent in the photograph makes him appear exhibitionistic, which the Cézanne boy definitely is not.

St. John was a better foil for *Bather,* even if it did evoke a cigar store's wooden Indian, because the two roughly contemporaneous works share a similar aesthetic. In the Dijkstra, the boy's strident, bright red bathing suit and discernible genitals distracted from and demeaned the Cézanne's monolithic strength of execution and form. The older masterpiece appeared as an accessory to the photograph, which in turn was catapulted into a realm of excellence and creativity that would normally elude it.

As discordant as the pairing of the two bathers was the juxtaposition at the entrance to the "Manet/Velázquez" exhibition in New York of Manet's *The Tragic Actor (Rouvière as Hamlet)* (1865–66) with Velázquez's *Jester Pablo de Valladolid* (c. 1632–35). For all the high marks justly deserved by the overall installation at the Metropolitan Museum, the exhibition began badly with the kind of contrived pairing often indulged in by museum professionals intent on promoting an idea (fig. 250).

251. Tate Modern, London (2000): Richard Long, *Waterfall Line* (2000) and *Red Slate Circle* (1988), on floor, partially obscured.

Gary Tinterow, the curator of "Manet/Velázquez," introduced the show with the two paintings placed side by side in order to alert visitors to the comparisons they should be looking for. But even he admitted the unfairness of pairing two painters with entirely different purposes, each approaching his art from a different perspective: whereas the Spanish artist worked mostly for Philip IV, executing royal portraits and occasionally religious paintings, the Frenchman was competing for a place in the Salon. Tinterow said of the juxtaposition, "It makes my teeth hurt: Manet is as good as Velázquez, but Velázquez is living on a different planet. They are the product of two different cultures: Velázquez is interested in the realism of the jester's face and gestures. Manet— for whom the portrait is a response to Velázquez's *Jester*—is concerned with the way paint is applied and making the figure aggressively theatrical."[66]

Because they lend themselves to storytelling, thematic installations that juxtapose works of different periods, and occasionally in different media, are often used to make difficult subjects more accessible. Such presentations have been employed for both permanent installations—the display can help to mask the weaknesses of a collection— and temporary exhibitions. Thematic presentations and storytelling have become a favorite means of marketing a wide range of activities, and not just in museums.[67] At the turn of the millennium, several major museums adopted thematic arrangements for their permanent collections, among them the newly separate Tate Britain and Tate Modern

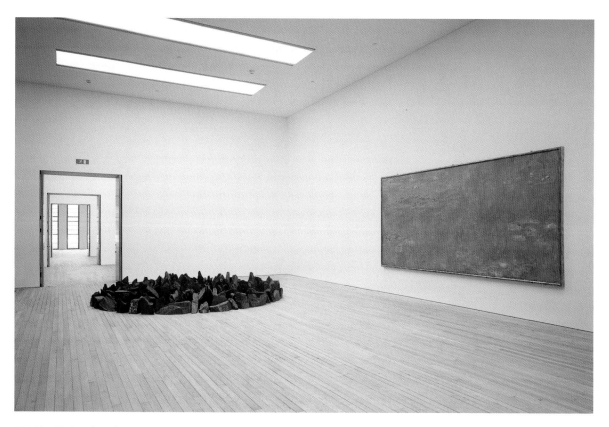

252. Tate Modern (2000): Richard Long, *Red Slate Circle* (1988); Claude Monet, *Water Lilies* (after 1916), hanging opposite *Waterfall Line.*

in London and the Pompidou Center in Paris, where galleries devoted to a single artist alternated with thematic ones (programmed for regular revision).

The Tate Modern's thematic installations were often simply genre classifications, such as landscape and the nude, facile correspondences that often came across as condescending predigestions of demanding material. For example, *Waterfall Line* (2000), a mud wall work by Richard Long, was placed opposite Monet's lyrical *Water Lilies* (1916) (figs. 251, 252). Both works are about landscape, yes. But once the viewer has taken this in, it is apparent that a superficial similarity of subject has buried deeper issues. Long's references to tribal fetishism and primitivism bear no relationship to Monet's urbane sophistication. For thoughtful viewers, the juxtaposition was puzzling.

For "The Stage of Drawing: Gesture and Act" (2003) at New York's Drawing Center, 146 works from the Tate Britain and Modern collections, dating from the eighteenth century to the present, were organized according to philosophical concepts rather than by iconography. None of the four divisions imposed a visual category, such as the nude, but instead encouraged viewers to think about the relationships between certain works. The groupings transcended history and demonstrated affinities between older and contemporary drawings.

The Drawing Center's current modest space is in the tradition of intimate settings for this intimate medium. Until the latter part of the twentieth century, drawings were

for the most part relatively small; their size, together with their subtle materials, called for close scrutiny. Also, because of their fragility, works on paper require lower light levels. (Even at the Salons, such works were exhibited in dimly lit, less trafficked galleries.)[68]

Selected from the Tate collections by the English artist Avis Newman, the works were arranged by Drawing Center director Catherine de Zegher in the organization's single room—sometimes hung three deep on the walls, sometimes hung at waist height or above eye level. Some were strewn in graceful showcases with slanted tops, a type of vitrine that imitates the drawing board and is often used to display works on paper. To emphasize the temporal nature of the pieces, these sheets were rotated so that different ones were visible on different days. The installation, determined solely by the visual links between drawings, revealed relationships that would have been less apparent had the works been conventionally isolated on the wall.

De Zegher placed each piece "so that it appeared as an on-going gesture, an intuitive movement closer to language than to the traditional concept of a preconceived, static visual statement."[69] The "stage" of the exhibition's title referred to an open-ended stage in time as well as to the theatrical stage and to artists staging themselves in self-portraits.

Six sketches by Bonnard titled *Coffee and the Bowl of Milk* (1915, 1919) climbed above a showcase containing Turner's water-damaged chalk drawings, some of male nudes; the showcase was, in turn, near Gwen John's *The Cat* (1904–8) (fig. 253). The exceptionally low hang of *The Cat,* drawn as a self-portrait, outraged many visitors, according to de Zegher—a surprising reaction, considering that a sleeping feline would normally be seen from above, just as in the watercolor. Furthermore, the unusual position attracted attention to an engaging, small composition that could easily have been overlooked. (All these works appeared in an area called "The Mirrored Self," since each bears physical or conceptual traces of the artists' own physicality.)

Featured in another assemblage were Alexander Cozens's conceptual watercolors and instructive books, which hark back to London's Royal Academy and its establishment of the intellectual rather than the technical component of art-making. The link between drawing and writing was emphasized by Fernand Léger's *ABC* (1927), hanging beside and level with the Cozens showcase (fig. 254). In another instance, placement of William Henry Hunt's tiny, undated *Photographer* below Henry Fuseli's weirdly fetishistic *Débutante* (1807) conveyed a sense of voyeurism (fig. 255).

In making her selections, Newman identified with the private collectors who had donated the drawings, individuals motivated by a passion for art and unconstrained by a museum's didactic mandate. And like a private collection, the exhibition was determined by the work itself, not, as in so many shows today, by a theory in need of illustration. The result was, in the words of the critic and scholar Norman Bryson, "a *mirabilia,*"[70] a return to historic installations designed primarily to delight and surprise rather than to instruct.

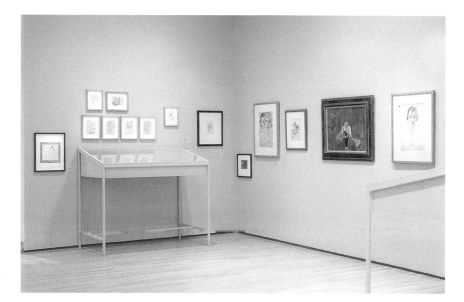

253. "The Stage of Drawing: Gesture and Act, Selected from the Tate Collection," Drawing Center, New York (2003): Pierre Bonnard, six sketches, above vitrine containing J. M. W. Turner drawings; Gwen John, *The Cat,* at right corner.

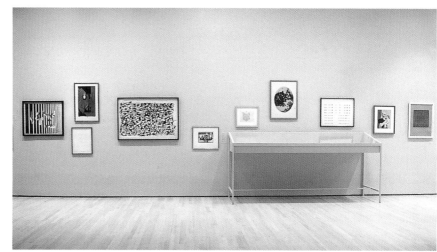

254. "The Stage of Drawing: Gesture and Act, Selected from the Tate Collection," Drawing Center (2003): Fernand Léger, *ABC* (1927), at left of vitrine containing Alexander Cozens watercolors and books.

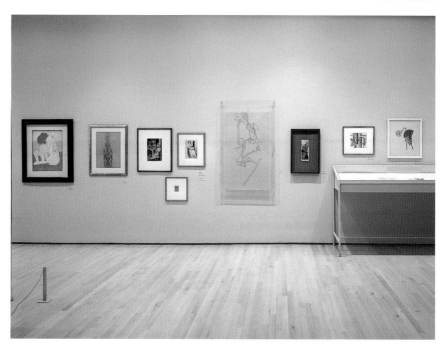

255. "The Stage of Drawing: Gesture and Act, Selected from the Tate Collection," Drawing Center (2003): William Henry Hunt, *Photographer* (undated), below *Débutante* (1807), at left, and *Charis Physkomené* (1791), at right, both by Henry Fuseli.

THE CHOICE OF VISUAL CONTEXT

A strict definition of context begins with the frame. Like pedestals and vitrines for three-dimensional objects, frames relate to both the work of art and its setting, acting as a buffer between the two and sending a signal about the art.

Since the Renaissance, collectors—and later, museums—have used pedestals and frames to make the work of others their own.[71] At the time of MoMA's reopening in 1984, William Rubin surprised the art world with a new installation for which he homogeneously reframed many paintings that had previously had their own distinct frame. Flat, narrow, antiqued gold strips were substituted for the deep, elaborately carved gilt frames of the Post-Impressionists. While some of the older frames had been added by former owners, others were the artists' choices. Changing them therefore suppressed an important aspect of the way painters wished to present their work. (Likewise, adding frames to small pre-seventeenth-century panel paintings, which were not usually hung on walls, confers a new meaning on them.)

Whatever the artists' aesthetic intentions, they were overridden by the curator's didactic purpose: "for the pictures to relate in the right way." In other words, Rubin opted for frames in harmony with the museum's Modern setting and the art history suggested by his installation rather than with the paintings themselves. In their new dress and in the same unchanging artificial light, these very different objects with different surfaces resembled nothing so much as a set of reproductions.[72]

Broadening the definition of context from the frame to the space around the frame raises some controversial questions. I have pointed out that eighteenth-century French paintings at the Wallace Collection have the advantage of being seen against fabric backgrounds that allude to those on which they were originally seen. In this eighteenth-century house, such backgrounds are part of a historic approximation that includes furnishings as well as fine art. The degree to which context is represented for decorative arts, and even for architectural exhibitions, offers interesting parallels with the display of painting and sculpture.

At one end of the wide range of possibilities are period rooms taken from historic buildings in their entirety. Replicas in varying degrees of exactness are also an option, as are subtle suggestions of specific environments. Often, however, even the faintest suspicion of context is regarded as a distraction from the object on display.

Period rooms have retained their popularity, especially in the United States, despite being considered outmoded by leading German museum directors as early as the first years of the twentieth century.[73] It is not easy to create the appropriate setting for decorative arts, yet these functional objects can seem meaningless on their own. Conversely, replacement of missing architectural elements or of incomplete contents often produces a mixed bag of authenticity and reproduction that justifies the mistrust of period rooms by today's curators.[74]

Few period rooms attain the ideal of Frank Lloyd Wright's living space for the Francis

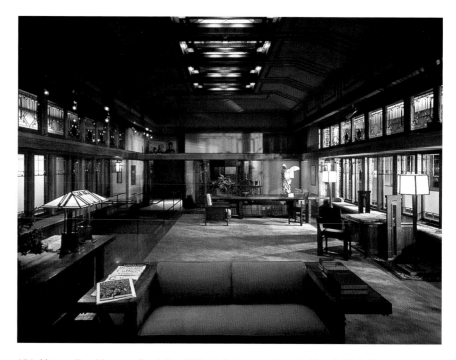

256. Metropolitan Museum: Frank Lloyd Wright, living room from the Francis Little House (1912–14), reconstruction; note *Winged Victory* replica, right background.

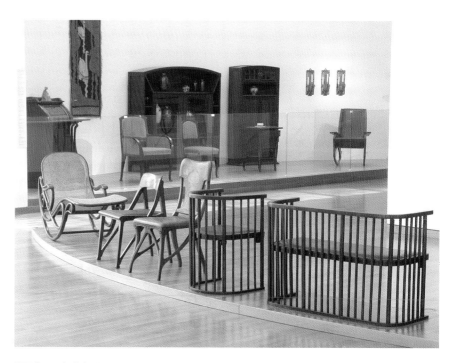

257. Jugendstil Gallery, Museum für Kunsthandwerk, Frankfurt am Main (2003).

W. Little House, erected in Peoria, Illinois (1912–14), and now at the Metropolitan Museum (fig. 256). With all materials in their original condition, and the furniture Wright designed for it intact and placed as it was for his client,[75] the Little House room offers an exceptional experience of a modern master's design aesthetic.

By comparison, to exhibit chairs, tables, and other furnishings as if they were precious sculptures is an arid approach to the implements of everyday life, one that divorces them from the purposes for which they were designed. This kind of easily recognized object was traditionally placed at the beginning of museum circuits to prepare visitors for what was considered the more challenging experience of fine art. Aligned in sanitized Modern spaces like those of Richard Meier's Museum für Kunsthandwerk (1985) in Frankfurt am Main, familiar objects are rendered unfamiliar (fig. 257). In the museum's Jugendstil Gallery, for instance, different furniture types are grouped together; but the result is neither a home nor a museum, neither private nor public.

The Museum für Angewandte Kunst in Vienna, built in 1852, offers a brilliant compromise between abstraction and literal re-creation. Seven permanent galleries, each reinstalled by an artist in 1986, subtly capture contextual allusions without resorting to stagelike reproductions. For the Romanesque, Gothic, and Renaissance collections, Günther Förg, a German artist who works in a variety of media, had the gallery's walls painted a bright cobalt blue that relates to, and visually ties together, objects as disparate as medieval religious paraments and Renaissance majolica (fig. 258). The late-nineteenth-century *grotteschi*-style paintings on the vaulted ceiling were left in place, contributing to the historical ambience. With no spotlights or labels in the transparent vitrines, the contents appear contiguous with the space around them, almost as if they were not under glass. As the curator, Christian Witt-Dörring, explains, "Even the absence of labels is so that you can make up your own mind first, before you get the facts."[76] (Explanations are available on portable sheets at the entrance to each gallery.)

Barbara Bloom, the American installation artist, created a different kind of context— one of merchandise rather than of art—for the MAK bentwood furniture collection (fig. 259). In a tribute to Michael Thonet's genius for mass production, advertising, and mail-order distribution, only the silhouettes of his chairs are visible initially, as if seen in a catalog. A Thonet sales sheet of about 1880, with chair contours that could almost be a reproduction in an Ikea catalog, and an actual page from an Ikea catalog explain Bloom's presentation. The chairs themselves can be examined behind the scrims that register their silhouettes. Each of the other five permanent installations— among them rooms by Donald Judd and by Jenny Holzer—likewise emphasizes aesthetics rather than information.

The Victoria and Albert Museum in London took the opposite stance, favoring

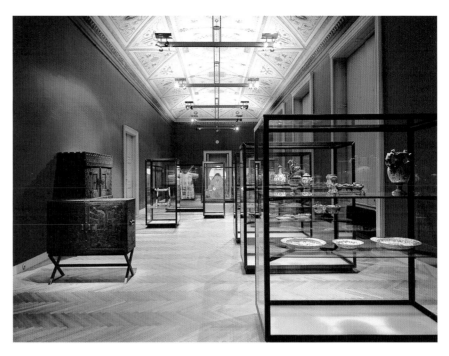

258. Romanesque Gothic Renaissance Gallery, Museum für Angewandte Kunst, Vienna (2003).

259. Historicism Art Nouveau Gallery, Museum für Angewandte Kunst (2003).

260. British Galleries, Victoria and Albert
Museum, London (2003): Arts and Crafts display.

261. British Galleries, Victoria and Albert Museum (2003): Antonio Canova,
The Three Graces (1814–17).

information in the reinstallation of its British Galleries (1500–1900), which opened in 2001. Casson Mann's redesign of fifteen rooms on two levels, devoted to the museum's unparalleled collection of British design from Henry VIII to Queen Victoria, is first and foremost educational, geared toward schoolchildren and students. Computer guides are everywhere; two electronic study areas and two film rooms provide even more information. Three discovery areas allow hands-on activities; visitors are encouraged to touch fabrics and have a go at weaving or other crafts related to the exhibits.

The museum is just beginning to intersperse furniture, textiles, paintings, sculpture, and works in other materials with one another in an attempt to convey the character of an era. The open display of many objects previously protected by transparent coverings is a welcome development. On the downside, storagelike alignments of furniture against layered wall panels deprive individual pieces of their three-dimensionality, presenting them more as illustrations in a book (fig. 260). Also, the heavy bases and tops of the vitrines isolate their displays of small or fragile objects.

Occasionally, a direct relationship between specific items and contextual groupings overcomes this separation and brings the exhibition to life. A brilliant example is the pairing of a portrait of Margaret Laton by an unidentified artist (c. 1620) and the finely embroidered linen jacket she is wearing in the painting. The Grand Tour section successfully evokes the experience of British noblemen traveling in eighteenth-century Italy to learn about its art and antiquities. Among a wealth of neoclassical objects favored by these visitors, Canova's *Three Graces* (1814–17) is the standout star, placed as it is before a gently curved yellow panel. The arrangement is discreetly reminiscent of the sculpture's original display, in a specially designed alcove for the sixth duke of Bedford at Woburn Abbey (fig. 261; see fig. 75).

The overall installation is truly revolutionary for an institution that, for most of its more than 150 years, was notoriously indifferent to the public. As quaint as the galleries that still display endless rows of objects grouped in showcases by material are for some, they are meaningful only to connoisseurs. Part of the V & A's ongoing renovation program, the British Galleries are a sort of funfair: visitors enjoy themselves and learn a great deal in the process.

For displays of architecture, the disparity in scale between drawings and models and the buildings they represent creates special problems for exhibition. It is also difficult to convey a spatial sense of the buildings. To overcome these limitations, a number of architects have shaped exhibition spaces in accordance with their own design style as miniversions of their built work.

For the French Pavilion at the 1970 Venice Biennale, Claude Parent rebuilt the

262. Claude Parent and artists at the French Pavilion for the 1970 Venice Biennale.

pavilion into a series of unsettling, tilted floors, canted partitions, and oblique ceilings that duplicated his architecture (fig. 262). In 1994, Peter Eisenman produced a similar effect for "Cities of Artificial Excavation," an exhibition of his work at the Canadian Centre for Architecture in Montreal (fig. 263). The architect totally reconfigured the existing rectilinear gallery using his own vocabulary, so that it read like a ruin. Eisenman's distorted Euclidean forms, like Parent's, gave visitors a palpable experience of his buildings. As the architectural historian David DeLong observed, "Eisenman's constructions framed views to a seemingly deserted series of vistas, which were, in fact, the original galleries made to appear like the abandoned semi-ruined shell one might encounter on an archaeological expedition."[77]

In another take on this concept, Frank Gehry built four freestanding rooms for "The Architecture of Frank Gehry" at the Walker Art Center in Minneapolis (1986). The curator Mildred Friedman requested structures that "you could walk into and have a sense of his architecture."[78] Accordingly, Gehry built containers that ranged from about ten to

263. "Cities of Artificial Excavation: The Work of Peter Eisenman, 1978–1988," Canadian Centre for Architecture, Montreal (1994).

264. "The Architecture of Frank Gehry," Walker Art Center, Minneapolis (1986): Fish lamp display.

265. "The Architecture of Jean Nouvel," Pompidou Center, Paris (2001–2).

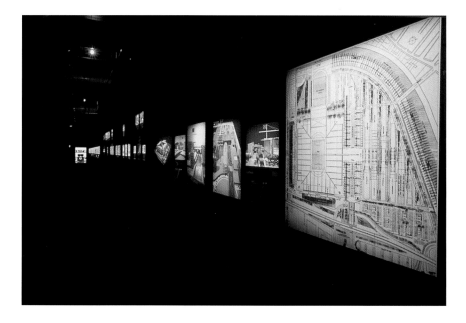

twenty feet long and eight to ten feet high and were fabricated in Finnish plywood, lead-coated copper, and corrugated cardboard (fig. 264). The architect's Snake and Fish lamps were presented in a fish-shaped construction sheathed, like the lamps themselves, in color-core Formica fragments shaped like fish scales, offering a dialogue between container and contents. As one critic said, the rooms were "a taste of the real thing, far more potent and informative than even the best models and graphics."[79]

Without this direct spatial experience, an exhibition of Jean Nouvel's work at the Pompidou Center (2001–2) failed to capture the magic of his architecture (fig. 265). Because Nouvel rarely draws and considers small exhibition models to be merely aesthetic objects, unrelated to the reality of a built structure, he prefers projected images as a means of placing the viewer within his buildings.[80]

But color slide projections in a black-box setting failed to convey what it feels like to be inside one of Nouvel's elegant structures, which make so much of natural light. And while darkness facilitated the projections, it rendered the extensive wall texts illegible and hampered circulation. For the method to work, it needed film clips and computer walk-throughs, elements originally included but dropped for budgetary reasons. The audio context of background noises—street sounds, the roar of a stadium—was almost inaudible. The show missed an opportunity to convey the message of Nouvel's work.

For an architect to suggest the nature of his or her built spaces is a valid, often helpful exhibition technique. However, for the display of fine art the device can degenerate into a fake stage set. Contextuality becomes kitsch, for instance, in three recently founded exhibition halls in the South.[81] Wonders: The Memphis International Cultural Series in Memphis, Tennessee, opened in 1991; it was followed by the Florida International Museum in St. Petersburg (1995) and the Mississippi Arts Pavilion in Jackson (1996). With no collections of their own, these blockbuster mills routinely spend enormous sums of money to transform their cavernous spaces into elaborate evocations of time and place. People associated with the first of these enterprises refer to them as "theatricals," but they are more like theme parks. The Mississippi Arts Pavilion concocted imperial ceiling paintings, gilded wall carvings, and intricately patterned parquet floors for its "Palaces of St. Petersburg" exhibition in 1996 (fig. 266). The show's overall cost was $10 million. An excessive emphasis on context over content confuses real and reproduction, reducing important objects to illustrations of a story line.

Conversely, a carefully conceived contextual environment can make objects more meaningful. The Getty Villa's re-created garden in Malibu promises to do so for the Villa dei Papiri bronze replicas (see page 102). MoMA applied the concept to Modern art in one of its "ModernStarts" shows "Seasons and Moments," with the display of four panels

266. "Palaces of St. Petersburg," Mississippi Arts Pavilion, Jackson (1996).

by Vasily Kandinsky in an exact replica of the hexagonal vestibule of Edwin R. Campbell's Park Avenue apartment, the space for which they were commissioned (figs. 267–69).

The Campbell panels are one of Kandinsky's many attempts to capture his experience of visiting a peasant hut in northern Siberia in 1889.[82] The installation of the so-called *Four Seasons* (1914) on facing walls achieved a lively interplay of colors, forms, and space that helped to convey the artist's feeling of having entered a picture when he was in the hut.

The gold frames that the panels were shown in at MoMA may have been inspired by the original Campbell installation,[83] but more important was the surround of the architecture. The replica vestibule's compressed space enframed the pictures; against the walls' slight curve, the straight panels cast narrow shadows that made them appear to exceed their boundaries. Furthermore, the circular arrangement dispensed with linear order, suggesting an analogy with music, in particular with the music of Schönberg, which Kandinsky greatly admired.[84]

Another example of context was created for the magnificent "Titian" exhibition (2003) at the National Gallery in London. The curators tried to evoke the famous Camerino of Alfonso d'Este (Isabella's brother), having reunited for the first time since their dispersal in 1621 four of the five large paintings commissioned for the duke's study. The Camerino was approximately twenty-one feet long and thirteen feet wide[85] and seems to have been in an elevated passageway between the family's castle and palace in Ferrara. The small room was accessible only to the owner.[86] In asking the foremost artists of the day to decorate the study, the warrior prince was competing with other renowned *studioli,* among them Isabella's (see pages 16–17).

Giovanni Bellini's *Feast of the Gods* was the first picture delivered (in 1514). But the deaths of two other artists chosen by Alfonso, Fra Bartolommeo and Raphael, prevented the completion of the room's bacchanalian program.[87] Consequently, Bellini's former student Titian completed it with *The Worship of Venus* (1518–20), *Bacchus and Ariadne* (1520–23), and *The Andrians* (1523–24). By the time Titian got to *Bacchus and Ariadne,* he had gone beyond Bellini to a totally new way of painting that must have seemed to his contemporaries as different from his predecessor and teacher as Warhol is from Morris Louis or de Kooning and Gorky are from Mondrian. To appease those for whom the new style made Bellini seem outmoded,[88] the younger artist made the aggressive decision to repaint parts of his master's work. Unlike the pupil-instructor confrontation between Manet and Couture at the Musée d'Orsay, at the Camerino the pupil had the last word: Titian altered Bellini's *Feast of the Gods,* completing it in 1529 to make it fit more harmoniously alongside his own work.

At the National Gallery, a space approximately five feet longer than the Camerino was set off at one side of the exhibition's first gallery, making a long, three-sided room;

267. "ModernStarts: Seasons and Moments," MoMA (1999–2000): Vasily Kandinsky panels (1914), in re-creation of Edwin R. Campbell apartment.

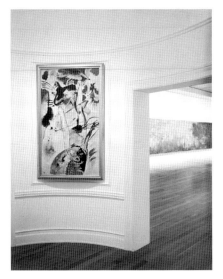

268. "ModernStarts: Seasons and Moments," MoMA (1999–2000): Vasily Kandinsky panels.

269. "ModernStarts: Seasons and Moments," MoMA (1999–2000): Vasily Kandinsky panels.

270. Camerino of Alfonso d'Este, diagrammatic reconstruction showing location of pictures.

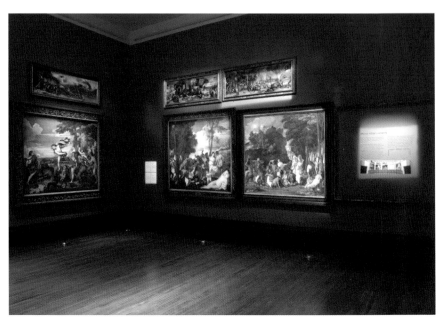

271. "Titian," National Gallery, London (2003): Camerino installation with Titian, *Bacchus and Ariadne* (1520–23) and *The Andrians* (1523–24); Bellini and Titian, *The Feast of the Gods* (1514–29); Dosso Dossi, three panels (1522–24), above.

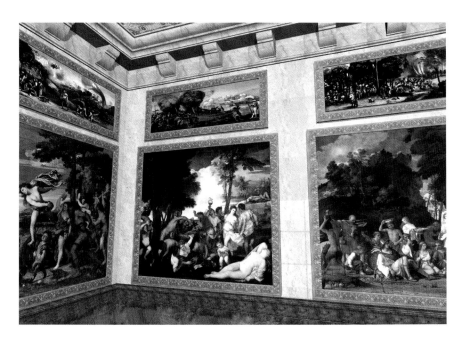

272. Camerino, computer reconstruction by Robert Cripps.

its open side corresponded to windows presumed to have been in the original room. Hung in what is thought to have been their original order were the large works by Bellini and Titian and, above them, three of the ten oblong canvases painted—possibly as a frieze—by Titian's contemporary Dosso Dossi (figs. 270, 271). (Dossi also contributed the fifth large painting to the Camerino, *Bacchanal with Vulcan,* now lost.) The paintings revealed a number of relationships.[89]

Placement of Titian's *Andrians* and Bellini and Titian's *Feast of the Gods* next to each other on the single long wall made clear how—among several changes—Titian's substitution of a rocky promontory and sunny grasslands for Bellini's static screen of trees in the left background of the latter established a continuity with the right background of his own *Andrians*. On the short wall at the viewers' right, the putti-filled *Worship of Venus* was positioned so that a cupid in the right foreground aimed his arrow at Ariadne in *Bacchus and Ariadne* (with its snake-entwined figure a quote of the *Laocoön*) on the short wall opposite. If, as believed, *The Worship of Venus* hung in a similar position in the Camerino, the two adult humans in it would have looked toward a door as if to see who was entering.

There are further suggestions of the site-specific nature of the paintings. For instance, the two canvases that are supposed to have hung perpendicular to the windows are notable for the *contre-jour* effect of shiny objects—the jug in *Bacchus and Ariadne,* the mirror held overhead by one of the female figures in *The Worship of Venus*. Additionally, the proximity of the duke's bedroom may have been acknowledged by the clothes strewn on the ground in *Bacchus and Ariadne,* possibly a humorous reference to Alfonso's amorous escapades.[90]

The installation's suggestion of the Camerino (explained in the diagram and a wall text) teased viewers with what might have been. The exhibition's chief curator, David Jaffé, explained that "re-creating the Camerino was not attempted because it presented too many unknowns."[91] This was all the more frustrating given the existence of a colorful computer image of the original setting based on recent research and produced by the architectural technologist Robert Cripps, which was not included in the show (fig. 272). Cripps's virtual reconstruction shows the canvases closer together in homogeneous frames and more tightly enclosed by the architecture in a brightly colored and elaborately detailed interior. Even the red, white, and black floor marbles and their circular and diamond pattern are believed to have related to the paintings.[92] Instead of suggesting the frames, the surrounding colors, and the available light to which Titian tailored his paintings in all the settings he knew,[93] at the National Gallery the Camerino paintings had different frames and hung on dark grayish-beige walls, quite far from one another at the ends, and deprived of natural light.

Much of the art seen today in large, crowded galleries was made for the relatively

small rooms of private collectors' homes; for an exhibition that was as heavily attended as "Titian," it may well have been impossible to convey the intimacy of a *studiolo*. Indeed, visitors' criticism of the Dosso installation for being hung too high, with the paintings too close together,[94] indicates the degree to which the public is resistant to authentic historic settings.

Yet in not taking advantage of the unique moment when so many of the Camerino's original paintings were in hand, the National Gallery let pass a rare opportunity to convey the experience of this kind of Renaissance viewing. The close scrutiny enforced by the small size of a typical *studiolo* would have been particularly enlightening for treasures that seem to have been commissioned for their own sake, for the sheer joy of contemplating them, with none of the self-glorification characteristic of comparable collections.[95]

Convinced that "daylight makes all paintings sing," Jaffé had wanted to stage "Titian" in galleries that had natural light; instead, it took place in the Sainsbury Wing's temporary underground exhibition spaces. At its only other venue, the Prado in Madrid, the show was seen in the lofty, daylit Main Gallery (fig. 273). With only the Bellini and two of the Camerino Titians available (the condition of the *Bacchus* precluded its traveling), the Prado curators ruled out the idea of a historical reconstruction. What was lost in terms of understanding the original installation was more than compensated for by seeing the paintings in daylight. So miraculously were they enlivened, especially the highlights and sky effects, that, at least for Titian, daylight might be considered the most important context of all.

If "Titian" offered an example of how viewing practices have changed between the Renaissance and the present, the renovated Egyptian galleries at the Brooklyn Museum of Art demonstrate the rapidity with which such change occurs today. The colorful, evocative setting for "Egypt Reborn: Art for Eternity," unveiled in 2003, offers an entirely different approach from that of the first phase of the department's reinstallation, monochromatic, neutral spaces designed by the Japanese architect Arata Isozaki, working with the New York firm of James Stewart Polshek. That renovation—in the Morris A. and Meyer Schapiro Wing—replaced some steel and glass with wood, considered more compatible with Ancient Egyptian objects; brought sculpture away from the walls; and mixed chronological and thematic displays in an effort to convey every aspect of life in ancient Egypt.[96] It was guided, however, by a strictly Modernist approach: each object was presented as a self-sufficient entity in an abstract, white-cube gallery (fig. 274). When it opened in 1993, *Architecture* magazine described the Schapiro Wing as chillingly antiseptic.[97]

In reaction to this dry presentation, the new installation was inspired by a 1930s image of Egypt: purple and yellow walls and stylized Egyptian motifs evoke nothing so much as an Art Deco nightclub (fig 275). As with the Royal Ontario Museum's installation of "Egyptian Art in the Age of the Pyramids" (see page 116), historical

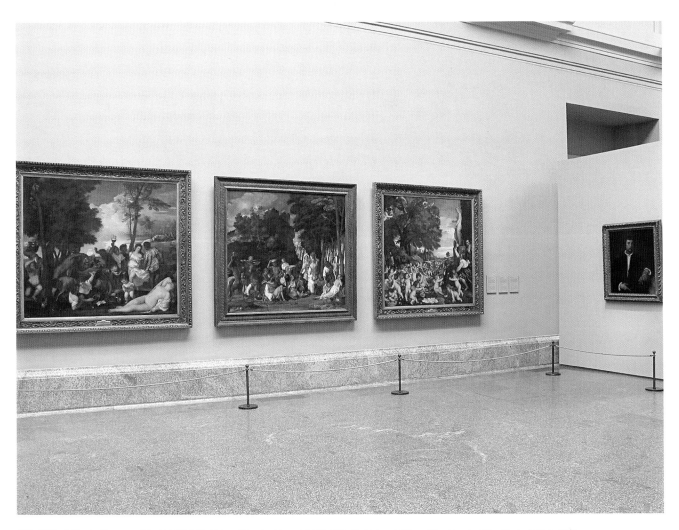

273. "Titian," Prado Museum, Madrid (2003): Titian, *The Andrians* (1523–24); Bellini and Titian, *The Feast of the Gods* (1514–29); Titian, *The Worship of Venus* (1518–20).

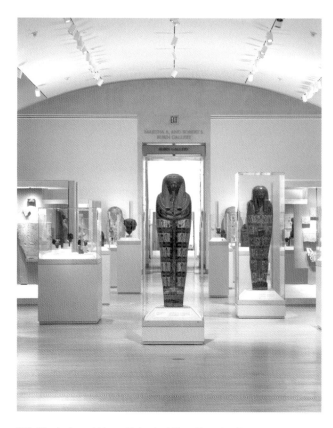

274. Morris A. and Meyer Schapiro Wing, Egyptian Department,
Brooklyn Museum of Art (inaugurated 1993): Mummy cartonnage
(linen mixed with plaster) of Nespanetjerenpere, possibly from Thebes
(Twenty-second–Twenty-fifth Dynasty, c. 945–712 B.C.), at center.

veracity was supplanted by the box office, possibly a new trend for institutions under
ever more pressure to increase attendance.

The late James F. Romano, a curator in the Brooklyn Museum's Egyptian
Department, wanted to evoke the bright colors of ancient Egyptian architecture with
a palette more familiar to the museum's audience. He also wanted to suggest how
westerners have perceived Egypt over time.[98] Greatly enlarged vintage photographs
of major archaeological sites add another historic dimension.

The large introductory gallery is given for the most part to unprotected sculptures
in the round, a presentation that is infinitely more welcoming than the forbidding
expanse of individual Plexiglas cases in the Schapiro Wing. In the central area are
statues of vastly different types and styles, dating from a period of several millennia,
arranged to answer viewers' frequently asked questions. The unusual juxtaposition
of such a wide range of artifacts illustrates clearly how form, iconography, and style
changed from the Old Kingdom to the Ptolemaic period. Smaller objects are generously
spaced in elegant vitrines, unencumbered by labels, which are relegated to the exteriors.

The next three galleries do not live up to the promise of the introduction. In these
crowded, claustrophobic areas, subdivided by era, bright red decorative motifs on the
walls recall the diamonds in a deck of playing cards, an image irrelevant to any known
vision of Egypt. Whereas the introductory gallery is surprisingly flattering to the

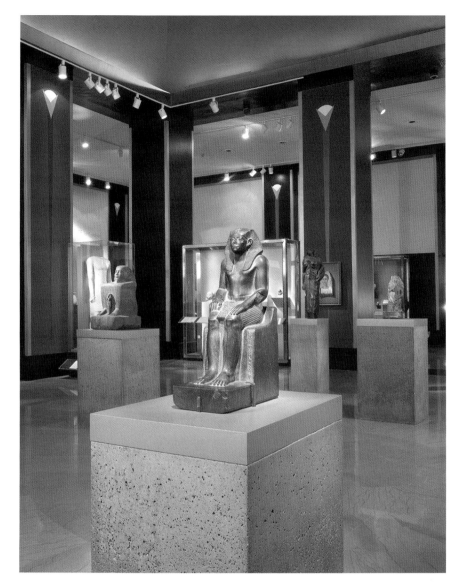

275. Introductory gallery, Egyptian Department, Brooklyn Museum (2003): King Senwosret III, granite, possibly from Hierakonpolis (Twelfth Dynasty, c. 1836–1818 B.C.), at center.

276. Third gallery, Egyptian Department, Brooklyn Museum (2003): Objects from Third to Sixth Dynasties.

sculpture, the truly extraordinary objects in the succeeding galleries are not shown to their best advantage (fig. 276).

If context can consist of something as narrow as the frame around a painting and as broad as the re-creation of a historic setting, contextual authenticity also covers a wide spectrum. In the most radical interpretation, since about 1980 it has been suggested that context might replace content altogether, that the object might disappear from museum galleries increasingly influenced by education and visitor services.[99] The change is not unlike the transition in terminology in the eighteenth century from the art cabinet to the collection, and the corresponding shift in emphasis from container to content.[100] In the early twenty-first century, that emphasis has been reversed.

Philippe Starck did just this for a retrospective of his work at the Pompidou Center (2003). Known internationally for offbeat designs of everything from evocative bull's-

277. "Philippe Starck," Pompidou Center (2003): Video projection of Starck's face below one image in sequence showing his products.

horn table lamps to theatrical Ian Schrager hotel interiors, Starck resisted an artful display of his mass-produced objects. Instead he made the show into a personal psychodrama.

The recent birth of his daughter inspired the designer's choice of pink for both the velour entrance curtains and the paper on which two exhibition-related publications were printed. Once through the curtains, visitors found themselves in a dark, cacophonous, circuslike space of more than eight thousand square feet and surrounded by projections of the designer's face, a treatment reminiscent of Tony Oursler's video art (fig. 277). At the center of the arena, light rose and fell on what Starck called the "Shadow," an enormous, bronze-coated form representing the designer's unconscious (fig. 278).

Starck's projected face topped eleven busts, each placed on a ten-foot-high bronze-painted pedestal and crowned with a laurel wreath. Above each bust, the designer's products passed endlessly across a framed video screen. From his multiple faces flowed a five-and-a-half-hour monologue on the mental and visual jokes behind his designs, successes and failures, reveries about his family, his wife, women in general, astronomy, evolution, film, and other subjects dear to him. In Starck's signature Surrealist mode, the talking heads occasionally morphed into skeletons.

Assuming the role of ringmaster, Starck began with the invitation *"Venez, venez, il n'y a rien a voir, il y a tout a recevoir!"* ("Step up, step up, there's nothing to see, everything to discover!") Close up, the transmissions were intelligible. From a distance, the eleven unsynchronized soundtracks produced an indistinguishable babble punctuated by bursts of song and incoherent yelps, likened by one reviewer to "speaking in tongues at a revivalist prayer meeting."[101] The deafening mix of Laurie Anderson music with Starck's own voice was part of the send-up: having invited the public to witness the workings of his mind, Starck took every opportunity to poke fun at himself, managing in the end to remain as mysterious as ever.

Starck's hypothesis was that his exhibition offered more than the actual objects could. Turning the traditional circus-barker formula into a promise not of amazing objects but of information, Starck's installation could be interpreted as a parody of the New Museology, dismissed by some as a potential "circus" of never-ending links that might eventually oblige viewers to read *Ulysses* and listen to Webern in order to appreciate a painting by Mondrian hanging next to a Breuer chair.[102]

The designer's installation also recalls Robert Venturi and Denise Scott Brown's concept of architecture as sign rather than as creation of space in what has become our two-dimensional, electronic era. Or perhaps he is simply reverting to the age-old idea that concealment enhances an object's value (see page 114).

Starck's exhibition invites a return to the analogy between fine art and high fashion.

278. "Philippe Starck," Pompidou Center (2003): "Shadow."

279. Film still, Robert Altman, *Ready to Wear* (1994).

In the climactic scene of Robert Altman's 1994 film *Ready to Wear,* nude models parade down the runway before a rapt audience: all the trappings of a conventional fashion show are there except the fashions (fig. 279). Starck's objects suffered the same fate as Altman's clothes: context completely took over content.

To a certain degree, the same is true of the Getty Villa's historical re-creation of the Villa dei Papiri peristyle garden and the sculpture replicas that will be displayed in it (see figs. 90, 91). There is, however, a major difference: while the Getty will indeed substitute imitation for authenticity, and reproduction for reality, it has not lost sight of the objects themselves.

As for how to display the original objects, which command such a wide audience today—be they painting, sculpture, post-studio art, the decorative arts, architectural drawings and models, or design—the debate goes on. In 2003 and 2004 in New York alone, a number of symposiums addressed the question of how the architecture of new museums might best relate to what such museums intend to exhibit.[103] One thing is certain: objects in different media and sizes from various historic backgrounds have distinct installation needs; the nature of the walls, the quality of light, and the scale of the spaces are among the many elements that constitute the equivalent of an appropriate dress for the event and for the season.

NOTES

Introduction

1. I am indebted to Julie Reiss for calling my attention to Daniel Buren's first use, in 1971, of the word *installation* in reference to art display, cited in his article, "The Function of the Studio," *October* 10 (Fall 1979): 51–58. Reiss points out that prior to about 1970 the relatively new medium of installation art (which is not discussed here) was usually referred to as environment art.

2. Brunilde Sismondo Ridgway, review of *Der Koloss von Rhodos und die Bauten des Helios: Neue Forschungen zu einem der Sieben Weltwunder,* by Wolfram Hoepfner, *Bryn Mawr Classical Review,* http://ccat.sas.upenn.edu/bmcr/2004/2004-01-25.html. See also J. J. Pollitt, "A Rhodian School of Sculpture," in Nancy T. de Grummond and Brunilde Sismondo Ridgway, eds., *From Pergamon to Sperlonga: Sculpture and Context* (Berkeley and Los Angeles: University of California Press, 2000), 92–110; and Herbert Maryon, "The Colossus of Rhodes," *Journal of Hellenic Studies* 76 (1956): 68–86.

3. Ellen Rice, "The Glorious Dead: Commemoration of the Fallen and Portrayal of Victory in the Late Classical and Hellenistic World," in John Rich and Graham Shipley, eds., *War and Society in the Greek World* (London and New York: Routledge, 1993), 224–57.

4. Unless otherwise indicated, the description of this incident is based on Saul Levine, "The Location of Michelangelo's *David:* The Meeting of January 25, 1504," *Art Bulletin,* March 1974, 31–49.

5. Charles de Tolnay, *The Youth of Michelangelo* (Princeton, N.J.: Princeton University Press, 1969), 152.

6. Kathleen Weil-Garris, "On Pedestals: Michelangelo's *David,* Bandinelli's *Hercules and Cacus,* and the Sculpture of the Piazza della Signoria," *Römisches Jahrbuch für Kunstgeschichte* (Tübingen: Ernst Wasmuth, 1983), 378–415.

7. For one of several alternative interpretations, see N. Randolph Parks, "The Placement of Michelangelo's *David:* A Review of the Documents," *Art Bulletin,* December 1975, 560–70.

8. Calvin Tomkins, "Profiles: A Touch for the Now," *New Yorker,* July 29, 1991, 33–57; Walter Hopps, conversation with the author, November 21, 2000.

9. Dorothea Rockburne, conversation with the author, May 20, 2003.

10. Exceptionally, some collections such as the holdings of the Medici in the Uffizi and those of the Grimani in the Public Statuary in Venice were accessible as early as the late sixteenth century.

11. Krzysztof Pomian, *Des saintes reliques à l'art moderne, Venise-Chicago XIII–XX Siècle* (Paris: Gallimard, 2003), 153–54, describes six changes in the relationship of some artworks with others and with viewers: place, juxtaposition, verbal context, exhibition method, audience, and behavior toward the object.

12. Andrew McClellan, "The Museum and Its Public in Eighteenth-Century France," in Per Bjurström, ed., *The Genesis of the Art Museum in the 18th Century* (Stockholm: Nationalmuseum, 1993), 61–80.

13. Michael Koortbojian, "Forms of Attention: Four Notes on Replication and Variation," in Elaine K. Gazda, ed., *The Ancient Art of Emulation: Studies in Artistic Originality and Tradition from the Present to Classical Antiquity* (Ann Arbor: University of Michigan Press, 2002), 173–204.

14. Giuseppe Olmi, "Science, Honour, Metaphor: Italian Cabinets of the Sixteenth and Seventeenth Centuries," in Oliver Impey and Arthur MacGregor, eds., *The Origins of Museums: The Cabinet of Curiosities in Sixteenth- and Seventeenth-Century Europe* (London: House of Stratus, 2001), 1–18. References to Giulio Camillo's Memory Theater, an elaborate early-sixteenth-century design intended to recall the history of the universe, may at times have reinforced such programs; Eileen Hooper-Greenhill, *Museums and the Shaping of Knowledge* (London and New York: Routledge, 1992), 97, 101. For Camillo's Memory Theater, see also Francis A. Yates, *The Art of Memory* (1966; reprint, London: Pimlico, 1992), 135–62; and Jocelyn Penny Small, *Wax Tablets of the Mind: Cognitive Studies of Memory and Literacy in Classical Antiquity* (London and New York: Routledge, 1997).

15. Paula Findlen, *Possessing Nature: Museums, Collecting, and Scientific Culture in Early Modern Italy* (Berkeley and Los Angeles: University of California Press, 1994), 101.

16. J. M. Fletcher, "Isabella d'Este, Patron and Collector," in *Splendours of the Gonzaga* (exhibition catalog, London: Victoria and Albert Museum/Milan: Amilcare Pizzi, 1981), 51–63.

17. Sylvia Ferino-Pagden, "La Prima Donna del Mondo," in *Isabella d'Este: Fürstin und Mäzenatin der Renaissance* (exhibition catalog, Vienna: Kunsthistorisches Museum, 1994), 164 and fig. 33.

18. Rose Marie San Juan, "The Court Lady's Dilemma: Isabella d'Este and Art Collecting in the Renaissance," *Oxford Art Journal* 14, no. 1 (1991): 67–78.

19. Claudia Cieri Via, "I Camerini di Isabella d'Este: Uno spazio culturale esemplare," in *Isabella d'Este, i luoghi del collezionismo* (exhibition catalog, Mantua: Palazzo Ducale, 1995), 16–34.

20. Egon Verheyen, *The Paintings in the Studiolo of Isabella d'Este at Mantua* (New York: New York University Press, 1971), 21.

21. The description of the *grotta* is based on Clifford M. Brown, "The Grotta of Isabella d'Este," *Gazette des Beaux-Arts,* May–June 1977, 155–71.

22. Fletcher, "Isabella d'Este, Patron and Collector."

23. San Juan, "Court Lady's Dilemma."

24. Larry J. Feinberg, "The Studiolo of Francesco I Reconsidered," in Cristina Acidini Luchinat et al., eds., *The Medici, Michelangelo, and the Art of Late Renaissance Florence* (exhibition catalog, Detroit: Detroit Institute of Art/New Haven: Yale University Press, 2002), 47–65; Michael Rinehart, "A Document for the Studiolo of Francesco I," in Moshe Barasch and Lucy Freeman Sandler, eds., Patricia Egan, coordinating ed., *Art, the Ape of Nature: Studies in Honor of H. W. Janson* (New York: Harry N. Abrams/Englewood Cliffs, N.J.: Prentice-Hall, 1981), 275–89.

25. Considerations regarding private/public viewing are based on Jacqueline Lichtenstein, "Eloquence du coloris: Rhétorique et mimesis dans les conceptions coloristes au 16e siècle en Italie et au 17e siècle en France," *Symboles de la Renaissance,* vol. 2 (Paris: Presses de l'Ecole Normale Supérieure, 1982), 187–203.

26. Gloria Fossi, *The Uffizi Gallery: Art, History, Collections* (Florence: Giunti, Firenze Musei, 2001), 8–9.

27. Paula Findlen, "The Museum, Its Classical Etymology and Renaissance Genealogy," in Bettina Messias Carbonell, ed., *Museum Studies: An Anthology of Contexts* (London: Blackwell, 2004), 23–50.

28. Detlef Heikamp, "Zur Geschichte der Uffizien-Tribuna und der Kunstschränke in Florenz und Deutschland," in Margarete Kühn, ed., *Zeitschrift für Kunstgeschichte* 26, vol. 3–4 (Munich and Berlin: Deutscher Kunstverlag, 1963): 193–268.

29. *Il terzo libro di Sebastiano Serlio, bolognese,* cited in Jeffrey M. Muller, "Rubens's Museum of Antique Sculpture: An Introduction," *Art Bulletin,* December 1977, 571–82.

30. See Marilyn Perry, "The Statuario Publico of the Venetian Republic," *Saggi e memorie di storia dell'arte* 8 (1972): 76–113, figs. 221–53.

31. Jeffrey M. Muller, *Rubens: The Artist as Collector* (Princeton, N.J.: Princeton University Press, 1989), 38–39.

32. Nicholas Penny, *Frames* (London: National Gallery Publications/New Haven: Yale University Press, 1997), 39–40.

33. Unless otherwise noted, the discussion of the French Royal Academy exhibitions and related quotes are based on Georges Lafenestre, "Le Salon et ses vicissitudes," *Revue des deux-mondes,* May 1, 1881, 104–35.

34. See Patricia Mainardi, *The End of the Salon: Art and the State in the Early Third Republic* (Cambridge: Cambridge University Press, 1993), 1–8. Mainardi points out that in one of the many changes in taste, sculpture declined in popularity and was almost ignored throughout the nineteenth century.

35. In the Grande Galerie, before skylights were installed (by 1810), lighting was also problematic. See John Gage, *Color in Turner: Poetry and Truth* (New York and Washington: Frederick Praeger, 1969), 148–64.

36. Patricia Mainardi, "Some Stellar Moments in

the History of Government-Sponsored Exhibitions," *Art in America,* July 1990, 154–57; Mainardi, *End of the Salon,* 12. In the salons of 1861–80, artists' works were hung alphabetically; John House, "Face to Face with *Le Déjéuner* and *Un bar aux Folies-Bergère,*" in James Cuno and Joachim Kaak, eds., *Manet Face to Face* (exhibition catalog, London: Courtauld Institute of Art, 2004), 55–97.

37. David H. Solkin, *Art on the Line: The Royal Academy Exhibitions at Somerset House, 1780–1836* (New Haven: Yale University Press, 2001), 25.

38. Gage, *Color in Turner,* 148–64; Solkin, *Art on the Line,* 16, 36.

39. See Mark Rosenthal, *Understanding Installation Art: From Duchamp to Holzer* (New York: Prestel, 2003). See also Martha Buskirk, "Context as Subject," *The Contingent Object of Contemporary Art* (Cambridge, Mass.: MIT Press, 2003), 161–208.

40. This description of David's installations is based on Dorothy Johnson, *Jacques-Louis David: Art in Metamorphosis* (Princeton, N.J.: Princeton University Press, 1993), 131–35, 269–72, nn. 273, 290–91.

41. Unless otherwise indicated, discussion of Impressionist and Neo-Impressionist installation practices and reactions to them is based on Martha Ward, "Impressionist Installations and Private Exhibitions," *Art Bulletin,* December 1991, 1, 599–622. The term "Impressionist" was not used for the first two exhibitions; Oskar Bätschmann, *The Artist in the Modern World: A Conflict Between Market and Self-Expression* (New Haven: Yale University Press, 1997), 138–42.

42. Kenneth John Myers, *Mr. Whistler's Gallery: Pictures at an 1884 Exhibition* (exhibition catalog, Washington, D.C.: Freer Gallery of Art, Smithsonian Institution/London: Scala Publishers, 2003), 10. A similar effort to coordinate art and decor (the *Gesamtkunstwerk*) was made at the end of the nineteenth century by Secession artists in Vienna and other central European countries.

43. Matthias Waschek, "Georges Seurat: The Frame as Boundary of the Artwork," in Eva Mendgen, ed., *In Perfect Harmony: Picture and Frame, 1850–1920* (exhibition catalog, Zwolle, Netherlands: Waanders Uitgevers, 1995), 149–62.

44. Brian O'Doherty, *Inside the White Cube: The Ideology of the Gallery Space* (Berkeley and Los Angeles: University of California Press, 1999).

45. Mary Anne Staniszewski, *The Power of Display: A History of Exhibition Installations at the Museum of Modern Art* (Cambridge, Mass.: MIT Press, 1998), 62, 64, 66.

46. See Bruce Altshuler, *The Avant-Garde in Exhibition: New Art in the Twentieth Century* (Berkeley and Los Angeles: University of California Press, 1994).

47. See Michael Fried, "Art and Objecthood," *Art-forum,* June 1967, 12–25; reprinted in Gregory Battcock, ed., *Minimal Art: A Critical Anthology* (New York: Dutton, 1968), 116–47.

48. See Carol Vogel, "Fight over Barnes Collection Ends," *New York Times,* December 14, 2004, A1.

49. Statistics provided by the respective museums.

50. Philippe de Montebello, conversation with the author, February 27, 2003.

51. Mainardi, "Some Stellar Moments."

52. Among innumerable articles on this subject, one of the most recent is Janet Tassel, "Reverence for the Object: Art Museums in a Changed World," *Harvard Magazine,* September–October 2003, 48–58, 98. See also Yve-Alain Bois, "Exposition: Esthétique de la distraction, éspace de démonstration," *Les Cahiers du Musée National d'Art Moderne,* Autumn 1989, 57–79; and for the museum's shift in orientation from its artifacts to its visitors, Barbara Kirshenblatt-Gimblett, *Destination Culture: Tourism, Museums, and Heritage* (Berkeley and Los Angeles: University of California Press, 1998), 138–39.

53. Barry Bergdoll, *Karl Friedrich Schinkel: An Architecture for Prussia* (New York: Rizzoli, 1994), 80.

54. Rem Koolhaas, *Content* (exhibition catalog, Berlin: Neue Nationalgalerie/New York: Taschen, 2004), 255.

55. Francis Haskell, *The Ephemeral Museum: Old Master Paintings and the Rise of the Art Exhibition* (New Haven: Yale University Press, 2000), 83.

56. Unless otherwise indicated, the description of the exhibition and its background is based on Christine Riding, "The *Raft of the Medusa* in Britain: Audience and Context," in *Constable to Delacroix: British Art and the French Romantics* (exhibition catalog, London: Tate Publishing, 2003), 66–73.

57. It was in fact moved to a lower position in a different area halfway through the exhibition; Lorenz E. A. Eitner, *Géricault: His Life and Work* (London: Orbis, 1983), 188, 345, n. 149.

58. Lee Johnson, "The *Raft of the Medusa* in Great Britain," *Burlington Magazine* 46 (August 1954): 249–54. See also Jonathan Crary, "Géricault, the Panorama, and Sites of Reality in the Early Nineteenth Century," *Grey Room* 9 (Fall 2002): 5–25. For the Egyptian Hall, see Richard D. Altick, *The Shows of London* (Cambridge, Mass.: Belknap Press of Harvard University Press, 1978), 235–52.

59. Stephan Oettermann, *The Panorama: History of a Mass Medium* (New York: Zone Books, 1997), 28, 54.

60. Johnson, "*Raft of the Medusa* in Great Britain."

61. Riding, "*Raft of the Medusa* in Britain."

62. Johnson, "*Raft of the Medusa* in Great Britain."

63. John Whitely, "Exhibitions of Contemporary Painting in London and Paris, 1760–1860," in Francis Haskell, ed., *Saloni, gallerie, musei e loro influenza sullo sviluppo dell'arte dei secoli XIX e XX* (Bologna: Clueb, 1981), 69–88.

64. This account of the exhibitions of Church's *Heart of the Andes* and Albert Bierstadt's *Domes of the Yosemite* is based on Kevin J.

Avery, "*Heart of the Andes* Exhibited: Frederic E. Church's Window on the Equatorial World," *American Art Journal* 18, no. 1 (Winter 1986): 52–72; and Avery, *Church's Great Picture: Heart of the Andes* (New York: Metropolitan Museum of Art, 1993). See also Barbara Novak, "Grand Opera and the Still Small Voice," *Nature and Culture* (New York: Oxford University Press, 1980), 18–33.

65. Louisa Buck, "Saatchi's Challenge to Tate," *Art Newspaper,* April 2003, 23.

66. Neil Harris, *Cultural Excursions: Marketing Appetites and Cultural Tastes in Modern America* (Chicago: University of Chicago Press, 1990), 56–81.

67. Julia Sapin, professor at Western Washington University, e-mail message to the author, March 22, 2004. Department store galleries, often officially designated as "museums of art," play an important educational role in Japan. See Millie Creighton, "Something More: Japanese Department Stores' Marketing of 'A Meaningful Human Life,'" in Kerrie L. MacPherson, ed., *Asian Department Stores* (Honolulu: University of Hawaii Press, 1998), 206–32.

68. The description of the 1889 Salons is based on M. J. Aquilino, "The Decorating Campaigns at the Salon du Champ-de-Mars and the Salon des Champs-Elysées in the 1890s," *Art Journal,* Spring 1989, 78–84.

69. Herbert Gibbons, *John Wanamaker,* vol. 2 (New York and London: Harper and Bros., 1926), 81; quoted in Harris, *Cultural Excursions.*

70. Nicolas Calas, "Mexico Brings Us Art," *View* 1, no. 1 (September 1940): 2. "Italy: The New Domestic Landscape" at MoMA in 1972 received similar criticism, and in retrospect, the shipping cases used for displays by the curator, Emilio Ambasz, seem particularly inspired.

71. John Tagliabue, "Department Stores Seek the Fountain of Youth," *International Herald Tribune,* December 17, 2003, 1, 4.

72. See Roberta Smith, "Rituals of Consumption," *Art in America,* May 1988, 164–71.

73. Liesbeth Bik and Jos van der Pol, *Moderna Museet Projekt* (exhibition catalog, Stockholm: Moderna Museet, 2001), 16–17.

74. George Schackleford, conversation with the author, August 14, 2003.

75. Robert Rosenblum, conversation with the author, October 22, 2003.

76. Susan Moore, "Art on the Line," *Apollo,* July 2002, 49–50.

77. David Sylvester's reputation and his 1960 MoMA experience are described in the unsigned "Notes on Installing Art," *Tate: The Art Magazine* 12 (Summer 1997): 30–37.

78. For the multiple layers of meaning, each with an endless series of determinants, invoked by theoreticians of the so-called New Museology to define context, see Mieke Bal and Norman Bryson, "Semiotics and Art History," *Art Bulletin,* June 1991, 174–208.

The Complexities of Context

How Place Affects Perception

1. Antoine C. Quatremère de Quincy, *Lettres à Miranda sur le déplacement des monuments de l'art de l'Italie (1796)* (Paris: Macula, 1989), 105, 101.

2. For Phidias and the Parthenon sculptures, see Adolf Lippold and Nikolaus Himmelmann-Widschütz, eds., "Phidias und die Parthenon-Skulpturen," *Bonner Festgabe Johannes Straub zum 65. Geburtstag am 18 Oktober, 1977* (Bonn: Rhineland Verlag, 1977), 67–90; for centauromachy, see Robin Osborne, "Framing the Centaur: Reading Fifth-Century Architectural Sculpture," *Art and Text in Ancient Greek Culture* (Cambridge: Cambridge University Press, 1994), 52–84; for the frieze, see Jennifer Neils, *The Parthenon Frieze* (Cambridge: Cambridge University Press, 2001); for the pediments, see Olga Palagia, *The Pediments of the Parthenon*, 2nd ed. (Leiden, Netherlands: E. J. Brill, 1998); and for public perception of the pediment sculpture, see Froma I. Zeitlin, "The Artful Eye: Vision, Ecphrasis and Spectacle in Euripidean Theater," in Simon Goldhill and Robin Osborne, eds., *Art and Text in Ancient Greek Sculpture* (Cambridge: Cambridge University Press, 1994), 138–96.

3. Brunilde Sismondo Ridgway, *Prayers in Stone: Greek Architectural Sculpture ca. 600–100 B.C.* (Berkeley and Los Angeles: University of California Press, 1999), 136 n. 28.

4. Irving Lavin, *Bernini and the Unity of the Visual Arts*, vol. 2, *The Cornaro Chapel in Santa Maria della Vittoria: The Glorification of St. Teresa* (New York: Pierpont Morgan Library, 1980), 85–86.

5. Rudolf Wittkower, *Art and Architecture in Italy, 1600–1750* (Harmondsworth, Middlesex: Penguin Books, 1973), 102.

6. Hans-Ulrich Cain, "Hellenistische Kultbilder: Religiöse Präsenz und museale Präsentation der Götter im Heiligtum und beim Fest," *Stadtbild und Bürgerbild im Hellenismus* (Munich: C. H. Beck'sche Verlagsbuchhandlung, 1995), 115–30. See also Simona Bettinetti, *La statua di culto nella pratica rituale greca* (Bari: Levante Editori, 2001), 66–89, 185–210.

7. Seymour Howard, *Antiquity Restored: Essays on the Afterlife of the Antique* (Vienna: IRSA, 1990), 28.

8. Aileen Ajootian, "A Day at the Races: The Tyrannicides in the Fifth-Century Agora," in Kim J. Hartswick and Mary C. Sturgeon, eds., *Studies in Honor of Brunilde Sismondo Ridgway* (Philadelphia: University Museum, University of Pennsylvania for Bryn Mawr College, 1998), 1–13.

9. See Matthias Winner, Bernard Andreae, and Carlo Pietrangeli, eds., *Il Cortile delle Statue: Der Statuenhof des Belvedere im Vatikan,*

Congress in Honor of Richard Krautheimer, Rome, Oct. 21–23, 1992 (Mainz am Rhein: Verlag Philipp von Zabern, 1998).

10. Andrew Stewart, "Narration and Allusion in the Hellenistic Baroque," in Peter J. Holliday, ed., *Narrative and Event in Ancient Art* (Cambridge: Cambridge University Press, 1993), 130–74.

11. Brunilde Sismondo Ridgway, *Hellenistic Sculpture*, vol. 2, *The Styles of ca. 200–100 B.C.* (Madison: University of Wisconsin Press, 2000), 150–56 and 159 for date. The *Nike of Samothrace* may have been commissioned to commemorate a naval battle in 190 B.C. won by the Romans, with help from Rhodes, against Antiochus the Great of Syria. For a dissenting opinion about the statue's origins, see Michèle Daumas, "La Révélation Cabirique," *Cabirica: Recherches sur l'iconographie du culte des Cabires* (Paris: De Boccard, 1998), 253–65.

12. Marianne Hamiaux, *Les Sculptures Grècques,* vol. 2, *La période hellénistique (IIIe–Ier siècles avant J.-C.)* (Paris: Editions de la Réunion des Musées Nationaux, 1998), 27–40.

13. These brief comments on early Hellenistic sculpture are based on Brunilde Sismondo Ridgway, "The Setting of Greek Sculpture," *Hesperia*, July–September 1971, 336–56.

14. Unless otherwise stated, my discussion of the two *Nikes* by Paionios at Olympia is based on Tonio Hölscher, "Die Nike der Messenier und Naupaktier in Olympia. Kunst und Geschichte im späten 5. Jahrhundert v. Chr.," *Jahrbuch des Deutschen Archäologischen Instituts* 89 (1974): 70–111.

15. Jennifer Neils, "The Panathenaia: An Introduction," in Jennifer Neils, ed., *Goddess and Polis: The Panathenaic Festival in Ancient Athens* (exhibition catalog, Hanover, N.H.: Hood Museum of Art, Dartmouth College/Princeton, N.J.: Princeton University Press, 1992), 13–28; Noel Robertson, "Athena's Shrines and Festivals," and Jennifer Neils, "Pride, Pomp and Circumstance," in Jennifer Neils, ed., *Worshipping Athena: Panathenaia and the Parthenon* (Madison: University of Wisconsin Press, 1996), 27–77, 177–97; Robert Parker, *Athenian Religion: A History* (New York: Oxford University Press, 1996).

16. My description of these later processions is based on Cain, "Hellenistische Kultbilder."

17. An interesting parallel took place in the late sixteenth and seventeenth centuries when the concept of museums was being formulated and theater was conflated with that concept; see Paula Findlen, "The Museum, Its Classical Etymology and Renaissance Genealogy," in Bettina Messias Carbonell, ed., *Museum Studies: An Anthology of Contexts* (London: Blackwell, 2004), 23–50.

18. Cain, "Hellenistische Kultbilder."

19. Marianne Hamiaux, ingénieur d'études, Louvre Museum, conversation with the author, July 5, 2001.

20. Heiner Knell, *Die Nike von Samothrake: Typus, Form, Bedeutung und Wirkungsgeschichte eines rhodischen Sieges-Anathems im*

Kabirienheiligtum von Samothrake (Darmstadt: Wissenschaftliche Buchgesellschaft, 1995), 45–81.

21. Knell, *Die Nike,* 90–99 and figs. 60, 62.

22. Knell, *Die Nike,* 79.

23. Phyllis Williams Lehmann and Karl Lehmann first published this theory in *Samothracian Reflections: Aspects of the Revival of the Antique* (Princeton, N.J.: Princeton University Press, 1973), 184–88.

24. James R. McCredie, director of excavations in Samothrace, conversation with the author, January 22, 2002. McCredie also suggests that the statue may have originally stood within a protective structure.

25. Ridgway, *Hellenistic Sculpture*, vol. 2, 154. Ridgway notes that a similar concept was expressed on the east pediment of the Elgin Marbles, where the Sun Chariot emerges from waves; conversation with the author, April 11, 2001.

26. Knell, *Die Nike,* 10–11.

27. Ridgway, *Hellenistic Sculpture*, vol. 2, 156.

28. Unless otherwise indicated, my description of the discovery, restoration, and placements of the *Nike* at the Louvre is based on Marianne Hamiaux, "La Victoire de Samothrace: Découverte et Restauration," *Journal des Savants,* January–June 2001, 153–223; Hamiaux, "La Victoire de Samothrace: Mode d'assemblage de la statue," *Comptes rendus des séances de l'année 1998, Académie des Inscriptions et Belles Lettres,* 356–76; and my conversation with Hamiaux, July 5, 2001, to whom I am indebted for her generous help with this description.

29. Kathleen Weil-Garris, "On Pedestals: Michelangelo's *David,* Bandinelli's *Hercules and Cacus,* and the Sculpture of the Piazza della Signoria," *Römisches Jahrbuch für Kunstgeschichte* (Tübingen: Ernst Wasmuth, 1983), 378–415.

30. Lehmann and Lehmann, *Samothracian Reflections,* 192–93.

31. Christiane Aulanier, *Histoire du Palais et du Musée du Louvre,* 10 vols. (Paris: Editions des Musées Nationaux, 1947–71), vol. 5, 47, 49.

32. Charles Ravaisson-Mollien, "La Critique des Sculptures Antiques au Musée du Louvre, à propos des Catalogues en préparation," pts. 1–3, *Revue Archéologique,* September 1876, 145–57, October 1876, 252–63, November 1876, 318–41.

33. For part of its time in the Salle des Caryatides, the *Nike* seems to have enjoyed some daylight, thanks to a window beside the fireplace (now blocked off); Héron de Villefosse, quoted in Hamiaux, "La Victoire de Samothrace," 169 n. 27.

34. There is a rich literature on museum culture. Basic, if slightly outdated, is Germain Bazin, *The Museum Age* (New York: Universe Books, 1967); see also Douglas Crimp, *On the Museum's Ruins* (Cambridge, Mass.: MIT Press, 1993), 44–65; Carol Duncan, *Civilizing Rituals: Inside Public Art Museums* (London and New York: Routledge, 1995); and Victoria

Newhouse, *Towards a New Museum* (New York: Monacelli Press, 1998).

35. Hamiaux, "La Victoire de Samothrace."

36. Ravaisson-Mollien, "La Critique des Sculptures Antiques," pt. 2, 252–63.

37. Marianne Hamiaux, letter to the author, August 6, 2002.

38. Aulanier, *Histoire du Palais,* vol. 4, 37.

39. Aulanier, *Histoire du Palais,* vol. 4, 37.

40. *Chronique des Arts,* September 1892, 235; quoted in Aulanier, *Histoire du Palais,* vol. 4, 38.

41. Aulanier, *Histoire du Palais,* vol. 4, 37.

42. Archives du Louvre, vol. 16, May 17, 1897; quoted in Aulanier, *Histoire du Palais,* vol. 4, 38.

43. André Hallays, "Le Louvre de Visconti et de Lefuel," *Les Débats,* July 1, 1910, quoted in Aulanier, *Histoire du Palais,* vol. 4, 38.

44. The installation of the Salle des Caryatides was described as being "stupefyingly profuse" (my translation); Aulanier, *Histoire du Palais,* vol. 4, 72.

45. Hamiaux, conversation.

46. Several decades earlier, J.-G.-F. Ravaisson-Mollien had pointed out that ancient coins portrayed the Goddess of Victory standing on an intermediary platform rather than directly on the deck as she did at the Louvre; Hamiaux, "La Victoire de Samothrace," 211. Remains of dowel cuttings on the surface of the ship's deck reinforce the idea. Ridgway, *Hellenistic Sculpture,* vol. 2, 178 n. 28.

47. Since the completed curved prow would hide the bottom part of the *Nike,* this discovery provides yet another argument in favor of the figure's oblique positioning; Hamiaux, conversation.

48. Hamiaux, conversation.

49. Marianne Hamiaux, e-mail message to the author, September 5, 2003.

50. Virgil, *The Aeneid,* trans. Robert Fitzgerald (New York: Random House, 1983), II:50–51.

51. Pliny the Elder, *Natural History,* trans. Harris Rackham et al. (Cambridge, Mass.: Harvard University Press, 1938–63), 36:37.

52. Unless otherwise indicated, my descriptions of the Belvedere Courtyard's design, its classical antecedents, and its impact on subsequent projects are based on James S. Ackerman, *The Cortile del Belvedere* (Vatican City: Biblioteca Apostolica Vaticana, 1954).

53. Hans Henrik Brummer, "On the Julian Program of the Cortile delle Statue in the Vatican Belvedere," in Winner et al., *Il Cortile delle Statue,* 68–75; see also Brummer, *The Statue Court in the Vatican Belvedere* (Stockholm: Almquist & Wiksell, 1970).

54. Caroline Elam, "Lorenzo de' Medici's Sculpture Garden," *Mitteilungen des Kunsthistorischen Instituts in Florenz* 36:1–2 (1992): 41–84.

55. Christoph Luitpold Frommel, "I tre progetti bramanteschi per il Cortile del Belvedere," in Winner et al., *Il Cortile delle Statue,* 17–66.

56. Brunilde Sismondo Ridgway, "Greek Antecedents of Garden Sculpture," in Elisabeth B. MacDougall and Wilhelmina F. Jashemski, eds., *Ancient Roman Gardens, 7th Dumbarton Oaks Colloquium on the History of Landscape Architecture, 1979* (Washington, D.C.: Dumbarton Oaks Trustees for Harvard University, 1981), 7–28.

57. Brummer, *Statue Court,* 232–33. See also David R. Coffin, *Gardens and Gardening in Papal Rome* (Princeton, N.J.: Princeton University Press, 1991), 3–27.

58. The drawing was discovered and published by Matthias Winner, "La Collocazione degli dei fluviali nel Cortile delle Statue e il restauro del Laocoönte del Montorsoli," in Winner et al., *Il Cortile delle Statue,* 117–28.

59. My chronology of the placement of statues in the Statue Court is based on Paolo Liverani, "Geschichte des Cortile Ottagono im Belvedere," in Bernard Andreae and Jens Köhler, eds., *Museo Pio Clementino, Cortile Ottagono* (Berlin: Walter de Gruyter, 1998), v–xv. See also Liverani, "Antikensammlung und Antikenergänzung," in *Hochrenaissance im Vatikan: Kunst und Kultur im Rom der Päpste, 1503–1534* (exhibition catalog, Bonn: Kunst- und Ausstellungshalle der Bundesrepublik Deutschland, 1998), 227–35; Liverani, "Restauro e allestimenti storici nei Musei Vaticani," in Autmella Romualdi, ed., *Le sculture antiche. Problematiche legate all'espozione dei marmi antiche nelle collezioni storiche* (Florence: Edizioni Polistampa, 2003), 27–48; Brummer, "On the Julian Program," 68–75.

60. David R. Coffin, "The 'Lex Hortorum' and Access to Gardens of Latium during the Renaissance," *Journal of Garden History,* July–September 1982, 201–32. Frommel dates the spiral stairway in "I tre progetti bramanteschi."

61. For the Roman development of niches, see Gertraut Hornbostel-Hüttner, *Studien zur römischen Nischenarchitektur* (Leiden, Netherlands: E. J. Brill, 1979), 203–13.

62. Weil-Garris, "On Pedestals."

63. Margaret Finch, "The Cantharus and Pigna at Old St. Peter's," *Gesta* 30:1 (1991): 16–26.

64. Tilmann Buddensieg, "Die Statuenstiftung Sixtus IV im Jahr 1471," *Römisches Jahrbuch für Kunstgeschichte* (Tübingen: Ernst Wasmuth, 1983), 35–73.

65. Brummer, "On the Julian Program," 68–75.

66. Arnold Nesselrath, "Wissenschaftliche und nichtwissenschaftliche Beschäftigung mit der Antike," in *Hochrenaissance im Vatikan,* 236–39; Brummer, *Statue Court,* 238–51.

67. Hanno-Walter Kruft, "Metamorphosen des Laocoon: Ein Beitrag zur Geschichte des Geschmacks," *Pantheon,* January–March 1984, 3–11. See also Maria Louro Berbara, *Christ as Laocoön: An Iconographic Parallel between Christian and Pagan Sacrificial Representations in the Italian Renaissance* (Hamburg: Buchdruckerei Gunter Stubbemann, 1999).

68. Winner, "La Collocazione degli dei fluviali." See also Liverani, "Antikensammlung und Antikenergänzung."

69. Kathleen Wren Christian, "The Della Valle Sculpture Court," *Burlington Magazine,* December 2003, 847–50. Christian points out that the cardinal's holdings eventually formed the core of the Uffizi's antique sculpture collection and that the court influenced the display of sculpture in Rome for many generations.

70. Liverani, "Antikensammlung und Antikenergänzung."

71. Liverani, "Geschichte des Cortile Ottagono."

72. Winner, "La Collocazione degli dei fluviali."

73. Ludovico Rebaudo, "I restauri del Laocoonte," in Salvatore Settis, *Laocoonte: Fama e stile* (Rome: Donzelli, 1999), 231–58.

74. Winner, "La Collocazione degli dei fluviali."

75. Howard, *Antiquity Restored,* 42–62, 249–51.

76. Naomi Miller, *Heavenly Caves: Reflections on the Garden Grotto* (New York: George Braziller, 1982), 17–18.

77. Ackerman, *Cortile del Belvedere,* 34–35.

78. Liverani describes the elimination of the orange grove and further installation changes in "Antikensammlung und Antikenergänzung." The theatrical masks now decorating the court were added in 1524; Liverani, "Geschichte des Cortile Ottagono."

79. Fritz-Eugen Keller, "Die Umwandlung des Antikengartens zum Statuenhof durch das architektonische Ornament Pirro Ligorios," in Winner et al., *Il Cortile delle Statue,* 411–20.

80. Liverani, "Geschichte des Cortile Ottagono."

81. Adolf Michaelis, "Geschichte des Statuenhofes im Vatikanischen Belvedere," *Jahrbuch des Kaiserlich Deutschen Archäologischen Instituts* 5 (1890): 5–67.

82. Liverani, "Geschichte des Cortile Ottagono."

83. Charles de Brosses, letter 43, 1739–40, *Lettres familières,* vol. 2 (Naples: Centre Jean Bérard, Institut Français Naples, 1991), 812 (my translation). My description of the Statue Court at the beginning of the eighteenth century is based on Carlo Pietrangeli, "Il Cortile delle Statue nel Settecento," in Winner et al., *Il Cortile delle Statue,* 421–29.

84. See Andrew Wilton and Ilaria Bignamini, eds., *Grand Tour: The Lure of Italy in the Eighteenth Century* (exhibition catalog, London: Tate Gallery, 1996).

85. Liverani, "Geschichte des Cortile Ottagono."

86. Gian Paolo Consoli, *Il Museo Pio-Clementino: La scena dell'antico in Vaticano* (Modena: Franco Cosimo Panini, 1996), 42–44.

87. My description of the loggia is based on Jeffrey Collins, "Pius VI and the Invention of the Vatican Museum," in Clare Hornsby, ed., *The Impact of Italy: The Grand Tour and Beyond* (London: British School at Rome, 2000), 173–94.

88. Jon J. L. Whiteley, "Light and Shade in French Neo-Classicism," *Burlington Magazine,* December 1975, 768–73; see also Paolo Liverani, "Dal Pio-Clementino al Braccio Nuovo," in Andrea Emiliani, ed., *Pio VI Braschi e Pio VII Chiaramonti: Due Pontefici cesenati nel bicentenario della Campagna d'Italia, Atti del convegno internazionale (maggio 1997)* (Bologna: Clueb, 1998), 27–41.

89. Alex Potts, *Flesh and the Ideal: Winckelmann and the Origins of Art History* (New Haven: Yale University Press, 1994), 15–16.

90. Alex Potts, "Winckelmann's Construction of History," *Art History* 5, no. 4 (December 1982): 377–407.

91. Paolo Liverani, "La situazione delle collezioni di antichità a Roma nel XVIII secolo," *Antikensammlungen des europäischen Adels im 18. Jahrhundert als Ausdruck einer europäischen Identität* (Mainz am Rhein: Verlag Philipp von Zabern, 2000), 66–73.

92. André Malraux, *Musée Imaginaire/Museum without Walls*, trans. Stuart Gilbert and Francis Price (Garden City, N.Y.: Doubleday, 1967).

93. See Liverani, "Dal Pio-Clementino."

94. Agnes Allroggen-Bedel, "Die Antikensammlung in der Villa Albani zur Zeit Winckelmanns," in Herbert Beck and Peter C. Bol, eds., *Forschungen zur Villa Albani* (Berlin: Mann, 1989), 303–80.

95. Carole Paul, *Making a Prince's Museum: Drawings for the Late-Eighteenth-Century Redecoration of the Villa Borghese* (Los Angeles: Getty Research Institute, 2000), 78, 88.

96. Consoli, *Il Museo Pio-Clementino,* 37–38.

97. Carlo Pietrangeli, *The Vatican Museum: Five Centuries of History* (Rome: Edizioni Quasar, 1993), 88; Liverani, "La situazione delle collezioni."

98. Liverani, "Dal Pio-Clementino."

99. Consoli, *Il Museo Pio-Clementino,* 45, 48–51.

100. Baron Alexis von Krüdener, *Voyage en Italie en 1786,* ed. Herbert Eisele (Paris: Fischbacher, 1983), 130.

101. Rebaudo, "I restauri del Laocoonte."

102. Liverani, "Dal Pio-Clementino."

103. Patricia Mainardi, "Assuring the Empire of the Future: The 1798 Fête de la Liberté," *Art Journal,* Summer 1989, 155–63.

104. Etienne Michon, "Les Origines de la Collection des Antiques au Musée du Louvre," *Mouseion* 1–2 (1932): 144–54.

105. Unless otherwise noted, my description of the Louvre renovation of the antiquarium is based on Aulanier, *Histoire du Palais,* vol. 5, 65–74.

106. Ennio Quirino Visconti, *Musée Pie-Clémentin* (Milan: T. P. Giegler, 1818), vol. 2, 277 (my translation).

107. For the Rome installation, see Visconti, *Musée Pie-Clémentin,* vol. 1, 34–35.

108. For the antiquities, Visconti himself, with the help of the French architect Léon Dufournay, wrote a seminal *Notice* in 1800; Isabelle le Masne de Chermont, "La Publication des *Notices* au Musée Napoléon," in *Dominique-Vivant Denon: L'Oeil de Napoléon* (exhibition catalog, Paris: Editions de la Réunion des Musées Nationaux, 1999), 160.

109. Hans Belting, *The Invisible Masterpiece* (Chicago: University of Chicago Press, 2001), 35.

110. Johann Gottfried Schweighaeuser, *Les Monuments Antiques du Musée Napoléon* (Paris: Piranesi Brothers, 1804), vol. 2, 104.

111. Daniela Gallo, "Les antiques au Louvre: Une accumulation de chefs-d'oeuvre," in *Dominique-Vivant Denon,* 160.

112. Henry Milton, *Letters on the Fine Arts, Written from Paris in the Year 1815* (London: Longman, Hurst, Rees, Orme, and Brown, 1816), 18.

113. Geneviève Bresc-Bautier, "Dominique-Vivant Denon, premier directeur du Louvre," in *Dominique-Vivant Denon,* 130–33.

114. Edouard Pommier, "Winckelmann et la vision de l'antiquité classique dans la France des Lumières et de la Révolution," *Revue de l'Art* 83 (1989): 9–20.

115. Alex Potts, "Greek Sculpture and Roman Copies I: Anton Raphael Mengs and the Eighteenth Century," *Journal of the Warburg and Courtauld Institutes* 43 (1980): 150–73.

116. Potts, *Flesh and the Ideal,* 61, 4, 30–33.

117. Unless otherwise indicated, my discussion of the revised dating and prestige of the Italian antiquities is based on Jacob Rothenberg, "Descensus ad Terram: The Acquisition and Reception of the Elgin Marbles" (Ph.D. diss., Columbia University, 1967), 443 and n. 7.

118. Alex Potts, "The Impossible Ideal: Romantic Conceptions of the Parthenon Sculptures in Early Nineteenth-Century Britain and Germany," in Andrew Hemingway and William Vaughan, eds., *Art in Bourgeois Society 1790–1850* (Cambridge: Cambridge University Press, 1998), 101–22.

119. Ian Jenkins, "Gods without Altars," in Winner et al., *Il Cortile delle Statue,* 459–70.

120. Potts, "Impossible Ideal."

121. My description of the contrast between the London and Paris displays is based on Potts, "Impossible Ideal."

122. Pommier, "Winckelmann et la vision."

123. Milton, *Letters on the Fine Arts,* 2–3.

124. Christopher M. S. Johns, *Antonio Canova and the Politics of Patronage in Revolutionary and Napoleonic Europe* (Berkeley and Los Angeles: University of California Press, 1998), 171–72.

125. Pietrangeli, *Vatican Museum,* 136.

126. Malcolm Baker, *Figured in Marble: The Making and Viewing of Eighteenth-Century Sculpture* (Los Angeles: J. Paul Getty Museum, 2000), 164. For some comparable changes in viewing sculpture after the 1950s, see "11 Notes on Sculpture, 1, 2, 3, 4," *Continuous Project Altered Daily: The Writings of Robert Morris* (Cambridge, Mass.: MIT Press, 1993), 1–70.

127. See Andrew L. McClellan, "The Politics and Aesthetics of Display: Museums in Paris, 1750–1800," *Art History,* December 1984, 438–64.

128. John Kenworthy-Browne, "The Sculpture Gallery at Woburn Abbey and the Architecture of the Temple of the Graces," in Hugh Honour and Aidan Weston-Lewis, eds., *The Three Graces* (exhibition catalog, Edinburgh: National Gallery of Scotland, 1995), 61–71.

129. Barbara Steindl, *Mäzenatentum im Rom des 19. Jahrhundert: Die Familie Torlonia* (Hildesheim: Georg Olms Verlag, 1993), 97–104.

130. Jürgen Birkedal Hartmann, *La Vicenda di una Dimora Principesca Romana: Thorvaldsen, Pietro Galli e il demolito Palazzo Torlonia a Roma* (Rome: Palombi, 1967), 30–31 (my translation).

131. Carlo Pietrangeli, *The Vatican Collections, the Papacy and Art* (exhibition catalog, New York: Metropolitan Museum of Art/Harry N. Abrams, 1982), 23.

132. Filippo Magi, "Il Ripristino del Laocoonte," *Memorie della Pontificia Accademia di Archeologia* 9, no. 1 (1960): 3–117. The last of Magi's several accounts of the *Laocoön* restoration, this is the most definitive.

133. Filippo Magi, "Monumenti, Musei e Gallerie Pontificie nel Quinquennio 1954–1958, I Relazione generale," *Atti della Pontificia Accademia Romana di Archeologia, Serie III, Rendiconti, XXX–XXXI, 1957–58, 1958–59* (Rome: Bretschneider, 1959), 245–71; Magi, "Novità nei Musei Vaticani," *L'Osservatore Romano,* August 25, 1960, 3.

134. Rebaudo, "I restauri del Laocoonte."

135. Magi, "Il Ripristino del Laocoonte," 7, 10.

136. Magi, "Monumenti, Musei e Gallerie."

137. Magi, "Il Ripristino del Laocoonte," 10.

138. Magi, "Novità nei Musei Vaticani."

139. Paolo Liverani, "Reparto Antichità Classiche (1984–1989)," *Bollettino Monumenti, Musei e Gallerie Pontificie* 12 (1992): 85.

140. Richard Brilliant, *My Laocoön: Alternative Claims in the Interpretation of Artworks* (Berkeley and Los Angeles: University of California Press, 2000), 2–3.

141. The Vatican had 3,528,042 visitors in 2000; *L'attività della Santa Sede nel 2000* (Vatican City: Libreria Editrice Vaticana, 2001), 1, 357.

142. Brunilde Sismondo Ridgway, *Hellenistic Sculpture,* vol. 3, *The Styles of ca. 100–31 B.C.* (Madison: University of Wisconsin Press, 2003), 87–90.

143. Brunilde Sismondo Ridgway, "Le Laocoon dans la sculpture hellénistique" in Elisabeth Décultot, Jacques Le Rider, and François Queyrel, eds., *Le Laocoon: Histoire et réception* (Paris: Presses Universitaires de France, 2003), 13–31.

144. Salvatore Settis, "La Fortune du Laocoon," in Décultot et al., *Le Laocoon,* 269–302; see also Settis, *Laocoonte.*

145. Christian Kunze, "Zur Datierung des Laokoon und der Skyllagruppe aus Sperlonga," *Jahrbuch des Deutschen Archäologischen Instituts* 3 (1996): 139–223; Ridgway, "Le Laocoon dans la sculpture hellénistique."

146. Bernard Andreae, "Problèmes d'histoire de l'art du Laocoon," in Décultot et al., *Le Laocoon,* 33–56.

147. These dates were proposed by Brunilde Sismondo Ridgway, as were the possible settings related to them, in a conversation with the author, April 30, 2002. See also Ridgway, "Le Laocoon dans la sculpture hellénistique."

148. Magi, "Il Ripristino del Laocoonte," 10 and n. 18, quoted in Ridgway, "Le Laocoon dans la sculpture hellénistique."

149. Brunilde Sismondo Ridgway, conversation with the author, May 1, 2002.

150. Baldassare Conticello and Bernard Andreae,

"Die Skulpturen von Sperlonga," *Antike Plastik* 14 (1974); See also Bernard Andreae, *Praetorium Speluncae: Tiberius und Ovid in Sperlonga* (Stuttgart: Franz Steiner Verlag, 1994).

151. Kunze, "Zur Datierung des Laokoon."

152. Conticello and Andreae, "Die Skulpturen von Sperlonga."

153. Brunilde Sismondo Ridgway, "Laocoön and the Foundation of Rome," *Journal of Roman Archaeology* 2 (1989): 171–81.

154. John H. D'Arms, *Romans on the Bay of Naples: A Social and Cultural Study of the Villas and Their Owners from 150 B.C. to A.D. 400* (Cambridge, Mass.: Harvard University Press, 1970), 41.

155. Peter Green, "Pergamon and Sperlonga: A Historian's Reactions," in Nancy T. de Grummond and Brunilde Sismondo Ridgway, eds., *From Pergamon to Sperlonga: Sculpture in Context* (Berkeley and Los Angeles: University of California Press, 2000), 166–90.

156. Kunze, "Zur Datierung des Laokoon."

157. Andrew F. Stewart, "To Entertain an Emperor: Sperlonga, Laocoön, and Tiberius at the Dinner Table," *Journal of Roman Studies* 57 (London: Society for the Promotion of Roman Studies, 1977): 76–90.

158. Eugenia Salza Prina Ricotti, "The Importance of Water in Roman Garden Triclinia," in Wilhelmina F. Jashemski, ed., *Ancient Roman Villa Gardens, 10th Dumbarton Oaks Colloquium on the History of Landscape Architecture, 1984* (Washington, D.C.: Dumbarton Oaks Research Library and Collection, 1987), 135–84.

159. H. Anne Weis, "Odysseus at Sperlonga: Hellenistic Hero or Roman Heroic Foil?" in de Grummond and Ridgway, *From Pergamon to Sperlonga,* 111–65.

160. Kunze, "Zur Datierung des Laokoon."

161. One of the most recent additions to a vast literature on the *Laocoön* find spot is Chrystina Häuber and Franz Xaver Schütz, *Einführung in Archäologische Informationssysteme (AIS): Ein Methodenspektrum für Schule, Studium und Beruf mit Beispielen auf CD*, vol. 1 (Mainz am Rhein: Verlag Philipp von Zabern, 2004), 116.

162. Hubertus Manderscheid limits the densest concentration of sculpture to the frigidarium; Manderscheid, *Die Skulpturenausstattung der kaiserzeitlichen Thermenanlagen* (Berlin: Monumenta Artis Romanae, 1981), 21. Miranda Marvin includes the palaestrae as well; Marvin, "Freestanding Sculpture in the Baths of Caracalla," *American Journal of Archaeology* 87 (1983).

163. Janet DeLaine, "The Baths of Caracalla: A Study in Design, Construction and Economics of Large-Scale Building Projects in Imperial Rome," *Journal of Roman Archaeology, Supplementary Series* 25 (1997): 83–84.

164. Paul Zanker, "Zur Funktion und Bedeutung griechischer Skulptur in der Römerzeit," in Hellmut Flashar, ed., *Le Classicisme à Rome aux 1ers siècles avant et après Jésus-Christ* (Geneva: Vandoeuvres, 1978), 283–306.

165. Manderscheid, *Die Skulpturenausstattung der kaiserzeitlichen Thermenanlagen,* 24.

166. Fikret Yegul, *Baths and Bathing in Classical Antiquity* (New York: Architectural History Foundation/Cambridge, Mass.: MIT Press, 1992), 142–46.

167. Unless otherwise specified, my description of the Baths of Caracalla is based on Marvin, "Freestanding Sculpture," 347–84, plates 47–53.

168. Cornelius C. Vermeule III, *Greek Sculpture and Roman Taste* (Ann Arbor: University of Michigan Press, 1977), 59. See also Brunilde Sismondo Ridgway, "The Farnese Bull (Punishment of Dirke) from the Baths of Caracalla: How Many Prototypes?" *Journal of Roman Archaeology* 12 (1999): 512–20.

169. Johann Joachim Winckelmann, *Gedanken über die Nachahmung der griechischen Werke in der Malerei und Bildhauerkunst* (1775); abridged in Helmut Pfotenhauer and Peter Sprengel, eds., *Klassik und Klassizismus* (Frankfurt am Main: Deutscher Klassiker-Verlag, 1995), vol. 3, 20. For a recent discussion of the passage, see Joachim Rees, "Ethos und Pathos: Der Apoll vom Belvedere und die Laokoon-Gruppe im Spektrum von Kunsttheorie und Antiken-rezeption im 18. Jahrhundert," in Ekkehard Mai and Kurt Wettengl, eds., *Wettstreit der Künste: Malerei und Skulptur von Dürer bis Daumier* (Wolfratshausen: Edition Minerva, 2002), 153–69, especially 164.

170. Carsten Schneider, *Die Musengruppe von Milet* (Mainz am Rhein: Verlag Philipp von Zabern, 1999), 60.

171. Charles Christopher Parslow, "Villa dei Papiri," *Rediscovering Antiquity: Karl Weber and the Excavation of Herculaneum, Pompeii, and Stabiae* (Cambridge: Cambridge University Press, 1998), 77–106.

172. D. Comparetti and G. De Petra, *La Villa Ercolanese dei Pisoni* (Turin: Ermanno Loescher, 1883). Important recent scholarship on the villa's sculptural program appears in Dimitri Pandermalis, "Zum Programm der Statuenausstattung in der Villa dei Papiri," *Athenische Mitteilungen Beiheft* 86 (1971): 173–209; Gilles Sauron, "Templa Serena," *Mélanges de l'école française à Rome* 92 (1980): 1, 277–301; Maria Rita Wojcik, *La Villa dei Papiri ad Ercolano: Contributo alla ricostruzione dell'ideologia della nobilitas tardorepubblicana* (Rome: L'Erma di Bretschneider, 1986), 259ff.; and Richard Neudecker, *Die Skulpturenausstattung der römischen Villen in Italien* (Mainz am Rhein: Verlag Philipp von Zabern, 1988). Several of the articles are reprinted in *Croniche Ercolanesi* 13 (1983). See also P. Gregory Warden, "The Sculptural Program of the Villa of the Papiri," *Journal of the Society of Architectural Historians,* March 1992, 89–90.

173. My description of Latium and Campania is based on D'Arms, *Romans on the Bay of Naples,* 18, 57–59.

174. Tonio Hölscher, "Hellenistische Kunst und römische Aristokratie," in Gisela Hellenkemper Salies, Hans-Hoyer von Prittwitz, and Gaffron and Gerhard Bauchhenss II, eds., *Das Wrack, der antike Schiffsfund von Mahdia* (Cologne: Rheinland-Verlag, 1994), 875–88.

175. My comments on the implications of sculpture's placement are based on Miranda Marvin, "Copying in Roman Sculpture: The Replica Series," *Retaining the Original: Multiple Originals, Copies, and Reproductions* (Washington, D.C.: National Gallery of Art, 1989), 29–45.

176. Jocelyn Penny Small, *Wax Tablets of the Mind: Cognitive Studies of Memory and Literacy in Classical Antiquity* (London and New York: Routledge, 1997), 98, 81–116. See also Bettina Bergmann, "The Roman House as Memory Theater: The House of the Tragic Poet in Pompeii," *Art Bulletin,* June 1994, 226–56; and for a general discussion of the subject, Frances A. Yates's seminal *The Art of Memory* (1966; reprint, London: Pimlico, 1992).

177. Elizabeth Bartman, "Sculptural Collecting and Display in the Private Realm," in Elaine K. Gazda and Anne E. Haeckl, eds., *Roman Art in the Private Sphere* (Ann Arbor: University of Michigan Press, 1991), 71–88.

178. Elaine K. Gazda, "Roman Sculpture and the Ethos of Emulation: Reconsidering Repetition," *Harvard Studies in Classical Philology* 97 (Cambridge and London, 1995): 121–56.

179. Unless otherwise specified, my description of the villa and its owner is based on Carol C. Mattusch, *The Villa dei Papiri at Herculaneum: Life and Afterlife of a Sculpture Collection* (Brentwood, Calif.: J. Paul Getty Center, 2004), 291–98; on Mattusch's lecture at the Institute of Fine Arts, New York University, February 22, 2002; and on my conversation with her, also February 22, 2002.

180. Bartman, "Sculptural Collecting and Display."

181. Norman Bryson, "Xenia," *Looking at the Overlooked: Four Essays on Still-Life Painting* (Cambridge, Mass.: Harvard University Press, 1990), 17–59.

182. Gilles Sauron, *La Grande Fresque de la Villa des Mystères à Pompeii* (Paris: Picard, 1998).

183. Elizabeth Bartman, "Décor et Duplicatio: Pendants in Roman Sculptural Display," *American Journal of Archaeology* 92 (1988): 211–25.

184. Jerzy Linderski, "Garden Parlors," in Robert I. Curtis, ed., *Studia Pompeiana e Classica in Honor of Wilhelmina F. Jashemski* (New Rochelle, N.Y.: Orpheus, 1989), 105–28.

185. Eugene J. Dwyer, *Pompeian Sculpture in Its Domestic Context: A Study of Five Pompeian Houses and Their Contents* (Rome: Giorgio Bretschneider, 1982), 125.

186. Sauron, "Templa Serena."

187. A. Wallace-Hadrill, "The Social Structure of the Roman House," *Papers of the British School at Rome* 56 (1988): 43–97.

188. Richard Brilliant, review of *Augustus: Kunst und Leben in Rom um die Zeitenwende,* by Erika Simon; *Kaiser Augustus und die verlorene*

Republik, by M. Hofter et al; and *The Power of Images in the Age of Augustus,* by P. Zanker, in *Art Bulletin,* June 1990, 327–30.

189. Pandermalis, "Zum Programm der Statuen-ausstattung."

190. Mattusch, *Villa dei Papiri,* 21–23.

191. Wojcik, *La Villa dei Papiri.*

192. Jás Elsner, *Art and the Roman Viewer: The Transformation of Art from the Pagan World to Christianity* (Cambridge: Cambridge University Press, 1995), 69, 76.

193. Italo Sgobbo, "Le 'Danzatrici' di Ercolano," *Rendiconti della Accademia di archeologia, lettere e belle arti,* new series 46 (1971): 51–74. Neudecker is among those who differ with this interpretation; see *Die Skulpturenausstattung der römischen Villen.*

194. For bibliography, see Mattusch, *Villa dei Papiri,* 212–15. See also Michael Koortbojian, "Forms of Attention: Four Notes on Replication and Variation," in Elaine K. Gazda, ed., *The Ancient Art of Emulation: Studies in Artistic Originality and Tradition from the Present to Classical Antiquity* (Ann Arbor: University of Michigan Press, 2002), 173–204.

195. *The J. Paul Getty Museum Guide to the Villa and Its Gardens* (1922), 19–21.

196. Agnes Allroggen-Bredel and Helke Kammerer-Grothaus, "Das Museo Ercolanese in Portici," *Cronache Ercolanesi,* December 1980, 175–217.

197. Unless otherwise indicated, my description of the Herculaneum Museum is based on Allroggen-Bredel and Kammerer-Grothaus, "Das Museo Ercolanese."

198. Mattusch, *Villa dei Papiri,* 56–64.

199. Johann Joachim Winckelmann, *Recueil de Lettres de M. Winckelmann sur les Découvertes faites à Herculaneum, à Pompei, à Stabia, à Caserte et à Rome* (Paris: Barrois Ainé, 1784), 145, 253.

200. Francis Haskell and Nicholas Penny, *Taste and the Antique: The Lure of Classical Sculpture, 1500–1900* (New Haven: Yale University Press, 1981), 269.

201. Winckelmann, *Receuil de Lettres,* 144.

202. Mariana Starke, *Letters from Italy between the Years 1792 and 1798* (London: Phillips, 1800), 121.

203. Friedrich Leopold Stolberg, *Travels through Germany, Switzerland, Italy, and Sicily,* trans. Thomas Holcroft (London: G. G. and J. Robinson, 1796–97), 59, 62. See also Starke, *Letters from Italy,* vol. 2, letter 21; and Abbé Richard, *Déscription Historique et Critique de l'Italie* (Paris: Saillant, 1769), vol. 4, 492.

204. My description of the early years of the Naples museum is based on Andrea Milanese, "Il Museo Reale di Napoli al tempo di Giuseppe Bonaparte e di Gioacchino Murat," *Rivista dell' Istituto Nazionale d'Archeologia e Storia dell'Arte,* 3rd series (1996–97): 345–405.

205. M. Gelas, *Catalogue des statues en bronze exposés dans une grande salle du Musée Bourbon à Naples* (Naples, 1820); Lorenzo Giustiniani, *Guida per lo Real Museo Borbonico* (Naples: Tipografia Francese, 1822); Andrea de Jorio, *Notizie sugli Scavi di Ercolano* (Naples: Stamperia Francese, 1827); *Guide des statues en marbre et bronze qui existent du Musée Bourbon à Naples* (Naples: R. Miranda, 1828); Achille Morelli, *Musée Royal Bourbon: Vues et descriptions des Galeries* (Naples: Fibrene, 1835).

206. About 1819, objects considered pornographic were removed from public display, and it may have been at this time that fig leaves were added, staying in place for most of the century. See Stefano de Caro, ed., *Il Gabinetto Segreto del Museo Archeologico di Napoli* (Milan: Electa, 2000).

207. Archivo Storico della Soprintendenza Archaeologica di Napoli, busta XVI B 8, fascicolo 9, busta XVI B 10, and busta XVI 8, fascicolo 9, National Archaeological Museum, Naples. Andrea Milanese is preparing an article on the decorative scheme.

208. See Pietro Paolo Farinelli and Giuseppe Zuccala, "Realizzazione sull'attuale ordinamento del Museo Nazionale di Napoli," *Bollettino del Collegio degli ingegneri ed architetti in Napoli* 21 (Naples, 1903): 15; A. Sogliano, "I rimutamenti del Museo Nazionale di Napoli," *Rendiconto della Real Accademia di archeologia, lettere e belle arti* 18 (Naples, 1905): 18–20.

209. Ettore Pais, *Il riordinamento del Museo Nazionale di Napoli. Parte Prima. Il memoriale della Real Accademia di Archeologia, Lettere e Belle Arti* (Naples, 1902), 12–13, 24; Domenico Monaco, *Handbook of the Antiquities in the National Museum at Naples, According to the New Arrangement* (Naples, 1906), 46–53.

210. Stefano De Caro, "The National Archaeological Museum of Naples: A Brief History," *The National Archaeological Museum of Naples* (Milan: Electa, 1996), 11–16.

211. Mattusch, conversation.

212. Marion True, director of the Villa Museum, believes that there was in antiquity a program for sculpture, although possibly not as strict as some writers have suggested; True, conversation with the author, March 25, 2002.

213. The Getty Villa was constructed with the help of Norman Neuerburg, an architect who served as historical consultant.

214. Mattusch, conversation.

215. Haskell and Penny, *Taste and the Antique,* 118.

216. Oliver Millar, "Portraiture and the Country House," in Gervase Jackson-Stops, ed., *Treasure Houses of Britain: Five Hundred Years of Private Patronage and Art Collecting* (exhibition catalog, Washington, D.C.: National Gallery of Art/New Haven: Yale University Press, 1985), 31–37.

217. Daniel Mendelsohn, "When Not in Greece," *New York Review of Books,* March 28, 2002, 35–37.

218. John Butt, "Authenticity," *New Grove Dictionary of Music,* www.grovemusic.com (accessed May 3, 2002).

219. Bazin, *Museum Age,* 196; see also Alexis Joachimides, "Die Schule des Geschmacks: Das Kaiser-Friedrich-Museum als Reform-projekt," in Alexis Joachimides and Sven Kuhran, eds., *Museuminszenierungen: Zur Geschichte der Institution des Kunstmuseums; Die Berliner Museumslandschaft, 1830–1990* (Dresden: Verlag der Kunst, c. 1995), 142–56.

220. Carlos Picón, curator in charge, Department of Greek and Roman Art, and Jeffrey L. Daly, chief designer, Design Department, both at the Metropolitan Museum of Art, conversation with the author, October 4, 2001.

221. Sarah Boxer, "The Formula for Portraying Pain in Art," *New York Times,* September 15, 2001, B9.

222. I am indebted to Richard Brilliant for his reference to these images in his "Le Laocoon moderne et la primauté des enlacements," in Décultot et al., *Le Laocoon,* 251–68.

223. Details of Hadrian's Egypt are based on Jean-Claude Grenier, "Le 'Serapum' et le 'Canope': Une 'Egypte' monumentale et une 'mediterranée,'" in Jacques Charles-Gaffot and Henri Lavagne, eds., *Hadrien: Trésors d'une Villa Impériale* (Milan: Electa, 1999), 75–77.

224. William L. MacDonald and John A. Pinto, *Hadrian's Villa and Its Legacy* (New Haven: Yale University Press, 1995), 151.

225. Barbara Kirshenblatt-Gimblett, *Destination Culture: Tourism, Museums, and Heritage* (Berkeley and Los Angeles: University of California Press, 1998), 133.

Art or Archaeology

How Display Defines the Object

The principal Egyptological consultant for this chapter, David O'Connor, played an important role in its development.

1. Peter Gay, *Freud: A Life for Our Time* (New York: W. W. Norton, 1988), 170, 48, 171. See also Donald Kuspit, "A Mighty Metaphor: The Analogy of Archaeology and Psychoanalysis," in Lynn Gamwell and Richard Wells, eds., *Sigmund Freud and Art: His Personal Collection of Antiquities* (exhibition catalog, New York: State University of New York, 1989).

2. Ian Jenkins, *Archaeologists and Aesthetes in the Sculpture Galleries of the British Museum, 1800–1939* (London: British Museum Press, 1992), 102.

3. Christiane Ziegler reports that, of the Louvre's five million visitors in 1997, seven hundred thousand went through the Egyptian Department, which also enjoys the biggest number of guided groups. It is the only department in the museum with a children's workshop. According to the staff of the Metropolitan Museum of Art in New York, its Egyptian Department also enjoys top attendance.

4. At the Center for African Art in New York, the exhibition "ART/artifact: African Art in Anthropology Collections" demonstrated how

African objects have been defined by their installation (exhibition catalog, New York: Center for African Art/Prestel, 1988).

5. Claas Jouco Bleeker, *Egyptian Festivals: Enactments of Religious Renewal* (Leiden, Netherlands: E. J. Brill, 1967), 5.

6. Stephen E. Thompson, "Cults: An Overview," in Donald B. Redford, ed., *Oxford Encyclopedia of Ancient Egypt* (New York: Oxford University Press, 2001), 326–32.

7. Herbert Walker Fairman, "The Kingship Rituals of Egypt," in S. H. Hooke, ed., *Myth, Ritual, and Kingship* (London: Oxford at the Clarendon Press, 1958), 74–104.

8. William Stevenson Smith, *The Art and Architecture of Ancient Egypt* (New Haven: Yale University Press, 1998), 132.

9. Lanny Bell, "The New Kingdom 'Divine' Temple: The Example of Luxor," in Byron E. Shafer, ed., *Temples of Ancient Egypt* (Ithaca, N.Y.: Cornell University Press, 1997), 127–84.

10. See Herbert Walker Fairman, "Worship and Festivals in an Egyptian Temple," *Bulletin of the John Rylands Library Manchester* 37 (September 1954): 165–203.

11. This brief discussion of restricted knowledge and decorum is based on John Baines, "Restricted Knowledge, Hierarchy, and Decorum: Modern Perceptions and Ancient Institutions," *Journal of the American Research Center in Egypt* 27 (1990): 1–23.

12. Gay Robins, *The Art of Ancient Egypt* (Cambridge, Mass.: Harvard University Press, 1997), 21, 24.

13. Robins, *Art of Ancient Egypt,* 24.

14. Henry George Fischer, *The Orientation of Hieroglyphs, Part 1: Reversals* (New York: Metropolitan Museum of Art, 1977), 3. For reversal of the hieroglyphs' orientation, see Henry George Fischer, *L'Ecriture et l'Art de l'Egypte Ancienne: Quatre leçons sur la paléographie et l'épigraphie pharaoniques* (Paris: Presses Universitaires de France, 1986), 63.

15. Robins, *Art of Ancient Egypt,* 24.

16. See Jaroslav Cerny, "Egyptian Oracles," in *A Saite Oracle Papyrus from Thebes in the Brooklyn Museum* (Providence, R. I.: Brown University Press, 1962), 35–48.

17. See Lanny Bell, "Luxor Temple and the Cult of the Royal *Ka*," *Journal of Near Eastern Studies,* October 1985, 251–94; and Dimitri Meeks and Christine Favard-Meeks, *Daily Life of the Egyptian Gods,* trans. G. M. Goshgarian (Ithaca, N.Y.: Cornell University Press, 1996), 120, 122.

18. This description of boats in relation to processions and the Sokaris procession is based on Bleeker, *Egyptian Festivals,* 77–80.

19. Unless otherwise noted, this description of the Min festival is based on Henri Gauthier, "Troisième épisode: La procession divine," *Les Fêtes du Dieu Min* (Cairo: Imprimerie de l'Institut Français, 1931), 157–206.

20. Gauthier, "Troisième épisode," 286–90.

21. David O'Connor, lecture at the Institute of Fine Arts, New York University, October 29, 1999.

22. Hans Belting, *Likeness and Presence: A History of the Image before the Era of Art* (Chicago: University of Chicago Press, 1994), 64–72. See also Herbert L. Kessler and Johanna Zacharias, *Rome 1300, on the Path of the Pilgrimage* (New Haven: Yale University Press, 2000), 38–157.

23. David Freedberg, *The Power of Images: Studies in the History and Theory of Responses* (Chicago: University of Chicago Press, 1989), 108–9.

24. All quotes by Dorothea Arnold are from a conversation with the author during a visit to the exhibition, November 9, 1999.

25. Unless otherwise indicated, quotes by Christiane Ziegler are from a conversation with the author, July 11, 2002.

26. Jean-François Bodin, conversation with the author, May 15, 2000.

27. *Egyptian Art in the Age of the Pyramids* (exhibition catalog, New York: Metropolitan Museum of Art, 1999), xxii–xxiii; referred to hereafter as *Egyptian Art.*

28. The description of design considerations at the Metropolitan Museum is based on my conversation with the museum's exhibition designers Jeffrey L. Daly and Michael Batista, January 10, 2000.

29. The description of design decisions for the Toronto installation is based on my conversation with Krzysztof Grzymski, February 16, 2000.

30. Neil Harris, *Cultural Excursions: Marketing Appetites and Cultural Tastes in Modern America* (Chicago: University of Chicago Press, 1990), 56–81.

31. Krzysztof Grzymski, e-mail message to author, September 5, 2002.

32. *Egyptian Art,* 180.

33. Christiane Ziegler, "Statues de Sepa et Nesa," *L'Egypte ancienne au Louvre* (Paris: Hachette, 1997), 49–52.

34. Ziegler, "Statues de Sepa et Nesa."

35. My discussion of the Sepa and Nesa inscriptions is based on Marianne Eaton-Krauss and Christian E. Loeben, "Some Remarks on the Louvre Statues of Sepa (A36 and 37) and Nesames (A38)," in Elizabeth Goring, Nicholas Reeves, and John Ruffle, eds., *Chief of Seers: Egyptian Studies in Memory of Cyril Aldred* (London: Kegan Paul International/ National Museums of Scotland, Edinburgh, 1997), 83–87.

36. *Egyptian Art,* 181.

37. Unless otherwise indicated, my description of the Louvre Ankh is based on Christiane Ziegler, "Ankh Seated with Hands Clasped," in *Egyptian Art,* 185.

38. Marianne Eaton-Krauss, "Two Masterpieces of Early Egyptian Statuary," *Oudheidkundige Mededelingen, uit het Rijksmuseum van Oud-heden te Leiden* (Leiden, Netherlands: Rijks-museum van Oudheden, 1997), 7–22.

39. Eaton-Krauss, "Two Masterpieces."

40. Anna Maria Donadoni Roveri, director of the Egyptian Museum in Turin, conversation with the author, December 4, 2002.

41. The description of the Leiden *Ankh Wearing Two Feline Pelts* is based on Eaton-Krauss, "Two Masterpieces."

42. Unless otherwise specified, my discussion of Reserve Heads is based on Nicholas B. Millet, "The Reserve Heads of the Old Kingdom: A Theory," in *Egyptian Art,* 233–34.

43. Catherine H. Roehrig, "Reserve Heads: An Enigma of Old Kingdom Sculpture," in *Egyptian Art,* 73–81.

44. Roehrig, "Reserve Heads."

45. The description of this head and its relationship to royal statuary is based on the catalog entry in *Egyptian Art,* 338–39.

46. Unless otherwise specified, my description of the statue is based on "King Menkaure and a Queen," in *Egyptian Art,* 269–71.

47. On the evidence of New Kingdom sculpture such as *Senay and His Wife Seated and Embracing One Another* (Cairo no. CG42126) and *Imenemhat and Imenemipat Seated and Embracing One Another* (Berlin no. E.2289), I have modified the claim made by Nadine Cherpion that intimacy was represented freely only in the Old Kingdom; Cherpion, "Sentiment Conjugal et Figuration à l'Ancien Empire," *Kunst des Alten Reiches, Symposium im Deutschen Archäologischen Institut Kairo am 29 und 30 Oktober, 1991* (Mainz am Rhein: Verlag Philipp von Zabern, 1995), 33–47.

48. *Egyptian Art,* 269–71; George A. Reisner, *Mycerinus* (Cambridge, Mass.: Harvard University Press, 1931), 43 and plate 54.

49. "Seal Bearer Tjetji as a Young Man," in *Egyptian Art,* 464.

50. Arnold, conversation.

51. William Stevenson Smith, *The History of Sculpture and Painting in the Old Kingdom* (Boston and London: Oxford University Press, 1946, 1978), 17.

52. Descriptions of the *Head of King Djedefre* and *Seated King Khafre* are based on *Egyptian Art,* 248–49, 252–53.

53. Rita Freed, conversation with the author, July 22, 2002.

54. Bodin, conversation.

Jackson Pollock

How Installation Can Affect Modern Art

1. Only in rare instances are these preferences known for earlier art; at the other extreme, artists' specifications as to presentation can determine the very existence of some contemporary art.

2. This and the following references to Andrew Sarris are taken from his "Notes on the Auteur Theory, 1962," *Primal Screen* (New York: Simon & Schuster, 1973), 38–53. He revised some of the dates in that essay during a conversation with the author, September 10, 2003.

3. William Rubin, "Jackson Pollock and the Modern Tradition," pt. 1, *Artforum,* February 1967, 14–22; Rubin's four-part series,

published in the February–May 1967 issues of *Artforum,* is reprinted in Pepe Karmel, ed., *Jackson Pollock: Interviews, Articles, and Reviews* (New York: Museum of Modern Art, 1999), 118–75.

4. For an overview of discussions about this change in Pollock's style, see Angelica Zander Rudenstine, *Peggy Guggenheim Collection, Venice* (New York: Harry N. Abrams/Solomon R. Guggenheim Foundation, 1985), 649–50.

5. Francis V. O'Connor and Eugene Victor Thaw, *Jackson Pollock: A Catalogue Raisonné of Paintings, Drawings, and Other Works,* 4 vols. (New Haven: Yale University Press, 1978), vol. 2, vii–viii; referred to hereafter as *JPCR.*

6. Rubin, "Jackson Pollock and the Modern Tradition," pt. 4, in Karmel, *Jackson Pollock,* 166–68. Rubin cites Francis Picabia, Joan Miró, Gordon Onslow-Ford, Wolfgang Paalen, Max Ernst, and Hans Hofmann.

7. T. J. Clark, *Farewell to an Idea: Episodes from a History of Modernism* (New Haven: Yale University Press, 1999), 322–23.

8. See Rosalind Krauss, "Six," *The Optical Unconscious* (Cambridge, Mass.: MIT Press, 1993), 243–308; Clark, *Farewell to an Idea,* 324–27. See also Rosalind Krauss, "The Crisis of the Easel Picture," in Kirk Varnedoe and Pepe Karmel, eds., *Jackson Pollock: New Approaches* (New York: Museum of Modern Art, 1999), 170.

9. "Unframed Space," *New Yorker,* August 5, 1950, 16. In an interview with Barbara Rose, Krasner pointed out that Pollock had worked with his father, a surveyor, in the Grand Canyon, "so he really had a sense of physical space"; Rose, "Jackson Pollock at Work: An Interview with Lee Krasner," *Partisan Review* 47, no. 1 (1980): 82–92; reprinted in Karmel, *Jackson Pollock,* 39–48.

10. Allan Kaprow, "The Legacy of Jackson Pollock," *Art News,* October 1958, 24–26, 55–57; reprinted in Karmel, *Jackson Pollock,* 84–89. See also Robert Rosenblum, "The Abstract Sublime," *Art News,* February 1961, 39–40, 56–57.

11. Michael Fried, "Optical Allusions," *Artforum,* April 1999, 97–101, 143–44. For Fried on Pollock's "opticality," see Fried, *Three American Painters: Kenneth Noland, Jules Olitski, Frank Stella* (Cambridge, Mass.: Fogg Art Museum, 1965), 3–53; reprinted as "Jackson Pollock," *Artforum,* September 1965, 14–17, and in Karmel, *Jackson Pollock,* 97–103.

12. Meyer Schapiro, "The Younger American Painters of Today," *Listener,* January 26, 1956, 446–47.

13. Harold Rosenberg, "The American Action Painters," *Art News,* December 1952, 22–23, 48–50.

14. Kaprow, "Legacy of Jackson Pollock."

15. *JPCR,* vol. 4, D90, p. 253.

16. B. H. Friedman, *Jackson Pollock: Energy Made Visible* (1972; New York: Da Capo Press, 1995).

17. Harvey Fergusson's *Modern Man: His Belief and His Behavior* is one example cited by Michael Leja in *Reframing Abstract Expressionism: Subjectivity and Painting in the 1940s* (New

Haven: Yale University Press, 1993), 178.

18. Leja, *Reframing Abstract Expressionism,* 283.

19. Rubin, "Jackson Pollock and the Modern Tradition," pt. 4, in Karmel, *Jackson Pollock,* 120. This tally (which does not include *Mural* of 1943, not a poured painting) depends for a guideline on the dimensions of *Mural* (1950) (72 by 96 inches), for the Geller House in Lawrence, Long Island (*JPCR,* vol. 2, no. 259, p. 80). The other abstract mural-size paintings, as listed in *JPCR,* vol. 4, are *Number 1A, 1948* (68 by 104 inches), no. 186, p. 3; *Number One, 1949* (63 by 104 inches), no. 252, p. 74; *Number 28, 1950* (68 by 105 inches), no. 260, p. 82; *Lavender Mist: Number 1, 1950* (7 feet 3 inches by 9 feet 10 inches), no. 264, p. 86; *Number 32, 1950* (106 by 180 inches), no. 274, p. 98; *One: Number 31, 1950* (106 by 209 ½ inches), no. 283, p. 105; *Autumn Rhythm: Number 30, 1950* (106 ½ inches by 212 inches), no. 297, p. 116; *Number 14, 1951* (57 ⅞ by 106 inches), no. 336, p. 154; *Number 11, 1951* (4 feet 9 ½ inches by 11 feet 6 ⅞ inches), no. 341, p. 162; *Blue Poles: Number 11, 1952* (6 feet 11 inches by 16 feet), no. 367, p. 193; and *Convergence: Number 10, 1952* (7 feet 9 ½ inches by 13 feet), no. 363, p. 186. The term "mural-size," rather than "large-scale," is used for the largest canvases to avoid issues of scale and size.

20. Francis V. O'Connor, letter to the author, November 24, 2000; Robert L. Scott, "Diego Rivera at Rockefeller Center: Fresco Painting and Rhetoric," *Western Journal of Speech Communication* 41 (Spring 1977): 70–82.

21. *JPCR,* vol. 4, p. 219. For two representational murals that Pollock executed during the 1930s and early 1940s, and his interest in mural commissions in the 1950s, see Francis V. O'Connor, ed., *Supplement Number One— Jackson Pollock: A Catalogue Raisonné of Paintings, Drawings, and Other Works* (New York: Pollock-Krasner Foundation, 1995), 52–53.

22. For the most recent dating of *Mural* and its installation at 155 East Sixty-first Street, see Francis V. O'Connor, "Jackson Pollock's *Mural* for Peggy Guggenheim: Its Legend, Documentation, and Redefinition of Wall Painting," in Susan Davidson and Philip Rylands, eds., *Peggy Guggenheim & Frederick Kiesler: The Story of Art of This Century* (Venice: Peggy Guggenheim Collection/Vienna: Austrian Frederick and Lillian Kiesler Private Foundation, 2004), 150–69. At the Geller house, the painting was installed by Giorgio Cavallon, who built it into the wall with a frame around it so that, in his opinion, it looked more like a mural; Francis V. O'Connor, letter to the author, December 2, 2000.

23. *JPCR,* vol. 1, p. 8.

24. E. A. Carmean Jr., "The Church Project: Pollock's Passion Themes," *Art in America,* Summer 1982, 110–22.

25. Transcript, MoMA Archive. See also Eric Lum, "Pollock's Promise: Toward an Abstract Expressionist Architecture," *Assemblage* 39 (1999): 62–93.

26. The discussion of Namuth's photography is based on Pepe Karmel, "Pollock at Work: The Films and Photographs of Hans Namuth," in *Jackson Pollock* (exhibition catalog, New York: Museum of Modern Art, 1998), 87–137.

27. Barbara Rose, "Jackson Pollock: The Artist as Culture Hero," *Pollock Painting: Photographs by Hans Namuth* (New York: Agrinde Publications, 1978), n.p.

28. O'Connor, "Jackson Pollock's *Mural.*" See Robert Goodnough, "Pollock Paints a Picture," *Art News,* May 1951, 38–41, 60; reprinted in Karmel, *Jackson Pollock,* 76; and the correction of this article by Pepe Karmel in *Jackson Pollock* (exhibition catalog), 94. Pollock worked outdoors only for Namuth's filming; Hans Namuth, "Photographing Pollock," in *Pollock Painting,* n.p.

29. Rose, "Jackson Pollock at Work," 82–92, in Karmel, *Jackson Pollock,* 46.

30. Francis V. O'Connor, letter to the author, August 16, 2000.

31. O'Connor, letter, August 16, 2000. See also T. J. Clark, "Pollock's Smallness," in Varnedoe and Karmel, *Jackson Pollock: New Approaches,* 15–32.

32. E. A. Carmean Jr., "Classic Paintings of 1950," in E. A. Carmean Jr. and Eliza E. Rathbone with Thomas B. Hess, *American Art at Mid-Century* (exhibition catalog, Washington, D.C.: National Gallery of Art, 1978), 127–53. T. J. Clark has remarked that "there has never been a studio so superintended by work already done"; *Farewell to an Idea,* 327, 340.

33. Carroll Janis, conversation with the author, September 15, 1999.

34. O'Connor, "Jackson Pollock's *Mural.*"

35. *JPCR,* vol. 4, D67, p. 238.

36. O'Connor, "Jackson Pollock's *Mural.*"

37. Peggy Guggenheim, *Out of This Century: Confessions of an Art Addict* (1946; New York: Universe, 1979), 296.

38. Guggenheim, *Out of This Century,* 296. The often repeated episode in which the artist urinated into Guggenheim's fireplace has no credible substantiation.

39. Carol C. Mancusi-Ungaro, "Jackson Pollock: Response as Dialogue," in Varnedoe and Karmel, *Jackson Pollock: New Approaches,* 117–53.

40. O'Connor, "Jackson Pollock's *Mural.*"

41. Pollock, letter to his older brother, Charles, July 29, 1943, *JPCR,* vol. 4, D44, p. 228; Francis V. O'Connor, letter to the author, March 8, 2004.

42. Karole Vail, conversation with the author, November 4, 1999.

43. Cynthia Goodman, "Frederick Kiesler: Design for Peggy Guggenheim's Art of This Century Gallery," *Arts Magazine,* June 1977, 90–95.

44. Jacqueline Bograd Weld, *Peggy: The Wayward Guggenheim* (New York: Dutton, 1986), 289. Pollock's work was never shown in the Abstract Gallery, as depicted in Ed Harris's 2000 film *Pollock.*

45. Virginia Admiral, conversation with the author, October 7, 1999.

46. Clement Greenberg, "Review of the Peggy Guggenheim Collection," *Nation,* January 30, 1943; reprinted in John O'Brian, ed., *Clement Greenberg: The Collected Essays and Criticism,* vol. 1, *Perceptions and Judgments, 1939–1944* (Chicago: University of Chicago Press, 1986), 140–41.

47. Greenberg, "Review of the Peggy Guggenheim Collection."

48. Rudenstine, *Peggy Guggenheim Collection,* 799.

49. The Barnett Newman Foundation has two snapshots of the 1946 Teresa Zarnower exhibition.

50. Charles Seliger, Fanny Hillsmith, and Virginia Admiral.

51. Guggenheim insisted on designing the installations herself; Bruno Alfieri and Charles Seliger, conversations with the author, September 1, 1999.

52. The Painting Library at the east side of the Daylight Gallery had been dismantled and its space added to the exhibition area; Lillian Kiesler, conversation with the author, September 14, 1999.

53. Vittorio Carrain, conversation with the author, November 3, 1999. Carrain helped Guggenheim install the 1950 Jackson Pollock exhibition at the Museo Correr in Venice.

54. O'Connor, "Jackson Pollock's *Mural.*"

55. O'Connor, "Jackson Pollock's *Mural.*"

56. A letter from Herbert Matter to John G. Powers, December 21, 1972 (in the possession of Francis V. O'Connor), relates Pollock's request to see his own wide painting *Number 7A, 1948* in the large *Vogue* studio Matter used for photography. The letter seems to indicate that it was in the same space that Matter photographed *Mural* in 1943, and that by the time of the later request (1948–49), Pollock was experimenting with the scale of spaces for his large paintings.

57. O'Connor, letter, March 8, 2004.

58. Aline B. Loucheim, "Betty Parsons: Her Gallery, Her Influence," *Vogue,* October 1951, 141, 194, 197.

59. Lee Hall, *Betty Parsons: Artist, Dealer, Collector* (New York: Harry N. Abrams, 1991), 67, 77; Loucheim, "Betty Parsons."

60. Clement Greenberg, "Art," *Nation,* January 24, 1948, 107–8; reprinted in Karmel, *Jackson Pollock,* 59–60.

61. Sam Hunter, "Among the New Shows," *New York Times,* January 30, 1949, 9; reprinted in Karmel, *Jackson Pollock,* 61; Stuart Preston, "Abstract Quartet," *New York Times,* November 27, 1949, B82.

62. Jock Truman, conversation with the author, July 28, 1999. John Richardson pointed out, in a conversation with the author on October 27, 1999, that the scruffy quality shared by the Daylight Gallery and the Parsons Gallery also characterized the Kahnweiler Gallery in Paris, where Georges Braque's canvases were squeezed into a tiny room for the benchmark 1908 exhibition that launched the term "Cubism."

63. Calvin Tomkins, "Profiles: A Touch for the Now," *New Yorker,* July 29, 1991, 33–57; also Walter Hopps, conversation with the author, August 9, 2000.

64. Annalee Newman, conversation with the author, Fall 1998.

65. Friedman, *Jackson Pollock: Energy Made Visible,* 89.

66. *Jackson Pollock* (exhibition catalog, Paris: Centre Culturel Georges Pompidou, 1982), 262.

67. This and subsequent quotes from Peter Blake are from conversations with the author, June 12 and September 6, 1996, and June 21, 1999.

68. "New Buildings for 194X," *Architectural Forum* 78, no. 5 (May 1943): 69–85.

69. Arthur Drexler, "Unframed Space: A Museum for Jackson Pollock's Paintings," *Interiors,* January 1950, 90–91. Drexler succeeded Blake as curator of architecture and industrial design at MoMA.

70. Friedman, *Jackson Pollock: Energy Made Visible,* 108, 153–54.

71. Carmean, "Church Project."

72. John Keenen, "Architecture," in *Tony Smith: Architect, Painter, Sculptor* (exhibition catalog, New York: Museum of Modern Art, 1998), 36–49.

73. Rosalind Krauss, "Contra Carmean: The Abstract Pollock," *Art in America,* Summer 1982, 123–31.

74. Giorgio Cavallon, who also assisted with the installation, reportedly described Ossorio, Ted Dragon, and himself helping Pollock unroll the canvases, "wrestling them onto stretchers" the night before the opening; Steven Naifeh and Gregory White Smith, *Jackson Pollock: An American Saga* (Aiken, S.C.: Woodward/White, 1989), 654.

75. Francis V. O'Connor, e-mail message to the author, July 20, 2004.

76. Jock Truman, letter to the author, August 30, 1999. There was another small room in which medium-size paintings looked bigger than they would have in the main room.

77. Allan Kaprow, "Jackson Pollock: An Artist's Symposium, Part I," *Art News,* March 1967, 29–33, 59–67.

78. Rubin, "Jackson Pollock and the Modern Tradition," pt. 2, in Karmel, *Jackson Pollock,* 148, 150.

79. Rubin, "Jackson Pollock and the Modern Tradition," pt. 2, in Karmel, *Jackson Pollock,* 144.

80. Rubin, "Jackson Pollock and the Modern Tradition," pt. 2, in Karmel, *Jackson Pollock,* 150.

81. Kiesler, conversation.

82. Rose Slivka, conversation with the author, October 4, 1999.

83. Dorothy Sieberling, "Jackson Pollock: Is He the Greatest Living Painter in the U.S.?" *Life,* August 8, 1949, 42–45.

84. Jasper Johns, conversation with the author, August 28, 1999.

85. Friedman, *Jackson Pollock: Energy Made Visible,* 187.

86. Clement Greenberg, "Feeling Is All," *Partisan Review,* January–February 1952; reprinted in John O'Brian, ed., *Clement Greenberg: The Collected Essays and Criticism,* vol. 3, *Affirmations and Refusals, 1950–1956* (Chicago: University of Chicago Press, 1993), 99–106.

87. Friedman, *Jackson Pollock: Energy Made Visible,* 187.

88. Carroll Janis described his father's installation methods in conversations with the author, August 18 and September 15, 1999.

89. Jeffrey Potter, *To a Violent Grave: An Oral Biography of Jackson Pollock* (New York: Pushcart, 1987), 157; Ileana Sonnabend, conversation with the author, November 11, 1999.

90. After her experiments with new ways of showing art in New York in the 1940s, Peggy Guggenheim eventually reverted to decorative hangings similar to Janis's after moving to Venice; the scholar Reesa Greenberg, conversation with the author, April 27, 2000.

91. Brian O'Doherty recalled Krasner's account in a conversation with the author, February 21, 2004.

92. Ben Heller, conversation with the author, September 15, 1999; Heller, letter to the author, August 11, 2000.

93. Cynthia Kellogg, "At Home with Art," *New York Times Magazine,* May 8, 1960, 84–86.

94. The taste for showing tribal sculpture and modern art together was initiated in about 1906 by Matisse, Derain, and Vlaminck, who were among the first to embrace African objects as art rather than ethnography; the trend was soon taken up by Picasso and others. Jean-Louis Paudrat, "The Arrival of Tribal Objects in the West from Africa," in William Rubin, ed., *"Primitivism": Affinity of the Tribal and the Modern,* vol. 1 (exhibition catalog, New York: Museum of Modern Art, 1984), 125–75.

95. Kirk Varnedoe, "Abstract Expressionism," in Rubin, *"Primitivism,"* 615–60.

96. Annalee Newman, conversation with the author, August 1999.

97. This and the following statements by Heller are based on a conversation with the author, September 15, 1999.

98. Klaus Kertess, "Eyewitnesses," *Alfonso Ossorio: Congregations* (exhibition catalog, Southampton, N.Y.: Parrish Art Museum, 1997), 13–19.

99. Francine du Plessix, "Ossorio the Magnificent," *Art in America,* March–April 1967, 56–65; Mike Solomon, director of the Ossorio Foundation (now defunct), conversation with the author, October 6, 2000.

100. Friedman, *Jackson Pollock: Energy Made Visible,* 167.

101. Francis V. O'Connor and David Whitney, a freelance curator, conversations with the author, October 30, 2000.

102. Muriel Newman, conversation with the author, October 23, 2000.

103. Hopps, conversation.

104. See Friedman, *Jackson Pollock: Energy Made Visible,* 205–36.

105. This and subsequent quotes from Sam Hunter

are from a conversation with the author, November 17, 1999.

106. *JPCR*, vol. 4, D87, p. 251.

107. Clement Greenberg, "The Situation at the Moment," *Partisan Review*, January 1948; reprinted in John O'Brian, ed., *Clement Greenberg: The Collected Essays and Criticism*, vol. 2, *Arrogant Purpose, 1945–1949* (Chicago: University of Chicago Press, 1986), 192–96.

108. Dore Ashton, "Art," *Arts and Architecture*, March 1957, 8–10, 38.

109. M.R., "Young Man from Wyoming," *Art Digest*, November 1, 1943, 11.

110. Thomas B. Hess, "Pollock: The Art of a Myth," *Art News*, January 1964, 39–40, 62–65.

111. Edward Alden Jewell, "Briefer Mention," *New York Times*, November 14, 1943, 2:6.

112. *Art News*, November 15–30, 1943, 23.

113. Howard Devree, "Among the New Exhibitions," *New York Times*, March 25, 1945; reprinted in Karmel, *Jackson Pollock*, 52.

114. Hunter, "Among the New Shows," in Karmel, *Jackson Pollock*.

115. "The Wild Ones," *Time*, February 20, 1956, 70, 75–76.

116. Sam Hunter, *Jackson Pollock* (exhibition catalog, New York: Museum of Modern Art, 1956), 5–12.

117. The description of the London installation is based on Trevor Dannatt's conversations with the author and a visit to the Whitechapel Art Gallery, January 6 and March 8, 2000, and Bryan Robertson's conversation with the author, February 11, 2000.

118. Because of the gallery's relatively small size, only twelve of the original twenty-nine drawings were shown, and those in a subsidiary area; Lawrence Alloway, "The Art of Jackson Pollock: 1912–1956," *Listener* (London), November 27, 1958.

119. Denys Sutton, "Arts and Entertainment: Jackson Pollock," *Financial Times* (London), November 25, 1958.

120. Carandente, an art historian, curator, and critic, is known for his installation, at the 1962 Festival of the Two Worlds, of David Smith sculptures on the tiers of Spoleto's Roman amphitheater, an arrangement that in turn inspired the stepped display of Smith sculpture in I. M. Pei's East Wing of the National Gallery in Washington, D.C., from 1988 to 1997. The description of Carandente's Rome installation is based on his telephone conversations with the author, September 2 and 17, 1999, and his letters to the author, October 25 and November 13, 1999.

121. Marco Valsecchi, "New American Painting," *Il Giorno* (Milan), June 10, 1958.

122. Jeremy Lewison, "Jackson Pollock and the Americanization of Europe," in Varnedoe and Karmel, *Jackson Pollock: New Approaches*, 201–32.

123. Guggenheim, *Out of This Century*, 347.

124. Marcello Venturoli, "Jackson Pollock e gli astrattisti italiani," *Paese Sera* (Rome), March 13–14, 1958.

125. Francis V. O'Connor, *Jackson Pollock* (exhibition catalog, New York: Museum of Modern Art, 1967). William Lieberman's opinions and quotations are taken from conversations with the author, March 25 and November 6, 1999.

126. Jennifer Licht Winkworth, then an associate curator of paintings at MoMA, conversation with the author, September 13, 1999.

127. Philip Johnson, who worked with Barr on many installations, asserts that walls for art should never be white because they make the area around the painting brighter than the painting itself, thereby detracting from it; Mary Anne Staniszewski, *The Power of Display: A History of Exhibition Installations at the Museum of Modern Art* (Cambridge, Mass.: MIT Press, 1998), 64.

128. William Rubin discussed Pollock's "conversion of drawing into painting" in "Jackson Pollock and the Modern Tradition," pt. 1, in Karmel, *Jackson Pollock*, 132. An exhibition entitled "Drawing into Painting" was later curated by Bernice Rose, who helped Lieberman prepare the 1967 exhibition.

129. Mel Bochner, "Jackson Pollock," *Art Magazine*, May 1967, 54.

130. "Pollock Revisited," *Time*, April 14, 1967, 8.

131. The exhibition catalog highlighted the paintings in an unusual way. Within the hefty 420-page book, only the reproductions were printed on traditional white coated stock; the texts were relegated to a deliberately poor-quality uncoated brown paper. In addition to dispelling the connotations of a coffee-table book, Abadie wanted to make a clear distinction between reproduction and information.

132. Abadie described his intentions in conversations with the author, December 9, 1999, and January 5, 2000.

133. See "La Première Exposition de Pollock en Europe," in Frédérique Villemur and Brigitte Pietrzak, *Paul Facchetti: Le Studio, Art Informel et Abstraction Lyrique* (Paris: Actes Sud, 2004), 92–102.

134. Robertson, conversation.

135. See Francis V. O'Connor, "Jackson Pollock: The Black Pourings," in *Jackson Pollock: The Black Pourings, 1951–1953* (exhibition catalog, Boston: Institute of Contemporary Art, 1980), 1–29.

136. Peter Schjeldahl, conversation with the author, February 29, 2000.

137. See William Rubin, "Pollock as Jungian Illustrator: The Limits of Psychological Criticism," *Art in America*, November 1979, 104–23, and December 1979, 72–91; reprinted in Karmel, *Jackson Pollock*, 220–261.

138. This and subsequent statements by Kirk Varnedoe are from a conversation with the author, June 26, 1999.

139. The configuration changed when *Full Fathom Five* or the Krasner went out on loan; Kirk Varnedoe, letter to the author, November 6, 2000.

140. Pepe Karmel, letter to the author, September 18, 2003.

141. This kind of symmetrical hang, commonly used for Old Master paintings, was a hallmark of Gaillard F. Ravenel, the designer of exhibitions at the National Gallery of Art in Washington, D.C., from 1970 until his death in 1996. Having worked with Ravenel on a Rodin exhibition (1981–82) at the National Gallery, Varnedoe may have been influenced by his approach.

142. Frank Stella, conversation with the author, June 12, 2000.

143. Details of the barn's reproduction are based on Jerry Neuner, conversation with the author, April 12, 2000.

144. Rubin has pointed out how Pollock's metallic pigments dissolve his skeins of color; together they become an all-over tonality; "Jackson Pollock and the Modern Tradition," pt. 2, in Karmel, *Jackson Pollock*, 143.

145. Francis V. O'Connor, "Pollock in Utopia: A Tour of the Exhibition," *Pollock Watch Review No. 9A* (O'Connor's Web site), December 1, 1998, http://www.members.aol.com/FVOC.

146. The International Association of Art Critics, a Paris-based organization, designated it the best exhibition at a New York museum in 1998–99 and the best catalog; attendance neared 330,000.

147. Sir Nicholas Serota, conversation with the author, May 12, 1999.

148. This and other explanations of why the Tate installed the exhibition differently from MoMA are based on Jeremy Lewison, conversation with the author, July 12, 1999.

149. David Sylvester, "The Grin without the Cat: David Sylvester Views Jackson Pollock at the Tate," *London Review of Books*, April 1, 1999, 3–9; and Sylvester, "Illuminating Pollock," *London Review of Books*, May 27, 1999, 4.

150. Firmly denied by Krasner, *JPCR*, vol. 2, no. 367, pp. 193, 196, and by Annalee Newman, conversation, Fall 1998.

151. Richard Serra, conversation with the author, September 7, 1999.

152. Rubin, "Jackson Pollock and the Modern Tradition," pt. 2, in Karmel, *Jackson Pollock*, 144, 150.

153. Clement Greenberg, "Jackson Pollock: Inspiration, Vision, Intuitive Decision," *Vogue*, April 1967, 160–61; reprinted in Karmel, *Jackson Pollock*, 110–14.

Placing Art

1. Beate Dube, wife of the former director of Berlin Museums, conversation with the author, November 26, 2002.

2. Antoine Picon, "Interview with Renzo Piano and Richard Rogers," in Renzo Piano and Richard Rogers, *Du Plateau Beaubourg au Centre Georges Pompidou* (Paris: Centre Culturel Georges Pompidou, 1987), 9–44.

3. Alanna Heiss, conversation with the author, September 1, 2001.

4. Maja Oeri, conversation with the author, November 12, 2003.

5. Christian Witt-Dörring, conversation with the author, October 7, 2003.

6. Brian O'Doherty, "Studio and Cube" (Franklin

Murphy Lecture, University of Kansas, Lawrence, March 17, 1980).

7. See, for example, Daniel Buren, "The Function of the Studio," *October* 10 (Fall 1979): 51–58.

8. Otto Friedrich, *Olympia: Paris in the Age of Manet* (New York: HarperCollins, 1992), 304–6.

9. Friedrich, *Olympia,* 4.

10. Brian O'Doherty, conversation with the author, November 23, 2001.

11. Madeleine Rebérioux, "Où est l'histoire? A la périphérie," *Le Nouvel Observateur,* January 16–22, 1987, 100.

12. Friedrich, *Olympia,* 8.

13. Eric Darragon, *Manet* (Paris: Fayard, 1989), 115, 120.

14. It would be fair to say that all the works shown on the museum's ground level have been downgraded in comparison to their previous displays at the Jeu de Paume and the Louvre.

15. Françoise Cachin, "Les Réponses," *Le Nouvel Observateur,* January 16–22, 1987, 100–101.

16. Rebérioux, "Où est l'histoire?"

17. Kirk Varnedoe, conversation with the author, May 21, 2003.

18. Dominique Defont-Reaulx, curator of architecture and decorative arts, Musée d'Orsay, conversation with the author, October 13, 2003.

19. John Walsh, conversation with the author, April 21, 2003.

20. Jo Hedley, curator of paintings pre-1800, Wallace Collection, conversation with the author, October 15, 2004.

21. Milton Esterow, "From Slot Machines to the Sublime," *Art News,* December 2001, 122–27.

22. This intention was described by Guggenheim director Thomas Krens in a conversation with the author, October 17, 2000.

23. Paul Schwartzbaum, who directed this research for the museum, in a statement to the author.

24. Esterow, "From Slot Machines to the Sublime."

25. This and the following quote are from Krens, conversation.

26. Unless otherwise specified, the curators' intentions are based on John Elderfield, Peter Reed, Mary Chan, and Maria del Carmen Gonzalez, "Making 'ModernStarts,'" in Elderfield, Reed, Chan, and del Carmen Gonzalez, *ModernStarts: People, Places, Things* (exhibition catalog, New York: Museum of Modern Art, 1999), 17–31.

27. "Modern Starts" was divided into three sections: "People," "Places," and "Things." The second cycle (1920–60) of "MoMA 2000" was entitled "Making Choices," the third (1960–2000), "Open Ends." For "white cube," see Brian O'Doherty, *Inside the White Cube: The Ideology of the Gallery Space* (Berkeley and Los Angeles: University of California Press, 1999).

28. Magdalena Dabrowski, conversation with the author, April 21, 2003.

29. Robert Boardingham, "Cézanne and the 1904 Salon d'Automne: 'Un chef d'une école nouvelle,'" *Apollo,* October 1995, 31–39.

30. Mary Anne Staniszewski, *The Power of Display: A History of Exhibition Installations at the Museum of Modern Art* (Cambridge, Mass.: MIT Press, 1998), 62.

31. See Gary Tinterow, "Raphael Replaced: The Triumph of Spanish Painting in France," and Jeannine Baticle, "The Galerie Espagnole of Louis-Philippe," in Gary Tinterow and Geneviève Lacambre with Deborah L. Roldán and Juliet Wilson-Bareau, *Manet/Velázquez: The French Taste for Spanish Painting* (New Haven: Yale University Press, 2003), 3–66, 175–90.

32. Comparison of the two installations is based on my own experience and on conversations with Jeffrey L. Daly, chief designer of the Metropolitan Museum of Art's Exhibition Design Department, April 16, 2003; with Gary Tinterow, April 21, 2003; and with Geneviève Lacambre, May 12, 2003.

33. Bernice Rose, conversation with the author, April 16, 2003.

34. William Feaver, conversation with the author, May 16, 2003.

35. Victoria Newhouse, *Towards a New Museum* (New York: Monacelli Press, 1998), 26.

36. John Richardson, *A Life of Picasso,* vol. 2, *1907–1917* (New York: Random House, 1996), 32.

37. Hilton Kramer, "MOMA Reopened: The Museum of Modern Art in the Postmodern Era," *New Criterion,* Summer 1984, 1–44.

38. Kirk Varnedoe's description of the picture and his installations is based on his conversations with the author, April 30, May 21, and June 6, 2003.

39. Richardon, *Life of Picasso,* vol. 2, 33.

40. Elderfield described the processin a conversation with the author, February 2, 2000.

41. Charles Curtis Mead, *Charles Garnier's Paris Opera* (New York: Architectural History Foundation/Cambridge, Mass.: MIT Press, 1991), 132.

42. Frank Stella, conversations with the author, February 2 and June 12, 2000.

43. Philip Johnson, conversation with the author, November 18, 1998.

44. Germain Bazin, *The Museum Age* (New York: Universe Books, 1967), 172.

45. Harald Szeemann, conversation with the author, December 17, 1998.

46. Brunilde Sismondo Ridgway, "*Athena Parthenos:* The Parthenon in Athens and Nashville" (lecture, Studio School, New York, April 9, 2003).

47. Kenneth D. S. Lapatin, "The Ancient Reception of Pheidias' *Athena Parthenos:* The Visual Evidence in Context," http://www.open .ac.uk/Arts/CC96/lapatin.htm

48. Discussion of the *Zeus* is based on Kenneth D. S. Lapatin, "The Pheidian Revolution," *Chryselephantine Statuary in the Ancient World* (New York: Oxford University Press, 2001), 61–95, figs. 149–204, plates VI–XIV.

49. Walter Burkert, "The Meaning and Function of the Temple in Classical Greece," in Michael V. Fox, ed., *Temple in Society* (Winona Lake, Ind.: Eisenbrauns, 1988), 28–47.

50. Peter Edgar Corbett, "Greek Temples and Greek Worshippers: The Literary and Archaeological Evidence," *University of London Institute of Classical Studies Bulletin* 17 (1970): 149–58.

51. Ridgway, "*Athena Parthenos.*"

52. Deborah Tarn Steiner, *Images in Mind: Statues in Ancient and Classical Greek Literature and Thought* (Princeton, N.J.: Princeton University Press, 2001), 101.

53. The description of Richard Serra's methods and intentions and the quotes from Serra are based on Lynne Cooke and Michael Govan, "Interview with Richard Serra," in *Richard Serra: Torqued Ellipses* (exhibition catalog, New York: Dia Center for the Arts, 1997), 11–32; for Serra's distinction between sculpture and architecture, see Richard Serra and Clara Weyergraf, *Richard Serra: Interviews, Etc., 1970–1980* (Yonkers: Hudson River Museum, 1980), esp. 16, 55, 73, 128.

54. Avigdor Arikha, "L'extinction de la peinture," *Le Monde,* March 15, 1997 (my translation).

55. Lapatin, "Pheidian Revolution"; see also Wolfgang Schiering, *Die Werkstatt des Pheidias in Olympia,* vol. 2 (Berlin: Walter de Gruyter, 1991).

56. The discussion of light in ancient Greek temples is based on Wolfram Hoepfner, "Der Parische Lichtdom," *Antike Welt* 32, no. 5 (2001): 491–506; see also Irmgard Heile, "Licht und Dach beim griechischen Templen," Christine Skrabei, "Fenster in Griechischen Templen," and Claudia Wölfel, "Erwägungen zur künstlichen Beleuchtung von Skulptur," in Wolf-Dieter Heilmeyer and Wolfram Hoepfner, eds., *Licht und Architektur* (Tübingen: Ernst Wasmuth, 1990), 27–51.

57. Michael Kimmelman, "The Dia Generation," *New York Times Magazine,* April 6, 2003, 72.

58. Philip Fisher, "The Future's Past," *New Literary History* 6, no. 3 (Spring 1975): 587–606.

59. Denise Allen, conversation with the author, May 28, 2004.

60. Philip Johnson, conversation with the author, November 8, 1999.

61. John Elderfield has pointed out that even Barr had misgivings about the genealogy when it came to the installation of the permanent collection, arranging artworks with respect to the architectural grid of the galleries rather than the genealogy; "After ModernStarts" (lecture, Art History School, Universidad Internacional Menéndez Pelayo, Santander, Spain, Summer 2000).

62. David Sylvester, "Mayhem at Millbank," *London Review of Books,* May 18, 2000, 19–20.

63. Stella, conversations; and "Dead Endings," *The Writings of Frank Stella* (Jena and Cologne: Walther König, 2001), 290–91.

64. Herbert Bayer, "Aspects of Design of Exhibitions and Museums," *Curator* 4, no. 3 (1961): 257–87.

65. Description of this rationale and of the paintings is based on John Elderfield, "Actors, Dancers, Bathers," in Elderfield et al.,

ModernStarts, 127–45; and Elderfield, conversation.

66. Tinterow, conversation.

67. Even the George W. Bush administration's media strategy for the war against Iraq was based on "story-lining" the conflict; Peter J. Boyer, "The New War Machine," *New Yorker,* June 30, 2003, 55–71.

68. Martha Ward, "Impressionist Installations and Private Exhibitions," *Art Bulletin,* December 1991, 599–622.

69. Catherine de Zegher, *The Stage of Drawing: Gesture and Act, Selected from the Tate Collection* (exhibition catalog, New York: Drawing Center Publications, 2003); and de Zegher, conversation with the author, May 22, 2003.

70. Norman Bryson, "A Walk for a Walk's Sake," in de Zegher, *Stage of Drawing,* 149–58.

71. Unless otherwise noted, the discussion of framing and the quotes on that subject are taken from the insightful analysis by Reesa Greenberg in "MoMA and Modernism: The Frame Game," *Parachute,* March–May 1986, 21–31.

72. Elderfield, "After ModernStarts"; and Elderfield, e-mail message to the author, July 9, 2003.

73. Malcolm Baker, "Bode and Museum Display: The Arrangement of the Kaiser-Friedrich-Museum and the South Kensington Response," *Jahrbuch der Berliner Museen* 58 (1966): 143–53. For another innovative approach to period rooms, Alexander Dorner's "atmosphere rooms" of the 1920s, see Samuel Cauman, *The Living Museum: Experiences of an Art Historian and Museum Director—Alexander Dorner* (New York: New York University Press, 1958), 88.

74. Jane Brown Gillette, "Rooms Once Removed," *Historic Preservation,* July–August 1991, 31–36, 71.

75. Morrison H. Heckscher, "Collecting Period Rooms: Frank Lloyd Wright's Francis W. Little House," in Thomas Hoving, ed., *The Chase, the Capture: Collecting at the Metropolitan* (New York: Metropolitan Museum of Art, 1975), 207–17.

76. Witt-Dörring, conversation.

77. David DeLong, e-mail message to the author, December 3, 2003.

78. Mildred Friedman, conversations with the author, August 21, 2000, and April 11, 2003.

79. John Pastier, "Frank Gehry at the Walker: 'A Taste of the Real Thing,'" *Architecture,* November 1986, 20–21.

80. Jean Nouvel, conversation with the author, May 13, 2003.

81. The description of blockbuster mills is based on Lee Rosenbaum, "Blockbusters, Inc.," *Art in America,* June 1997, 45–53.

82. Unless otherwise specified, the discussion of the Kandinsky paintings and their installation is based on Magdalena Dabrowski, "Vasily Kandinsky: The Campbell Commission," *MoMA Bulletin,* November 1999, 2–5; and Dabrowski, conversation.

83. James Coddington and Magdalena Dabrowski,

"The Installation of Kandinsky's Paintings Numbers 198–201" (unpublished paper, annual meeting of the College Art Association, Boston, February 24, 1996).

84. Coddington and Dabrowski, "Installation of Kandinsky's Paintings."

85. Dimensions were provided by the architect Marco Borella, who is currently investigating the Camerino's original disposition.

86. Charles Hope, "The 'Camerini d'Alabastro' of Alfonso d'Este, I," *Burlington Magazine,* November 1971, 641–50.

87. Unless otherwise indicated, the description of the Camerino is based on David Jaffé, Nicholas Penny, Caroline Campbell, and Amanda Bradley, "Alfonso d'Este's Camerino," in *Titian* (exhibition catalog, London: National Gallery, 2003), 100–111.

88. John Walker, *Bellini and Titian at Ferrara* (London: Phaidon Press, 1956), 64.

89. I am indebted to Amanda Bradley and David Jaffé for details of the National Gallery installation.

90. The description of relationships between the paintings is based on David Jaffé, conversation with the author, August 25, 2003.

91. Jaffé, conversation.

92. This conjecture of David Jaffé's is based on Marco Borella's discovery of part of the original floor.

93. Ingrid Rowland, "From Heaven to Arcadia," *New York Review of Books,* August 14, 2003, 8–11.

94. Amanda Bradley, letter to the author, October 8, 2003.

95. Jaffé et al., "Alfonso d'Este's Camerino."

96. Richard A. Fazzini, chairman of the Department of Egyptian Art at the Brooklyn Museum, conversation with the author, November 20, 1998.

97. Donald Albrecht, "Brooklyn Museum Renovation Unveiled," *Architecture,* January 1994, 25.

98. James F. Romano described concepts for the new galleries in a visit with the author, May 27, 2003.

99. Barbara Kirshenblatt-Gimblett, *Destination Culture: Tourism, Museums, and Heritage* (Berkeley and Los Angeles: University of California Press, 1998), 138.

100. Krzysztof Pomian, *Des saintes reliques à l'art moderne, Venise-Chicago XIII–XX Siècle* (Paris: Gallimard, 2003), 273–74.

101. Deyan Sudjic, "Cinque minuti di celebrità," *Domus,* April 2003, 18–19.

102. Yve-Alain Bois, "Exposition: Esthétique de la distraction, éspace de démonstration," *Les Cahiers du Musée National d'Art Moderne,* Autumn 1989, 57–79.

103. "If You Build It, Will They Come?: Art's Gamble for Architectural Glory" (symposium, American Institute of Architects, New York, February 14, 2004); "Museum Architecture" (symposium, American Federation of the Arts, Columbia University, New York, March 29, 2004).

INDEX

Page numbers in *italics* refer to illustrations.

ILLUSTRATION CREDITS

Numbers refer to figure numbers. The author and the publisher have made every effort to identify owners of copyrighted material. Any omissions will be rectified in future editions.

© Hervé Abbadie/Jean-François Bodin architect: 109, 119

Berenice Abbott/Commerce Graphics, Ltd.: 147

© 2000 The Absolut Company. Courtesy TBWA/Chiat/Day: 33

Courtesy Ace Gallery, New York: 31

© Alinari/Art Resource, New York: 6, 7, 65, 66, 86, 87

© Alinari Photo Archive: 78

Courtesy Bernard Andreae: 79, 80, 81

Archaeological Museum, Olympia: 41

© Art Institute of Chicago: 92

© Bruno Barbey/Magnum Photos: 104

© Reproduced with permission of the Barnes Foundation. All rights reserved: 19

Courtesy Bellagio Gallery of Fine Art, Las Vegas: 219

© Raffaello Bencini, 2003: 8

Courtesy Biblioteca Nazionale Marciana, Venice: 12

Bibliothèque Nationale de France, Paris: 13, 14, 17

© Bildarchiv Preussischer Kulturbesitz/Art Resource, New York: 56

R. O. Blechman. Copyright © 1990 Condé Nast Publications, Inc. Reprinted by permission. All rights reserved: 96

© The British Library: 61, 62

© The British Museum, London: 15, 37, 57, 73, 98, 100, 137

Courtesy Brooklyn Museum of Art: 274, 275, 276

Courtesy Giovanni Carandente: 173, 174, 175, 178

© Centre des Monuments Nationaux, Paris: 82

© Centre Pompidou/Georges Meguerditchian: 277, 278

Comte de Clarac, *Déscription du musée royal des antiques du Louvre* (Paris, 1847): 51

© Roger Dong: 3, 5

© Doria Pamphili, Rome: 35

Courtesy The Drawing Center, New York: 253, 254, 255

© Todd Eberle: 4, 226, 240, 241

© Engelman: 97

Courtesy Fine Arts Museums of San Francisco: 161

Courtesy FLICK Collection/photograph A. Burger: 32

Courtesy Fondazione Canova: 244

Brian Forest, courtesy Janine Antoni and Luhring Augustine, New York: 29

© R. Friedrich: 177

Courtesy J. Paul Getty Museum/photograph Tom Bonner: 246

© David Gibson: 139

Courtesy Grand Palais, Paris: 114, 120, 126

Courtesy Grand Palais, Paris/Jean-François Bodin: 105

William Grigsby, courtesy The Ossorio Foundation: 163

© FMGB Guggenheim Bilbao Museoa/photograph Erika Barahona Ede. All rights reserved: 239

© Solomon R. Guggenheim Foundation, New York: 30, 149

David Heald; © Solomon R. Guggenheim Foundation, New York: 218

Mark Heathcote/Tate Britain: 21

Courtesy Ben Heller: 159, 160

Courtesy Carroll Janis: 157, 158

© Judd Foundation 2004/photograph © Todd Eberle, 2004: 210

© 2004 Tobias Kaempf: 77

Courtesy Kimball Museum of Art: 215

Courtesy Kleihues + Kleihues/photograph Christian Richters: 235

Courtesy Heiner Knell: 43, 44

Courtesy Jeff Koons Productions, Inc.: 28

Courtesy Kunsthaus, Bregenz, 1997–98, Per Kirkeby Austellungsansicht/photograph © KUB (Bereuter): 217

© Kupferstichkabinett, Berlin/Jorg P. Anders, Atelier am Kulturforum: 58

Denis L. Kurutz, ASLA & Associates. © 2001 J. Paul Getty Trust. Reproduced with permission: 90

Michel Legendre/© Collection Centre Canadien d'Architecture, Montreal: 263

Mirko Lion, courtesy Eugene V. Thaw Archive: 145

Courtesy Richard Long/photograph © Tate Modern, 2000: 251, 252

© Giacomo Lovera: 135, 136

© Manchester Archives and Local Studies, Manchester, England: 20

© Guy Marineau: 47, 50, 72, 130, 131, 138, 232

© C. Mattusch: 84

Courtesy Metropolitan Museum of Art, New York: 22, 93, 106, 110, 113, 116, 121, 122, 124, 127, 129, 221, 222, 250, 256

Courtesy Miramax Films, 1994: 279

© The Mississippi Commission for International Cultural Exchange, Inc., and Steven Brooke: 266

Derry Moore/Victoria and Albert Museum, London: 260, 261

Courtesy Documentation Photographique du Musée d'Orsay: 211, 213

Courtesy Documentation Photographique du Musée d'Orsay/photograph S. Bregly: 223, 224

© Musée d'Orsay/J.-P. Pinon: 212, 214

© Musée National d'Art Moderne-Centre Georges Pompidou: 188, 189, 190, 191, 192, 193

© Musée National d'Art Moderne-Centre Georges Pompidou, Bibliothèque Kandinsky: 265

Courtesy Museum für Angewandte Kunst, Frankfurt am Main: 257

© Museum of Fine Arts, Boston: 34, 132, 133

Courtesy The Museum of Fine Arts, Houston: 176

© The Museum of Modern Art, New York: 18, 25, 36, 150, 165, 166, 179, 180, 181, 182, 183, 184, 185, 186, 187, 194, 197, 198, 199, 200, 201, 202, 220, 229, 247, 249, 267, 268, 269

© The Museum of Modern Art, New York/Licensed by SCALA/Art Resource, New York/Artists Rights Society: 45

© Hans Namuth Studio: 141, 142, 155, 156

© Hans Namuth Studio, courtesy The Ossorio Foundation: 162

© 2004 Board of Trustees, National Gallery of Art, Washington, D.C.: 11, 245

Courtesy National Gallery Picture Library: 271

Courtesy National Gallery Picture Library/reconstruction by Robert Cripps: 272

Courtesy Neue Galerie/photograph Mary Hilliard: 242

© 1974 Newsweek, Inc. All rights reserved. Reprinted by permission: 95

General Research Division, The New York Public Library, Astor, Lenox and Tilden Foundations: 40

Rare Books Division, The New York Public Library, Astor, Lenox and Tilden Foundations: 1

Copyright © 2004 by The New York Times Co. Reprinted with permission: 94

© Claes Oldenburg and Coosje van Bruggen/photograph Robert McElroy: 27

© Oriental Institute of Chicago: 103

Oriental Institute Publications, vol. 51:IV: 101, 102

Courtesy Claude Parent: 262

Courtesy The Parthenon, Nashville, Tennessee/photograph Gary Layda: 236

© Patrimonio Nacional, Spain: 59

© Robert Pettus/Pulitzer Foundation for the Arts: 233, 234

© Nicholas Picardo: 140

Courtesy Pollock-Krasner House and Study Center, East Hampton, New York/model Patrick Bodden under Peter Blake's supervision, photograph Jeff Heatley: 153

Courtesy Pollock-Krasner House and Study Center, East Hampton, New York/photograph Ben Schultz: 152

Courtesy Prada USA Corp.: 26

Courtesy Prado Museum, Madrid: 273

Réunion des Musées Nationaux: 48, 49, 52, 53, 123

Réunion des Musées Nationaux/Art Resource, New York: 16, 39, 70, 71

© Rijksmuseum van Oudheden, Leiden: 134

© Roemer- und Pelisaeus Museum, Hildesheim: 112

The Royal Collection © 2004, Her Majesty Queen Elizabeth II: 9

© Royal Museums of Fine Art, Belgium: 60

© Royal Ontario Museum: 107, 108, 111, 115, 117, 118, 125, 128

The Saatchi Gallery, London: 23

Courtesy Richard Serra studio/photograph Ivory Serra: 238

Julius Shulman/© J. Paul Getty Trust: 91

© Sir John Soane's Museum, London: 55

© Fritz Simak, Vienna, 2003: 243

Courtesy Tony Smith Estate: 154

Tony Soluri. Courtesy *Architectural Digest*. © The Condé Nast Publications. Used with permission. All rights reserved: 164

Soprintendenza Archeologica di Napoli e Caserta (Laboratorio Fotográfico): 88, 89

Staatliches Museum, Schwerin: 38

Courtesy Staatliches Museum Ägyptischer Kunst, Munich: 99

Courtesy Stiftung Insel Hombroich: 227

© Szépmüvészeti Múzeum, Budapest: 2

Courtesy Tate Britain: 225

Courtesy Tate Gallery, London: 204, 205, 206, 207, 208, 209

© Teylers Museum, Haarlem: 63

University of Iowa Museum of Art: 151

© Kirk Varnedoe, courtesy The Museum of Modern Art, New York: 230

© The Vatican Museums: 54, 64, 69, 74

Courtesy Walker Art Center: 264

Reproduced by kind permission of the Trustees of the Wallace Collection, London: 216

Courtesy The Whitechapel Art Gallery, London: 168, 169, 170, 171, 172

© Tim Willis, courtesy The Museum of Modern Art, New York: 231, 248

Gerald Zugmann/MAK, Austrian Museum of Applied Arts/Contemporary Art, Vienna: 258, 259